RAPHAEL AND AMERICA

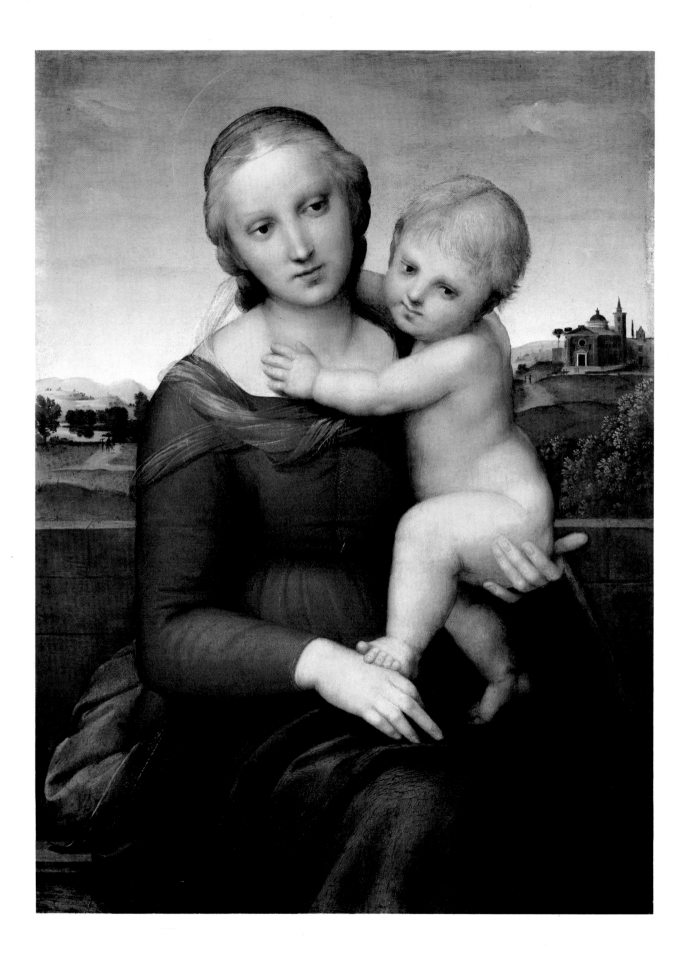

Raphael and America

DAVID ALAN BROWN

NATIONAL GALLERY OF ART
WASHINGTON

This catalogue was produced by the Editors Office, National Gallery of Art, Washington
Printed at Wolk Press, Inc., Baltimore, Maryland
The type is Galliard, set by Composition Systems Inc., Arlington, Virginia
The text paper is Warren Lustro Offset Enamel Cream, with matching cover
Edited by Paula M. Smiley
Designed by Melanie B. Ness

Exhibition dates at the National Gallery of Art:
January 9-May 8, 1983

Cover: Raphael, *Saint George and the Dragon.* National Gallery of Art, Washington, Andrew W. Mellon Collection, 1937

Frontispiece: Raphael, *Small Cowper Madonna.* National Gallery of Art, Washington, Widener Collection, 1942

Library of Congress Cataloging in Publication Data
Brown, David Alan, 1942-
Raphael and America.
 Catalog of an exhibition held at the National Gallery of Art, Washington, D.C. in 1983, in commemoration of the 500th anniversary of Raphael's birth.
 1. Raphael, 1483-1520—Exhibitions. 2. Painting, Italian—Collectors and collecting—United States—Exhibitions. I. Raphael, 1483-1520. II. National Gallery of Art (U.S.) III. Title.
ISBN 0-89468-064-1 ND623.R2A4 1983 759.5 82-22405

Contents

Foreword J. CARTER BROWN 7

Acknowledgments 8

Lenders to the Exhibition 10

Introduction 13

 I *Raphael's Prestige* 15

 Early American Artists and Collectors 15

 Later American Collectors 28

 Notes to Part I 97

 II *Raphael's Creativity as Shown by*
 His Paintings in America 109

 Formation 110

 Florence 123

 Rome 164

 Notes to Part II 188

List of Objects in the Exhibition 202

 GRETCHEN HIRSCHAUER

Detail, Raphael, Small Cowper Madonna. *National Gallery of Art, Washington, Widener Collection, 1942.*

Foreword

As the "Prince of Painters," Raphael once enjoyed a unique status. Many admirers in his own time and afterwards ranked him above all other artists. Today, however, he takes his place among, not above, a small number of supremely gifted painters. Consequently, we can regard his prestige as a part of cultural history and approach his art without preconceptions.

The adulation of Raphael may belong to the past, but the value given to his works remains as great as ever. As we looked ahead to his 500th anniversary, we wondered if a loan exhibition in celebration of it would even be possible, so treasured by their owners are his works and so fragile are the 500-year-old panels on which most of them were painted. We are most grateful, therefore, to the owners of his pictures and drawings who have agreed to lend to this celebration of Raphael and America. We are also greatly indebted to The National Italian American Foundation for its generous contribution in support of the exhibition.

The organizing concept for the exhibition is Raphael's importance for American artists and collectors. The esteem in which his works were held by artists who imitated them and by collectors who acquired them provides the theme of the first part of our tribute. The exhibition then reassesses Raphael's paintings in America. It offers a look at the creative process lying behind the pictures by comparing them with preliminary or related drawings by Raphael and with works by other artists which he took as sources of inspiration.

Americans were latecomers as collectors of Raphael. Nevertheless, they did succeed in acquiring fine paintings by him, nine of which are exhibited here. They have been brought together with objects that provide a context for the Raphael masterworks on display. The exhibition focuses on paintings by Raphael which pertain to the history of taste and collecting in this country. Drawings by him are included only insofar as they relate to the paintings on view. Of the twelve Raphael drawings exhibited, one is a sheet recently acquired by the National Gallery of Art as a study for our *Saint George and the Dragon*, a painting whose extraordinary condition, quality, and provenance make it easy for us to appreciate the special admiration for Raphael that has existed since colonial times in America.

J. Carter Brown
Director

Acknowledgments

IN ORGANIZING THE exhibition and writing the book which accompanies it I have been helped by many colleagues in other institutions. My thanks go to all of them. A few fellow curators who should be mentioned by name are Konrad Oberhuber, Jane Roberts, Keith Christiansen, William Johnston, William Voelkle, Deborah Gribbon, James Kettlewell, Annamaria Petrioli Tofani, Fiorella Superbi, Gertrude Rosenthal, and James Welu. Scholars who provided counsel include Federico Zeri, Cornelius Vermeule, Marilyn Perry, William Gerdts, Richard Saunders, Lillian Miller, and William Mostyn-Owen. In addition, we are most grateful to Cecil Anrep and to Rollin van N. Hadley for permission to consult and to publish correspondence at Villa I Tatti and at Fenway Court.

The complicated negotiations for loans from the Uffizi were aided by the interest taken in the exhibition by His Excellency Ambassador Petrignani in Washington and by the Cultural Attaché of the Italian Embassy, Professor Bozzetti.

The exhibition involved wide-ranging research, and able assistance of various kinds was offered by Ann Priester, Carolyn Wells, Marty Donnellan, Jane Van Nimmen, Nadia Stanley, and Gigliola Tatge. The theme of Raphael's importance for America has many aspects which could not be treated in the form of an exhibition. Evelyn Samuels Welch, who, as a Gallery intern, contributed much to our

project, will continue her Raphael investigations as part of a larger study of America and the Italian Old Masters.

Gallery staff members made major contributions, too. In the Department of Early Italian Paintings, Gretchen Hirschauer performed an infinity of research tasks and prepared the checklist of objects, and Anne Christiansen typed the manuscript. Gaillard Ravenel and Mark Leithauser undertook the installation. Russell Sale read the manuscript and worked on the wall texts and labels. Ross Merrill was responsible for the conservation of the *Small Cowper Madonna*, which, in its newly cleaned state, is one of the high points of the exhibition, and Carol Christensen prepared technical reports on our Raphael paintings. Andrew Robison and Shelley Fletcher were helpful in investigating our recently acquired drawing for *Saint George and the Dragon*. The Gallery's library, with its extensive Raphael holdings, and our photo archive were invaluable resources. Dorothy Faul of the library staff bound a book for the exhibition.

The short film in the exhibition was produced by Robert Pierce/ Films, Inc. They were assisted by David McGannon. The film is distributed through the Gallery's Department of Extension Programs.

David Alan Brown
Curator of Early Italian Paintings

Lenders to the Exhibition

Graphische Sammlung Albertina, Vienna
The Visitors of the Ashmolean Museum, Oxford
The Baltimore Museum of Art
Bowdoin College Museum of Art, Brunswick
Trustees of the British Museum, London
The Governing Body, Christ Church, Oxford
The Cleveland Museum of Art
The Detroit Institute of Arts
Ecole Nationale Supérieure des Beaux-Arts, Paris
H.M. Queen Elizabeth II, Royal Collection,
 Windsor Castle
The Fogg Art Museum, Harvard University, Cambridge
Isabella Stewart Gardner Museum, Boston
The Hyde Collection, Glens Falls, New York
Thomas Jefferson Memorial Foundation, Monticello
Kennedy Galleries, Inc., New York
Samuel H. Kress Foundation, New York
The Library of Congress, Washington
Mr. Paul Mellon, Upperville, Virginia
The Metropolitan Museum of Art, New York

Members of Henry Siddons Mowbray's Family
Musée du Louvre, Paris
Cabinet des Dessins, Musée du Louvre, Paris
Museum Boymans-van Beuningen, Rotterdam
Museum of Fine Arts, Boston
Nelson Gallery-Atkins Museum, Kansas City
North Carolina Museum of Art, Raleigh
The Pierpont Morgan Library, New York
Rijksprentenkabinet, Rijksmuseum, Amsterdam
Joseph Shepperd Rogers, Landover, Maryland
Mr. and Mrs. St. Clair M. Smith, Punta Gorda, Florida
Mr. and Mrs. Bernard C. Solomon, Beverly Hills
Gabinetto Disegni e Stampe degli Uffizi, Florence
Utah Museum of Fine Arts, Salt Lake City
Villa I Tatti, Harvard University Center for Italian Renaissance
 Studies, Florence
Wadsworth Atheneum, Hartford
The Walters Art Gallery, Baltimore
Worcester Art Museum
Yale University Library, New Haven

Introduction

THE YEAR 1983 marks the 500th anniversary of Raphael's birth. The National Gallery of Art, fortunate to possess the finest and most comprehensive collection of the artist's paintings in America, is celebrating with an exhibition, including the Gallery's own holdings and works from American and foreign lenders.

The exhibition honoring Raphael is divided into two parts. The first focuses on his prestige and, in particular, on his importance for American artists and collectors. Artists, like Benjamin West, imitated Raphael, while early collectors obtained copies of his masterpieces or paintings mistaken as originals. Though not widely recognized, American collecting of original works by Raphael is a twentieth-century phenomenon. Such great collectors as Isabella Stewart Gardner, J. P. Morgan, the Wideners, and Andrew Mellon vied to acquire whatever works were still available by the great painter.

Having placed Raphael in a context that relates to modern times, the exhibition goes on to examine his creativity, as shown by his paintings in American collections. The paintings are compared with preparatory and related drawings by Raphael and with his sources of inspiration in the work of other artists.

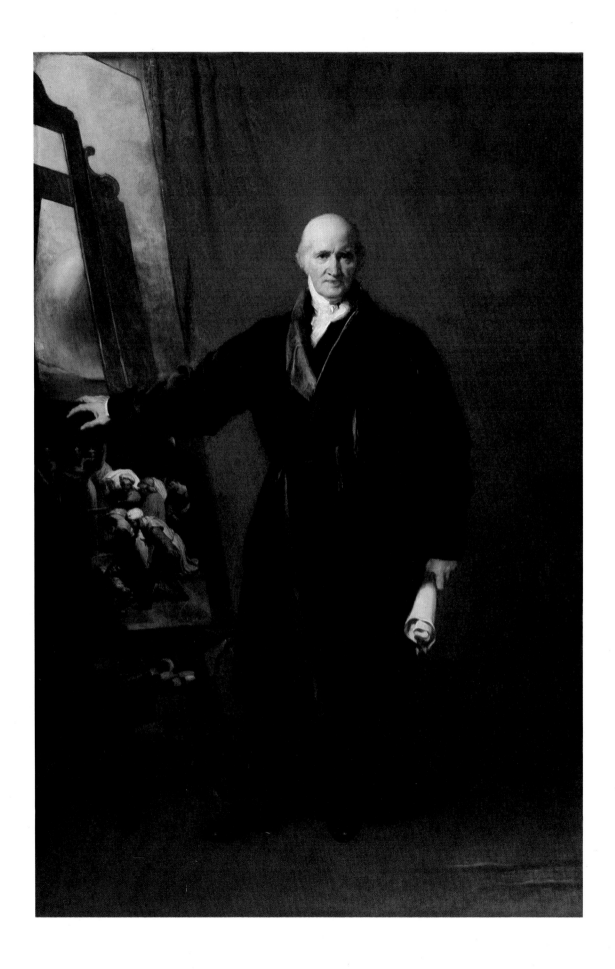

I Raphael's Prestige

RAPHAEL HAS LONG BEEN recognized as a leading force in European culture. Following his death in 1520, his paintings set the standard by which the artists who came after him were judged. But the significant role that Raphael—his reputation and his works—played in American cultural life is not well known. Americans have been intensely concerned with Raphael at two moments in our history. First, a number of artists went abroad in the eighteenth and nineteenth centuries, seeking inspiration from his pictures and identifying themselves with his tradition. The public that these artists left behind also became familiar with Raphael's masterworks through copies widely diffused in the form of paintings, prints, and photographs. During the second major phase of American interest in Raphael, a group of collectors, turning their backs on copies, set out at the beginning of this century to acquire the master's few remaining available works.

Early American Artists and Collectors

The image Americans held of Raphael in the nineteenth century may be seen in a statue [1]* of the artist (fig. 1) by Thomas Crawford. The first American sculptor to settle in Rome, Crawford (1813-1857) soon absorbed the prevailing classical taste. He became the center of a bustling expatriate community, executing many works for friends and visitors to his studio. His method was to provide a plaster model for assistants to carve in stone. One of these commissions was probably the half-life-size portrait of Raphael, known in two versions, one of which is exhibited.[1] In this statue, signed and dated 1855, Crawford combined a literal realism of detail with an idealized conception of his subject. Raphael appears as an elegantly dressed, soulful young man. Behind the standing figure of the painter is a delicately incised scroll, representing sketches for the *Madonna of the Chair* in the Pitti Gallery in Florence. Though the costume Raphael wears and the palette he holds are not historically accurate, Crawford meant to show the artist at work, in the act of painting or contemplating his most celebrated masterpiece.

Crawford's Raphael is the embodiment of high-minded idealism. The link the marble makes between the artist's nature and the spiri-

Fig. 1. Thomas Crawford, Portrait of Raphael. *Kennedy Galleries, Inc., New York.*

Left: Plate 1. Sir Thomas Lawrence, Portrait of Benjamin West. *Wadsworth Atheneum, Hartford, Purchased by Subscription.*

*Numerals in brackets refer to the list of objects in the exhibition.

15

tuality of his work is precisely what we find in the literature of the period. The little we know about Raphael's character suggests that ambition was the mainspring of his career.[2] The nineteenth century admired him, however, for the "spirit of beauty, which filled his whole being." Out of this "elevation of mind" and "purity of soul" grew his pictures.[3] As Kugler explained in his influential handbook on Italian painting, "Raphael is always greatest when . . . he follows the free, original impulse of his own mind. His peculiar element was grace and beauty of form. . . . Hence, notwithstanding the grand works in which he was employed by the Popes, his peculiar powers are most fully developed in the Madonnas and Holy Families of which he has left so great a number."[4] This passage was singled out for quotation in the *Book of Raphael's Madonnas,* published in New York about the same time that Crawford's statue was made.[5] It expresses the widely held belief that the Madonnas were central to Raphael's achievement.

Though "born to paint Madonnas," Raphael did not create the genre, of course.[6] Rather he "first revealed the world of feeling and endearment" between the Virgin and Child.[7] Taking as their real subjects "maternal tenderness and the joys of childhood," the Madonnas, one writer claimed, "have little to remind one of the mysteries of religion."[8] Their universal appeal made it possible for Protestants and Catholics alike to appreciate fully this aspect of Raphael, for "to glorify the most noble of feelings—maternal and filial love—is assuredly the best form of religious art."[9]

But Raphael's versions of the Madonna and Child had not always been his best loved pictures. They represent only a fraction of his production, and in his own time they were overshadowed by his portraits, altarpieces, mural decorations, and tapestry cartoons. Until well into the nineteenth century Raphael's fame still rested primarily on his historical compositions. The American collectors whose activities we will examine naturally focused on the master's easel paintings, one or another of which they hoped to acquire. But the artists who earlier turned to Raphael took his great historical and religious narratives as models for the works they wished to paint.

Benjamin West, in Europe before Crawford, held both Raphael's narrative pictures and his Madonnas in high esteem. The first internationally renowned American artist, West (1738-1820) was called, in fact, the "American Raphael." His title was more than a compliment, for he admired and copied Raphael and referred to the older artist's example in formulating and teaching his art theories. Most important, he used Raphael's works as sources to elevate his own style. Even before leaving America, West would have known about his Renaissance forebear through books and engravings. During his years of study in Rome between 1760 and 1763, West, according to his contemporary biographer John Galt, directed "his principal attention to the works of Raphael."[10]

Fig. 2. Benjamin West, The Water Bearer. *The Pierpont Morgan Library, New York.*

After 1763 West chose to remain in London, where he helped to found the Royal Academy. Sir Thomas Lawrence portrayed West as President of the Academy in a picture [2] commissioned in 1818 by the American Academy of the Fine Arts in New York. When the American Academy closed in 1841, the painting was acquired for the Wadsworth Atheneum in Hartford.[11] Lawrence's portrait (plate 1) shows West full length, delivering a lecture on the "immutability of the colors of the Rainbow."[12] To make his point, he gestures toward a small-scale copy of the *Death of Ananias,* one of Raphael's famous set of tapestry cartoons in the Royal Collection. In another lecture specifically on Raphael, West elaborated on the master's achievement as a composer and colorist in the cartoons.[13]

Representing the Acts of the Apostles, the cartoons were the single most important inspiration for West and his circle.[14] But other models by Raphael were also relevant to contemporary practice. Sir Joshua Reynolds, West's predecessor as President of the Royal Academy, advocated Raphael's frescos over his easel pictures as objects of study.[15] West, too, had been impressed by the mural decorations in the Vatican, as we gather from a drawing [3] of *The Water Bearer* (fig. 2), after Raphael, now in the Pierpont Morgan Library.[16] The drawing, imitating the Renaissance technique of black chalk on prepared paper, probably dates from the latter part of West's sojourn in Rome, after Anton Raphael Mengs, his mentor, had oriented him toward neoclassicism. Far more assured than any of West's American productions, the sheet comes from a sketchbook which also included drawings after Michelangelo, another master West later recommended to young painters studying in Rome. The water bearer on the extreme right of the fresco of the *Fire in the Borgo* was one of the most admired of all Raphael's figures. The way it combines agitated movement with classical poise must have given it a special interest for West, who sought to achieve the same effect in his own pictures.

Themes from ancient life, depicted in classical language, were remote, some critics charged, from ordinary human concerns. But there was another vein in Raphael which appealed to the prevailing taste for portraits and scenes of everyday life—his Madonnas. A copy of the *Madonna of the Chair* (fig. 3) hung in West's studio, where Trumbull saw it as a student. In his autobiography Trumbull later recalled that, without knowing what it was, he selected this picture to copy. West, Trumbull said, strongly approved his choice, regarding it as a good omen.[17] The religious significance of Raphael's painting went unseen by the young American pupil. It was the secular, sentimental nature of the Madonna that spoke to Trumbull, as it did to so many other eighteenth- and nineteenth-century viewers. West also regarded the picture as the perfect expression of a mother's love for her child. He used the composition in four versions of a portrait [4] of his wife Elizabeth and their first-born son, appropriately named Raphael. In the version exhibited (plate 2), now in the Utah

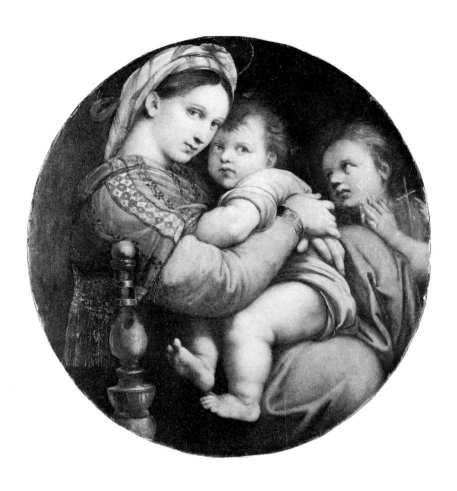

Fig. 3. Raphael, Madonna of the Chair. *Galleria Pitti, Florence.*

Right: Plate 2. Benjamin West, Mrs. Benjamin West and her Son Raphael. *Utah Museum of Fine Arts, Salt Lake City, Gift of the Marriner S. Eccles Foundation.*

Museum of Fine Arts, the round format, the color, the poses and facial expressions, even the embroidered drapery, make the comparison with Raphael's tondo unmistakable. The portrait shows how Raphael's Madonnas could be adapted to suit the needs of contemporary taste.[18]

Lawrence's portrait (plate 1) affirms the esteem in which Raphael was held by Benjamin West. It also indicates how West used Raphael as an exemplar in his teaching. But West's audience was larger than the students who attended his lectures. His studio became the headquarters for other Americans studying abroad,[19] and he impressed his veneration for Raphael on three generations of artists, beginning with John Singleton Copley (1738-1815). Though well established as a portrait painter in Boston, Copley, at West's urging, went abroad in 1774 to acquire the Grand Manner. The letters he wrote to his brother, Henry Pelham, in America document his reactions to works of art he saw in Europe. Raphael appears often in their correspondence, as Copley considered him the "greatest of the modern painters."[20] Though Pelham had to content himself with engravings after Raphael, the only sources available to Americans who could not get to Europe, Copley now had the opportunity to study the originals of masterpieces he knew secondhand.

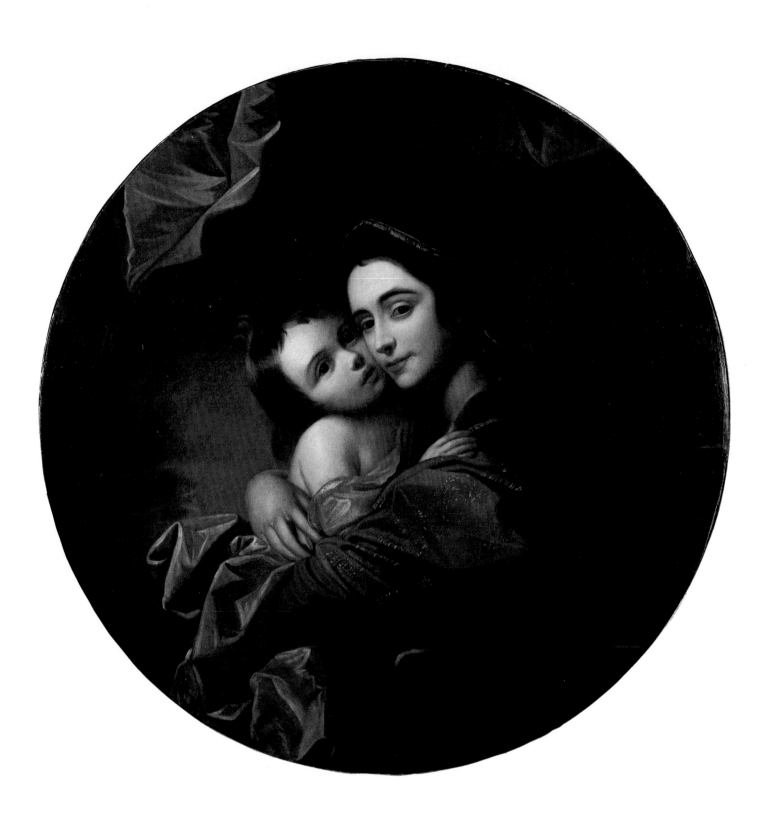

Fig. 4. John Singleton Copley, The Ascension. *Museum of Fine Arts, Boston, Bequest of Susan Greene Dexter, in memory of Charles and Martha Babcock Amory.*

Copley rarely mentions a Madonna by Raphael. Instead he dwells repeatedly on the tapestry cartoons and on the master's other narrative works. The *Transfiguration*, which Copley would have seen in the church of S. Pietro in Montorio in Rome, provided a stimulus for his first attempt [5] at an original historical composition.[21] His *Ascension* (fig. 4), now in the Museum of Fine Arts in Boston, was composed, Copley wrote Pelham in 1775, in the manner of Raphael.[22] Thus the individual figures in the painting, whose faces have the intensity of Copley's portraits, are arranged according to compositional ideas he took over from the older master. The American artist undoubtedly meant his own essay in the Grand Manner to stand comparison with his prototype, then considered to be the "greatest picture in the world."[23] As the letter to Pelham makes clear, Copley regarded Raphael as a living force centuries after his death in 1520. Copley sought to unite the European Grand Manner with the phenomenal realism which had accounted for his success as a portraitist in America. He employed the same formula for *Watson and the Shark* of 1778, which secured his reputation as a history painter.[24] He extended it the following year in the *Death of The Earl of Chatham* by depicting the dramatic event of recent memory in modern dress.[25]

John Vanderlyn (1775-1852) was the first of a younger generation of American painters to go abroad.[26] Though he chose Paris in 1796 as the place to realize his artistic goals, he also worked in Rome. There he completed the *Marius amid the Ruins of Carthage*, for which Napoleon awarded him a gold medal. Vanderlyn's other major achievement, the *Ariadne on Naxos*, was equally popular among connoisseurs, who recognized its allusions to tradition. But when he left the scene of his triumphs to return to this country in 1815, Vanderlyn met defeat. He found no audience for his lofty themes from ancient history and mythology.

Fig. 5. John Vanderlyn, The Calumny of Apelles. *The Metropolitan Museum of Art, New York, Gift of the Family of General George H. Sharpe, 1924.*

Fig. 6. Washington Allston, Beatrice. *Museum of Fine Arts, Boston, Anonymous Gift.*

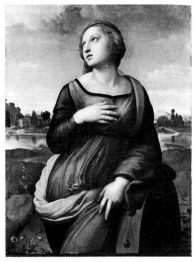

Fig. 7. Raphael, Saint Catherine. *The National Gallery, London.*

Vanderlyn's sense of discouragement is reflected, perhaps, in the subject of a work he chose to copy after Raphael. While in Paris he came to know a drawing of the *Calumny of Apelles*, then believed to be by Raphael, in the Louvre.[27] Vanderlyn's copy (fig. 5), painted in oil on canvas, is now in the Metropolitan Museum in New York.[28] Datable late in his career, the painted copy [6] may go back to a study Vanderlyn made during one of his Paris sojourns, perhaps while he was there as a student.[29]

The Louvre drawing follows a literary description of a lost work by the ancient painter Apelles, who portrayed himself being slandered.[30] In Vanderlyn's copy of Raphael's vision of the theme, Apelles is the young man who raises his arms in prayer. The American may originally have copied Raphael as an exercise. But over the years, as he suffered one setback after another, he could well have found a personal relevance in the image of the unfortunate artist. It was Vanderlyn's fate to have Aaron Burr as a patron. After Burr's disgrace, his hopes for a career as a history painter were shattered. In identifying himself with Apelles Vanderlyn might have assuaged his sense of failure, but his painting did not find a purchaser. Six months before he died in 1852—having long since pawned his medal—Vanderlyn complained that he could not sell the picture.

Vanderlyn's canvas remained unsold because its abstruse subject and classical relieflike style did not suit mid-century taste in America. Washington Allston (1779-1843), the greatest painter of his generation, was more successful than Vanderlyn in exploiting his interest in Raphael.[31] After receiving a literary education at Harvard University, Allston went to London. There he learned from Benjamin West how to align his art with tradition by borrowing from the Old Masters. His largest and most important history pictures—*Jason Returning* of 1807-1808, *Dead Man Restored* of 1811-1814, and *Christ Healing the Sick* of 1813—all predictably depend upon Raphael, above all on the tapestry cartoons.[32] But when Allston finally came back to America in 1818, where he was removed from classical sources, he turned from the epic mode to one that was often more lyrical. He developed a new genre, painting a series of images of contemplative young women.

The first and perhaps the finest of these idylls is *Beatrice* (fig. 6) of 1819, now in the Boston Museum of Fine Arts. Though this portrait [7] of Dante's beloved is in the literary vein of so much of Allston's work, it does not attempt to look medieval. Instead, the lady wears a generalized costume that has a flavor of the past. The pose of Beatrice, slightly inclined with one arm raised and the other lowered, derives from Raphael's *Saint Catherine* (fig. 7), which Allston could have known in London.[33] The American took over the graceful attitude of Raphael's saint but not her expression. In place of a passionate upward gaze, Beatrice is portrayed in a meditative mood. Allston likewise eliminated the attribute of martyrdom in his prototype in

favor of the cross Beatrice discreetly holds at her bosom.

The sweetness of expression and soft idealization of *Beatrice* have the quality of a Raphael Madonna. They remind us of how West had similarly used a Madonna by the older master for a portrait of his wife. The examples of Allston and West show how a religious work by Raphael might be adapted to the popular contemporary genre of portraiture. Though both were conceived in the spirit of Raphael, Allston's painting is more sentimental than West's. The *Beatrice* and its successors accordingly won the admiration of critics in the 1820s and 1830s. Raphael continued to appeal to artists and critics. But increasingly it was the Raphael of the sweet Madonnas whom they admired.

The fondness for Raphael's Madonnas during the mid-to-late nineteenth century first appeared as a distinct attitude soon after 1799, when the Grand Duke of Tuscany purchased an early *Virgin and Child* (fig. 64). Though he paid relatively little for it, the duke prized the picture so highly that he refused to be separated from it, taking it with him wherever he went, even into exile. Consequently, the picture became known as the *Granduca Madonna*. The duke's special affection for the painting came to be shared by the public when it was put on view in the Pitti Gallery.

America, no less than Europe, developed a pronounced taste for the Madonnas. As the Index of Exhibitions before 1877 reveals, some fifty works attributed to Raphael or admitted to be copies after him were shown in this country up to that time.[34] No fewer than seventeen were Madonnas, and of these six were of the *Madonna of the Chair*. Others included the *Granduca Madonna* and the *Sistine Madonna*. Only two were of the tapestry cartoons and two of the *Transfiguration*.

The demand for Raphael's Madonnas in America could not be satisfied by works purporting to be originals. Copies were more numerous and more important. Vanderlyn was only one of a number of painters who provided such copies of famous pictures for their patrons. He, like many other artists and collectors, was suspicious of the heavily varnished canvases passed off in America as original works by Raphael and other masters.[35] A copy by a qualified artist, labeled as such, allowed the public at home to appreciate European art without being deceived. Vanderlyn's defense was characteristic of the prevailing attitude toward copies of paintings and plaster casts of statuary. "Copies," he said, "would be infinitely preferable in every respect, to originals of inferior masters. They would in exhibiting the various excellencies, which respectfully distinguish each of the great masters, serve as comparison to the student and lover of art."[36] Copies after the Old Masters, frequently exhibited in this country, were admired and bought and sold as reputable works of art.[37] The copying of pictures abroad reached such proportions that one American painter complained that it was necessary to wait at least two years be-

Fig. 8. Attributed to John Smibert, Madonna and Child with Saints Elizabeth and John. *Bowdoin College Museum of Art, Brunswick, Maine.*

fore the *Madonna of the Chair* became available.[38]

A considerable number of Old Master copies were in this country as early as 1729. John Smibert (1688-1751), a portrait painter of Scottish origin, brought them to Boston, where he decided to practice his trade. During his lifetime Smibert displayed the copies in his shop, and they could still be seen there after his death. Young American artists, notably Copley, Trumbull, and Allston, took advantage of the opportunity to examine these works, which were of great educational value. Among the copies was one of the *Madonna of the Chair*, which remained in Smibert's studio long enough to be studied by Copley. When he got to Florence Copley found the original much superior.[39] Trumbull also recalled that as a beginner he had derived some benefit from the Raphael copy.[40]

The copy of the *Madonna of the Chair* is now lost. But another record of Raphael [8] survives to show the image of the master and his work that could be obtained in Smibert's studio. This copy (fig. 8), after the *Small Holy Family* in the Louvre, is now at the museum at Bowdoin College.[41] James Bowdoin II probably purchased it, along with other of the contents of Smibert's shop, sometime after the artist's death. Bowdoin's son of the same name bequeathed it to the college in 1811. The painting's origins were forgotten, however, and it was soon taken as an original. Gilbert Stuart, visiting the collection in 1821, was not alone in proclaiming it a Raphael.[42] Only recently has it been realized that the picture is either by Smibert himself, or, more likely, a work he purchased.

Since Smibert's copy is reversed from the original in Paris, it was probably made from an engraving [9]. An example of the kind of source the copyist adopted is a print inverting the design of an engraving after Raphael by Caraglio.[43] Significantly, in certain details, such as the position of the Christ Child's feet in the crib, the painted copy follows the print, not Raphael's original. Smibert collected engravings as well as paintings after the Old Masters, and if he was responsible for the copy, he might have used a print from his own collection. In any case, the artist, whoever he was, chose to vary the background in his copy, which resembles neither the wall in the print nor the landscape in the painting. The fantastic architectural setting is reminiscent of Poussin, another great master whom Smibert is known to have admired.

The copy after Raphael that Smibert kept in his studio functioned as a means of instruction, initiating students into the classical style. Copies also served to decorate the houses of wealthy merchants and landowners. Little is known about America's early collectors, such as Robert Gilmor of Baltimore, who bought a Madonna by Mabuse under the impression that it was a Raphael.[44] More information survives about the collecting activities of Thomas Jefferson, thanks to his fame as a statesman.[45] Here, as in his other interests, Jefferson was far ahead of most of his contemporaries. Benjamin Franklin, for

example, claimed that the "invention of a machine or the improvement of an implement is of more importance than a masterpiece by Raphael."[46] Jefferson's friend, John Adams, had even stronger views. In a letter to the French sculptor Binon, Adams wrote, "The age of painting and sculpture has not arrived in this country and I hope it will not arrive soon . . . I would not give a sixpence for a picture of Raphael. . . ."[47] Both men believed that as a new country the United States should evolve in a practical direction. Raphael represented the world of culture to which the nation might aspire at a later stage in its development.

But Jefferson, an amateur architect, was an avid reader of books about art, many of which he had in his library.[48] He also collected engravings. From these sources he compiled lists of works of art, such as the *Medici Venus* or the *Apollo Belvedere*, which he would ideally like to own. The lists of about 1771 and 1782 also include one of Raphael's tapestry cartoons.[49] What Jefferson clearly had in mind were copies of the famous pictures and statues that he knew second hand.

Fig. 9. After Raphael, Holy Family of Francis I. *Thomas Jefferson Memorial Foundation, Monticello.*

His "wish list" became a reality when he joined Adams and Franklin in Paris in 1784 as the American Minister to France. There Jefferson purchased a number of art works. Though few were the ones he originally desired, he did obtain two copies after Raphael. His version of the *Transfiguration* is now lost, having been dispersed with much of the rest of his collection after his death in 1826. But his copy (fig. 9) of the *Holy Family of Francis I* is still at Monticello. According to a descendent, Jefferson commissioned the copy [10] to be made in the Louvre.[50] Originally it hung in the dining room at Monticello, in the uppermost of three tiers of paintings. Jefferson's taste, like that of later American collectors of Raphael, was not personal. It represents the choice of any cultivated gentleman of his time. Nevertheless, he was as seriously interested in Raphael as later collectors would prove to be. He drew up careful inventories of his seventy-odd paintings, listing the titles and the names of the artists after whom the copies were made.[51]

Smibert, who owned a Raphael copy, was an artist; Jefferson, who had another such copy, was an aristocrat. But the interest Americans took in Raphael was not limited to a cultural elite. Copies of his works were widely disseminated. According to the *Book of Raphael's Madonnas*, already mentioned as a barometer of mid-century taste, the *Madonna of the Chair* (fig. 3) was "without exception, the best known of Raphael's Madonnas, and that from which the greatest number of copies have been taken. It is, therefore, incontestably the favorite with the public, if not with artists and amateurs."[52] Remarkably, in view of the enormous popularity the *Madonna of the Chair* enjoyed, nothing is known of its early history. Vasari did not mention it, nor did any of Raphael's contemporaries. The painting appealed to later generations more for its sentiment than for its compo-

sition. For Raphael not only solved the difficult problem of composing figures in a circle, he also made divinity seem accessible. The legends that grew up around the picture—that it was painted on the end of a barrel or that the model for the Virgin was Raphael's mistress—gave it the quality of belonging to everyday life.

At the same time the painting represented a divine mystery. As Henry James observed in the Pitti Gallery, viewers treated the "lovely picture as a kind of semi-sacred, an almost miraculous manifestation. People stand in worshipful silence before it, as they would before a taper-studded shrine."[53] Indeed, the *Madonna of the Chair* was a cultural icon. Like the *Mona Lisa* in our own day, it was recognized by people who knew nothing else about art. And it was enjoyed by people who were not experts. Admirers of the painting often had it copied. The copy [11] of fine quality exhibited here descended to its present owner from Horace Brooks of New York, who purchased it while on a world tour in 1855. Painted in oil on a wood panel, the copy is exact; even the massive gilt frame reproduces that of the original. As a work of value, the picture was cradled by Goupil of Paris for its ocean voyage.[54]

Once in America such a copy would have formed part of the furnishings of a comfortable house. As we see in an interior of the Latimer House (plate 3) in Wilmington, North Carolina, a version of Raphael's beloved masterpiece deserved a prominent place in the scheme of decoration, over the marble mantel in the parlor.[55] Half a century earlier Jefferson had displayed his Raphael copies among a large number of works reproducing the Old Masters. His pictures were records of respected works of art. The *Madonna of the Chair*, on the other hand, symbolized moral as well as artistic values. By displaying a version of the picture, the owner affirmed his belief in these values. Jefferson's copies after Raphael and other great masters all conformed to a uniform taste. In the mid-nineteenth-century parlor, however, the *Madonna of the Chair* hung among other works of a markedly different character: family portraits, genre scenes, landscapes, mementos. What united these works was not their artistic form but the feelings they evoked.

No copy succeeded in conveying the spirit of the original, however, as Nathaniel Hawthorne realized when he saw the *Madonna of the Chair* for the first time on a visit to Florence in 1858. The novelist was "familiar with it in a hundred engravings and copies and therefore it shone upon me with a familiar beauty, though infinitely more divine than I had ever seen it before. An artist was copying it, and producing something certainly like a facsimile, yet leaving out, as a matter of course, that mysterious something that renders the picture a miracle."[56] Nevertheless, the demand for echoes of Raphael did not ebb, and neither did the supply. Hawthorne observed great numbers of copyists at work in both the Pitti and the Uffizi Galleries. In his journal he noted a conversation with a painter who lamented that the

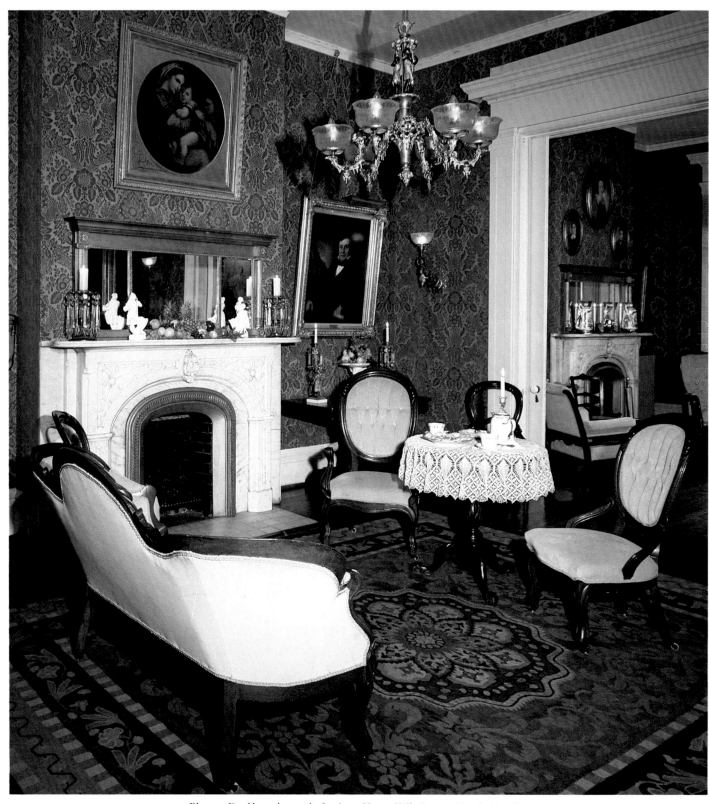

Plate 3. *Double parlor at the Latimer House, Wilmington, North Carolina.*
Helga Photo Studio for The Magazine Antiques.

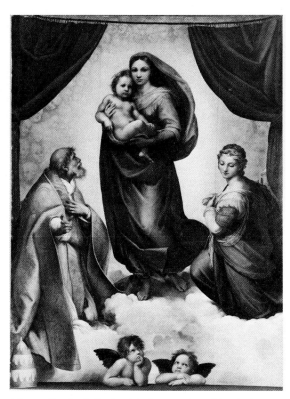

Fig. 10. Raphael, Sistine Madonna. *Gemäldegalerie, Dresden.*

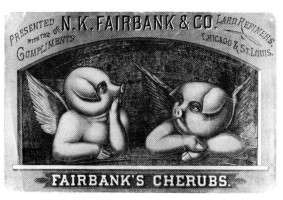

Fig. 11. "Fairbank's Cherubs," Chromolithographic tradecard. Library of Congress, Washington.

copying of pictures had reached such proportions that it threatened the very "existence of a modern school of painting."[57] Some artists even went to the extreme of specializing in the reproduction of a single work.

Hawthorne used this comment when he came to describe Hilda, the innocent American artist, in his novel, *The Marble Faun* [12]. Specially bound editions of the book—also issued as *Transformation: or the Romance of Monte Beni*—were illustrated with photographs of Raphael's pictures,[58] with an eye to the tourist trade. Like painted copies and engravings, photographs helped to make the artist and his works widely known. But Hawthorne's treatment of copyists and their work in the text reveals that they were becoming problematic. In the novel Hilda achieves what Hawthorne thought the professional copyist incapable of doing: she captures the magic of the original. She is able to do this because she is the "handmaid of Raphael, whom she loved with a virgin's love."[59] Hilda does not copy Raphael merely to learn his style nor to earn a living. Her ideal of approaching the uniqueness of the original sets her work above contemptible reproductions which, Hawthorne claimed, were being "produced by thousands." These were the work of "Raphael machines."[60]

The *Sistine Madonna* (fig. 10) was once nearly as renowned as the *Madonna of the Chair.* Mrs. Jameson, perhaps the most widely read Victorian writer on art, made the pilgrimage to Dresden six times to see the painting. Her memory of the original would be "disturbed by feeble copies and prints," she said, so that she had to return to experience its sublimity.[61] In the picture she found her ideal of the Madonna. "There she stands," Mrs. Jameson wrote, "the transfigured woman, at once completely human and completely divine, an abstraction of power, purity, and love, poised in the empurpled air, and requiring no other support; looking out . . . quite through the universe, to the end and consummation of all things. . . ."[62] A small-scale reproduction simply failed to do such a painting any justice. The early photograph [13] exhibited here, for example, even though it was hand colored to suggest the texture of paint, reduces the masterpiece it seeks to repeat.

With the advent of photography and new printing techniques, Raphael became a household word. Reproductions of his most famous pictures were now easily available at reasonable prices. Prang's chromolithograph of the *Sistine Madonna,* measuring 22 inches square, cost twelve dollars in 1891.[63] Such prints, claiming to be almost indistinguishable from the original, were embossed to resemble brushwork, glued to canvas, varnished, and placed in gold frames. Prang also reproduced the two little angels from the bottom of Raphael's painting. This photolithographic detail cost twenty-five cents in 1869.[64] But Prang and his customers were not the only ones to delight in the motif of the two cherubs. Crowe and Cavalcaselle, authors of the standard monograph on Raphael, made note of

the way they "lean on the parapet . . . and dart their glances upwards as they shake their coloured winglets in serene and sparkling gladness. . . ."[65] The chubby-cheeked sentimentality of the infants was so appealing that they were often reproduced, not only by Prang. They became familiar enough, in fact, to be parodied. A chromolithographic trade card [14] for Fairbank's Lard Refiners of Chicago and St. Louis (fig. 11) features two winged piglets posed like the cherubs. The viewers of this advertisement may not have known Raphael's painting in Dresden, but they were surely aware of the detail borrowed from it or the pun would have gone unnoticed. The proliferation of reproductions during the nineteenth century made Raphael's images seem commonplace. But such familiarity did not diminish the mystique of the originals. Hawthorne felt their aura, and so did Mrs. Jameson, for unlike copies, the product of the master's hand was unique.

Later American Collectors

Less than a century ago there were no paintings by Raphael in America. Today there are, perhaps, thirteen. Though the number may seem insignificant compared with the riches of European galleries, it represents a remarkable achievement on the part of American collectors. In assessing what they did, we need to bear in mind that Raphael died relatively young after devoting much of his activity to frescos. His easel paintings are not numerous, therefore, and they were highly prized and eagerly sought by European collectors from the Renaissance down to the end of the nineteenth century. The Americans came late to collecting Raphael, when the harvest was nearly over. They succeeded, nevertheless, in bringing to these shores a number of fine works by the artist in a short period of time.

The story of American collecting of Raphael is told in outline form in Bernard Berenson's famous Lists of early Italian paintings. The foremost authority in the field for more than half a century, Berenson (1865-1959) appended to his four essays on the Italian painters of the Renaissance indexes of those pictures he accepted as authentic. The indexes informed the reader about where to find works by the masters treated in the essays. The Raphael List in *The Central Italian Painters of the Renaissance* of 1897 does not include a single American entry.[66] Berenson's rival Roger Fry, while a curator at the Metropolitan Museum, also complained that to see original works by Raphael, as opposed to copies or reproductions, it was necessary to go to Europe.[67]

Scanning the revised and enlarged edition of Berenson's Lists of 1909, we find little change. He could cite only the *Portrait of Tommaso Inghirami* and the *Lamentation* in Boston, both of which he himself had obtained for the collection of Isabella Stewart Gardner.[68]

By 1932, however, when Berenson collected the Lists into a uniform edition, the situation had improved dramatically. To the beginnings of the Gardner Collection, Berenson was now able to add the following autograph works by Raphael, making a total of nine: the *Portrait of Emilia Pia*, which belonged to Jacob Epstein in Baltimore; the *Madonna of the Candelabra* in the Walters Art Gallery in the same city; the *Agony in the Garden* in the collection of Clarence Mackay in Roslyn, Long Island; the Colonna altarpiece, part of the Morgan bequest to the Metropolitan Museum; the *Portrait of Giuliano de' Medici* in the possession of Jules Bache in New York; the *Small Cowper Madonna* in the Widener Collection in Philadelphia; and the *Large Cowper* or *Nicolini-Cowper Madonna*, belonging to Andrew Mellon in Washington. Berenson also listed an important copy after a lost work by Raphael in the University Museum in Princeton.[69]

There is an equally significant change in the Berenson Lists published posthumously in 1968.[70] A few more Raphaels were added. But the most remarkable difference is that those paintings in private hands in 1932 and the others which had since come to America were now all in public museums. The Epstein *Emilia Pia* entered the Baltimore Museum of Art, and the *Agony in the Garden* and the *Giuliano de' Medici* (now listed as a copy) followed the Colonna altarpiece into the Metropolitan museum. Another work not listed previously, the *Northbrook Madonna,* attributed to Raphael, was bequeathed to the Worcester Art Museum by Theodore Ellis. As late as 1965 a predella panel by Raphael came to Raleigh, North Carolina. In addition, the two Cowper Madonnas were reunited in the National Gallery of Art in Washington, founded in 1937 and opened to the public in 1941. As listed, the Gallery's holdings of works by Raphael included three other pictures which private collectors had obtained from a most unusual source, namely European museums: the *Saint George and the Dragon* and *Alba Madonna* from the Hermitage in Leningrad and the *Portrait of Bindo Altoviti* from the Alte Pinakothek in Munich. The donation of these three works and of the two Cowper Madonnas to the National Gallery by Joseph Widener, Andrew Mellon, and Samuel H. Kress formed what one expert called the "only real group of Raphael's paintings in America."[71]

To the works by Raphael mentioned above should be added the early *Madonna with a Book* (fig. 12), purchased by Norton Simon from Wildenstein in New York in 1972. Bringing the total to thirteen (not all of which are unquestionable), the *Madonna* is the last work by Raphael acquired by a major American collector, one who conforms in some ways to the type of magnate-turned-collector described in the following pages. Berenson authenticated the *Simon Madonna,* for which several preparatory drawings survive, in Florence in 1951. And since the time of its acquisition, the picture has aroused further interest among scholars.[72]

Berenson's were not the only lists. Raphael's paintings in America

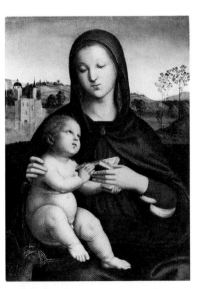

Fig. 12. Raphael, Madonna and Child with a Book. *Norton Simon, Inc. Museum of Art, Pasadena, California.*

were counted from time to time by other scholars and in the press, often when a new one was bought, and the various tabulations reflect a growing sense of pride and accomplishment. Though they do not always agree as to what is and is not by Raphael, the pattern is clear.[73] Toward the end of the nineteenth century, when Berenson began compiling his Lists, there were no Raphaels in America. Collectors then set out to remedy this deficiency. The trickle of works they first brought together became a steady stream, and by mid-century that stream was channeled into public museums.

This new era in the history of American taste and collecting began late in the last century. At that time the fortunes made when the country changed from an agricultural to an industrial economy were often spent acquiring European Old Master paintings. Demanding masterpieces and willing to pay for them, American millionaires did not so much enter the art market as create it anew on their own terms. Most of these collectors invested not only vast sums of money but also a great deal of time and energy. And the works of art they acquired would play a large part in their lives. Whatever their individual differences of taste and temperament, the men and the woman whose activities we will examine all shared one ambition: to crown their collections with a painting by Raphael. The anecdotes told and retold about J. P. Morgan, Isabella Stewart Gardner, and others by their biographers are unimportant compared to their inherently more interesting pursuit of this goal. What image of Raphael did they have? Why did they value his works so highly, and what were their motives and methods in seeking them out? What did it mean to acquire a work by Raphael? As these questions suggest, we will focus on the search for a Raphael by this group of like-minded collectors, surveying the evidence which lies scattered in letters, newspaper accounts, material in museum archives, as well as in published sources.

Before examining the activities of these American collectors of Raphael, it is important to understand the climate of taste and opinion in which they flourished. For reasons that are still not entirely clear, Americans began to turn seriously to the Old Masters toward the end of the last century. Earlier, in the decades after the Civil War, it had been fashionable for millionaires to decorate their new houses with French academic and Barbizon pictures.[74] Even the major collectors of the next generation—J. P. Morgan, Isabella Stewart Gardner, Henry Clay Frick, P. A. B. Widener, and others—first indulged in this vogue for contemporary European art.[75] Jean-François Millet's *L' Attente* or *Waiting* (fig. 13), which once belonged to the Widener Collection, is an example [15] of the kind of anecdotal painting that appealed to American collectors before they turned to the Old Masters.[76] Combining landscape with a biblical subject, the picture depicts the story of Tobit and Anna waiting for their son Tobias. We are now aware of the autobiographical meaning which lends a genuine poignancy to the painting, completed soon after the

Fig. 13. Jean-François Millet, L'Attente (Waiting). Nelson Gallery-Atkins Museum (Nelson Fund), Kansas City, Missouri.

death of the artist's mother.[77] But the nineteenth-century viewer would have responded to its overt sentimentality. *Waiting* no longer seemed sufficiently distinguished to the Wideners, however, once they acquired a Raphael, and they promptly disposed of it.

The taste for the Old Masters that American millionaires came to share excluded modern art as well. Our collectors, leaders of commerce and industry, remained untouched by the radical transformation in artistic values brought about by the modern movement of their own time. Yet the growth of American interest in earlier European painting took place at the same time as the emergence of the avant-garde around the turn of the century. However opposed to each other, both phenomena grew out of the same recognition that the kind of contemporary European art which appealed to conventional taste was moribund. The search for a more authentic art thus led in two directions: avant-garde artists and cultural visionaries tried to subvert the classical tradition, while conservative collectors sought to reinforce it by going back to its roots in the past.[78] In a period of rapid growth and unprecedented change, when tradition was threatened as never before, the "divine" Raphael and his pictures, with their sweet harmony, were held up as a source of moral and not just aesthetic values. In acquiring a Raphael, then, a collector was, in effect, reaffirming his belief in the values of order and discipline that the painting was taken to represent.

As the greatest prize for any collector, Raphael's paintings qualified as "acquisitions on the highest terms."[79] Describing what would come to seem the Golden Age of American collecting, Henry James thus drew the connection between great wealth and art and distinguished between collecting the art of the past and patronage of contemporary art. As James intimated, paintings like Raphael's appealed to collectors who neither knew nor wanted to know about the innovations that were transforming the arts of their own time. The Wideners, for example, acquired the *Small Cowper Madonna* a year after the tumultuous Armory Show of 1913, marking the advent of modern art in America. At the time they purchased their Raphael for the record sum of $565,000, Marcel Duchamp's *Nude Descending a Staircase (No. 2),* to choose the most notorious work in the show, was bought for $324. The enormous difference in price indicates that the traditional system of values, whereby the Old Masters were worth much more than works by living artists, was still intact. Indeed, the gulf between them must have seemed insurmountable.

Though it is the avant-garde developments which capture our attention today, the pursuit of Raphael is actually more representative of the period which has been called the American Renaissance.[80] Around the turn of the century America's leading artists, architects, and designers turned to Europe and especially to Renaissance Rome for inspiration, aspiring to re-create on these shores a grandeur befitting the new role of their country as a world power. As Americans be-

gan to travel to Europe more frequently and for longer periods of time, they developed a sense of history in which the United States was seen as the heir of the European past. Naturally, given their common language and cultural ties, the Americans were drawn first and foremost to the British aristocracy, whose ancestral portraits were acquired and pretentiously displayed as heirlooms in the houses of the new rich.

An even deeper kinship was felt for the famous men and women of the Renaissance. They had played an active, indeed paramount role in the political and economic life of their times and had also sponsored the splendid cultural movement by which they were chiefly remembered. The concept of the Italian Renaissance as a high point of Western civilization, formulated in the mid-nineteenth century by Jacob Burckhardt and spread among the English-speaking peoples by John Addington Symonds, stressed the spirit of individualism.[81] American collectors of Raphael do not seem to have been great readers, and scholarly historical interpretations such as Burckhardt's may have escaped them. But the widespread notion of the Renaissance as the Golden Age was demonstrated in a whole series of biographies which some of our collectors undoubtedly knew. Julia Cartwright, for example, brought her subjects, Raphael's friend Castiglione, among them, vividly to life with a wealth of absorbing detail. These biographies once enjoyed a phenomenal popularity among scholars and the general public alike, coming out in edition after edition.[82] Raphael's paintings, about which Julia Cartwright also wrote at length, would not have been seen in isolation, therefore. They belonged to the world she evoked for her readers.[83]

With the Renaissance pictured so convincingly, it was almost inevitable that certain of our collectors would identify themselves or be identified with specific individuals from that period. In a remarkably prescient essay called "A Lesson for Merchant Princes," published in 1883, James Jackson Jarves, then America's leading writer on art and aesthetics, called upon captains of industry to follow the example of their Florentine "ancestor," Giovanni Rucellai, who rose from humble origins to make a fortune which he spent on works of art.[84] Though the "merchant princes" we are considering did not patronize contemporary art, as their Renaissance forebears did, Jarves would have been gratified, nevertheless, that his plea soon began to have results. Berenson, who admired Jarves and shared his goals, encouraged his patron Isabella Gardner to identify herself with Isabella d'Este. On February 16, 1896, he urged her to buy a picture by a Titian follower because it was a portrait of "the greatest and most fascinating lady of the Renaissance—your worthy precursor and patron saint—Isabella d'Este, Marchioness of Mantua."[85] Berenson compared the two Isabellas once more when he wrote to Mrs. Gardner on May 3, 1903, advising her to "get and read at once Julia Cartwright's 'Isabella d'Este.'" The book [16], he explained, "very much

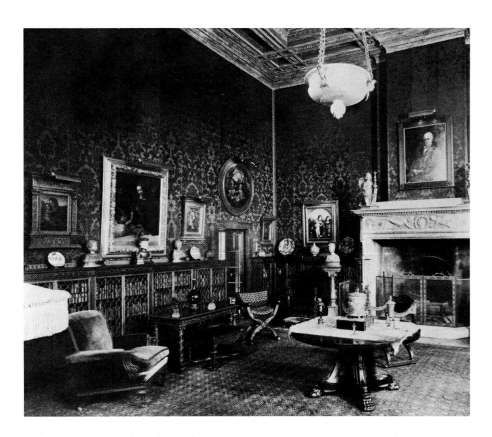

deepens the idea I have always had that she was your precursor. Change the time, the place and the circumstance, and the Isabella Gardner that I know is so singularly like the Isabella d'Este of whom I read that one could believe the one was the other reappearing after four centuries."[86] Acting on Berenson's advice, Mrs. Gardner got and presumably read at once the first American edition, which she inscribed "June 1903." The biography was so popular it was reprinted thirteen times between 1903 and 1932. According to the author, Isabella, "fortunate in the time of her birth and in the circumstances of her life . . . was above all fortunate in this, that she saw the finest works of the Renaissance in the prime of their beauty."[87] Though somewhat dimmed by time, works of Renaissance art also decorated Fenway Court. And there Isabella Gardner, like her predecessor, sought to create a courtly environment with herself as its center, surrounded by artists, writers, and musicians who sang her praises.

Another collector of Raphael, J. Pierpont Morgan was celebrated as an "American Medici" for his concern with banking and art.[88] Both interests were brought together in the resplendent room he used as a study in the library next to his residence in New York. Designed by Charles F. McKim, the Pierpont Morgan Library was completed in 1906. The Renaissance inspiration of the exterior carries over into Morgan's study (fig. 14), called the West Room [35]. Decorated with Italian paintings and marble busts, the room has a carved wooden ceiling which likewise dates from that period. "No one could really know Mr. Morgan," his son-in-law claimed, "unless he

had seen him in the West Room, which was regarded as peculiarly his own . . . because [it] expressed his conception of beauty. . . ."[89]

The red brocade wall covering came from the Chigi Palace in Rome, according to Morgan's son-in-law, and into its pattern was woven the crest of that family. It seems likely, though hard to prove, that by using the Chigi emblem Morgan meant to compare himself to Agostino Chigi, the Roman banker and patron of Raphael whom he so much resembled.[90] Morgan could have learned about Chigi from Eugène Müntz' monograph on Raphael, a copy of which he acquired in 1899.[91] Chigi's sumptuous villa on the banks of the Tiber, the present-day Farnesina, was a place to escape from the practical world of business. Morgan, on the other hand, saw no incongruity in conducting the vital business of the day in the cultured atmosphere of his study. The Renaissance was, after all, the time of men like Chigi who, though shrewd and ruthless in their business affairs, were, nevertheless, enlightened patrons of the arts.

The Morgan Library is celebrated as one of the finest monuments of the American Renaissance. The inspiration it took from Roman prototypes, particularly Pinturicchio, is well established. What does not seem to have been sufficiently stressed, however, is the fact that the decoration persistently refers to murals originally created for Agostino Chigi.

With Morgan supervising every detail, work on the Library was a collaborative effort between McKim and the leading sculptors and painters of the day, including Henry Siddons Mowbray (1858-1928). In 1904 Mowbray was chosen to decorate the East Room and the Rotunda of the Library on the basis of his murals, just completed, for the library of the University Club in New York. There his inspiration had been Pinturicchio, the leading Umbrian painter of the Renaissance after Perugino and Raphael. Pinturicchio's richly ornamental style was ideally suited for mural decoration, and McKim, the architect of the University Club, wished to revive it. Soon after Mowbray's paintings were installed at the club, Morgan came to see them. His enthusiastic response undoubtedly played a role in determining the interior aspect of his own library.

What Morgan wanted for the East Room and the Rotunda of the Library was clearly an ambient that would evoke the glowing interiors of the churches and palaces he knew so well in Rome. Pinturicchio was not Mowbray's sole guide in the Library, however. The form and basic idea of the zodiacal spandrels in the East Room were also derived from Raphael's Loggia of Psyche and from the ceiling of the Sala di Galatea, both in the Villa Farnesina, which, we recall, was built for Morgan's predecessor in art and finance. Combined with the use of Chigi's arms in Morgan's study, the visual echoes of Chigian models in the murals lead us to wonder if the collector or his architect and decorator were not conjuring the spirit of his "patron saint," to use Berenson's term of flattery for Isabella Gardner.[92]

Though the lunettes of the Rotunda (the original entrance hall) were derived from Pinturicchio, the design of the vaulted ceiling and north apse was again inspired by Raphael. The details of the decoration were worked out in preliminary drawings. One of these, a watercolor presentation drawing [17] by the architect's office, now in the Morgan Library, shows proposed designs for the ceiling and apse of the Rotunda. The apse scheme at the bottom of the sheet is based on Raphael's Villa Madama in Rome. And the design of the ceiling, we find, is virtually a copy of Raphael's vault of the Stanza della Segnatura in the Vatican, though the subjects are differently arranged. The painter Mowbray's involvement with the Stanza della

Fig. 16. Henry Siddons Mowbray, Study for "Religion," on the Ceiling of the Rotunda in the Morgan Library. Lent by a member of the artist's family.

Fig. 15. Henry Siddons Mowbray, Copy of Raphael's Vault of the Stanza della Segnatura. Lent by a member of the artist's family.

Segnatura is shown [18] by his watercolor copy (fig. 15) of a section of Raphael's vault. He did not include the main subjects in the copy, the Flaying of Marsyas and the Theology in the medallion, on the Rotunda ceiling, however. As a pencil study [19] for "Religion" (fig. 16) shows, for his own ceiling Mowbray chose to adapt, not to copy, Raphael's Theology and the other medallions of the Stanza della Segnatura. An additional source by Raphael for the tablet-bearing putto in Mowbray's pencil drawing was the *Madonna of Foligno*. But whether copying or adapting, Mowbray took Raphael as his basic inspiration for the Morgan ceiling.

The admiration for Raphael which permeates the Library indicates the receptive climate in which his easel paintings were beginning to be acquired. Above all, the decoration shows that Raphael was still a living force in American culture. For millionaire collectors who considered themselves the heirs of the Renaissance and who surrounded themselves with its trappings, to add a Raphael to their collection had a significance beyond that of simply acquiring a beautiful object or filling a gap in a historical sequence. Often, as we shall see at Fenway Court, the Morgan Library, and the galleries of Henry Wal-

ters, the Wideners, Clarence Mackay, and Samuel Kress, the new acquisition was enshrined in a setting of furniture and decorative arts meant to evoke the one from which it originally came. Like Renaissance collectors of classical antiquities, our collectors contemplating the Raphael in their possession could believe themselves transported to an ideal past of which the painting was a potent symbol.

To the collecting of Raphael Americans brought the taste for his works and the wish and means to acquire them. Nevertheless, when they entered the market at the end of the nineteenth century, there were scarcely any paintings by Raphael for sale. Their predicament—that Raphael's pictures were available in inverse proportion to the esteem in which they had been held in Europe—may be imagined from Johann Zoffany's painting *The Tribune Gallery of the Uffizi* of 1777. On the left (plate 4) Zoffany introduced himself holding up Raphael's *Large Cowper Madonna* to an admiring group of connoisseurs. Although Andrew Mellon would eventually purchase the painting and bequeath it to the National Gallery in Washington, the *Madonna* was then newly acquired by Earl Cowper, a British expatriot in Florence here shown pointing at the picture. Cowper and his companions are comparing the new acquisition with Raphael's *Madonna of the Chair,* included on the wall behind them even though it was not actually in the Tribuna.[93] The exercise in connoisseurship which they perform illustrates the high value placed on Raphael's works and their consequent scarcity.

Taken to England by Earl Cowper, the *Madonna* was only one of a number of Raphael's paintings to leave Italy for northern Europe in the late eighteenth and early nineteenth centuries. As Francis Haskell has shown, the "vast upheavals in Europe between 1793 and 1815 encouraged and, above all, enabled both the English and the French to acquire, either privately or publicly and on a massive scale, pictures whose status had already been consecrated by centuries of praise."[94] While some of these works by Raphael remained in private hands and thus were potentially available to American collectors, others went into the new national galleries in London, Berlin, and St. Petersburg. Though they had only entered the scene recently, interested Americans were apprised of these developments in Berenson's and other lists of Raphael's paintings.[95] They were not slow to act on this information. A century after works by Raphael left Italy in large numbers for the north of Europe, history seemed to repeat itself when many of them crossed the Atlantic to America. Of the thirteen pictures by or reasonably attributed to Raphael in America, only one came here directly from Italy. No fewer than seven were purchased via the art market from English private collections. In addition, two others had been in English collections at one time, and a third had long been exhibited in London, where, moreover, an English nobleman was involved in its sale.

The two waves of English and American collecting were not dis-

Right: Plate 4. Johann Zoffany, The Tribune Gallery of the Uffizi. *Windsor Castle, Reproduced by gracious permission of H.M. Queen Elizabeth II.*

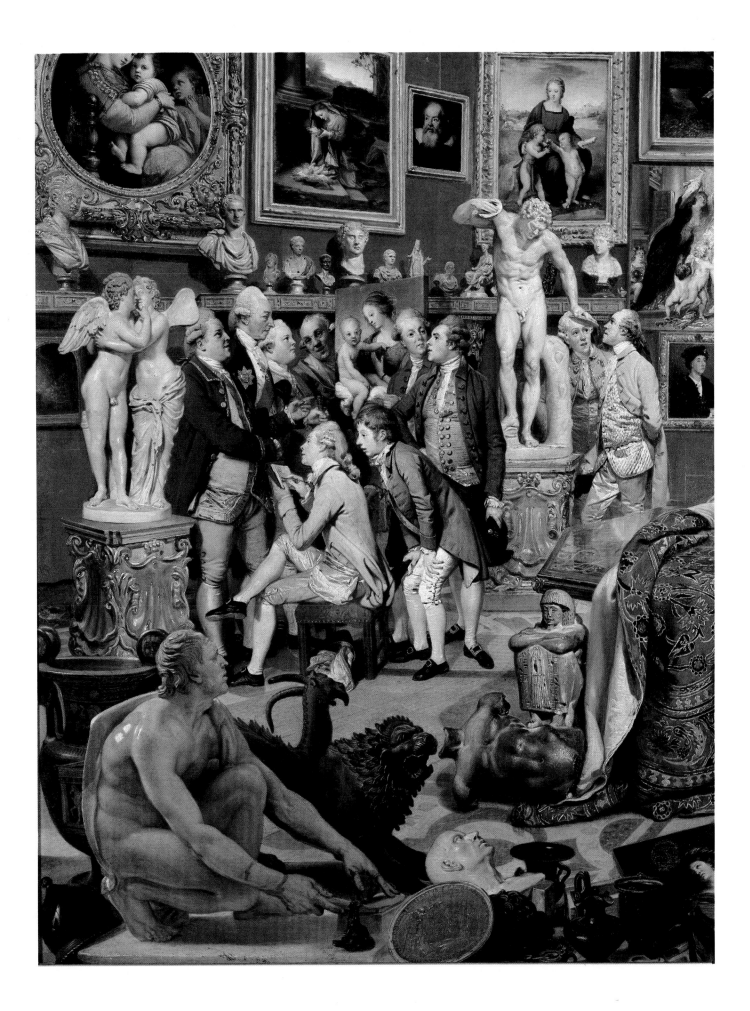

similar: having become familiar with Italian art through travel, a group of new, wealthy, and mostly uninformed collectors competed for masterworks, raising prices dramatically. In each case they were plagued by misattributions. The difference between the beginning and the end of the nineteenth century, as far as the collecting of Raphael is concerned, was that a fundamental change of taste had occurred. In this revaluation, Raphael continued to be the most admired of artists, but it was a different Raphael. His early works came to be preferred to the late ones, his easel paintings to his frescos, his Madonnas to his narrative subjects, and his small paintings to his large ones. The early pictures which arrived in England and France around the turn of the nineteenth century at first disappointed art lovers whose taste had been formed on engravings of famous masterpieces. Thus, the two predella panels from the Colonna altarpiece which would later come to America, the *Agony in the Garden* and the *Lamentation,* brought very low prices when they were sold to an English collector in 1800. By mid-century, however, the little *Dream of the Knight* was purchased for the National Gallery in London for a relatively large sum. In 1869 the Czar of Russia had to pay an even larger amount for the tiny *Conestabile Madonna.* A record price was obtained by the Duke of Marlborough for the Ansidei altarpiece, acquired for the London National Gallery in 1885.[96] As these and other early works by Raphael became more popular and as they began to enter the European galleries, opportunities for American collectors were lost.[97]

Small early works by Raphael, which had hitherto been considered minor or marginal, were coming to be admired on their own merits as independent pictures. This was in large part due to the pioneering study by Johann David Passavant (1787-1861).[98] While Passavant's meticulous catalogue was aimed at scholars, another of the great nineteenth-century monographs on Raphael had a broader appeal. Published in 1882-1885, *Raphael: His Life and Works* [20], by Joseph Archer Crowe and Giovanni Battista Cavalcaselle was also based on a painstaking study of the original works. In the first volume, Crowe and Cavalcaselle stated that, like Passavant, they "ventured to explore and attempted to illustrate the period of Raphael's youth, which had hitherto been comparatively neglected."[99] But they did so in a lively and informative manner which recommended the book to collectors like Joseph Widener, to whom the copy in the exhibition once belonged. When collectors like Widener became interested in Raphael around the turn of the century, they could not help but share the widespread predilection for his lyrical and spontaneous youthful works.[100] The fact that these paintings had only recently been appreciated by European critics and collectors meant that a few at least were still available to Americans. And these possible acquisitions were the very pictures the taste of their time led them to prefer.

Since Raphael's paintings were so costly and so difficult to obtain,

they cannot be considered a veneer, like good manners, to mask financial rapacity. Why were American collectors determined to capture his works? The love of beauty, it has been claimed, prompted them to seek out Raphael's pictures.[101] But weighing their motives squarely, we find that what might seem to be the most obvious among them, namely, aesthetic appreciation, played a relatively small part. We cannot be sure of this, of course, as such feelings are not likely to be recorded for posterity. But it is remarkable that even among the more discriminating of our collectors, there is little or no evidence to suggest that the pleasure they derived from looking at their possessions was at all commensurate with the enormous cost of obtaining them. And their aesthetic pilgrimages abroad turn out to have been mostly buying trips. We are obliged to look elsewhere, then, for the source of their veneration for Raphael's paintings.

Though they were not conventional art lovers, their seriousness of purpose cannot be doubted. We need to remember, however, that there was no tradition of connoisseurship behind collecting in this country. Whereas previous centuries had seen the European type of connoisseur-collector with an expert knowledge of his holdings, the Americans were men of commerce, not of art. Thus it is logical that their business activities shaped their collecting attitudes and habits. The gathering of Old Masters was in this sense an investment in the culture of the past—an investment, not speculation, as nothing suggests that Raphael's paintings counted as something to be sold for profit.

American millionaires were not necessarily purchasing great art, that is, works of exceptional quality or importance, but rather those by—or hoped to be by—great artists. Their attitude is suggested by the author of *Old World Masters in New World Collections,* who observed rather grandly that "fashions may come and fashions may go, but while these changing tides ebb and flow the great manifestations and expressions of genius shine with undimmed splendor. . . ."[102] The truth is that even great artists' reputations rise and fall. It is difficult for us to realize today, when Raphael has taken his rightful place among the first rank of painters, how truly exceptional was his fame. As the only artist whose prestige had endured all changes of taste and fashion up to the end of the nineteenth century, Raphael was referred to by Berenson without exaggeration as the "most famous and most beloved name in modern art."[103] Indeed, his name was synonymous with Art.

American collecting of Raphael, as a form of cultural aspiration, was oriented toward the past. It also looked to the future. Nearly all of the collectors concerned wished to benefit the American public. Unlike the aristocracy in Europe, the newly rich in America felt the need to justify their enormous expenditures. The case for wealth is the good that wealth can accomplish. Europeans believed that Americans were simply accumulating art without any appreciation of it.[104]

Fig. 17. Anonymous Photographer, Bernard Berenson, *c. 1909. Villa I Tatti, Harvard University Center for Italian Renaissance Studies, Florence.*

They failed to comprehend the concept of collecting out of public-spirited motives which was taking root in this country just as collectors were turning from fashionable art to the Old Masters. Their purchases of works by Raphael were not just another example of Veblen's "conspicuous expenditure," like titled sons-in-law and other self-indulgent luxuries. Though they enjoyed the benefits of great wealth, our collectors were not foolishly extravagant. Having spent most of their careers making vast fortunes, they were now prepared to expend them on works of art they would not live very much longer to enjoy. Significantly, too, these magnates-turned-collectors did not often live in the company of their treasures. They were displayed in specially built galleries open to the public, at first by appointment and then on a daily schedule, or they were soon donated to public museums. Most important, at the same time our collectors began to enrich the cultural heritage of this country by founding or supporting museums, they made their Raphael acquisitions. The destination they had in mind for their pictures may well have prompted their decision to acquire a work by the "Prince of Painters."

Though American collecting of Raphael is a modern phenomenon, those responsible for it kept many of the artistic assumptions of an earlier time. Responding more to the associations their paintings

evoked than to their artistic form, they held an image of Raphael and his works inherited from the nineteenth century. Increasingly, however, the literary praise of Raphael had become trite and hollow sounding, and the descriptions of his pictures, clichés. According to one leading Victorian writer, for example, Raphael "found in this world nothing but its joy" and "shunned stern and painful subjects."[105] In pointing only to the "serenity" of Raphael's style, not its broad range, and in particular to the "divine purity of his early pictures," John Addington Symonds and other critics came close to isolating their subject from what people actually think and feel.

The task of interpreting Raphael for the modern generation was taken up by Bernard Berenson (fig. 17).[106] In the *Central Italian Painters* [22] of 1897, one of four essays on Renaissance painting which he brought out around the turn of the century, Berenson [21] explained simply but eloquently Raphael's appeal for the modern viewer.[107] Acknowledging that the artist had created "images that to this day . . . embody for the great number of cultivated men their spiritual ideals," he did not ignore the nineteenth-century Raphael. But with remarkable foresight he then went on to ask how we would respond to Raphael's works if we no longer shared his classical culture. Berenson's answer was that we would be able to tell simply from looking at his pictures that Raphael was the "greatest master of Composition—whether considered as arrangement or space—that Europe down to the end of the nineteenth century had ever produced." Taking as his example the *Marriage of the Virgin* in the Brera, which he had recently reassessed, Berenson indicated to his readers how they should feel before the painting.[108] He described a "poignant thrill of transfiguring sensation, as if, on a morning early, the air cool and dustless, you suddenly found yourself in the presence of a fairer world, where lovely people were taking part in a gracious ceremony, while beyond them stretched harmonious distances line on line to the horizon's edge." It may be significant that Berenson chose to emphasize this aspect of Raphael's achievement when he did. At the same time his essay appeared, radical changes threatened the concept of space that had dominated art since the Renaissance. If the new perspective of avant-garde painting seemed alarmingly subjective and distorted, the "space compositions" Berenson urged his readers to admire in Raphael were reassuringly harmonious. By stressing the artist's spatial effects and not his sentiment and perhaps opposing them to the beginnings of abstract art, Berenson's interpretation offered early-twentieth-century viewers a viable way to respond to Raphael. We do not know what our collectors thought of Berenson's ideas, but five of them at least—Isabella Gardner, Morgan, Walters, Widener, and Kress—had copies of his essay in their libraries.[109]

Berenson's influence on the taste for Raphael and the collecting of his works was not limited to his essay. His Lists have already been mentioned. But he may have had his greatest impact as an expert, au-

thenticating paintings for dealers and collectors. Investing in Raphael's reputation, American collectors needed to attach his name to the object in their possession. For this reason they were preoccupied with matters of attribution rather than aesthetics. Recognizing that they were ignorant about art, they turned to experts for advice. As artistic knowledge grew more specialized, functions performed earlier by the connoisseur-collector broke down into those of dealer, expert adviser, and buyer. Accordingly, this period saw the rise not only of major collectors but also of dealers like the flamboyant Sir Joseph Duveen and of experts like Berenson. Their achievement in bringing art to America was due to an arrangement in which each played a role: the collector brought the wish to acquire Old Masters and the wherewithal to do so, the dealer supplied the painting, and the expert provided the counsel.

The expert's contribution was essential because of a fundamental change in the attitude of American collectors. Owning a copy after Raphael, as Jefferson had done, was no longer a mark of taste and distinction, once such copies and reproductions had become commonplace. Collectors now sought the rare and unique. Thus, it came about that an original work by Raphael's hand, however modest, was preferable to the best copy of one of his most famous pictures. The collectors who concern us here wanted an object in which they could take pride of ownership. That object might or might not be beautiful or important; its value lay primarily in the name that could be attached to it.

Inevitably, American collectors made mistakes, acquiring "Raphaels" that have turned out to be poor imitations, copies, or outright fakes. One reason for their difficulties—lack of cultural sophistication—is suggested by Edith Wharton's *False Dawn* of 1924. In the short story, set in the 1840s, Lewis Raycie's father, a self-made man, sends his son to Europe, saying, "select for me a few masterpieces which shall not be copies." Raphael, Mr. Raycie feared, "we can hardly aspire to." But when he received five thousand dollars to buy pictures, Lewis "wondered why his father, in advance, had given up all hope of a Raphael." Returning, Lewis brings back the first group of Italian primitives in America. Inspecting them dubiously, Mr. Raycie now wished to "begin with the Raphael." To Lewis' excuse that "a Raphael nowadays—I warned you it would be far beyond my budget," he replies that he "had hoped nevertheless . . . for an inferior specimen."[110]

This satire was inspired by the plight of two pioneering collectors, Thomas Jefferson Bryan (1802-1870) and James Jackson Jarves (1818-1888). Unlike the hero of *False Dawn*, however, Bryan and Jarves succeeded where Lewis Raycie had failed, acquiring works supposedly by Raphael. Bryan, a wealthy Philadelphian, during a long residence in Europe brought together a large group of Old Master paintings.[111] Though of uneven quality, the collection would form

the nucleus, Bryan hoped, of an American national gallery of art. Having exhibited it to the public as "Bryan's Gallery of Christian Art," he bequeathed the collection to the New-York Historical Society. In addition to a copy of the *Bridgewater Madonna*, acknowledged as such, Bryan had, among many other optimistic attributions, a pair of panels of the Nativity and the Resurrection which he claimed were by Raphael.[112] Bryan never doubted the authenticity of his pictures, but his cataloguer felt obliged to warn visitors to the Gallery that only "experienced and cultivated taste" would enable them to make out any resemblance between the "meagre" little pictures and the familiar masterpieces by the artist "whom we worship as Raphael." For like the "unopened bud" to the "ripe fruit," they were by the "youthful hand of the divine painter." Bryan's paintings, now said to be "after Raphael," were, with much of the rest of the collection, regrettably sold at auction in 1971.[113]

During an extended stay in Italy Jarves gathered a well-known group of early Italian paintings that also included an alleged Raphael.[114] The collection did not consist of masterpieces by the great painters, Jarves readily admitted. Since those pictures had been "absorbed into the chief public galleries [in Europe], and can never be seen in America,"[115] he contented himself with "characteristic specimens," meant to illustrate the progress of Italian art. Jarves treated his pictures as companions to *Art Studies*, his history of Italian painting published in 1861. Accordingly, the book features reproductions of Jarves' works, one of which was of a *Pietà* (fig. 18) labeled Raphael.[116] Jarves did not attach Raphael's name to his picture arbitrarily. That practice, he well knew, had become "almost a byword of doubt or contempt in America, owing to the influx of cheap copies and pseudo originals, of no artistic value whatever."[117] Jarves' painting was a copy, too. But according to him, it was Raphael's own copy of a Perugino fresco then in the Albizzi palace in Florence.[118] Though no masterpiece, the *Pietà*, its owner believed, was nothing less than Raphael's earliest known work, "one of many replicas he made of his master's pictures, with but very slight variations of treatment and design."[119] While allowing for a certain "hardness and timidity," all too evident today, Jarves professed to be able to make out in the panel the "pure ideal and religious sentiment that characterized the earliest efforts of Raphael. . . ."[120] Some thirty years later when Berenson visited the collection, now installed in the Yale University School of Fine Arts, he called the "Raphael" a modern forgery, a judgment posterity has accepted.[121]

Jarves regarded his collection as a comprehensive survey, and no survey would have been complete without a Raphael. The difficulty he faced was that if the primitives he acquired were cheap and plentiful, works by Raphael were much rarer, though not so rare as he supposed. As a collector of Raphael, Jarves was a failure. Nevertheless, he pointed the way for later Americans. To solve the problem of find-

Fig. 18. Formerly attributed to Raphael, Pietà. *Yale University Art Gallery, New Haven, Jarves Collection.*

Fig. 19. Catalogue of Paintings and Sculpture in the Collection of Charles T. Yerkes, Esq. *(New York, 1904). Plate 80,* Holy Family and the Sparrow. *National Gallery of Art Library, Washington.*

Fig. 21. Claude Monet, Waterlilies. *Collection of Dr. and Mrs. Barnett Malbin, New York (The Winston-Malbin Collection, New York).*

ing a Raphael he turned to a putative early work. Equally significant, he shared with Bryan the hope of establishing a public gallery. The collectors who concern us here did not take a historical survey as their aim. But they inherited Jarves' ideal of a collection of European Old Master paintings, crowned by a Raphael, that would further the "rapidly growing artistic taste and ambition" of their country.[122]

Later American collecting of Raphael in part continued the story of failure. The mistakes collectors made were generally of two kinds, involving misattributions or copies, and most were due to ignorance. Typical of the former category is the so-called *Holy Family and the Sparrow,* bought from a princely European collector before 1893 by railway magnate Charles T. Yerkes. In the sumptuous privately printed catalogue [23] in which his pictures were illustrated (fig. 19), Yerkes admitted to being "unsure as to whether the names attached to them are the correct ones."[123] His doubts were confirmed when, after examining the picture, Berenson pronounced it a later copy of a Raphaelesque model.[124] Despite that verdict, the *Holy Family* was sold at auction after its owner's death as a Raphael.[125] A more discriminating collector, John G. Johnson, exclaimed in a letter to Berenson that a "female lover of the highest art succeeded in obtaining the Raphael for $4,000. The only wonder is, as she has plenty of money, she was not obliged to pay $50,000 for it. Prejudiced, as you are, against some of the examples of the Higher Art, which reach this country, I think you would be compelled to admit that it was worth $25 or $50."[126] When the picture changed hands again in 1949 it was still "attributed to Raphael."[127]

Another misattribution was that of William R. Valentiner, whose greatest desire in life, a colleague once explained, was to obtain a Raphael for the Detroit Institute of Arts, where he was the director. The alleged Raphael rediscovered by Valentiner in 1935 was a half-length profile portrait of a kneeling donor (fig. 20), cap in hand, seemingly signed and dated 1506. Suggesting that the sitter might be none other than Raphael's friend Taddeo Taddei, Valentiner praised the painting as one of the outstanding achievements of Raphael's Florentine period. A "remarkable addition to the small number of easel paintings created by the master," Detroit's recent acquisition took a "notable place," he said, "beside the eight other originals by [Raphael] owned in this country."[128] To the scarce funds available for purchasing the picture, the museum was obliged to offer the dealer, E. A. Silberman Galleries in New York, several works from its own collection in exchange, including a splendid Monet *Waterlilies* (fig. 21) of 1907.[129] The exchange of the genuine avant-garde masterpiece for the putative Old Master clearly demonstrates the length to which the Institute and its European-born director were prepared to go to add Raphael's name to the list of artists represented in the collection.

One writer even went so far as to attempt to reconstruct an imaginary pictorial ensemble from which the Detroit picture would have

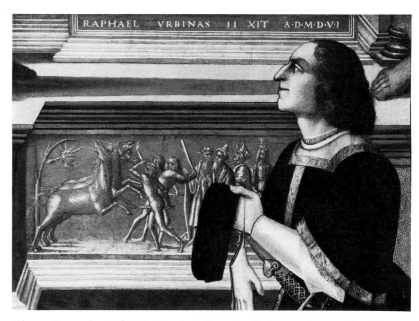

Fig. 20. Formerly attributed to Raphael, Portrait of a Donor. *Present whereabouts unknown. Photo courtesy of the Detroit Institute of Arts.*

Fig. 22. Photograph of an altarpiece of the Madonna and Child Enthroned with Saints and a Donor, published in 1948.

come.[130] In an article of 1948, however, Federico Zeri, an Italian scholar, proved that the panel at Detroit was a repainted fragment cut from an altarpiece of the Madonna enthroned. Zeri published an old photograph (fig. 22), showing that the all important "Raffaello," inscribed on the panel, referred not to the artist but to the archangel Raphael depicted in the altarpiece.[131] The painter, Zeri suggested, may have been a minor Umbrian named Gerolamo Nardini. After this startling revelation the "Raphael" was returned to the dealer in exchange for two paintings now in the Institute. The whereabouts of the fragment and of the altarpiece from which it was removed is unknown. The incident shows that even a reputable scholar like Valentiner could be so carried away by enthusiasm for a newly acquired Raphael that he failed to judge the picture, supposedly signed by the artist, on its own merits. When cleaning revealed the feet of the figures now identified as Raphael and Saint Sebastian, indicating that the panel was only a fragment, Valentiner still clung to the belief that it was by Raphael, because of the signature, which he took to be genuine.[132] The "Detroit Raphael," as Valentiner called it, thus offers a striking instance of the tendency of American collecting earlier in this century to pursue great names and not necessarily great works of art.[133]

More recently the Boston Museum of Fine Arts made a similar mistake by acquiring in 1969 a *Portrait of a Young Girl,* misattributed to Raphael. According to the scholar who first published this "newcomer to the family of Raphael's works," its acquisition by the museum was the "surprise and focus of the current centenary celebrations."[134] In fact, both the Boston Museum and New York's Metropolitan Museum were celebrating their one hundredth anniversa-

ries in 1970. It now seems clear that in making the single spectacular acquisition of a presumed Raphael, Boston hoped to outdo any of the events honoring its rival. The coup was widely reported in the press, *The New York Times* declaring on December 16, 1969, that "as a newly discovered addition to the short list of early paintings by Raphael, the picture represents a major acquisition for an American museum."[135] Bought with a fund earmarked for the purchase of a very important painting and prominently displayed in the rotunda of the museum, the portrait was dated about 1505 and was said to represent Isabella d'Este's daughter, Eleonora Gonzaga. Nevertheless, the Raphael attribution has not met with approval.[136]

It sometimes happened, too, that a painting acquired as the work of a lesser master was rebaptized as a Raphael after its arrival in this country.[137] The *Madonna of the Veil* (fig. 23) from the collection of the Duke of Westminster was shown at the Princeton University Art Museum in 1925. Though the painting had long been considered one of several known copies of a lost original, the museum director, Frank Jewett Mather, Jr., did not hesitate to attribute it, at least in part, to Raphael himself. Mather claimed that Raphael began the landscape in Florence in 1508 and painted the face and hands of the Madonna and the sleeping Christ Child in Rome. There pupils finished the work, Penni being responsible for the draperies and Giulio Romano for the figure of Saint John.[138] Acknowledging that signed, fully autographed paintings by Raphael were "absolutely unobtainable at any price," the studio production would suffice, Mather said, to "fill an important gap in the museum's gallery showing the development and history of art."[139] The loan attained permanent status when a Princeton alumnus presented the panel to the museum.

Upon technical examination and comparative study of the other versions, the "Princeton Raphael" might actually turn out to be a product of Raphael's studio, as Mather believed. In other cases, however, American collectors, out of ignorance or to strike a bargain, acquired what were no more than copies of well-known works by the master.[140] As late as 1939, when Raphael's paintings were well known in America, Felix Warburg of New York purchased a version of the early *Madonna and Child with Saints* in Berlin from the dealer Count Alessandro Contini-Bonacossi. Though it was given to Raphael by Bode, Longhi, and other experts, the picture, since 1959 in the Fogg Museum, is nothing more than a poorly preserved contemporary copy of the original.[141]

The most instructive of these mistakes is the *Annunciation* (fig. 24) in the Kress Collection in the National Gallery, which since it demonstrates the pitfalls that awaited would-be purchasers of Raphael, is worth examining in greater detail.[142] The composition of the picture [24] is unusual: the angel and Madonna are shown in two roundels before a parapet opening on to a landscape. The dark background surrounding them is decorated with the classical type of or-

Fig. 23. School of Raphael, The Madonna of the Veil. *The Art Museum, Princeton University, Presented by Gerard B. Lambert in memory of Prof. Howard Crosby Butler.*

Fig. 24. *Giannicola di Paola,* Annunciation. *National Gallery of Art, Washington, Samuel H. Kress Collection, 1939.*

nament known as *grottesche,* consisting of arabesques and two pairs of nude winged putti resting on candelabra. The attribution has been disputed between Perugino and the early Raphael. While in the Coesvelt Collection in London, the painting was given to Raphael, and it was exhibited as his work throughout the nineteenth century.[143] As late as 1968 an attempt was made in the Kress catalogue to defend the Raphael attribution.[144] Most modern critics have agreed, however, in ascribing it to Perugino.[145] The face of the Madonna, the

"girlish roundness of her cheeks and features," seemed especially Peruginesque to one writer,[146] though another found it "sweeter and more fascinating" than any of Perugino's.[147]

The only critic who had a definite attribution other than Perugino or Raphael, thus implying that the painting was less than a masterpiece, was Berenson. In posing an alternative he had little to go on beyond the doubts expressed by a few predecessors. Mrs. Jameson, cataloguing the Coesvelt Collection, had admitted to her readers that the picture was without any "just pretensions to originality."[148] Subsequently, Crowe and Cavalcaselle also noted that the handling

Left: Fig. 25. X-radiograph of the Annunication. *National Gallery of Art, Washington.*

Right: Fig. 26. Early photograph of the Annunication *before restoration. Villa I Tatti, Harvard University Center for Italian Renaissance Studies, Florence.*

was not Raphael's.[149] More specifically, one writer, viewing the *Annunciation* at the Manchester Exhibition of 1857, had already observed that the head of the Virgin was not at all like Raphael.[150] Berenson in 1909 gave the picture to a Perugino imitator whom he called Giannicolo Manni, known today as Giannicola di Paolo.[151] Later, on the back of a photograph sent to him in 1938, Berenson wrote "Studio of Perugino, perhaps Alfani." In the posthumous edition of his collected Lists, the painting is simply designated a Perugino workshop production.[152]

Today, we can turn to technical evidence [25] for help in determining whether or not the *Annunciation* is by the young Raphael. An x-radiograph (fig. 25) reveals that the panel is divided in a straight line down the middle. It also shows that the gesso ground of the two halves of the painting is not continuous, nor are the brush marks. What would appear to be one picture with a rather odd design can be seen in light of this newly discovered evidence to be a composite of two separate panels. Given their ornamental character, narrow rectangular shape, and modest dimensions, it seems likely that the two panels now joined vertically were originally the painted reverse of the

wings of a small folding altarpiece. When closed over the central panel, whatever that may have been, the reverse would probably have appeared much as the painting does now.

The x-radiograph also reveals the fact that the Madonna's face, so much discussed by the critics, has been almost completely ruined. Comparison with the corresponding area in the x-radiograph indicates the extent to which the present head has been repainted. The loss tells us that the Madonna's face is now unreliable. Further evidence suggests how it was originally different. There is a discrepancy in the Madonna's face, as it first appears in an engraving in the Coesvelt catalogue of 1836 and in an etching illustrating Mrs. Jameson's *Legends of the Madonna* of 1857.[153] In the two illustrations the Madonna's eyes and mouth are subtly different. What we can scarcely detect as a difference in the prints, separated by about twenty years, is confirmed by old photographs of the *Annunciation,* one of which (fig. 26) is preserved in the Berenson archive at Villa I Tatti.[154] In the photograph [26] the unlovely quality of the Madonna's face is most evident. The photographs and the engraving must represent the painting before it was restored around the middle of the nineteenth century. At that time the Madonna's face took on the character that it still bears today. The restoration might have been prompted by criticism of the Madonna's face by visitors to the exhibition of 1857, one of whom, we recall, found it "not at all Raphaelesque."

Working from the old photograph of the *Annunciation* in its previous state, Berenson understandably attributed it neither to Raphael nor to Perugino but to Giannicola di Paolo. For the caricaturelike aspect of the Madonna's face is not the work of a clumsy restorer repairing a loss. Rather it is a hallmark of Giannicola's style.[155] Besides the unpleasing aspect of the Madonna's face (in the painting in its original state), the *Annunciation* resembles the work of Giannicola in other ways too.[156] Technical evidence, early reproductions, and comparison with authenticated works vindicate Berenson's first attribution to Giannicola di Paolo. Both Giannicola and Raphael were pupils of Perugino, possibly at the same time. But Giannicola's Peruginesque paintings lack the inventiveness and refinement that characterize the youthful works of Raphael. Although Kress acquired the *Annunciation* in 1935 as a Perugino, certain critics, and possibly the collector himself, were reluctant to give up the traditional attribution to Raphael.[157] In this case, as in that of Detroit, deceptive restoration was misleading. Yet American collectors were only too eager to look beyond the paintings in their possession, seeing instead the great name attached to them.

Fortunately, the efforts of Kress and other Americans were also crowned with success. A new era of collecting in this country began when Isabella Stewart Gardner (1840-1924) acquired the first authentic Raphael to reach these shores.[158] Her preeminence derives

Fig. 27. Baron Adolph de Meyer, Isabella Stewart Gardner, c. 1905. Isabella Stewart Gardner Museum, Boston.

Right: Plate 5. The Raphael Room at Fenway Court. Isabella Stewart Gardner Museum, Boston.

from the head start she had over rivals who only began to buy Old Masters a few years after she had already made her initial purchases. We have previously noted that our collectors came late to Raphael after pursuing careers in banking and industry. Significantly, a woman with the leisure time to devote to the search for art was the first among them to obtain an autograph work. Strong-willed, vivacious, and charming, Mrs. Gardner (fig. 27), shown here in a photograph [27] by Baron Adolph de Meyer, was in fact the first great collector (after Jarves) of Italian paintings in America. Admittedly, she made a poor start with fashionable contemporary art and remained a patron of young artists who caught her fancy. Old Masters like Bellini and Titian, examples of whose work would later enter her museum, were at first represented only in photographs. As a step toward collecting early art, she began in the 1880s to acquire rare books, particularly editions of Dante. A Rembrandt *Self-Portrait*, purchased in 1896, was, she said, the first picture bought with the intention of developing a real museum collection. From then on she was determined to acquire masterpieces.[159] Berenson's idea for her collection,

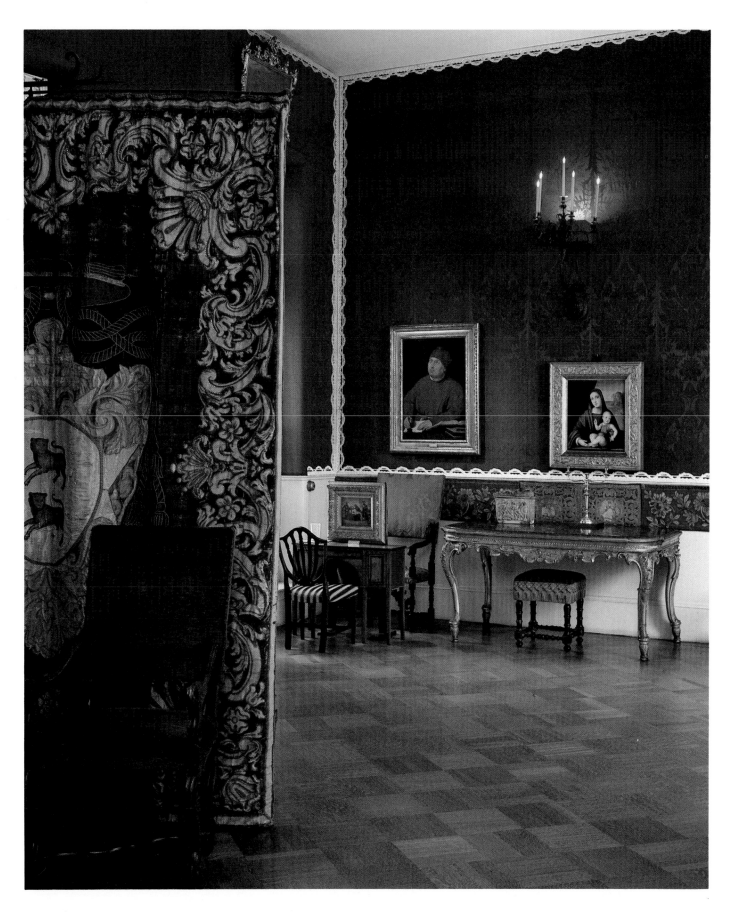

he explained in a letter of February 16, 1896, was that it should "possess a masterpiece by each of the world's great masters."[160] Like Jarves' survey, but not for historical reasons, Mrs. Gardner's gallery of masterworks by the great painters had to include a Raphael.

By 1898 all the factors necessary for an American collector to acquire a Raphael were in place. First, Mrs. Gardner had a knowledge of his works gained from extended sojourns abroad. Then, to her wish to form a collection of great European paintings she was able to add the financial means to do so in the form of inheritances she received from her father in 1891 and her husband in 1898. Finally, she had the expert advice she needed from Berenson to overcome any fear of failure. And in that very year she acquired the first painting generally accepted as Raphael's to come to America, the *Portrait of Tommaso Inghirami*.

When Mrs. Gardner purchased her Raphael, she was planning a gallery to house her collection in Boston. Completed in 1903, the museum (plate 5), called Fenway Court, remains almost unchanged today.[161] There her paintings are featured in a rich setting of furniture and decorative arts, recalling the Palazzo Barbaro in Venice, where she was a frequent visitor. Mrs. Gardner displayed the Raphael portrait and the *Lamentation,* a small predella panel by the master, which she acquired two years later, against a background of red brocade-covered walls. The pictures were installed in a room named after Raphael on the second floor of the museum.

Despite her acquisitions of a portrait and a predella panel, the one painting Mrs. Gardner wanted above all others was a *"heavenly Raphael Madonna."*[162] Her correspondence with Berenson shows that she kept after him to find one. He had no success, however, and tried to placate her with alternatives. Since her remaining funds were needed to endow her museum, she would tap them for nothing less, she said in July of 1901, than the "best Raphael Madonna."[163] Later that same year Berenson offered instead a *Madonna* by Pinturicchio from his own collection, ingeniously suggesting that it was a "link between Raphael and his precursors," and that, in any case, "Raphael is not at all so rare as Pinturicchio."[164] To overcome any doubts about the picture, Berenson wrote again a month later, claiming that the older artist must have painted it while Raphael was in his atelier.[165] Early Madonnas by Raphael in museums in Russia and Berlin were little more than copies, he said, of the painting she could have for four thousand pounds. Persuaded to purchase the Raphael substitute, she persisted, nevertheless, that her "remaining pennies must go to the greatest Raphael . . . Nothing short of that. I have tasted blood you see."[166]

Isabella's determination to hold out for a "very few *great* things," like the Raphael Madonna, distressed her agent who was working on a commission.[167] To her question "How does my A No. 1 Raphael Madonna get on?" he could only reply, "Not very well I fear. A Raph-

ael that is completely autograph & in good condition is as good as hopeless. I make no doubt very attractive pictures passing themselves off as Raphaels are to be had, but nothing real. So if possible try to rest contented with the two Raphaels you have already and turn your attention to something no less great if not greater."[168] Berenson reassured her that "you may implicitly rely on my moving heaven and earth to get you a Raphael Madonna. But I confess the chances of success are few, unless indeed you are satisfied as everybody else seems to be with pictures that Raphael barely looked at, like Pierpont Morgan's extravagant purchase [the Colonna altarpiece]."[169] Undaunted, Isabella still wished to "aim for a Raphael Madonna,"[170] to which Berenson retorted, "If only you knew how eagerly I look out and about. Of Raphaels to satisfy Whitney [the Hyde portrait, to be discussed presently] or Morgan I know a number, but not one worthy of you as yet."[171] He had, he said, repeatedly been offered a copy of the "Casa Alba picture at the Hermitage [now in the National Gallery in Washington], itself only partially a Raphael. They have the impudence to ask £60,000 for this poor copy and I make no doubt that some flush countryman of ours will end by taking it."[172] Another Raphael then on the market, the *Giuliano de' Medici*, later acquired by Jules Bache from Duveen, was next proposed, but Mrs. Gardner would have none of it. Prices were rising, she complained, and "all that money is not within my grasp—and the Raphael I *want* is a Madonna."[173]

Isabella coveted one Raphael in particular, the smaller and earlier of two Madonnas (frontispiece) belonging to Earl Cowper at Panshanger in England. As early as 1900, when she pressed Berenson to get it, she was disappointed to learn that "the 'noble Lord' would not conceivably dream of selling his Raphael . . . So please put that out of your mind," he pleaded, "and try to console yourself with other pictures, less famous conceivably, infinitely less expensive, but not necessarily less beautiful as works of art."[174] Seven years later Mrs. Gardner had still not given up hope, for on August 14, 1907, an exasperated Berenson repeated that he knew "for a fact that the Panshanger Raphael is not to be had for money. As there is no other Raphael Madonna in view . . . I beg and urge and entreat you to spend some of the reserve of which you have frequently spoken to me, in making purchase of the three pictures I am proposing now."[175] In the end Berenson could only exclaim that the "Raphael in private possession that I built hopes on, the Panshanger one is absolutely not for sale. What have I not done to get it for you, but all to no purpose."[176]

The correspondence exchanged between Berenson and his patron provides the most complete documentation of an American collector's overriding desire for a Raphael Madonna. Though it is conceivable that Mrs. Gardner longed for such a picture because she was the mother of a son who had died in infancy, her remarks suggest that she

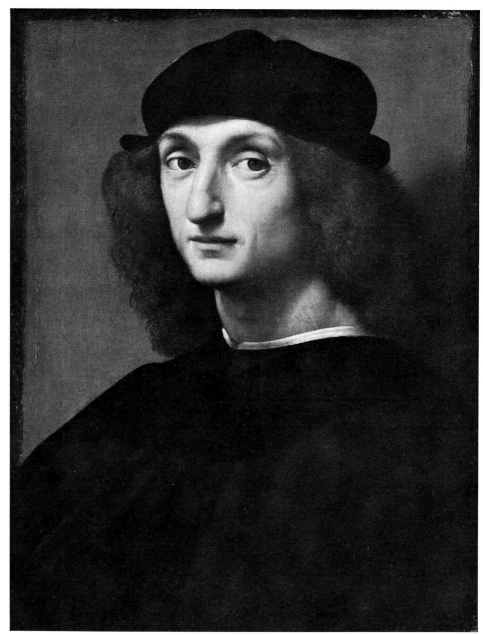

Fig. 28. Attributed to Raphael, Portrait of a Young Man. *The Hyde Collection, Glens Falls, New York.*

was movitated primarily by the concerns she shared with other collectors. Berenson's difficulties in finding a picture she wanted so badly, one which would have greatly profited him, show how exceedingly rare Raphael's Madonnas were. Indeed, it is one painting to which they return again and again in the correspondence. The letters also reveal that there was for collectors a quintessential Raphael, the artist as a painter of Madonnas. The portrait and the predella panel Mrs. Gardner already owned and the portraits she turned down had less value and significance than the ideal. Furthermore, the Madonna had to be by Raphael himself; a version of the theme by another painter similar in style and sentiment was no substitute. From the

standpoint of connoisseurship, there were "real" or "worthy" Raphaels and then there were others, easier to obtain but less certain, not to speak of copies passed off as originals. Finally we learn that the interest in Raphael was not just or not even chiefly aesthetic; as Berenson assured her, other pictures could be found which were just as beautiful but not so famous or expensive.

The "Whitney Raphael" to which Berenson slightingly referred is the striking *Portrait of a Young Man* (fig. 28), now in the Hyde Collection at Glens Falls, New York.[77] The picture [28] had been offered to Mrs. Gardner for twenty thousand pounds, and Berenson wrote her from Berlin [29] on September 16, 1898, recommending against the purchase.[78] He was unable to comply with her request that he inspect the portrait in London, he said, for "so convinced am I that in every probability the picture is a *humbug* that Agnew would have refused to show it to me. . . ." Berenson suspected that the portrait offered by Agnew's was one with which he was already familiar. "All last winter," he went on unraveling the mystery, the painting "was at a dealer's named Volpi in Florence. It was Raphaelesque, much prettified by restoration, and obviously by Raphael's Florentine imitator Ridolfo Ghirlandajo." The dealer, however, "had got it into his head that it was a Raphael." Could the "Raphael" Mrs. Gardner was considering be the portrait Berenson knew as Ridolfo Ghirlandaio? He asked her to send him a photograph, which he had been unable to obtain. After examining it, he would cable back. "If it is what I suspect NO will do." This photograph exists at Villa I Tatti today, and on the reverse Berenson's wife duly wrote "Ridolfo Ghirlandajo?" and "W. C. Whitney, who bought it as a Raphael (!) from Agnew." A financier and Secretary of the Navy, William Collins Whitney (1841-1904) held a New York streetcar franchise in common with another of our collectors of Raphael, P.A.B. Widener. In the 1890s, Whitney had commissioned an Italian Renaissance style palazzo from McKim, Mead, and White. In such surroundings, he must have felt, his new acquisition would find an appropriate home.

After Whitney's death in 1904, his executors returned the painting to Agnew's, who exhibited it that year in London.[79] In 1938 it was again sold by Agnew's to another American collector, Mrs. Louis Hyde.[80] A letter dated November 4, 1938, from a dealer to Mrs. Hyde advised her that the portrait was "exceptionally reasonably priced, and from that point of view represents a very good investment."[81] Later that month Mrs. Hyde acquired the picture, sending Agnew's a check for eighteen thousand dollars, a bargain price indeed for a Raphael.[82] Charlotte Pruyn Hyde (1867-1963) and her husband, a paper manufacturer, had developed an early interest in art and art collecting in Boston.[83] Then, apparently impressed by Isabella Stewart Gardner's achievement at Fenway Court, they built a house in the style of an Italian villa at Glens Falls in 1912. There they displayed a similarly eclectic collection with an emphasis on the Ren-

aissance. When she acquired the "Raphael" Mrs. Hyde could not have known that forty years earlier her predecessor had turned down the same picture.[184]

The portrait by Raphael which Mrs. Gardner did buy is the *Tommaso Inghirami* (fig. 29).[185] Her acquisition was an act of faith not only in Berenson's judgment but in modern connoisseurship itself. The *Inghirami* portrait was only the first to cross the Atlantic of a series of Raphaels which had been recently rediscovered or given new prominence.

One of Raphael's most brilliant inventions, the painting overcomes the obvious difficulties the fat, wall-eyed sitter presented to the artist. Raphael adopted the pose traditionally used to depict an Evangelist, showing Inghirami seated at his desk, book open and pen in hand, turning and looking up for inspiration. The portrait of the Roman prelate was known in two versions, one in the Inghirami palace in Volterra and the other in the Pitti Palace (fig. 30). Painted on panels of virtually the same dimensions, they disagreed only in the smallest details. Therefore, one was presumably the original and the other a copy. The Pitti version was long celebrated in the Medici Collection, having possibly been given by Inghirami to the Medici pope, Leo X. Up to the end of the nineteenth century the other version remained almost unknown. At that time Crowe and Cavalcaselle said that it was more attractive than the painting in the Pitti. Nevertheless they decided on close inspection that it was only a contemporary copy and not a replica by Raphael's own hand, as the owners believed.[186]

The fortune of the Volterra version took a dramatic turn, however, when Giovanni Morelli, the founder of modern connoisseurship, pronounced it the original by Raphael and the famous panel in the Pitti Palace a copy. Morelli had eagerly set out to revaluate the work of early Italian painters on the basis of "scientific" connoisseurship. His method of comparing such details as painted hands and ears had disconcerting results.[187] Before the Inghirami portrait in the Pitti, for example, he invited critics to "look at the hard fixed eye and badly modeled mouth, at the thumb of the right hand which is completely out of drawing, and at the crude colours of the book." The original belonging to the Inghirami family at Volterra, though ruined by modern restoration, Morelli said, was "still recognizable in parts as the work of Raphael."[188] If amid all the controversy, Morelli's warning about the condition of the picture was overlooked, his reattribution found widespread support.[189]

As a disciple of Morelli, Berenson followed the master's view. Thus, it was the Volterra version of the Inghirami portrait, not the one in the Pitti, which was listed as Raphael's in the *Central Italian Painters* of 1897.[190] Noting a passage in Julia Cartwright's *Raphael in Rome*, in which she lamented that the "original of this vigorous and impressive work remains hidden away in the palace of the Inghirami

Fig. 29. *Raphael?*, Portrait of Tommaso Inghirami, *Isabella Stewart Gardner Museum, Boston.*

Fig. 30. *Raphael?*, Portrait of Tommaso Inghirami. *Galleria Pitti, Florence.*

at Volterra," Berenson was determined to obtain the painting for his patron.[191] On January 16, 1898, he wrote her about an opportunity of the "most extraordinary and unexpected kind. Let me say it at once, I have to propose to you a portrait by—Raphael. . . .

The photograph [30] I am sending you is of the version in the Pitti, and because it is of the copy, and because it is a photograph it grossly exaggerates the mere unattractiveness of the sitter . . . In the original, you would either not notice it at all, or soon forget it, overpowered by the splendid, classic style of the thing as art. . . .

Well, if I had been asked what in the whole range of art seemed the hardest to acquire I should have said a portrait of *any* kind by Raphael. Madonnas are hard enough to get, but a portrait of any kind has almost never been in the market. And this particular portrait is almost universally acknowledged as one of Raphael's two or three best existing portraits.

I think I have said enough to convince you that this is the chance of chances to acquire a work of art in itself great, englamoured in glory, for a price almost ridiculous. Believe me, to be perfectly moderate, if I get you this portrait, at the price I hope to get it for you, I shall be almost as good as making you a present of from twenty to thirty thousand pounds.

Remember also that the only other Raphael worth your while is Lord Cowper's Madonna, really not so great a work, altho' pleasanter. . . .

So, please cable just as soon as you can YESANZIO, if I am to get the Inghirami for you. If you do not want it I shall be sorely tempted to turn dealer; for had I the capital to purchase it outright, I could make my fortune quickly. But I had rather you got it, for I have your collection at heart only after my own work. And a prize like this I scarcely can hope ever again to try to fetch home to you."[192]

Mrs. Gardner delayed, however, leading Berenson to warn her on February 2 that the Raphael was "fast slipping from my hands."[193] That same day she explained that the delay was due to her husband's absence. She did "not know which way to turn for money. And I can't raise a cent without him . . . so what to be done about the Raphael portrait?"[194] Returning earlier than expected, Jack Gardner, to the chagrin of his wife, took an immediate dislike to the Raphael—or rather to the photograph of the copy of it—and "therefore says 'quite impossible for me to buy it.' However I believe in you so much," Mrs. Gardner wrote Berenson, "that I don't in the least like to give up the Raphael . . . so tell me again if I must have it & what is the lowest price."[195] Mrs. Gardner's unwilling husband, who controlled her purse strings, was disappointed, we may presume, because the portrait did not conform to the image of Raphael and his work held at the end of the nineteenth century. For instead of a sweet and lovely Madonna, Berenson was offering Mrs. Gardner an uncompromisingly realistic portrayal of an ugly subject. Even if the portrait was by Raphael, it seemed uncharacteristic. To such an attitude Berenson could only reply that the "chance we still have of getting one of Raphael's two most excellent works for a price that relatively speaking is a mere song . . . occurs but once in a generation, and that to let it slip would be making *il gran rifiuto.* I should be sorry in the first place for us both, and then for America."[196] To convince the Gardners of the greatness of the portrait as a work of art, Berenson made up his mind, he told them, to "go to Volterra to see the Raphael again. This morning I saw it, & I can not tell you how much it impressed me."[197]

Reexamining the picture, Berenson noted, as Morelli had previously, its poor state of preservation. He mentioned it now for the first time. But his discreet warning was lost on Isabella, as she was preoccupied with another different matter. An Italian dealer named Costantini, who acted as an intermediary in the negotiations, had contacted the Gardners directly, offering the portrait at a price nearly half that quoted by Berenson.[198] There was reason to hope that at the lower price Mr. Gardner, who still "hated" the painting, might relent and allow his wife to purchase it. Less than a week later Berenson re-

plied, without further explanation, that the "Inghirami is yours, one of Raphael's very greatest works, & for a price that must be considered the greatest bargain of the century. . . . And I am delighted that you want it sent to Boston. It will add greatly to the difficulty of getting it out of the country, but I look forward keenly to your first good look at it."[199] Berenson would have the portrait copied for the Inghirami family, he said.[200] Isabella and her husband wanted to know why the price had been lowered, for that "simply made it possible for me to have it."[201] She was impatient for news of the picture.[202] A month later Berenson explained that he had managed to acquire it for the lower price by luck. Happening to learn that the Inghirami family had unsuccessfully applied for a loan, he was able to use that knowledge to strike the same bargain Costantini offered. "It has been great sport," he added, and "an immense instruction to keep going to & fro between it & the Pitti version. You are almost the first private collector who can boast of possessing the original of a great work which in one of the most famous galleries of the world is represented by a copy."[203]

Not long after Isabella acquired it, the *Tommaso Inghirami* was featured in a book [31] of 1907 of great interest for the history of taste and collecting entitled *Noteworthy Paintings in American Private Collections*. Undertaken by August F. Jaccaci and edited by him and by the painter John La Farge, the book was "meant to illustrate the fact that we have not only become the leaders of the world in finance and industry, but that we are taking possession of the world of art."[204] Though only the first in what was intended to be a series of luxurious volumes describing the major private art collections in America, *Noteworthy Paintings* prompted critics to reassess the American achievement to date.[205] European experts also contributed notes on the paintings included in the volume. Two such experts, noting that the Gardner *Tommaso Inghirami* differed slightly from the Pitti version in the position of the head and in the red garment, suggested that the Boston picture was the earlier of the two.[206] This is the prevailing view today.[207] The difficulty in deciding which of the two versions is autograph is that their respective quality cannot be judged very well without juxtaposing the paintings themselves. If they were placed side by side, it is the sadly abraded state of the Gardner version that would probably emerge from the comparison. After the removal of the old repaint of which Berenson had complained to Mrs. Gardner, much of what is left has the character of an underpainting with the final layers missing.[208]

From the standpoint of condition, Mrs. Gardner's second Raphael, the *Lamentation* (fig. 31), was impeccable.[209] On October 25, 1900, Berenson wrote her of a picture "of the utmost importance, for it is nothing more nor less than a Raphael I propose to you this time. Let me say at once that it is not a Madonna, but then the price as you shall see is not what would be asked for a Madonna. . . .

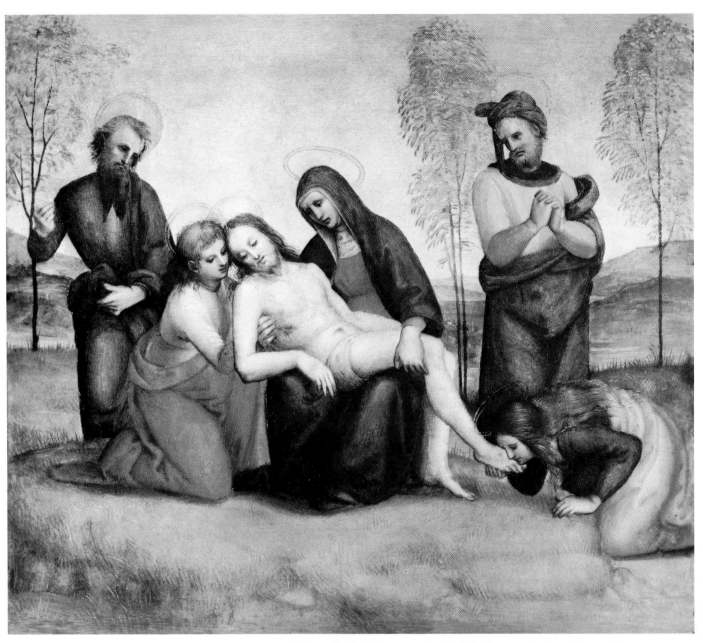

Fig. 31. Raphael, Lamentation. *Isabella Stewart Gardner Museum, Boston.*

As you see this little Pietà shows us Raphael at that exquisite moment when he was still searching, still almost a Perugino. Indeed the little picture but for its childlike delicacy, and sweet shyness might be Perugino's, so golden clear is the colour, so dainty the feathery trees. The subject scarcely could have been treated in a gentler, more hushed, deeper spirit. The almost boyish touch has the greatest fascination. In a word the little picture puts you in a mood as if somewhere far away. . . .

This little Pietà originally formed part of the predella for the S. Antonio altar at Perugia painted in 1505. This you must know is the picture known as the "King of Naples" Raphael [Colonna altarpiece], which was offered you several years ago and which I advised you not to buy. For the altar-piece was never entirely from Raphael's own hand, and now entirely repainted.

The other parts of the predella are not all Raphael's own, nor in good condition. It is my firm conviction that the Pietà is absolutely in every touch Raphael's and it certainly is in perfect preservation. . . .

The history of this little predella is known from the day it left Raphael's hand to this day that I am writing. It was sold by the nuns of S. Antonio on June 7, 1663 to no less a person than the erratic, gorgeous Queen Christina of Sweden, who had finer taste than any other person of her time. On the sale of her collection they passed into the famous Orleans Gallery, and in 1798 were sold in London with the rest of that renowned collection.

So you see it is a Raphael of exquisite quality, of finest Umbrian feeling, of unquestionable authenticity, of perfect preservation, and with an almost matchless pedigree.

The price is Five Thousand Pounds (£5000) *tutto compreso.*

To give you some idea how reasonable, nay how cheap it is let me tell you that some thirty years ago the Conestabile Madonna was bought by the Czar for £20,000 and that some twenty years ago the Duc d' Aumale paid £24,000 for the Three Graces—both pictures even smaller than this. And you must remember that in the last 30 years Italian pictures have tripled and quadrupled in value.

It may be objected that those pictures are more attractive as subjects. I will not deny that for the vulgar this may be so, but scarcely so for you and me who can distinguish the great quality of a work of art apart from its subject. Moreover thanks to this feeling of the vulgar, you can get the little gem for £5000, and not for $50,000 which to say the least would be the present price of the others.

I need say no more. There will be no other chance in our life-times if ever to acquire a first-rate Raphael, at such a price. . . ."[210]

Berenson's eloquent account of the painting made it irresistible to Mrs. Gardner, who cabled without delay to accept it. She purchased it from the London dealer Colnaghi through Berenson on November 17, 1900.

Although he noted that the *Lamentation* came from the base of an altarpiece, Berenson discussed it as if it were an independent composition. His approach reflects a new attitude toward this and the other panels from the predella which, Crowe and Cavalcaselle said, "are now, as it were, isolated pictures;—claiming attention for themselves instead of being modestly lost in the framings of a large altarpiece."[211] Adolfo Venturi went so far as to state that the predella was the most attractive part of the whole altarpiece.[212] Berenson described the *Lamentation* in terms strongly reminiscent of his treatment of Raphael as a space-composer. Before the predella panel, with its gentle, hushed spirit, the viewer was transported "somewhere far away." Though others might prefer a superficially more appealing theme—a Madonna or a mythology—Mrs. Gardner, like Berenson, should recognize quality in a painting regardless of the subject. He was asking her, in effect, to make a formal appreciation. Nevertheless, his own account—and this is surely the way she would have seen the painting too—was not immune from the prevailing sentimental view of Raphael. Thus, Berenson used terms associated with youth itself—"searching," or "childlike delicacy and sweet shyness" or

"boyish touch"—to describe a panel which Raphael had completed at the age, mature for an artist, of twenty-one.

Reading this effusive description it comes as a surprise to realize that neither Berenson nor Mrs. Gardner had ever seen the picture. The whole discussion and transaction depended upon a photograph. Along with the letter of praise, Berenson sent Mrs. Gardner a photograph of the *Lamentation,* which was, he said, "unhappily a caricature. Being a jewel of the most exquisite delicacy no photograph could do it the slightest justice, and least of all the one I enclose which is the exact size of the original. Now photographs that are the exact size of the original have an advantage in that they show every touch as the picture itself would, but have the immense disadvantage . . . of coarsening the outlines and blackening the shadows." He begged her to "make every allowance, and to use your imagination."[213] This was not the only time Mrs. Gardner, separated from the actual work of art, had to decide whether or not to acquire it on the basis of a photograph supplied by Berenson.

The exhibited photograph [32] of the *Lamentation* is not the one Berenson sent to Mrs. Gardner, which no longer exists. Made from the same negative as hers, it is a print Berenson retained for study purposes. Mrs. Gardner had special reasons for putting this technological innovation to the service of collecting. The fortunes she inherited gave her the wherewithal to be a great collector. But her resources were small compared with those of such rivals as Morgan and the Wideners. To compete with these wealthier collectors in the market for masterpieces, she had to act quickly. Because time was short, Isabella, in America, and Berenson, in Europe, turned to photography—and to the telegraph—to hasten the normally slow and cumbersome process of acquiring a work of art. The *Lamentation* was purchased in less than a month. Yet this photographic way of collecting has a wider significance. Several other of our collectors probably never saw their Raphaels before acquiring them, except in the form of reproductions. No collector today, considering a comparable acquisition, would fail to seek out the original, and the difference in method reflects a difference in attitude. Acquiring works of art on the basis of photographs, as collectors of Mrs. Gardner's generation tended to do, suggests that the aesthetic form of the object, what could only be experienced in front of it, was of secondary importance or at least that the purchaser was willing to trust an enthusiastic description. The practice of commenting on a reproduction of a work of art is still considered sufficient for teaching purposes but not anymore for collecting.

In her search for a Raphael Madonna, Isabella Stewart Gardner acquired two works by the master in only two years, before being upstaged by another collector. Pierpont Morgan (1837-1913) so dominated the art world that the early years of this century came to be known as the "Morgan era."[214] Edward Steichen's famous photo-

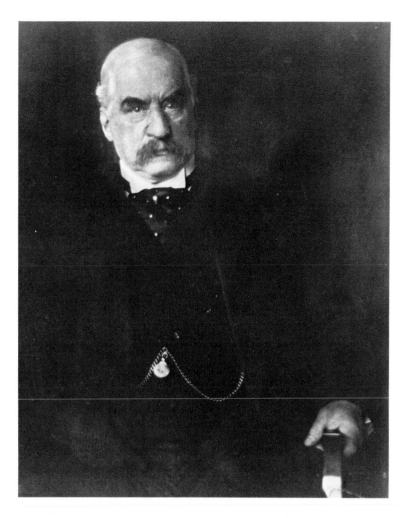

Fig. 32. Edward Steichen, J. Pierpont Morgan, 1903.
The Pierpont Morgan Library, New York.

graph (fig. 32) of 1903 [33] shows how Morgan appeared to his contemporaries. The photographer was supposed to have shown real insight into Morgan's character by having his hand grasp the glinting arm of the chair as if it were a knife.[215] Whether or not this is true, the photograph of Morgan personifies the type of arrogant and ruthless tycoon. Physically imposing, blunt-spoken, with fierce dark eyes, Morgan overawed those with whom he dealt. The photograph also reveals that however adventurous in his business dealings, Morgan was conservative in dress and, it might be added, in his habits. The same is true of his activity as a collector. He began by acquiring fashionable art. Only after he received an inheritance upon his father's death in 1890, did Morgan begin to collect seriously. At first concentrating on rare books and manuscripts, as Mrs. Gardner had, by the turn of the century he began to purchase major works of art. Collecting on a grand scale then became his consuming passion, as he increasingly turned over responsibility for financial matters to his son and subordinates. "Having become the greatest financier of his age," it was said, Morgan "determined to be its greatest collector."[216] Between the 1890s and 1913, the year of his death, Morgan spent more than half of his fortune to achieve his goal.

Coming late to the task, Morgan wisely chose to buy entire collections *en bloc* and not only selected masterpieces. This practice left him open to the charge of being a mere accumulator. Foreign critics, such as Bode, who acted as Morgan's agent, found his motives incomprehensible, as he did not conform to the European type of collector-connoisseur. The bitter criticism of Roger Fry, another agent, is well known. "A crude historical imagination," Fry said of Morgan, "was the only flaw in his otherwise perfect insensibility toward art."[217] Though Morgan was not, perhaps, sensitive to artistic form, he was by no means uncultivated. As a collector, his cultural preparation was more than adequate. Educated abroad and able to speak or write three foreign languages, he lived in London much of the time and was familiar with the contents of the major European galleries. As for Italian art, Morgan, on a Grand Tour at the age of nineteen, spent several months in Italy, including seven weeks in Rome. Later, after a period in which he concentrated on financial affairs, he made almost annual visits to the Eternal City, where, in fact, he died.

If we consider the amount of time and energy he devoted to collecting, we cannot doubt his seriousness of purpose. Morgan did not acquire works of art solely to contemplate their beauty, however. Rather he wished to bring his native country up to the level of cultural awareness of the Old World. A trustee of the Metropolitan Museum since 1889, he became its president in 1904.[218] In the museum Morgan saw an opportunity to realize Jarves' dream of creating a truly great national gallery to rival those of Europe. He intended his own collection to form the nucleus for the expanding museum, but as the city of New York failed to provide funds to construct a wing to house it, he left his works of art to his son. "I have been greatly interested for many years in gathering my collections," Morgan affirmed in his will, "and it has been my desire and intention to make some suitable disposition of them . . . which would render them permanently available for the instruction and pleasure of the American people."[219] Unfortunately, after being exhibited together in 1913-1914, his collection was broken up and partly dispersed.

The Colonna altarpiece (fig. 33), regarded as the single most important of Morgan's pictures, was donated to the Metropolitan Museum by his son, "in pursuance of my father's wishes," in 1916.[220] Morgan's painting was one of three parts of the altarpiece to find their way into American collections. [221] Morgan owned the central panel of the Madonna and Child enthroned with saints and its semicircular lunette with God the Father between two angels. After having been separated from the rest of the altarpiece little more than a century and a half after Raphael painted it for the convent of Sant' Antonio in Perugia, the main panel with its lunette came into the possession of the Colonna family in 1678. Then, after many years in Rome, it was acquired by the King of Naples. From this point on the picture became controversial. It descended to Francis II, the last

Fig. 33. Raphael, Madonna and Child Enthroned with Saints *(Main panel of the Colonna altarpiece). The Metropolitan Museum of Art, New York.*

Neapolitan king, who was exiled in 1860. Ten years later the Duke of Ripalda, who had the picture in custody from the king, lent it to the Louvre as a possible acquisition. But his plan was frustrated by the outbreak of the Franco-Prussian War. Transferred to London, the altarpiece was next shown at the National Gallery in 1871-1872. When its ownership came into dispute, it was stored there until 1886. Having been adjudicated to the dethroned king, the painting was then

displayed in the room with Raphael's tapestry cartoons in the Victoria and Albert (then South Kensington) Museum. There it remained for a decade without finding a purchaser. In 1896 it was sold by the executors of the king (who had died two years before) through Lord Ashburnham to the dealer Martin Colnaghi for less than half the amount—£40,000 or about $200,000—of the asking price. Another dealer, Charles Sedelmeyer in Paris, bought the painting from Colnaghi later that same year. During this period, as one writer said, the "eyes of the artistic world [were] turned on this great art treasure," for "there are very few of Raphael's paintings in the possession of private individuals," and this was the "most important of all the works of Raphael that has not as yet found its way into public collections. . . ."[222] Even Ruskin, who never cared for Raphael, felt called upon to publish a letter in 1874, urging the merchants of Liverpool to buy the altarpiece for their new gallery.[223] The National Gallery in London considered the painting, too, but on examination in 1895 found it in "such an unsatisfactory state as to make it unfit for public exhibition."[224] After it had been offered to two national museums in France and England, the altarpiece was acquired, we have seen, by a dealer, who restored it, improving its appearance.[225]

Nevertheless, when the picture was proposed to Isabella Stewart Gardner, Berenson could not recommend it. Writing her on November 9, 1897, about its "genuineness" and "artistic value," he allowed that "while doubtless Raphael superintended the execution of this altarpiece, laid it in himself, and painted *some* upon it, the altar-piece as a whole when it left his studio could not have been called an *autograph* work by Raphael. . . .

So much for the Colonna "Raphael" when it left the master's studio. Since then it has suffered every vicissitude, and even now that it has been restored as well as it can be, I venture to doubt whether a seeing eye can discern a square quarter of an inch of the *original* painting.

But leaving aside the question of the authenticity and condition of the picture, let us look at it as a work of art, on its own merits. . . . Raphael is great, and greater than anybody else in his *composition*. Now, I beg you to look at the Colonna Madonna, and then tell me whether you find therein that spacious eurhythmy, that airy buoyancy which Raphael gives you in the Sposalizio, in the Belle Jardinière, in his Stanze, and in scores of other works? Instead you have a squat, crowded composition, with a top heavy baldachin. . . ."[226]

Using such arguments Berenson had, he said, induced the London National Gallery not to acquire the picture. They had the same effect on Mrs. Gardner, who immediately wrote back, indignant that she had even been asked to consider purchasing that "tiresome dreary Colonna Raphael."[227] Berenson replied that he was "truly pleased" she would have nothing to do with it.[228] Later, after Morgan had acquired the altarpiece and exhibited it at the Royal Academy, Berenson, as if to reassure Isabella that they had not been mistaken, reported that the critics were "pretty well agreed about its

worthlessness—relatively to its pretensions and price."[229] To understand why Berenson held the Colonna altarpiece in such low esteem, we must allow for his tendency to belittle any painting offered to Mrs. Gardner in which he had no stake. Just as he resented the offer, so he disliked the painting. It is also important to remember that as a connoisseur, the young Berenson was a revisionist in the Morellian mold, frequently demoting pictures, like the Colonna altarpiece, which in some cases he later upgraded.[230] Likewise, his remarks about the condition of the painting seem unnecessarily severe, now that it has been responsibly cleaned and found to be very well preserved. The evaluation Berenson made of the painting as a work of art also seems misguided. Objecting to the "squat, crowded composition, with a top heavy baldachin," he did not give sufficient importance to the factor of tradition. For, as we shall see, Vasari's account clearly implies that Raphael was obliged to conform to the traditional taste of the nuns who ordered the picture. Berenson applied a uniform, and in this case not entirely appropriate, standard of judgment—"space composition"—to the altarpiece. Inevitably, he dismissed the picture, as it failed to measure up to Raphael's achievement, as he had defined it.

If, as the evidence suggests, Berenson's hypercritical attitude toward the painting was shared by other critics and collectors, we may wonder what Morgan's motives were in acquiring it. He was surely aware of the fact that it had been more or less openly offered for sale for more than thirty years.[231] Nevertheless, he bought it in April 1901 for a price said to be nearly half a million dollars.[232] His personal taste ran to small, finely wrought objects, like portrait miniatures. This is the most ornate of Raphael's pictures, and conceivably its decorative richness, recalling Pinturicchio, appealed to him.[233] Morgan evidently bought the picture out of an exhibition held at Sedelmeyer's in Paris in the spring of 1901. His main source of information, a brochure on the painting prepared by the dealer, evaded the stickier questions. The book begins by pointedly comparing the *Colonna Madonna* with the *Ansidei Madonna* by Raphael, which the Duke of Marlborough had sold to the London National Gallery in 1885 for the equivalent of $350,000, then the largest sum ever paid for a picture. The two early altarpieces were reproduced side by side to show that the Colonna, larger and with more figures, was the "richest and most important composition of all the various Madonna pictures of Raphael." Such a comparison would surely have sharpened Morgan's appetite.[234] In addition, the Colonna altarpiece offered the challenge of being beyond the reach of a private collector. The price asked for it was so exorbitant that when it was shown at the Louvre in 1870, it became known as the "Madonna of a million" francs. European governments, not private individuals, contended for it. Then there was the romance of its history, which would surely have struck a responsive chord in Morgan, who adored royalty. Why

should this treasure of an exiled king not belong to an uncrowned monarch?

However much these factors weighed on Morgan's decision, Sedelmeyer's pamphlet presented yet another argument in favor of the acquisition. The book consists mostly of enthusiastic reviews by critics of the picture when it was displayed in Paris in 1870. They all raise the chauvinistic cry that it "should be bought for France."[235] The painting, one writer pleaded, not only offered a "unique chance of filling up the only conspicuous gap in an admirable series of Raphaels in the Louvre," it was also a "work of the highest order, which every European Gallery should be eager to secure." And in more general terms still, "when such a treasure falls into one's hands, it would be sheer barbarism to let it escape." With the eventual disposition of his collection in mind, Morgan may well have felt it was his patriotic duty to acquire the painting.

"Mr. J. Pierpont Morgan gives Record Sum for Raphael" read the headline in *The New York Herald* for January 1, 1902. The publicity surrounding this and other of Morgan's acquisitions added a new element to American collecting which is still with us today. If Mrs. Gardner made her purchases without fanfare, everything that Pierpont Morgan did was newsworthy. Significantly, he acquired the Raphael at the height of his financial dominance. In 1901, the very year he purchased the painting, Morgan shrewdly bought out Andrew Carnegie and formed United States Steel, the most important commercial enterprise he had ever undertaken. Its capitalization made it the world's first billion dollar corporation. In the realm of art collecting the purchase of the Raphael was of comparable magnitude, and Morgan's example in acquiring it must have acted as a powerful stimulus on other American collectors. For just as his reputation as a financier had prevented a financial panic on more than one occasion, so his art purchases set the standard for the Golden Age of American collecting. "No price is too high for an object of unquestioned beauty and known authenticity," Morgan used to say, and prices for works like the Colonna altarpiece increased enormously during the years of his ascendancy.[236] Paintings by Raphael now soared out of the range of all but the wealthiest collectors.

The Colonna altarpiece was featured in a deluxe hand-printed, leather-bound, gold-tooled catalogue [34] of Morgan's pictures.[237] Since he delighted in looking at this and other catalogues recording his possessions, copies were placed by his bed. The catalogues were also distributed to rival collectors, like the Wideners, whose copy of the paintings volume is included in the exhibition. Though most of Morgan's pictures were kept at his houses in England, the Raphael, which had long been on public view there, went back on loan to the National Gallery in London in 1901. It was not brought to America at that time as the tariff duty on works of art was prohibitive. At not less than 20 percent of declared value, the tax on the Colonna altar-

Fig. 34. Early photograph of a Madonna and Child *mistakenly attributed to Raphael. Villa I Tatti, Harvard University Center for Italian Renaissance Studies, Florence.*

piece would have been one hundred thousand dollars. In 1909, however, the Payne-Aldrich tariff bill, for which Morgan had lobbied, abolished the import duty on works of art more than twenty years old. Morgan, therefore, resolved to bring his collection to America, and in 1912 the vast process of packing and shipping began. From the walls of the National Gallery in London, the Colonna altarpiece went on exhibition at the Metropolitan Museum in New York in 1913. Upon its arrival, the picture was hailed in the *New York Sun* on December 11, 1912, as the most important ever brought to America. And when it was presented to the museum, *The New York Times* on February 3, 1916, again called it the "finest painting ever brought to this country."[238] Critics might carp, but American public opinion was in agreement over the enormously high value Morgan placed on Raphael's picture.

Yet, however celebrated, the Colonna altarpiece did not satisfy Morgan's desire for a Raphael, any more than the portrait and the predella did that of Mrs. Gardner. He, too, seems to have wanted a Madonna. Her wish was frustrated, we have found, but Morgan eventually acquired two such pictures attributed to the artist. Both were sent to New York to hang in his study in the Library (fig. 14), as we see in a photograph [35] of the room about 1910. On the extreme left is a half-length Madonna seated with the Child in her arms before a landscape. A photograph [36] belonging to Berenson (fig. 34) gives a better idea of the picture's appearance. Berenson first learned about the painting from Otto Gutekunst, the director of Colnaghi's, who "called on Morgan the other day [and saw] how delighted he was with some awful rubbish various people—robbers—must have palmed off on him quite lately! And at phenomenal prices too & there I was unable to tell him the truth because I did not dare make him feel ashamed of himself. Amongst other things he showed me a small Italian picture quite passably pretty & I pretended to like it. But when he began talking about Raphael, I felt funny. . . ."[239] Berenson saw the painting at Agnew's in London on July 9, 1909, and made a careful description of it, kept at I Tatti. Since the present whereabouts of the picture is unknown, his eyewitness account is worth quoting. The "handling of flesh" he found to be "thoroughly characteristic of P[inturicchio], niggling with . . .

flushes of coppery pink, totally unlike the more fluent smoother Peruginesque handling of Raphael. Very pretty are the gold points in the haloes & in the lining of the Madonna's cloak. Landscape greyish blue, heavy & opaque with the foliage fussily lit up with yellow. Head of Mad[onna] very poor & there is scarcely any shoulder. The only approach toward a reason for ascribing this to R[aphael] is a certain warm velvety glow in her eyes & her small mouth. But . . . the very fine stipple proves that P[inturicchio] did the painting."

Soon after inspecting the panel, Berenson wrote Mrs. Gardner that "the world—that is to say some hundred people at the utmost-·

has been in a fit of excitement the last seven or eight weeks about a Raphael Morgan bought of Volpi on Bode's recommendation for £40,000 [about $200,000]. It would take a book to write down all the gossip regarding it. Well, I have just seen it at last, and it turns out to be a Pinturicchio, larger but of inferior quality to yours. . . ."[240] As in the Colonna altarpiece, the Pinturicchiesque flavor Berenson detected in the *Madonna* may explain why it appealed to the collector. It is likely that Morgan was reminded of the early Madonnas by Raphael in the Kaiser Friedrich Museum in Berlin, which he would have seen when he visited Bode, the director, to engage his services in 1902. Nevertheless, if Raphael and Pinturicchio were the names first proposed for the painting, Berenson later changed his mind, calling it in a note at I Tatti a "fake." From the estate of Morgan's son the *Madonna* was sold at auction in New York in 1944 as "School of Raphael" for $2,500.[241] It was subsequently in the hands of Avis Silberman, the New York dealer.[242] The present owner is unknown.

The other painting of half-length format [37], called Raphael in the Morgan Collection, the *Holy Family* (fig. 35), was not donated to a museum or sold off but remained as part of the contents of the Library. In the old photograph of the collector's study it is centrally placed on the left wall, between the Madonna we have just discussed and another treatment of the subject then given to Pinturicchio. The room also contained Madonnas by Francia, Raphael's friend, and by Perugino, his teacher, forming an ensemble of Raphaelesque works, all of them variations of the same theme, that was unique in America. When Morgan raised his eyes from his work or his habitual game of solitaire, what he saw was a virtual pantheon of Umbrian painting.

The *Holy Family* is a version of the so-called *Madonna of Loreto*, the original of which has recently been rediscovered in the Musée Condé at Chantilly.[243] Morgan purchased his version of the *Holy Family* from the French dealer Imbert in Rome in March-June of 1910. He had Agnew's transfer it from its original wood support to canvas and ship it directly to the Library. The picture, which had previously belonged to Charles Fairfax Murray, the noted collector and another of Morgan's agents, was listed in the bill of sale as Raphael. Little more than half a century before Morgan acquired it, the painting had created a sensation when its owner, an Englishman living in Florence named Laurie, submitted it to the Accademia di Belle Arti of Rome for a judgment of authenticity. On June 3, 1857, the academy declared the painting an original by Raphael of his best period.[244] Their verdict was widely reported in the press, and even among experts, Sir Charles Eastlake, director of the London National Gallery, was prepared to admit that the picture was very close to the master, if not by him.[245] A French critic might prefer the example in the Louvre,[246] but Crowe and Cavalcaselle in their authoritative monograph stated unequivocally that the Laurie *Holy Family* was the best of all the versions after the presumed lost composition by Raphael. If, as they be-

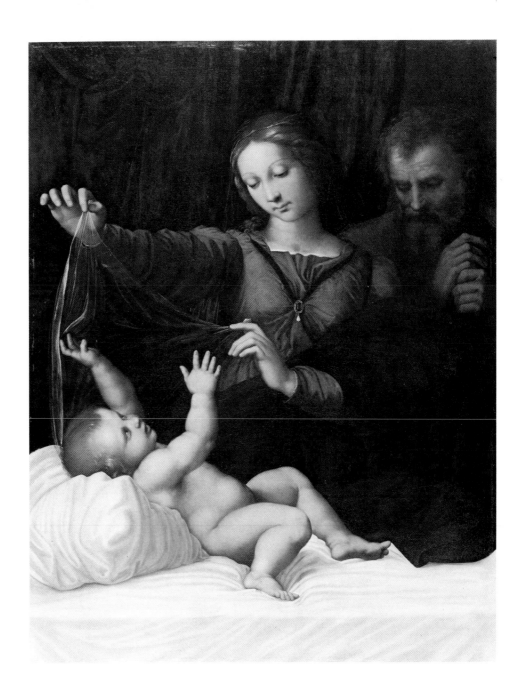

Fig. 35. After Raphael, Holy Family called the Madonna of Loreto. The Pierpont Morgan Library, New York.

lieved, Giulio Romano was responsible for the Saint Joseph and Perino del Vaga for the other two figures, then a "very favorable opinion might concede the intervention of Raphael in the head of St. Joseph."[247] The acquisition was a gamble, therefore. Morgan bought the painting, which is in fact of very good quality, obviously hoping that it might some day prove to be Raphael's lost original. We do not know how he responded to Berenson's view that it ought "to be exterminated as soon as possible,"[248] but in later photographs the picture has disappeared from the study.[249]

Morgan's record—one genuine early altarpiece, one possible fake, and one copy—does not do him justice as a collector of Raphael. For quite apart from the works he acquired, the interest he took in the artist was significant for America. Berenson might complain that the financier's opinion of a picture mattered more than his own,[250] but the fact remains that as a result of Morgan's activities, Raphael and the collecting of his works were now seen to be of the highest importance. Where Morgan ventured to lead, other collectors emulating his example would follow.

Like Morgan, Henry Walters (1848-1931) of Baltimore was a patrician born to wealth.[251] Small of stature, quiet and modest in manner, Henry Walters resembled a Southern gentleman. As a businessman, he followed in the footsteps of his father, William Walters, linking and consolidating railroads, until at the height of his career he was said to be the richest man in the South. As a collector, too, Henry took after his father. William Walters was a patron of contemporary European artists, acquiring many fine academic and Barbizon pictures. Upon his father's death in 1894, his son inherited not only his collection but also a considerable fortune which he vastly increased. This gave him the resources to practice Morgan's kind of collecting, not as a pastime but as a serious and time-consuming pursuit. The younger Walters was more of a collector than a patron, being primarily interested in the art of the past. His personal taste, like Morgan's, seems to have been for objects rather than paintings, particularly for medieval art. Educated abroad, he had a long exposure to European culture, returning annually for three months or more to acquire works of art, for which he was reputed to have spent more than a million dollars each year. His policy was similar to Morgan's: he bought collections already formed, to which he added individual masterworks of great beauty and importance. Thus, for the Raphael he acquired in 1901, Walters was able to provide a context in the form of the Massarenti Collection, consisting mostly of Italian paintings, which he purchased the following year. His art collection soon outgrew his house in Baltimore, however, so in 1906 an adjacent gallery was built in the approved Renaissance style. Open to the public on certain days during his lifetime, the gallery was left by Walters to his native city, and in 1934, three years after his death, it opened as a public museum.

Walters was the first American collector to succeed in obtaining a Raphael Madonna [38]. The painting was a celebrated tondo (plate 6) representing the Virgin and Child between two angels holding candlesticks. As there are almost no records of Walters' collecting activities—he was secretive about his expenditures on art and cut up bills of sale—we know very little about the acquisition. It has been suggested that he probably purchased the picture through the dealer Ichenhauser in London.[252] More certain but hardly more helpful is the fact that the old frame for the circular panel was delivered to a

warehouse in New York on November 30, 1901. With so little evidence, a letter Walters wrote Berenson about the painting on January 4, 1910, takes on considerable importance. Answering Berenson's query about which of his Italian paintings did not come from the Massarenti Collection, Walters singled out the *Madonna of the Candelabra* by Raphael, which he "bought from a nephew of Munro of Novar." He admitted that "like others, I doubt if Raphael painted the two angels, but there are few obtainable pictures by him that I would have in preference to the *Madonna of the Candelabra*."[253] Walters' liking for such a relatively late work was unusual by the turn of the century. It may be explained, perhaps, by the particular interest the tondo held for Ingres, who was well represented in the collection Walters inherited from his father. During the French occupation of Rome, the painting passed from the Borghese Palace into the hands of Lucien Bonaparte. It was then copied by Ingres, who further used it as a model for his *Virgin with the Host* and other works.[254] The aloofness of the Madonna in Raphael's painting is due to the fact that it was cut down, eliminating the little Saint John on the right at whom she was gazing. Though accidental, the mood appealed to Ingres. It does not seem to have disturbed Henry Walters either, as it did other critics and collectors, who preferred the innocent sweetness of Raphael's early Madonnas. Nevertheless, Walters felt called upon to defend his acquisition to Berenson. The expert had warned Mrs. Gardner that "in the Candelabra Madonna," evidently offered to her, "there is of Raphael nothing but the idea of the composition. All the execution and even the blocking out of the composition is the work of pupils."[255]

Long before Walters acquired the *Madonna of the Candelabra*, the question of Raphael's part in the painting was controversial. At the sale in London of the collection of the Duke of Lucca in 1841, the panel was bought as a Raphael by Turner's patron, A. H. J. Munro of Novar, Scotland. There it was seen by Waagen, who described it as a work of collaboration, Raphael being responsible only for the head of the Virgin.[256] Passavant likewise believed the Novar Madonna was a joint product of Raphael and his pupils, though he credited the master with the Christ Child, as well as the Madonna.[257] The angels were invariably considered inferior to the principal figures and for that reason were sometimes omitted altogether from engravings of the tondo. When put up for auction at the Munro sale at Christie's in London in 1878, the *Madonna of the Candelabra*, widely regarded as the prize of the collection, failed to meet its reserve. It was bought in at £19,500, the highest price recorded for a picture up to that time. Aside from adverse scholarly opinion, the rumored discovery of another version of the composition may have deterred the bidding. A letter to the *London Times*, printed several days after the sale, suggested that it would be "of the utmost interest to students of Raphael" if the rival picture could be compared with the Novar Ma-

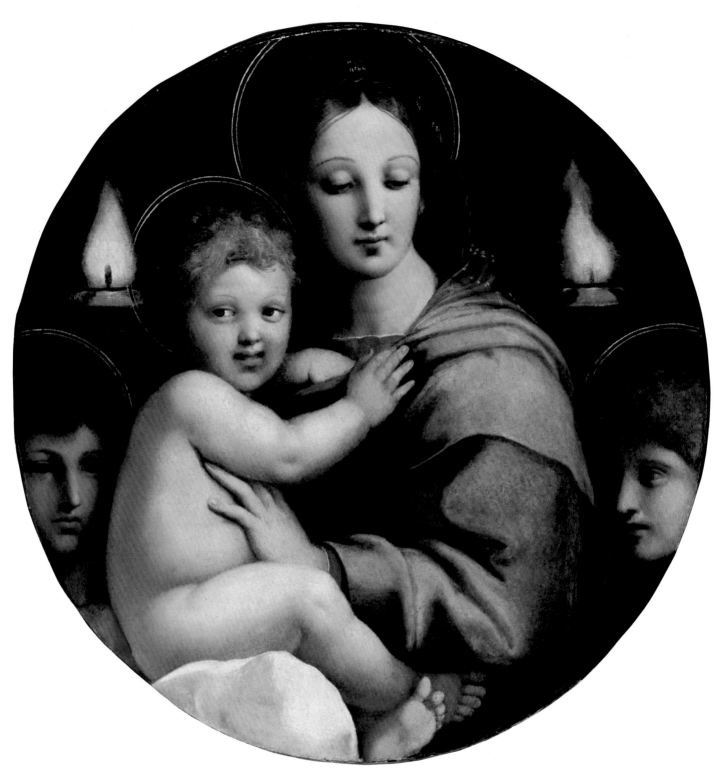

Plate 6. Raphael and Workshop, Madonna of the Candelabra.
Courtesy of the Walters Art Gallery, Baltimore.

Fig. 36. After Raphael, Madonna of the Candelabra. *Mr. & Mrs. Bernard C. Solomon, Beverly Hills.*

donna.[258] Sir J. C. Robinson, who had purchased the other *Madonna of the Candelabra* as a copy three years before the Novar sale, accordingly came out with a forty-five-page booklet comparing the two paintings.[259] The author of a catalogue of Raphael's drawings at Oxford, Robinson argued that his *Candelabra Madonna* [39], painted on a circular panel identical in dimensions to Munro's, was superior in both design and execution. Sold at auction by Robinson's heirs at Christie's in London on December 15, 1978 (lot no. 12), the picture (fig. 36) now belongs to Bernard Solomon in Beverly Hills, California.

The existence of another *Madonna of the Candelabra*, promoted and put on public view by a prominent connoisseur, effectively prevented the sale of the Novar version in England. Thus, in 1882, nineteen years before Walters eventually acquired it, Munro's heir, H. A. Munro Butler-Johnstone, decided to take the picture to New York. There, he must have supposed, a purchaser could surely be found. What happened afterwards, as it can be reconstructed from newspaper accounts, is one of the most fascinating incidents in the history of American taste and collecting.

William Henry Hurlbut, editor of the *New York World*, arranged a long-term loan.[260] The painting would be shown at the Metropolitan

Museum, whose first director, an Italian expatriate named Palma di Cesnola, predicted a new "era in art for this country when an important work of Raphael can be placed before the American people."[261] On Sunday, November 5, 1882, Hurlbut's newspaper headlined the "Memorable Loan Exhibition About to Open with the First Genuine Raphael Ever Seen in America." The *World* also reminded its readers that this was "one of the very few pictures of the first rank by Raphael which are still owned by private individuals."[262] While the painting and its owner were still bound for New York, anticipation grew that the "exhibition in America of such an important example of the great Italian will be an event of the highest interest."[263] With the arrival of the Raphael expected momentarily, *The New York Herald* devoted a lengthy article to it on November 14, quoting the discussions of Passavant, Waagen, Gruyer, Müntz, and other scholars.[264] At the same time it was understood that the painting was "for sale, and probably a group of our public spirited citizens will present it to the museum." The *Madonna of the Candelabra* was repeatedly compared to the world-renowned *Madonna of the Chair*, the *Herald* reporting the following day, for instance, that according to tradition the "Munro Raphael and the Madonna della Sedia in the Pitti Palace were painted on the ends of the same barrel."[265]

Under special instructions from the Secretary of the Treasury, the *Madonna of the Candelabra* was allowed to enter the country duty free, while exhibited, and to proceed directly to the museum.[266] There the panel would be installed outside the director's office in a brick niche, "guarded in front by an iron screen, which will be rolled down each afternoon and secured by locks at the close of the museum for the day." Such a receptacle would prove useful, *The New York Herald* said on November 18, if, as was hoped, the panel was eventually acquired for the museum.[267] Until it was installed, visitors had to content themselves with the display of an engraving after the picture.

Even before the Raphael went on public view, *Harper's Weekly* was confident that the Metropolitan Museum, which was "making annually great strides toward a magnificent future . . . will undoubtedly seek to acquire as a permanent possession this great work of the prince of Italian painters."[268] Though the picture would need to be examined, of course, "at present all will be content to enjoy the presence of a Raphael in America, almost four hundred years after its discovery by Christopher Columbus, the contemporary of Raphael Sanzio." On December 11, having been touched up after its long journey by the landscape painter Frederic Church, the *Madonna of the Candelabra* was at last unveiled at a private reception for more than a thousand guests. Artists, patrons of the arts, the cream of society, everyone concerned was present, except for the British owner of the painting, who soon after landing in New York went on a hunting trip to Utah. The crowd made viewing of the masterpiece difficult, even more so as it was displayed under glass and at a height of six

feet.[269] Making the by now customary comparison with the *Madonna of the Chair*, the museum issued a handbook on the tondo, the acquisition of which, it said, "concerns every nation in the civilized world."[270]

Amidst all the fanfare of the opening, the first sign of trouble went unnoticed. The *Art Amateur* for December 1882 warned that before the public was led to accept the *Candelabra Madonna* as a "perfect Raphael," its authenticity should be acknowledged as "more than doubtful."[271] Worse still, three prominent painters present at the reception, when asked to express their views on the picture in the *Daily Tribune*, were less than enthusiastic.[272] One of them frankly confessed that he was more interested in the spectators than in the *Madonna*. The enormous price reportedly asked for it—$200,000—would, he felt, be better spent assisting the "growth of modern American art." The second painter to respond likewise questioned whether so vast a sum should be "sunk in a relic." Finally, no less an authority than William Merritt Chase contrasted the *Madonna* unfavorably with other "good old pictures at moderate prices" that it was still possible to buy.

Such criticism on the part of artists might be put down to self-interest. But the opposition to the intended purchase raised by Clarence Cook, a leading art critic, could not be so easily discounted. Pointing out that neither documentary evidence nor preparatory studies existed for the picture, Cook, in a long letter to *The New York Times* the day after the opening, carefully reviewed the scholarly literature, according to which, he determined, the painting was of doubtful authenticity.[273] His suspicions had been aroused when he learned of the abortive attempt to sell the tondo in London and of the existence there of another, perhaps better, version of the composition. Cook concluded that the picture was "certainly a disappointing one after all that has been said and written upon it, especially since its arrival here."

Other voices soon joined the chorus of protest over the picture. *The Critic* attempted to distinguish between the museum's misrepresentation of the *Madonna* with the "hocus-pocus of prominent names, of the picture being loaned and not for sale, statements that no other example of Raphael exists in America" and the actual merits of the painting, which though a "beautiful work of art, impressive and lovely, is not altogether satisfactory. A fine or very great example of Raphael it is not."[274]

In defense of the picture the editor of the *New York World* countered that the "presence in New York of the first painting by Raphael ever brought across the Atlantic" had a special importance, as art museums were springing up across the country.[275] Though the Raphael might not appeal to artists nor to the taste of the moment, it was the museum's responsibility to instruct the general public to appreciate the unchanging value of the great art of the past. In an

echoing end-of-the-year interview with the *New York World*, the director of the Metropolitan Museum disingenuously claimed that the only purpose in bringing the Madonna to America was "to give our people a chance to see and admire a real and worthy work of Raphael. Since it has been exhibited," he went on, "thousands have thronged to see it, and it has excited universal admiration and praise."[276]

With the perspective that was called for, the *Boston Evening Transcript* pointed out the "comic elements" in the debate that had erupted in New York. On the one hand there were the artists and critics who were "filling the press and the air with anathemas and curses upon the upholders of the picture, and denouncing the soft-eyed Madonna as an imposter, a fraud and a libel on the memory of Raphael. An answering chorus retorts by casting slurs upon the [detractors] and deifying the gentle mother above all other Madonnas painted by Raphael." To those who know Raphael "in all his glory" in Europe, the *Transcript* continued, the *Candelabra Madonna*, installed among the sculpture casts at the Metropolitan Museum, was like a "rose lying on a desolate and dusty roadway." Nevertheless, the first view of the painting must be the "beginning of an art experience." To the many Americans "who never have visited, and never will visit, the Old World and its art treasures . . . the picture is full of interest." As for its exorbitant price, a "valuable work of art of the time of the 'old masters' is worth more in America today than it is in Europe. To the National Gallery in London, which already possesses some of Rafael's finest works, this picture is not worth one-half what it is to us, or what it would be to our national gallery, were we so fortunate as to possess one." Unfortunately, the writer concluded, the "lovely face of the Madonna is seen through a cloud of doubt, prejudice, passion and distrust."[277]

American collectors were put off by the controversy surrounding the painting, and among critics and artists the view prevailed that money for the Raphael "might be spent with better results to the interests of American art."[278] Not having found a purchaser in this country, the *Madonna of the Candelabra* went back to England, where its owner mortgaged it for a loan on which the bank eventually foreclosed. This "international incident," as it was called, would have been a subject worthy of Henry James, as it raises some of the central issues of his fiction. The Old World intrigue in this case was the marketing practice of placing a picture on long-term loan to a leading museum. The American response was at first predictably innocent, as newspaper writers repeated again and again that this was the first genuine Raphael ever to come to America. To understand their enthusiasm we must recall that a century of collecting in this country had so far produced, as far as Raphael was concerned, only misattributions and copies, not to speak of outright fakes like the one belonging to Jarves. Public opinion was swayed by the *New York World*, whose editor was involved in promoting the sale. Nor would

the ambiguity of the museum's conduct have been lost on James. To be fair, however, we should allow that, whatever its methods, the museum had a worthy goal: the acquisition of a work believed to be by Raphael. When the *Madonna of the Candelabra* was exhibited and critics, diligent and remarkably well-informed, turned against it, a mood of disillusionment set in. The frequent comparison made to the more famous *Madonna of the Chair* backfired as well, when visitors brought unrealistically high expectations to the tondo on loan to the Metropolitan. American artists naturally regarded the new Old Master with distrust, and well they might have for it was the harbinger of a shift of patronage away from contemporary art.

The question remains as to why the *Madonna of the Candelabra*, having failed to interest an American collector in 1882, succeeded in doing so only twenty years later. One reason might be simply that the controversy had abated, except that the Robinson version was on loan to the London National Gallery at the time Walters bought his. The answer probably lies more in the collector than in the painting. Urbane, tradition-minded, European-looking, Henry Walters represents the rising type of culturally sophisticated collector in America. He recognized that, although the *Candelabra Madonna* was not the *Madonna of the Chair*, it would, nevertheless, fairly represent Raphael in a country where so few of his works were to be found. At the turn of the century the United States was still "rich in dollars, poor in art." But conditions were changing. The rich were much richer and better able to afford the high prices European collectors put on their remaining treasures. Collectors who felt an imperative need for a Raphael were obliged to seize the opportunity offered, as his pictures were rapidly becoming unavailable.

The Novar Madonna came not once but twice to America, as we have seen. It is even more remarkable that both versions of the *Candelabra Madonna*, belonging to Munro and to Robinson, should find their way to this country. Juxtaposed with its former rival in the exhibition, the painting in the Walters Art Gallery is still regarded by most scholars as a workshop piece. Painted about 1514, the picture appears to be a collaborative effort, with the master responsible for the head of the Virgin, some of her drapery, and the upper part of the figure of the Child.[279]

The *Madonna of the Candelabra* might be a "celebrated masterpiece," but the "most pleasing of the Raphaels in the United States," one critic found, was undoubtedly the *Small Cowper Madonna* (frontispiece) in the Widener Collection at Lynnewood Hall, near Philadelphia.[280] This painting [63], acquired by the Wideners in 1914 and now in the National Gallery, is the early Madonna that Mrs. Gardner coveted. The profound change taking place in American collecting in those years is shown by the fact that the picture arrived here less than a decade after Berenson assured his patron that it was unobtainable. The collection was formed by the elder Widener in collaboration

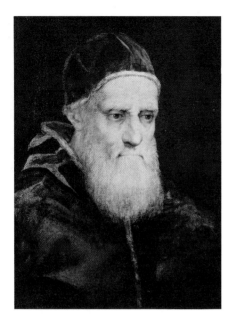

Fig. 37. After Raphael, Portrait of Julius II. *Formerly Widener Collection, present whereabouts unknown.*

with his son Joseph.[281] P. A. B. Widener (1834-1915), who began as a butcher supplying meat to Union troops in the Civil War, made an immense fortune in street railways in Philadelphia and other cities. Of all of our collectors of Raphael, he came closest to the type of capitalist known as a robber baron. Like other self-made multimillionaires, Widener aspired to culture. He first acquired fashionable contemporary art, which, as we have seen in the Millet, was afterwards sold from the collection. He then turned to the Old Masters, as did other of our collectors, in the 1890s, acquiring mostly inferior paintings from unscrupulous dealers.

Among these was a *Portrait of Julius II* (fig. 37), purchased from the dealer Nardus in 1897. In the Widener catalogue [40] published three years later, the panel figures as a Raphael, even though it is no more than a bust-length reduction of a portrait of the pope known in other versions, the best of which was then believed to be in the Uffizi.[282] The one considered autograph today is in the National Gallery in London.[283] The trumped-up provenance of the Widener portrait included no less a personage than Michelangelo's friend Vittoria della Rovere, with a Medici thrown in for good measure. On journeys to America in 1903-1904 and 1908 Berenson and his wife went to Philadelphia, J. P. Morgan heard, to "bust up Widener's collection." On the first visit they found "mostly horrors masquerading under great names" and on the second "nothing of importance among their Italians. . . ."[284] It was probably on one of these occasions that Widener, according to his grandson, "discovered that certain paintings purchased as Botticellis and Raphaels were actually the work of some talented copyist."[285] In Berenson's catalogue of the collection of 1916, the portrait was accordingly demoted to a copy and given a reasonable provenance.[286] Berenson aptly noted, too, that the free brushwork seemed Venetian. The painting long remained the one acknowledged second-rate work in the collection, appearing in the catalogues of 1923 and 1931. It did not, however, come to the National Gallery with the Widener bequest in 1942 but was sold at auction by Samuel T. Freeman & Co. of Philadelphia in 1944.[287]

The "Raphael" of P. A. B. Widener belongs to the kind all too familiar in nineteenth-century America. The *Small Cowper Madonna,* on the other hand, was obtained by entirely different means. It was probably Joseph Widener (1872-1943) who was the moving force behind the acquisition in February 1914, since his father had long been ill and inactive. Whereas P. A. B. Widener was outgoing by nature and enthusiastic and eclectic in his art purchases, his son was reserved in manner and discriminating in his tastes. Collecting for the father, like the pearl stick-pin which he wore when he was portrayed by Sargent, remained a matter of fashion, while for the son it was an absorbing interest.

The distinction between P. A. B. and Joseph Widener as collectors

is one of generation, not only personality. Their approach and methods differed as well as their taste. Seeking to refine the collection and to add only major works, Joseph Widener reduced it from some 500 pictures of nearly every school and period to the 100 which eventually came to the National Gallery. When he did make purchases, they were undisputed masterpieces with established provenances from the leading dealers. Like Morgan, he was prepared to offer sums large enough to tempt European collectors to part with their genuine treasures. Consequently, he was successful as a collector of Raphael where his father had failed.

Like his rivals, Joseph Widener's reasons for wanting a Raphael do not seem to have been primarily aesthetic. He had a real feeling for works of art and their arrangement, but his taste, John Walker has noted, was for pictures in the Grand Manner, like the Genoese Van Dycks that today form an impressive series in the National Gallery.[288] Since the provenance of an object mattered greatly to the Wideners, father and son, the fact that the *Small Cowper Madonna* came from an aristocratic English collection was undoubtedly important to them. Acquired in Florence toward the end of the eighteenth century by the already mentioned Earl Cowper, the picture was proudly displayed, after his return to England, at Panshanger, the now demolished neo-Gothic seat of the family in Hertfordshire. The painting had descended, with the rest of the collection, to Lady Desborough, the grandaughter of the sixth earl, who sold it to Duveen Brothers in 1913.

The picture's reputation, even more than its provenance, made it seem particularly desirable. In purchasing the *Small Cowper Madonna* from Duveen for $565,000, Joseph Widener paid an unprecedented sum for a picture which had been of little interest half a century before. When Passavant traveled to Panshanger to see the painting in preparation for his monograph on Raphael, it made a poor impression. Clearly disappointed, he went so far as to suggest that the painting might have been partly executed by a fellow pupil of Raphael in Perugino's workshop.[289] When it was shown at the Art Treasures exhibition in Manchester in 1857, the handbook lamented that "not one example can be pointed out of Raphael's fullest or more developed power. . . . All the genuine specimens," the book continued, "are of the Peruginesque period, where sentiment transcends all other qualities."[290] As an amateur, self-taught in matters of art, Nathaniel Hawthorne devoted six weeks to studying the exhibition, only to conclude that "there is nothing of Raphael's here that is impressive."[291] Likewise Crowe and Cavalcaselle, some twenty-five years later, had only qualified praise for the *Small Cowper Madonna*, which they found "just inferior to its rival," the *Granduca Madonna* in Florence. And they, too, discerned in it the hand of an assistant.[292]

The consensus among critics that this was a modest work by Raphael, perhaps not even entirely by his own hand, was shattered

when Morelli declared it "perhaps the most lovely of all Raphael's Madonnas" in 1883. The painting, Morelli went on, "sets the young artist before our eyes in the full blaze of his independence. From this picture, especially from the Infant Christ, the bewitching fragrance of his godlike soul breathes upon us. . . ."[293] Thereafter, Morelli's judgment that this was the quintessential Raphael comes up again and again in the literature on the artist in almost exactly the same terms. Thus A. R. Dryhurst quoted Morelli in 1905 as saying that this was "perhaps the most admirable of all Raphael's Madonnas,"[294] while the following year Louis Gillet said that Morelli preferred it to all the Madonnas by the artist.[295] Echoing Morelli, Gustavo Frizzoni in 1915 found this one of the purest and most gracious among Raphael's Madonnas.[296] The same estimate of the *Small Cowper Madonna* found its way into the catalogue [42] Berenson compiled for the Wideners, in which he referred to it as "perhaps most completely characteristic of Raphael's earlier Madonnas."[297]

The leading defender of the painting was the familiar Julia Cartwright, who more than any other writer established its modern reputation among English-speaking peoples. During the years immediately preceding the Wideners' acquisition she published it three times. In *The Early Work of Raphael* of 1895 she claimed that "there is, perhaps, more actual charm and beauty in this youthful Madonna and in the smiling Child who clings with both arms around her neck, than in any other of Raphael's Virgins."[298] And in the lavishly produced *Christ and His Mother in Italian Art* of 1897, Cartwright quoted Morelli and called the picture the "earliest and, in some ways, the most beautiful of his Madonnas."[299] Again quoting Morelli in her *Raphael* [41] of 1905, Cartwright reproduced the *Small Cowper Madonna* as the frontispiece to the book.[300] The truly exalted status of the painting was confirmed, when in 1910 it was again reproduced as a frontispiece in the exhibition catalogue of pictures of the Umbrian School at the Burlington Fine Arts Club in London. Unlike Hawthorne, no visitor to this exhibition would have found the *Madonna* unimpressive.

Although Joseph Widener was most likely responsible for the acquisition, his father received credit for it. It was P. A. B. Widener's lawyer and friend, John G. Johnson (1841-1917), who interested him in art collecting. Unlike the Wideners, however, Johnson did not pursue great names but bought what he liked.[301] Yet if he avoided the high-priced masters, Johnson, nevertheless, favored the acquisition of the *Madonna*. A letter from him to Berenson hints that he may originally have hoped to purchase the picture for himself.[302] But once he realized the price it would fetch, he recommended it instead to Widener. He did "not care much for the porcelain finish of [Raphael's] Madonnas," Johnson later told Berenson, "but this one was most exceptional. Madonna exquisite—landscape delightful; Child naive and delicious,—color charming." He also clearly grasped that

there "was no other possible buyer, Altman gone, in America for that picture at £113,000. Such sums can be given by the Billionaires. It would be criminal to take out of public funds for any work such an amount. Too many other things could be gotten for that prestigious price."[303] The issue was, in fact, a crucially important one for the whole art collecting enterprise in America, and Johnson returned to it again, explaining that "no museum should expend so much as £113,000 of its funds on any one work. I feel that Mr. Widener with his millions ought to do so and urged the acquisition upon him very strongly."[304] Acting on his advice, Widener "got the Raphael," Johnson informed Berenson, adding that it "is a most beautiful work."[305] Since Johnson was the most discerning American collector of Old Masters, his advocacy of the Raphael purchase is significant. Public funds, he understood, were needed to build up museum collections that were still relatively meager. Only a private collector could afford to buy the most prestigious and expensive works of art. In 1914, when the Wideners acquired the *Small Cowper Madonna*, the total amount the Metropolitan Museum spent on all its acquisitions was less than the cost of that one painting. In Johnson's opinion such high prices were justified if the work was exceptionally fine.

Like Fenway Court, Lynnewood Hall [43] had a Raphael Room (fig. 38) in which, according to Joseph Widener's son, the "focus of every eye" was the *Small Cowper Madonna*.[306] The picture was "small in size," he admitted, "and yet the family paid a greater price for it

than any other painting in the collection. However, Father has always felt it worth the great sum it took to procure it." Still echoing the judgment passed down from Morelli, the younger Widener added that the painting was "considered one of Raphael's loveliest Madonnas." This last comment, offered as a kind of justification, clearly documents the way in which American collectors were influenced by connoisseurs like Berenson and his mentor. In a tastefully refined setting of furniture and decorative arts, the Widener paintings were displayed without labels, except for the *Small Cowper Madonna*, which bore Raphael's name on its frame. We view Raphael's paintings today primarily as aesthetic objects, but to collectors like the Wideners they were more like emblems, the significance of which lay both in the image or the picture itself and in the text or the label affixed to the painting.

Widely reported in the press, the Wideners' acquisition in 1914 signaled America's coming of age as a nation of collectors. More than any other single event, it showed that great wealth had brought civilization, as it was then defined in terms of European culture, to this country. At the same time the departure of the painting was bitterly protested in England. Isabella Stewart Gardner had been unable to obtain the *Madonna* because the family to whom it belonged had resolutely refused to sell. However, after inheriting the picture from the widow of the last earl, his niece Lady Desborough decided to dispose of it to pay the taxes levied on the estate. Receiving an offer in September 1913, she gave the National Gallery the first option on the painting at the price the dealer had offered. But the British Nation—or so the director of the National Gallery and certain of its trustees felt—could not afford to pay as much as £70,000 for a work by an artist already well represented in their collection. Consequently Duveen Brothers purchased it later that autumn.

Newspaper accounts of the acquisition [44] begin with *The New York Times* which reported on November 25, 1913, that this was the last Raphael in private hands that could be bought. The others were destined for public collections. Grasping the significance of the opportunity, the *Times* confidently announced that the picture would come to America.[307] The next day the *London Daily Telegraph* lamented that the "loveliest of all the master's Virgins, according to . . . Morelli," was leaving England. "American millionaires," the columnist continued, "are becoming animated with a glowing zeal to endow their national art institutions with their private possessions," and the "eventual purchaser of the Panshanger Raphael," he predicted, "will one day hand it over to his countrymen."[308] *The New York Herald*, in an article of the same day headlined "England Loses and America Gains," suggested that the *Madonna*, "one of the greatest pictures in existence," would probably find a final home in the Metropolitan Museum in New York.[309] The price Duveen paid caused a sensation, *The New York Times* claiming (erroneously, it

would seem) on November 26, that the picture had been bought for more than $500,000, the highest price on record. But even this sum was not too large for what was "said to be the most valuable and important painting in private hands in England," for "if it comes to America it will, of course, hold that distinction here."[310] The picture, *The Evening Sun* opined on November 28, was a "first rate example of its kind—the simpering elegant Peruginesque kind . . . and those who regard that style of Raphael as the most entrancing will be satisfied with it. It is not the finest kind but it is the kind that accounts very largely for the immense popularity of Raphael."

To appease British opinion the second of the two Cowper Madonnas by Raphael was given the place of honor in the National Loan exhibition at the Grosvenor Gallery in London in 1913. The exhibition, the *Morning Post* reported on November 26, was meant to reassure the public that "despite the exodus of so many masterpieces from England, we can still boast of vast artistic possessions."[311] Nevertheless, the *London Times* that same day quoted Berenson as preferring the *Small Cowper Madonna* to the one exhibited. It was, he said, "more suave" and "more peculiarly Raphaelesque."[312] English art lovers apparently agreed, for the sale of this national treasure prompted an outburst of indignant patriotism. Though the exhibition "may well fill every Briton's heart with justifiable pride at the apparently inexhaustible wealth of this country's artistic patrimony," *The Daily Mail* admitted, "what the loss of this picture to England signifies may be realised when it is taken into consideration that this precious little panel is . . . the last Raphael painted entirely by the master's own hand that remained in private possession. . . ."[313] The definitive comment was made by Sir Claude Phillips in the *Daily Telegraph* on December 22. Asking whether the *Small Cowper Madonna* would be known in the future as the "Frick Madonna," the "Widener Madonna," or the "Metropolitan Madonna," Phillips claimed that the loss of the painting was a "catastrophe that we should not cease to deplore, though it is one among the many of late years we have been compelled to suffer." Nevertheless, he concluded that if the National Gallery possessed no Madonna so lovely as this, it had, perhaps, other more pressing needs.[314]

With Duveen Brothers insisting all the while that it was not necessarily bound for America, the picture made its inevitable journey across the Atlantic early the following year. Rumors that it had been bought by an American collector for a million dollars were touched off when it arrived in New York on the White Star liner *Olympic* on January 21. The news broke soon afterwards that the painting had been sold to P. A. B. Widener of Philadelphia for the astonishing sum of $700,000.[315] On February 7 *The New York Herald* (fig. 39) headlined the acquisition as the "most important single art transaction ever made in this country." Predictably quoting Morelli that this was the "loveliest of all Raphael's Madonnas" (Morelli's "perhaps" had

Mr. Widener Pays More Than $500,000 for Raphael's "Madonna and Child"

Duveen Brothers End Most Important Single Art Transaction Ever Undertaken.

HINTED PHILADELPHIA COLLECTOR PAID $700,000

One of World's Greatest Pictures, Known as "Panshanger Madonna," To Be Exhibited Here.

For a sum said to be greatly in excess of $500,000—it is hinted that the amount is nearer $700,000—Mr. P. A. B. Widener, of Philadelphia, has bought from Duveen Brothers, art dealers of this city, a "Madonna and Child" by Raphael, formerly in the collection of Earl Cowper. It is the most important single art transaction ever made in this country, the previous record being Mr. Widener's purchase of "The Mill," by Rembrandt, for which he paid $500,000. The picture is variously known as "The Little Cowper Madonna" and "The Panshanger Madonna," the latter title being derived from Earl Cowper's seat in England, in Hertfordshire, where the picture was kept.

The painting recently arrived in this country from England, where it was purchased last November by Duveen Brothers from the Desborough family at a price declared to be in excess of $500,000. The picture was first offered to the National Gallery, in London, but funds were not available for its purchase. The press of England at the time protested against the loss of the famous Madonna.

To Be Exhibited Here.

Duveen Brothers in selling the painting to Mr. Widener arranged for the public exhibition of it next January in their galleries, No. 720 Fifth avenue, where it will be shown with a collection of pictures sold by the firm to American collectors and lent by them.

The "Panshanger Madonna" was painted about 1505, when the artist was twenty-two years old. The original sketch which the artist followed almost exactly in his finished work is preserved in the Accademia della Bell' Arti, in Florence. This sketch is exactly the same size as the finished picture, which is on a panel twenty-four inches in height and seventeen inches wide. The panel is two inches thick. It was originally acquired by George Nassau, third Earl Cowper, when he was British Minister at Florence in 1780, and has been often reproduced and described in works on Raphael.

The picture, which Morelli, the leading authority on Raphael, describes as "the loveliest of all Raphael's Madonnas," belongs to the master's early Florentine period. The execution is easy and graceful and the drawing of the hands, especially those of the Virgin, is of an elegance seldom seen in other works of Raphael.

The Coloring Beautiful.

The color is beautiful. The Madonna is seen seated on a stone seat near a bank

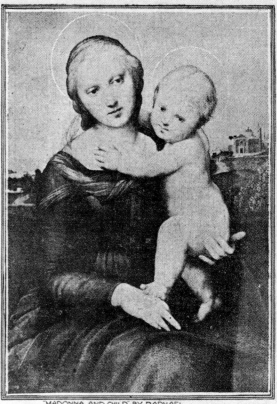

"MADONNA AND CHILD" BY RAPHAEL

overlooking an open landscape. She holds the naked Child in her left arm. She is dressed in red, with a blue mantle lined with green loosely thrown round her waist and over her knees.

The background is a beautiful feature of the picture. It shows on the left a winding river flowing between wooded banks to the hills. To the right is seen, with its dome and campanile, the Church of San Bernardino, near Urbino, standing in bright sunshine under an almost cloudless sky of exquisite graduating blue.

After the sale of the picture to Duveen Brothers and their announcement that it would be sold to the National Gallery if the price could be raised in England, Sir Claude Phillips, writing in the London Daily Telegraph, said:—

Its Loss to England.

"That the Desborough collection should lose and the nation fail to secure so exquisite a thing as this 'Panshanger Raphael' is a catastrophe that we should not cease to deplore, though it is one among the many that of late years we have been compelled to suffer. The blows of this kind follow one another with such regularity and at such short intervals that they must in the long run harden those upon whom they descend.

"But this is one of the keenest. This Raphael would undoubtedly have been a most desirable addition to the National Gallery, which contains many Raphaels, but no 'Madonna' of a beauty so suave or so characteristic of the Urbinate in his profoundly interesting time of transition. The 'Panshanger Raphael' would have been, we repeat, a most delightful addition to the Umbrian group, and its acquisition would have given the national collection a lovelier 'Madonna' by the Urbinate than at present it can boast."

It is understood in art circles, both of New York and Philadelphia, that Mr. Widener intends that the public shall eventually enjoy his art collection, and consequently the conjecture is made that some day the "Panshanger Madonna," together with Rembrant's great picture "The Mill" and the other pictures of the Widener collection, will, like the Altman collection, be the heritage of the people. Mr. Widener, like the late Mr. Altman, has demanded and obtained only the very greatest works of art.

Fig. 39. Clipping from The New York Herald, *February 7, 1914, on the acquisition of the* Small Cowper Madonna.

long since been forgotten), the *Herald* hoped that the painting would eventually become the heritage of the American people.[316] Not to be outdone, *The New York Times* the same day heralded the *Small Cowper Madonna* as the "most valuable picture ever brought to this country."[317] What caught the public imagination was that Widener had paid a record price—exaggerated by the press, it turns out—for a painting that measured only 24 by 17 inches. The cost per square inch was even computed by the *London Morning Post* on February 9. On the same day the *Standard* speculated that Widener desired to assume "the mantle of art connoisseur so regally worn by Mr. Pierpont Morgan."[318]

It was not until ten years after the Wideners acquired the *Small Cowper Madonna* that another Raphael came to America. This was the *Agony in the Garden* (plate 10), the third and last of the panels from the Colonna altarpiece to arrive in this country. Having purchased the painting [56] at the Burdett-Coutts sale in London in 1922 for the equivalent of $36,750, Duveen Brothers sold it to Clarence Mackay (1874-1938) two years later for a reputed sum of half a million dollars. Immensely wealthy, Mackay could afford such a mark up. He headed an international cable and telegraph system founded by his father, a miner who had struck it rich in Nevada's Comstock Lode. Though less colorful than the elder Mackay, Clarence conformed to the type of Raphael collector. He was educated abroad and was a leading patron of the arts (he induced Toscanini to come to America). Like Morgan and others of our collectors, Mackay was a force for industrial consolidation. Unfortunately, however, after his empire collapsed with the stock market crash of 1929, he was forced to sell a number of works of art, including the Raphael predella, which was acquired by the Metropolitan Museum in 1932. During the relatively short period that Mackay owned it, the *Agony in the Garden* headed the series of Italian paintings and sculpture he had gathered, nearly all of which dated from the Early Renaissance.[319] His art works were displayed, along with a magnificent collection of armor, at Harbor Hill, Mackay's mansion at Roslyn, Long Island, built in the style of a French chateau by Stanford White in 1900. Before they were dispersed, Mackay's holdings were recorded in a catalogue; the copy [45] in the exhibition was presented to Andrew Mellon.[320] The catalogue fails to mention that there were once two paintings of the *Agony in the Garden* in America. Not long before Mackay made his acquisition, another version of the composition in a private collection in Washington was claimed to be the original.[321] The copy is virtually identical to the panel in the Metropolitan Museum, except for its lower quality. We do not know if Mackay was aware of the other version of his painting, nor if he was, how he reacted to it. His predicament was shared by nearly all of our collectors, who, faced with rivals to their Raphaels, could never be absolutely sure of their authenticity. We have seen this most acutely with the *Tommaso Inghi-*

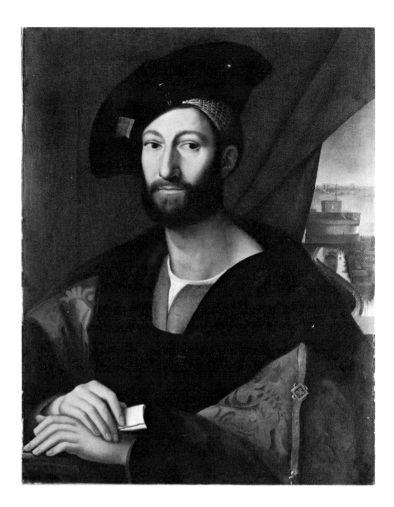

Fig. 41. Attributed to Raphael, Portrait of Giuliano de' Medici. *The Metropolitan Museum of Art, New York.*

rami and the *Madonna of the Candelabra*. And these are not the last examples we will find.

As the fortunate owner of three paintings by the artist, Andrew Mellon (1855-1937) ranks as the foremost collector of Raphael in America.[322] Having amassed an enormous fortune in banking and industry in Pittsburgh, Mellon (fig. 40) embarked on a second career, that of an art collector. Though at first he bought what was merely fashionable, Mellon, like his mentor, Henry Clay Frick, soon began to acquire the Old Masters. He was not an adventurous collector, however, as we might have expected from his acumen in financing little-known but promising business ventures. Instead, Mellon's taste was conservative, inclining to English and Dutch portraits and landscapes [46]. At this stage of his collecting he bought what he liked. Raphael was apparently not among the painters he particularly admired. This we can deduce from the first record connecting him with a painting by the artist. When he became Secretary of the Treasury in 1921, Mellon took a large apartment in Washington. As his collecting interests expanded, he needed further paintings, and these were provided by dealers on approval. One of the pictures Mellon considered was the problematic *Portrait of Giuliano de' Medici* (fig. 41), then thought to be by Raphael.[323]

Fig. 40. Andrew W. Mellon in his Washington apartment, about 1930. Photo courtesy of Mr. Paul Mellon, Upperville, Virginia.

In the portrait Giuliano is portrayed half-length, life-size, turned slightly to the left and looking at the viewer, with his hands folded, the right holding a sheet of paper. He is richly dressed in a black cap and gray damask robe trimmed with fur. Behind the sitter a green curtain has been pulled aside to reveal a view of the Castel Sant 'Angelo from the Vatican. Several versions of the composition were known. This was the only one, however, to include a landscape background, the castle probably alluding to Giuliano's appointment as Captain of the Church.[324] Raphael, we know, made a portrait of Giuliano, which was referred to by Pietro Bembo in 1516, soon after the subject's death, and which was later seen by Vasari. The version of the portrait offered to Andrew Mellon was rediscovered in the mid-nineteenth century.[325] No less an authority than Bode catalogued the picture as by Raphael when it belonged to the Berlin banker Oskar Huldschinsky.[326] After long negotiations using Agnew's as an intermediary, Duveen bought the painting from that collection in April 1925. The purchase, which brought Duveen much publicity, led the art critic Royal Cortissoz to predict that once in this country the picture was "almost certain to be acquired by an American collector, and, though it would then pass to a private gallery, precedent justifies the supposition that sooner or later one of our museums will possess it."[327]

Indeed, the picture was offered by Duveen to Andrew Mellon. For a short period it hung in Mellon's apartment. "The Raphael portrait of Giuliano de'Medici," he wrote Frick's daughter, "was in my possession some time, but had been purchased under an agreement by which I had the privilege of returning it against any additional purchases I might make. As you know, I have a limited amount of room, and Duveen brought some other pictures which I desired and I decided to return the Raphael. There was nothing concerning the state of the picture nor its quality that actuated me in the matter. It seemed to me a strong work but not particularly attractive for a private living room."[328] Though Mellon's dismissal of the Raphael astounded a dinner guest who failed to find it in its accustomed place,[329] he returned it to the dealer, regardless of its importance, because it failed to please him. It was probably the sitter's personality that he found distasteful.[330]

The painting returned by Mellon was purchased in late 1928 or early 1929 by another banker, Jules Bache (1861-1944), founder of the investment firm of that name.[331] An old photograph of the picture from the Berenson archive at Villa I Tatti, records the names of both owners on the back, Mellon's being cancelled. "To pay $600,000 for a painting reveals a high cultural desire," affirmed *The New York Times*, commenting on Bache's recent purchase. "So long as American millionaires are willing to go to such heights to acquire the gems of civilization," the *Times* added, "Europeans may as well be resigned to seeing many of them come to this country."[332] Bache's mo-

Fig. 42. Colonel G. F. Young, The Medici *(London, 1925), open to frontispiece. Villa I Tatti, Harvard University Center for Italian Renaissance Studies, Florence.*

tive in acquiring the picture may not have been aesthetic. It was more likely the subject that appealed to him. Giuliano was the son of Lorenzo the Magnificent and the brother of the Medici pope, Leo X. And the portrait which Bache bought was illustrated (fig. 42) in these very years as the frontispiece [47] to Colonel Young's popular book on the Medici.[333] Bache, who was self-made, lacked the assurance of a millionaire like Mellon, who was born to wealth. Acquiring the portrait would have buttressed his prestige, therefore, strengthening his feeling of identification with the great family of Renaissance bankers.

Bache bequeathed his collection, including its chief ornament, to the Metropolitan Museum in 1944. At that time the painting was considered a Raphael, though the attribution had been questioned. Since then its authenticity has often been doubted or rejected by scholars. Though a portrait is now labeled "contemporary copy after Raphael," a final judgment as to whether it is, in fact, the best of the surviving copies of a lost original or possibly a studio production must await the results of the cleaning currently underway at the museum.

Like Mrs. Gardner's *Tommaso Inghirami*, with its uncompromising realism of portrayal, the portrait of Giuliano de' Medici was not the kind of archetypal Raphael that most American collectors wanted. Duveen fared better with a Madonna. In May of 1928 he purchased from Lady Desborough the later and larger of the two Raphaels she had inherited. Known as the *Large Cowper* or *Nicolini-Cowper Madonna* (plate 14), the painting [81] was particularly desirable because, having been signed by the artist, it was of undoubted authenticity. In secret negotiations, Duveen beat out the competition, chiefly Knoedler's, who, he learned, were trying to obtain the picture for a client.[334] The agent Duveen employed in the transaction claimed the dealers' rivalry drove the price up to the point where the owner was persuaded to sell.[335] As had been the case when Duveen bought the *Small Cowper Madonna* from the same source in 1913, the acquisition set a record for the highest price ever paid for a picture.[336] Before it was exported, he placed the *Large Cowper Madonna* on exhibition in London (with the *Giuliano de' Medici* which remained unsold).[337] Then, cleaned and reframed, it was brought to New York in October 1928. The departure of the picture did not provoke the kind of patriotic outburst that had occurred in 1913, as the British were by now more resigned to seeing their national treasures cross the Atlantic.

Though Bache was rumored to be interested, it was Mellon as the leading collector of the day to whom Duveen offered the *Large Cowper Madonna*. This time, toward the end of 1928, Mellon accepted the offer of a Raphael. The reason for his change of mind does not lie simply in the greater appeal a Madonna had over one of the artist's portraits. In the late 1920s a remarkable change had taken place in

Mellon's collecting. With his own works of art as the nucleus, he decided to found a national gallery in Washington to rival the great European galleries. As entries in his diary record, the idea of making his collection available to the public began to take shape in Mellon's mind at least as early as 1928.[338] Taking the National Gallery in London as his model, the collector now sought masterpieces to represent the highest achievements of Western art and not merely to satisfy his own taste. Thus, there would appear to be a definite correlation between Mellon's plan for a national gallery and his decision to acquire the Raphael.

Because the role perfectly suited his character, Mellon soon became the epitome of the public-spirited private collector in America. The approach he took to the final phase of his collecting was analogous to his sense of responsibility as a government official. The Secretary of the Treasury stood for sound management of public monies; as an art collector for the public benefit, he was equally conservative. Far from being an isolated phenomenon, however, Mellon culminated the efforts we have seen of generations of American collectors to obtain the few remaining available works of Raphael. It is altogether fitting that Mellon should have finally realized Jarves' dream for an American national gallery. Until the plan for the gallery was completed and the building erected, Mellon gave his paintings to be held in trust by a foundation bearing his name. As the single most important work in his collection up to that time, the first picture he transferred to the trust, in December 1930, was the *Large Cowper Madonna*.[339]

Duveen's earlier acquisition of the *Madonna* was an "event of great significance," *The New York Times* [48] said on May 11, 1928. The reason was not only that the picture probably coming to this country was famous but also that "works by Raphael are nearly all in museums abroad, and therefore beyond the reach of American purchasers."[340] With private collections practically depleted of their Raphael holdings and with public museums off limits, it was reasonable to assume that no more works by the artist would find their way over. The proposed national gallery in Washington would have to be content, therefore, with only one work by Raphael, considerably fewer than London, Paris, or Berlin. Nevertheless, not long after he had bought the *Large Cowper Madonna*, Andrew Mellon had an extraordinary opportunity to obtain additional pictures of the highest quality. We have seen that the enormous prices American collectors were willing to pay had succeeded in prying a number of Raphaels out of European private collections. Now such sums were to tempt public officials to part with treasures from their museums. In the late 1920s and 1930s the Soviet government, desperate for foreign currency to pay for imports, initiated a series of sales of antiques and art objects, measured literally in tons. By a most fortunate circumstance the Soviets' need for cash coincided exactly with Andrew Mellon's wish for

paintings for his projected national gallery. The triumph of his career accordingly came in 1930-1931, when he acquired a group of twenty-one of the finest pictures from the Hermitage Museum in Leningrad.[341]

At first the Soviets denied that they were prepared to part with masterpieces for ready money. To dispel rumors circulating to that effect, Martin Conway published *Art Treasures in Soviet Russia* in 1925, in which he made special mention of two Raphaels, the *Saint George and the Dragon* [77] and the *Alba Madonna* [92].[342] Ironically, the book informed would-be buyers what was available for purchase. From Conway's book Andrew Mellon would have discovered that the *Saint George* (plate 12) had been painted for the Duke of Urbino as a present for the English King Henry VII, who had awarded the duke the Order of the Garter. Later the picture had been bought by Catherine the Great through Diderot at the auction of the Crozat Collection in Paris. Bought for Czar Nicholas II in 1836 from the already mentioned Coesvelt Collection in London, the *Alba Madonna* (plate 15) may have had a less distinguished provenance. But it was one of Raphael's most famous paintings. Nevertheless, even this renowned work had its rival. In 1924 a panel of square format known as the *Gaeta Madonna*, with the same figures as the *Alba Madonna* but a slightly different setting, came on the art market in Germany. And a booklet [49] was issued in English, of the extensive literature by German scholars attempting to prove that the *Gaeta Madonna* was Raphael's original.[343] The booklet, which featured facing color plates of the rival pictures, was evidently presented to Mellon, to interest him in making a purchase. He failed to take the bait, however, and the painting is now dismissed as a copy.[344]

With Knoedler's acting as his agent, Mellon instead acquired the two superb Raphaels from the Hermitage. The more than one million dollars he had to pay for the *Alba Madonna* broke the record established only three years before by the *Cowper Madonna* as the highest price ever given for a painting. At least among collectors of Mellon's rank, Raphael's reputation, despite the upheavals of the twentieth century, was as high as it had always been. He was willing to pay only slightly less ($747,500) for the little *Saint George*, arguably the most perfect small picture ever painted. The provenance of the painting may also have held a special appeal for the collector, who was an Anglophile. The Hermitage acquisitions, including the Raphaels, never hung in their new owner's apartment but went directly from one museum to another. Intended for the public, they were stored in a vault in the Corcoran Gallery in Washington until they could enter the newly built National Gallery. By contrast to the publicity surrounding the spectacular sales of the two Cowper Madonnas, Mellon's purchases from the Hermitage were kept secret until 1935, when he claimed them as a deduction on an earlier tax return. There were good reasons for his silence. On a personal level,

Mellon was reticent by nature. It was Duveen's flair for publicity which made the acquisition of the *Cowper Madonna* front page news. Politics played a role as well. At the time of the sale the United States had not yet recognized the U.S.S.R. Moreover, during a time of hardship, public reaction to his purchases might have been adverse.[345] But as a result of Mellon's policy of collecting with a public destination in mind, and not only for personal enjoyment, millions of visitors to the National Gallery have been able to admire some of Raphael's finest works. As one critic observed, it is a mark of Mellon's aims and achievement as a collector that "having once refused to buy a Raphael, he should have ended by owning three."[346]

A European museum also provided the next American Raphael [98]. The painting (plate 18), purchased by Samuel H. Kress and now in the National Gallery, is generally identified as the portrait mentioned by Vasari of Bindo Altoviti, when he was young, by Raphael.[347] A Florentine banker who lived in Rome, Altoviti was a noted patron of artists, such as Cellini, who portrayed him in a bronze bust in the Gardner Museum.[348] The painted portrait of the banker as a young man descended in the Altoviti family until in the late eighteenth century connoisseurs decided, erroneously, that it represented not Bindo but Raphael himself. The family accordingly sold the picture, as a self-portrait of Raphael, in 1808 to Crown Prince Ludwig of Bavaria, who presented it to the Alte Pinakothek in Munich.

Though the *Bindo Altoviti* was highly regarded by Raphael's nineteenth-century biographers, Morelli, nevertheless, cast doubts on Vasari's attribution.[349] These doubts grew into certainties for many critics, who suggested alternatives, H. Dollmayr proposing, for example, Raphael's pupil, Giulio Romano.[350] The Munich catalogues of the early part of this century reveal the steady decline in the picture's reputation. Called Raphael in 1908, it was catalogued as Giulio in 1911, only to be taken away from him in 1925 and given to the School of Raphael.[351] With three certain Raphaels in its collection, the museum decided in 1938 to dispose of the dubious portrait. It was sold not because it is of poor quality but because it failed to conform to the image of the artist and his work based on the early paintings. Just as Morelli's revaluation of the *Tommaso Inghirami* and of the *Small Cowper Madonna* led to their coming to this country, so his reappraisal of the *Bindo Altoviti*, in this case downward, made the picture available for purchase by an American collector.

As early as 1924 Duveen Brothers explored the possibility of acquiring the portrait from the museum in exchange for a Tintoretto. On September 22 of that year Edward Fowles of the firm wrote Berenson soliciting his opinion. The firm could not dispose of the portrait without Berenson's authentication, and he was on record as giving it to Peruzzi. "As you know," Fowles continued, "we have a client who is most anxious to acquire a portrait by this Master, which

means that it is sold already. . . ."[352] Nothing came of this proposal, perhaps because Duveen was presently able to offer the *Giuliano de' Medici* to Mellon and to Bache. The chance to reconsider the Munich portrait led Berenson to reverse his previous opinion, however. In the 1932 edition of the Lists he gave it to Raphael.[353] Despite his reattribution, the museum sold the picture to Duveen six years later as a work of little value.

After having it restored, Duveen offered the panel in 1940 to Samuel Kress (1863-1955), a self-made millionaire [50] who was engaged in forming a collection of Italian paintings.[354] Kress had begun as a schoolteacher in Pennsylvania, but he soon made a fortune founding a chain of stationery and novelty stores. Though he displayed his pictures in the customary setting of Renaissance furniture and decorative arts, Kress differed from the more worldly collectors we have considered, many of whom owned racehorses, as well as Raphaels. The collector from the past he does resemble is the missionary Jarves, who had tried long ago to make a comprehensive collection that would be broadly educational. Kress succeeded, however, where Jarves had failed by distributing his paintings to museums throughout the country.

At first Kress bought indiscriminately and on his own initiative a large number of comparatively unimportant works. Then, after he was persuaded to give his collection to the newly founded National Gallery of Art in Washington, he bought individual paintings of higher quality. John Walker has described how, once the collection was accepted for the Gallery in 1939, the improvement began almost immediately. At this time Kress turned for advice to Walker, Berenson's disciple, and for art to the major dealers, like Duveen. With his younger brother Rush, Samuel Kress now began to buy the greatest masterpieces which came on the market. The transformation of the Kress Collection and the radical change in values that it represented were signaled by his acquisition of the *Portrait of Bindo Altoviti* in 1940.[355] Kress was following the example of Isabella Stewart Gardner, Henry Walters, the Wideners, and Andrew Mellon, who had all raised the standard of their holdings by adding a Raphael. His purchase of *Bindo Altoviti* was meant to enhance the prestige of his collection, which in the National Gallery would have to stand comparison with Andrew Mellon's three paintings by Raphael. Kress got the recognition he deserved when he was compared as a benefactor specifically to Andrew Mellon and when his Raphael was reproduced with the *Large Cowper Madonna* in *Duveen Pictures in Public Collections in America* [51] of 1941. The book celebrated paintings added to public collections through the generosity of American collectors.[356] Mellon's Raphaels were unquestionably authentic, but at the time Kress donated *Bindo Altoviti*, it was ascribed without reservation to the master by Berenson alone, among recent critics. The cloud of doubt surrounding the picture, which allowed it to be sold

from Munich in the first place, began to dispel only in the last few years, when a number of scholars have come out in favor of the Raphael attribution.[357]

Reexamining the efforts of American collectors to obtain a Raphael, we have found that their successes far outweighed their failures. The mistakes they made were due in part to the experts advising them. Today we have the benefit not only of hindsight but of a higher level of connoisseurship. The collectors of Raphael succeeded in acquiring a number of original works by him, not all of them masterpieces, perhaps, but all bearing his stamp. The Americans turned to Raphael out of a combined sense of nostalgia, ambition, and cultural responsibility. Behind their motives lay the assumption—fitting for the heyday of entrepreneurial capitalism—that an individual or a nation might acquire culture by purchasing works of art. American collectors saw their fortunes not as ends in themselves but as a means of attaining the supreme goal of owning a painting by Raphael, preferably a Madonna. By contrast to our absorption in the present, the collectors whose activities we have studied showed a deep respect for past achievement. Raphael stood at the summit of a long tradition which was felt to be lacking in this country and which could be supplied, they believed, by acquiring one of his works. More importantly, our collectors also looked to the future. And we are the beneficiaries of their vision. Present-day viewers in America can thus enjoy looking at pictures by Raphael which not long ago were remote and inaccessible.

1. The second version, which is in a New York private collection, is illustrated in William H. Gerdts, *American Neo-Classic Sculpture* (New York, 1973), 106. About Crawford see: Robert L. Gale, *Thomas Crawford, American Sculptor* (Pittsburgh, 1964); and Sylvia Crane, *White Silence: Greenough, Powers and Crawford, American Sculptors in 19th Century Italy* (Coral Gables, Fla., 1972).

2. See the letters to his uncle of 1508 and 1514 in Vincenzo Golzio, *Raffaello nei Documenti* (Vatican City, 1936), 18-19, 31-33.

3. Franz Kugler, *Handbook of Painting: The Italian Schools*, ed. Sir Charles Eastlake, 2 vols. (London, 1869), 2:328.

4. Kugler, *Handbook*, 2:372.

5. James P. Walker, *Book of Raphael's Madonnas* (New York, 1860), 19-20. The book is illustrated with photographs of engravings.

6. Eugène Müntz, *Raphael, His Life, Works and Times*, 2d. rev. English ed., trans. Walter Armstrong (London, 1888), 70.

7. Lady Eastlake (Elizabeth Rigby), "The Life and Works of Raphael," in *Five Great Painters*, 2 vols. (London, 1883), 2:149.

8. Müntz, *Raphael*, 120.

9. Müntz, *Raphael*, 121.

10. John Galt, *The Life of Benjamin West*, ed. Nathalia Wright (Gainesville, Fla., 1960), 131.

11. *Handbook of the Wadsworth Athenaeum* (Hartford, Conn., 1958), 124. For a summary of the painting's history and a discussion of another version in the Tate Gallery in London, see C. C. Cunningham, "Letter to the Editor," *Art in America* 39 (April 1951), 95-96.

12. *Wadsworth Athenaeum*, 124.

13. Galt, *Benjamin West*, 163.

14. On the tapestry cartoons see, John Shearman, *Raphael's Cartoons in the Collection of Her Majesty the Queen, and the Tapestries for the Sistine Chapel* (London, 1972).

15. Sir Joshua Reynolds, *Discourses on Art*, ed. Robert R. Wark (San Marino, Calif., 1959), 81.

16. Ruth S. Kraemer, *Drawings by Benjamin West and his Son Raphael Lamar West* [exh. cat., Pierpont Morgan Library] (New York, 1975), 81, cat. no. 202. Inv. no. 1970.11:248.

17. John Trumbull, *Autobiography, Reminiscences and Letters* (New York, 1841), 66-67. Trumbull was also involved with another Raphael painting, the *Belle Jardinière*, now in the Louvre. During a trip to France in 1794, he purchased a copy of the painting from the Mazarin Collection. He made his own copy before selling the French picture to Benjamin West. Trumbull exhibited his copy in New York on his return to the United States and eventually donated it, along with a copy of Raphael's *Madonna of the Chair*, to the Yale University Art Gallery in 1831. Trumbull was not the only American artist attracted by the *Belle Jardinière*. A version once belonged to Miner Kellogg, one of the few American artists, according to James Jackson Jarves, qualified to speak intelligently of Old Masters. See Kellogg's pamphlet entitled *Researches into the History of a Painting by Raphael of Urbino entitled "La Belle Jardinière"* (London, 1860).

18. The West painting was in Reynolda House in Winston-Salem, North Carolina, until recently and is catalogued in Barbara Lassiter, *Reynolda House, American Paintings* (Winston-Salem, N.C., 1971), 10, 52. West's portrayal of his wife and child inspired other American portraitists to take the *Madonna of the Chair* as a model. Thomas Sully, for example, similarly painted Louisa Carroll and her child in a picture illustrated in the Baltimore Museum of Art exhibition catalogue *Anywhere So Long as There Be Freedom: Charles Carroll of Carrollton, His Family and His Maryland* (Baltimore, 1975), 262, cat. no. 86.

19. On West's influence on American artists see Dorinda Evans, *Benjamin West and His American Students* (Washington, 1980).

20. *The Letters and Papers of John Singleton Copley and Henry Pelham 1739-1776* (Boston, 1914), 301.

21. Jules David Prown, *John Singleton Copley in England 1774-1815*, 2 vols. (Cambridge, Mass., 1966), 2:250.

22. *Copley-Pelham Letters*, 39.

23. *Copley-Pelham Letters*, 295-299.

24. Irma B. Jaffe, "John Singleton Copley's *Watson and the Shark*," *American Art Journal* 9, no. 1 (May 1977), 15-25. One of the versions of Copley's painting is in the National Gallery of Art in Washington.

25. See Prown, *Copley*, 2:275-291.

26. About Vanderlyn, Allston, and other American artists studying and working abroad see most recently Wayne Craven, "The Grand Manner in Early Nineteenth Century American Painting: Borrowings from Antiquity, the Renaissance, and the Baroque," *The American Art Journal* 11, no. 2 (April 1979), 5-43. Evelyn Samuels Welch is currently researching the interest nineteenth-century Americans had in the Italian Old Masters in preparation for a forthcoming book.

27. Gabriel Rouches, *Raphaël, Quatorze dessins . . .* (Paris, 1939), cat. no. 14.

28. Albert Ten Eyck Gardner and Stuart P. Feld, *American Paintings: A Catalogue of the Collection of the Metropolitan Museum of Art. Painters Born by 1815* (New York, 1965), 126-127. Inv. No. 24.168. The painting has an inscription written below: "After a drawing in bister by Raphiel composed from the discription given by Lucien of a picture painted by Apelles/representing Calumny, on the occasion of a false accusation brought against the painter Apelles."

29. Suggested to me by Evelyn Samuels Welch. According to his early biographer, Vanderlyn returned from his years in Paris with "copies of highly finished drawings, heads, etc. from Raphael . . . and other masters." (Marius Schoonmaker, *John Vanderlyn* [Kingston, N.Y., 1950], 9). Dunlap reported that the artist presented a New York collector with a "head with the hands and arms after a female figure in the *Transfiguration* of Raphael." (William Dunlap, *History of the Rise and Progress of the Arts of Design in the United States*, 3 vols., ed. Alexander Wyckoff [New York, 1965], 2:162). Vanderlyn would have known the *Transfiguration* and many other

confiscated works by Raphael in the Musée Napoleon.

30. On the tradition of portraying the *Calumny of Apelles*, see David Cast, *The Calumny of Apelles: A Study in the Humanist Tradition* (New Haven, 1981).

31. On Allston see William Gerdts' authoritative work, "The Paintings of Washington Allston," in *"A Man of Genius" The Art of Washington Allston* [exh. cat., Museum of Fine Arts, Boston; Pennsylvania Academy of Fine Arts, Philadelphia] (Boston, 1979).

32. Craven, "Grand Manner," 26-27.

33. Carol Troyen, *The Boston Tradition, American Paintings from the Museum of Fine Arts, Boston* (Boston, 1980), 86, makes the connection with the *Saint Catherine* which was in a private collection in London by 1800. See Luitpold Dussler, *Raphael: A Critical Catalogue of his Pictures, Wall Paintings and Tapestries* (London, 1971), 25. As Gerdts has noted, there are Venetian antecedents for Allston's picture (*Allston*, 135). See also Craven, "Grand Manner," 24-25.

34. This data was compiled from information made available by the National Museum of American Art's Exhibition Catalogue Index. I am grateful to Jim Yarnell who assembled a copy index of works exhibited as attributed to or copied after Raphael.

35. See an article from *The New York Herald Tribune* entitled "Picture Buying," reprinted in the *Crayon Magazine* 1 (1855), 100.

36. Schoonmaker, *Vanderlyn*, 44.

37. For further information on American copyists, see most recently H. Nichols B. Clark, "The Impact of Seventeenth-Century Dutch and Flemish Genre Painting on American Genre Painting, 1800-1865," (Ph.D. diss., University of Delaware, 1982), 151-156.

38. Clark, "Impact," 155.

39. *Copley-Pelham Letters*, 304.

40. Trumbull, *Autobiography*, 49-50.

41. On the *Small Holy Family*, see Dussler, *Raphael*, 49-50. About the Bowdoin bequest see *An Illustrated Handbook of the Bowdoin College Museum of Fine Arts in the Walker Art Building* (Brunswick, Me., 1950), 5.

42. *Bowdoin*, 24.

43. See the list of engravings after the picture in Johann David Passavant, *Raphael d'Urbin et son Père Giovanni Santi*, 2 vols. (Paris, 1860), 2:265.

44. On Robert Gilmor as a collector see Anna Wells Rutledge, "Robert Gilmor, Jr., Baltimore Collector," *Journal of the Walters Art Gallery* 12 (1949), 19-39.

45. Harold E. Dickinson, "Jefferson as an Art Collector," in *Jefferson and the Arts*, ed. William Howard Adams (Washington, 1976), 101-132.

46. Quoted in Lillian B. Miller, *Patrons and Patriotism: The Encouragement of the Fine Arts in the United States, 1790-1860* (Chicago, 1966), 12.

47. Quoted in James Thomas Flexner, *America's Old Masters* (New York, 1939), 291-292. On Adams and the fine arts see Wendell D. Garrett, "John Adams and the Limited Role of the Fine Arts," *Winterthur Portfolio* 1, no. 1 (1964), 243-255.

48. William Bainter O'Neal, *Jefferson's Fine Arts Library* (Charlottesville, Va., 1976).

49. Dickinson, *Jefferson*, 109-110.

50. Dickinson, *Jefferson*, 125. On the *Holy Family of Francis I*, see Dussler, *Raphael*, 48.

51. Jefferson's "Catalogue of the Paintings at Monticello," survives in the archives of the University of Virginia at Charlottesville.

52. Walker, *Raphael's Madonnas*, 39.

53. Henry James, *Transatlantic Sketches* (Boston, 1875), 293. In James' short story "The Madonna of the Future" of 1873, a deluded American painter in Florence, who identifies with Raphael, attempts to create a Madonna equal to the *Madonna of the Chair*, of which he had made innumerable copies. "Other works," the painter claimed, "are of Raphael: this is Raphael himself. Others you can praise, you can qualify, you can measure, explain, account for: this you can only love and admire" (New York Edition [1908], 448). Having set himself this futile goal, the painter and his model grow old, and his canvas remains blank. James contrasts the inimitable perfection of Raphael's *Madonna* specifically with the realism of his *Portrait of Tommaso Inghirami*, also in the Pitti (fig. 30). The trivializing of Raphael's masterpiece is suggested by the way another expatriate "always wore on her bosom a huge, if reduced, copy of the Madonna della Seggiola" as a token of her devotion to art (p. 458).

54. Brooks' great-granddaughter, Mrs. St. Clair M. Smith provided this information in a letter of August 18, 1982.

55. James Robert Warren, "History in Towns, Wilmington, North Carolina," *Antiques* 118 (December 1980), 1263. The Raphael copy was not part of the original contents of the house but was brought there when it was restored to represent the taste of the owners.

56. Nathaniel Hawthorne, *Passages from the French and Italian Notebooks of Nathaniel Hawthorne*, 2 vols. (Boston, 1899), 2:18.

57. Hawthorne, *French/Italian Notebooks*, 2:28.

58. C. E. Frazer Clarke, Jr. *Nathaniel Hawthorne: A Descriptive Bibliography* (Pittsburgh, 1978), 254.

59. Nathaniel Hawthorne, *The Marble Faun, or the Romance of Monte Beni* (New York, 1960), 73.

60. Hawthorne, *Faun*, 72.

61. Quoted in Walker, *Raphael's Madonnas*, 98.

62. Quoted in James Jackson Jarves, *Art-Hints: Architecture, Sculpture and Painting* (New York, 1855), 355.

63. Larry Freeman, *Louis Prang: Color Lithographer* (Watkins Glen, N.Y., 1971), 187.

64. Freeman, *Prang*, 57.

65. Joseph Archer Crowe and Giovanni Battista Cavalcaselle, *Raphael: His Life and Work*, 2 vols. (London, 1882-1885), 2:370.

66. Bernard Berenson, *The Central Italian Painters of the Renaissance* (New York, 1897), 171-174. In an essay of 1896 lamenting the scarcity of Italian paintings in America, Berenson was able to cite, with regard to Raphael, only a copy of his early *Saint Sebastian* in Bergamo ("Les peintures Italiennes de New York et de Boston," *Gazette des Beaux-Arts* 16 [March 1896], 211-213). The copy, which Berenson gave to Lo Spagna, is now in the Museum of Fine Arts, Boston (Inv. no. 06.120).

67. Roger Fry, "Ideals of a Picture Gallery," *Bulletin of the Metropolitan Museum of Art* 1 (March 1906), 59.

68. Bernard Berenson, *The Central Italian Painters of the Renaissance*, 2d revised and enlarged ed. (New York, 1909), 232-236.

69. Bernard Berenson, *Italian Pictures of the Renaissance* (Oxford, 1932), 479-483.

70. Bernard Berenson, *Italian Pictures of the Renaissance: Central Italian and North Italian Schools*, 3 vols. (London, 1968), 1:350-355.

71. Frank Jewett Mather, Jr., "The Widener Collection at Washington," *Magazine of Art* 35, no. 6 (October 1942), 195.

72. John Pope-Hennessy, *Raphael* (New York, 1970), 178-181; and Anne H. van Buren, "The Canonical Office in Renaissance Painting: Raphael's *Madonna at Nones*," *The Art Bulletin* 57, no. 1 (March 1975), 41-52; and Letter to the Editor in *The Art Bulletin* 57, no. 3 (September 1975), 466. About the acquisition see *The New York Times*, December 2, 1972, 1 col. 6.

73. In an article entitled "Raphaël in America" Seymour De Ricci claimed that only seven genuine paintings by the artist had crossed the Atlantic ("Raphael en Amerique," *La Renaissance de l'art français et des industries de luxe* 9 [December 1926], 1012-

1018). The first was the Inghirami portrait in the Gardner Collection. Three parts of Raphael's altarpiece for the convent of Sant'Antonio in Perugia, after it was dismembered, had found their way separately to America: the central panel with its lunette, the so-called *Colonna Madonna*, was "perhaps the most important picture" in the Metropolitan Museum, while two of the predella panels, the *Agony in the Garden* and the *Lamentation*, were owned respectively by Mackay and Mrs. Gardner. The *Small Cowper Madonna* in the Widener Collection, Ricci felt, was the "most pleasing of the Raphaels in the United States," though the *Madonna of the Candelabra* was also celebrated. The "last Raphael to reach America" was the *Portrait of Giuliano de' Medici*, said to belong to an unnamed American collector. This list thus agrees with Berenson's of 1932, except for the *Emilia Pia*, which, as it was only acquired in 1924, Ricci probably did not know, and the *Large Cowper Madonna*, which Mellon purchased two years after the article appeared. In *Italian Paintings in America* Lionello Venturi cited six Raphaels, all of which are found in Berenson's List (*Italian Paintings in America*, 3 vols. [New York, 1933], 3: plate nos. 441-446). Perhaps because it was not meant to be exhaustive, Venturi omitted from his influential survey the Inghirami portrait and the pictures in Baltimore. His failure to include the three paintings cast a shadow on them, and the doubts have not diminished in recent years. According to Creighton Gilbert, "the American Raphaels which have appeared to be beyond question in modern times are four in Washington, the New York altarpiece and its predella pieces (there and in Boston), and the Raleigh predella. Two portraits are very uncertain (Washington and Boston) as are both pictures in Baltimore." ("A Miracle by Raphael," *North Carolina Museum of Art Bulletin* 6, no. 1 [fall 1965], 32, note 1). In a census of Italian paintings in American collections, Burton Fredericksen and Federico Zeri cite all of the above mentioned paintings as Raphael's, except for the *Giuliano de' Medici*, considered a copy, and for a few attributions such as the Princeton picture, designated "studio," and the *Northbrook Madonna* in Worcester (*Census of Pre-Nineteenth-Century Italian Paintings in North American Public Collections* [Cambridge, Mass., 1972], 171-172).

74. See René Brimo, *L'Evolution du goût aux Etats-Unis d'après l'histoire des collections* (Paris, 1938), 48-61; and W. G. Constable, *Art Collecting in the United States of America*

(London, 1964), 69-75.

75. The celebrated American collections of Old Masters seem to have been preceded in nearly every case by gatherings of contemporary art which, bringing little credit to their owners, are not prominently discussed in their biographies. For some instances of this phenomenon see Constable, *Art Collecting*, 105, 106, 119-120.

76. The painting is now in the Nelson Gallery-Atkins Museum in Kansas City, Missouri (*William Rockhill Nelson Gallery of Art and Mary Atkins Museum of Fine Arts. Handbook* [Kansas City, 1973], 157). According to the manuscript catalogue of the Widener collection, of 1900, kept at the National Gallery, the picture was acquired in 1895 from Boussod, Valladon & Co. Though in 1915 it was still in the collection (Catalogue by W. Roberts of the British and Modern French Schools), soon afterwards it was traded.

77. André Fermigier, *Jean-François Millet* (New York, 1977), 93.

78. About the attempts of late nineteenth-century American artists to link themselves to the tradition of Western art through such devices as portraying their contemporaries in Renaissance guise see Lois Marie Fink, "The Innovation of Tradition in Late Nineteenth Century American Art," *The American Art Journal* 10, no. 2 (November 1978), 63-71.

79. Henry James, *The American Scene*, ed. Leon Edel (Bloomington, Ind., 1968), 192.

80. *The American Renaissance 1876-1917* [exh. cat., The Brooklyn Museum] (Brooklyn, 1979), (with bibliography).

81. Burckhardt's *Die Kultur der Renaissance in Italien* of 1860 was translated into English as *The Civilization of the Renaissance in Italy* as early as 1878 (trans. S. G. C. Middlemore, 2 vols., London). It appeared with a New York imprint in 1879. Symonds' *The Renaissance in Italy* was published in seven volumes between 1875 and 1886 and remains to this day the only detailed survey of the whole field in English. A second edition was called for in 1900. The third volume on the fine arts appeared under a New York imprint in 1879.

82. Cartwright's *Baldassare Castiglione the Perfect Courtier: His Life and Letters 1478-1529*, in which Raphael figures prominently, was first published in New York and London in 1908 and again in the two cities in 1927. Her *Beatrice d'Este, Duchess of Milan, 1475-1497: A Study of the Renaissance* was published seventeen times in London and New York between 1899 and 1928.

83. Of Renaissance painters it was Raphael

upon whom Cartwright focused her attention. *The Early Work of Raphael* was published five times in New York and London between 1895 and 1907. Other books on the artist followed, including the complementary *Raphael in Rome*, which likewise came out five times in London and New York between 1895 and 1907. In a review of her *Raphael* of 1905 in *The Athenaeum* (November 18, 1905), 690, Roger Fry praised the way in which the author brought a sense of actuality to her account of Raphael's art.

84. James Jackson Jarves, "A Lesson for Merchant Princes," in *Italian Rambles* (New York, 1883), 361-380. Jarves distinguished between the successful merchants of the Renaissance, "prosperous, shrewd, worldly," and their degenerate descendants.

85. Mrs. Gardner objected to the lady's hand, however, and Berenson was forced to clarify that "purely and solely as a picture I should not be urging you to get it." (Letters from Berenson to Isabella Stewart Gardner of February 16, 1896, and of March 25, 1896, at Fenway Court). The "potent attraction" of the painting he explained, was as the portrait of Isabella. Needing no further persuasion, Mrs. Gardner welcomed the new acquisition upon its arrival in Boston with music and incense (letter from Mrs. Gardner to Berenson, dated May 10, 1896, at I Tatti). The *Lady with a Turban* is now given to Francesco Torlino (Philip Hendy, *European and American Paintings in the Isabella Stewart Gardner Museum* [Boston, 1974], Inv. no. P26W7, 260-261), and the sitter is no longer identified as Isabella d'Este. A similar case offered, perhaps, by one of the few unattributed pictures in the Widener collection, a portrait which was probably acquired because it was believed to represent Castiglione (Fern Rusk Shapley, *Catalogue of the Italian Paintings, National Gallery of Art* [Washington, 1979], no. 632, 94-96).

86. Letter from Berenson to Isabella Gardner, dated May 3, 1903, at Fenway Court.

87. Julia Cartwright, *Isabella d'Este. Marchioness of Mantua, 1474-1539: A Study of the Renaissance*, 2 vols. (New York, 1903), 1:x.

88. Gardner Teall, "An American Medici: J. Pierpont Morgan and his Various Collections," *Putnam's Magazine* 7, no. 2 (November 1909), 130-143, esp. 131, 133. According to James Henry Duveen, Morgan's "greatest pleasure was to be compared to the great art-protecting princes of the Renaissance. It is more likely that his open contempt for the value of money where art purchases were concerned was somewhat of a pose in

the manner of Lorenzo the Magnificent." (*Art Treasures and Intrigue* [New York, 1935], 136).

89. Herbert L. Satterlee, *J. Pierpont Morgan: An Intimate Portrait* (New York, 1939), 562-563.

90. Morgan's son-in-law says only that the "wall covering of the west room . . . satisfied him." (Satterlee, *Portrait*, 435). The present covering is a replica of the original damask.

91. In 1899 Morgan purchased a copy of Müntz' *Raphael: Sa vie, son oeuvre et son temps* (Paris, 1881). This monograph, which was translated into English in 1882, came out in a revised French edition in 1886 that in turn appeared in English in 1888. Yet another English version was issued in 1896. Müntz' monograph emphasized the historical background for Raphael's work.

92. Except for my emphasis on Chigi and on Raphael, the following discussion of the decoration of the Morgan Library draws heavily on William Voelkle's exhibition, "The 75th Anniversary of the Morgan Library Building," November 10, 1981-February 7, 1982. My hypothesis that Morgan was emulating Chigi has received support from Voelkle's recent discovery that the zodiacal signs refer to Morgan's horoscope. Accoding to Voelkle the "two signs over the entrance to the East Room—the 'lucky stars' under which Morgan could walk—are isolated from the rest and coincide with the dates of two important events in his life: his birth on 17 April 1837 (Aries), and his second and long marriage to Frances Louise Tracy on 31 May 1865 (Gemini). As it happens the deities associated with the signs are also appropriate, for they were married on Wednesday (Mercury's day) and Venus is the patroness of marriage. Morgan's first marriage was short-lived, for Amelia 'Mimi' Sturges, his childhood sweetheart, died on 17 February 1862, a little over four months after they had been married. Aquarius, located on the east wall directly opposite Gemini, is above the Muse of Tragedy. Directly opposite Morgan's sign, and above the Muse of Comedy, is Libra, his adopted sign as a member of the Zodiac of Twelve club."

93. Zoffany and Cowper were perhaps conspiring to interest King George III, the commissioner of the *Tribuna*, in buying Raphael's *Madonna*. See Oliver Millar, *Zoffany and his Tribuna* (London, 1967), 27-28.

94. Francis Haskell, *Rediscoveries in Art: Some Aspects of Taste, Fashion and Collecting in England and France* (Ithaca, N.Y., 1976), 70-71. About the transfer of Raphaels to northern Europe see, in addition to Haskell,

Rediscoveries, Gerald Reitlinger, *The Economics of Taste* (London, 1961), 5-6, 33-34, 43-45, 54-56, 112-114, 178.

95. The following all contain such lists: Frank Tryon Charles (Karl Karoly), *Raphael's Madonnas and Other Great Pictures Reproduced from the Original Paintings* (London, 1894); *Raphael*, Masters in Art Series (Boston, 1900); Henry Strachey, *Raphael* (London, 1907); and Adolf Paul Oppé, *Raphael* (London, 1909).

96. Reitlinger, *Economics*, 33-34.

97. The five paintings by the artist in Berlin, for example, are all youthful Madonnas, while of the seven in the London National Gallery, five are pre-Roman, including two altarpieces. Coming last, the Americans had almost no chance to secure pictures from Raphael's mature period. Among the thirty of the artist's "most celebrated paintings," nearly all in his developed style, in *The Great Works of Raphael Sanzio of Urbino* of 1866 only two would reach America, the *Alba Madonna* and the *Portrait of Bindo Altoviti* (*The Great Works of Raphael Sanzio of Urbino: A Series of Thirty Photographs from the Best Engravings of his Most Celebrated Paintings*, 2d ed., ed. Joseph Cundall [London, 1866]). A second volume in the series consisted of twenty-six further masterpieces, most of them mature easel paintings, and of these an American collector would obtain only one, the *Madonna of the Candelabra* (*Great Works . . . Twenty-Six Photographs from the Best Engravings of his Most Celebrated Paintings*, Second Series [London, 1869]).

98. The modern approach to Raphael, integrating his hitherto neglected early works with the later ones, was first undertaken by Johann David Passavant (1787-1861), director of the museum at Frankfurt. Published in German in 1839-1858 and in a revised and more useful French edition in 1860, Passavant's monograph on Raphael became a model for all subsequent studies of an artist (*Rafael von Urbino und sein Vater Giovanni Santi*, 3 vols. [Leipzig, 1839-1858]; and *Raphael d'Urbin et son père Giovanni Santi*, rev. ed., 2 vols., trans. Jules Lunteschutz and ed. Paul Lacroix [Paris, 1860]). The value of the book lies less in its rather romanticized biography than in the systematic catalogue, which remains an indispensable instrument of Raphael research. Passavant's monograph became known in the English-speaking world through a review by Charles Eastlake, for whom the most valuable part of the book was that "relating to the earlier history and productions of Raphael" (*Quarterly Review*

56, no. 131 [June 1840], 1-48, reprinted in Eastlake's *Contributions to the Literature of the Fine Arts* [London, 1848], 180-271). The book was translated in an abridged English edition of 1872 (*Raphael of Urbino and his Father Giovanni Santi* [London, 1872; reprinted in 1978 by Garland Publishing Co.]). The importance of Passavant's book was brought home to American readers in Herman Grimm's *Life of Raphael*, trans. Sarah Holland Adams (Boston, 1888), 302-308. It had a further impact in England in the formation by Prince Albert of the Raphael Study Collection in the Royal Library at Windsor Castle (now deposited in the British Museum). The aim of the collection carried out by the prince and his advisor was to amass all the available evidence relating to an artist's work. Partly due to Passavant's labors, Raphael was chosen in preference to any other master (Carl Ruland, *The Works of Raphael Santi da Urbino as Represented in the Raphael Collection, in the Royal Library at Windsor Castle Formed by H.R.H. The Prince Consort 1853-1861 and Completed by Her Majesty Queen Victoria* [n.p., 1876]).

99. Crowe and Cavalcaselle, *Raphael* I:viii.

100. Müntz' monograph on Raphael had to be revised owing to the "increased interest taken in the work of Raphael's youth" (note to the second English edition by Walter Armstrong [London, 1888]).

101. Royal Cortissoz, "The American Collector," in *The Painter's Craft* (New York, 1930), 448.

102. Esther Singleton, *Old World Masters in New World Collections* (New York, 1929), x.

103. *Central Italian Painters*, 1897, 112. The literature on Raphael's fame is scattered in works such as the following: Anthony Blunt, "The Legend of Raphael in Italy and France," in *Italian Studies* 13 (1958), 2-20; Pope-Hennessy, *Raphael*, 223-256; and Claude Foucart, "L'Oeuvre de Raphael: Etapes et formes d'une critique litteraire," in *Revue d'histoire litteraire de la France* 80, no. 6 (November-December 1980), 1003-1025.

104. The prestige of culture keenly felt by our collectors was attacked by Roger Fry in "Culture and Snobbism," ostensibly a book review but, in fact, an important essay on the proper way to approach works of art (*Transformations: Critical and Speculative Essays on Art* [London, 1926], 56-66). Fry, who had fallen out with his former patron J. P. Morgan, distinguished between the devotee of culture, with his uncritical admiration for masters like the "divine Sanzio," and the patron of the avant-garde, whose enjoyment of

art came from looking and understanding.

105. John Addington Symonds, *Renaissance in Italy: The Fine Arts* (London, 1877), 239-246.

106. About Berenson's importance for American collectors see David Alan Brown, *Berenson and the Connoisseurship of Italian Painting* [exh. cat., National Gallery of Art] (Washington, 1979); and Ernest Samuels, *Berenson: The Making of a Connoisseur* (Cambridge, Mass., 1979).

107. *Central Italian Painters*, 1897, 112-129.

108. "The Caen 'Sposalizio,'" in *The Study and Criticism of Italian Art*, 2d series (London, 1902), 1-22 (reprinted from the *Gazette des Beaux-Arts* 15 [April 1896], 273-290). In this article Berenson attempted to prove that Raphael's supposed model, a painting of the same theme in Caen, was not by Perugino, as was then universally believed, but rather an imitation of Raphael's painting by a Perugino follower.

109. The notion of "space composition" was taken over and elaborated in a popular book on Raphael which also belonged to Joseph Widener (Strachey, *Raphael*, 46-49). Originally published in 1900, the book was revised in 1902 and reissued again in 1907. Berenson's essay was quoted, too, in *Old World Masters in New World Collections*, 88-89, specifically in connection with the *Small Cowper Madonna* in the Widener Collection.

110. Edith Wharton, *False Dawn* (New York, 1924), 52. All quotations are from this edition.

111. About Bryan as a collector see Constable, *Art Collecting*, 29-30.

112. Richard Grant White, *Companion to the Bryan Gallery of Christian Art* (New York, 1853), 17-21, cat. no. 25; see also *Catalogue of the Gallery of Art of the New-York Historical Society* (New York, 1915), 60-61, cat. no. B-25.

113. Parke-Bernet Galleries, New York, December 2, 1971, lot no. 9.

114. About Jarves see Francis Steegmuller, *The Two Lives of James Jackson Jarves* (New Haven, 1951); and Brown, *Connoisseurship*, 32-33.

115. James Jackson Jarves, *Descriptive Catalogue of "Old Masters"* (Cambridge, Mass., 1863), 6.

116. Jarves, *Descriptive Catalogue*, 20, cat. no. 95. Compare James Jackson Jarves, *Art Studies: The "Old Masters" of Italy; Painting* (New York, 1861), 442, plate K and fig. 33.

117. Jarves, *Art Studies*, 51.

118. Ettore Camesasca, *L'opera completa del Perugino* (Milan, 1969), 89-90, no. 17.

119. Jarves, *Descriptive Catalogue*, 20.

120. Jarves, *Descriptive Catalogue*, 20. Jarves would have rejoiced to read in a monograph of 1877 on Raphael that although the other "pictures now in America attributed to Raphael are not mentioned . . . because the proofs of their authenticity are not easily accessible," his *Pietà* was "undoubtedly an early work" (Moses Foster Sweetser, *Artist Biographies: Raphael. Leonardo da Vinci* [Boston, 1877], 149).

121. Russell Sturgis, *Manual of the Jarves Collection of Early Italian Pictures* (New Haven, 1868), 77-78, cat. no. 89. The annotated copy of the manual is at Villa I Tatti in Florence. About Berenson's visit see Brown, *Connoisseurship*, 19. His verdict was accepted by Charles Seymour, Jr., in *Early Italian Paintings in the Yale University Art Gallery* (New Haven, 1970), 272.

122. Jarves, *Descriptive Catalogue*, 8.

123. *Catalogue of Paintings and Sculpture in the Collection of Charles T. Yerkes, Esq.*, 2 vols. (New York, 1904), 1:Introduction and cat. no. 80. In the *Catalogue from the Collection of Charles T. Yerkes* (Chicago, 1893), the picture is no. 44.

124. Bernard Berenson, "Le pitture italiane nella raccolta Yerkes," *Rassegna d'Arte* 6, no. 3 (March 1906), 34.

125. *Catalogue of the Exceedingly Valuable Ancient and Modern Paintings . . . Belonging to the Estate of the Late Charles T. Yerkes*, American Art Galleries, New York, April 5-8, 1910, lot no. 96.

126. The woman to whom Johnson refers in this letter of April 25, 1910, to Berenson, kept at Villa I Tatti, was Mrs. J. W. N. Cardoza of Philadelphia.

127. *Old Masters*, Parke-Bernet Galleries, New York, February 24, 1949, lot no. 66. A note on the back of a photograph in the Frick Art Reference Library in New York. The painting later belonged to Mrs. Morris Tilden of Saranac Lake, New York.

128. W. R. Valentiner, "An Unknown Raphael," *Bulletin of the Detroit Institute of Arts* 15, no. 2 (November 1935), 18-27. Two predella panels with stories from the life of Saint Nicholas in the Detroit Institute of Arts (nos. 25.146 and 27.10) were also incorrectly given to Raphael by Valentiner (*Bulletin of the Detroit Institute of Arts* 20, no. 7 [April 1941], 70-72). The two pictures, originally published by Valentiner in the *Festschrift für Max J. Friedlaender* (Leipzig, 1927), 244-258, will appear, I am kindly informed by Curator J. Patrice Marandel, as Circle of Perugino in the forthcoming catalogue of early Italian paintings by Burton Fredericksen.

129. For details see Margaret Sterne, *The Passionate Eye: The Life of William R. Valentiner* (Detroit, 1980), 243, 276. The other works exchanged were Degas' *Two Women Seated*, Redon's *Dream of the Butterflies*, and a Flemish thirteenth-century casket. The Monet had been purchased by the museum in 1920 on the recommendation of one of its strongest supporters, Albert Kahn. When the canvas was deaccessioned fifteen years later, Kahn, an architect, bought it for himself and bequeathed it to his daughter, Lydia Winston Malbin, the noted collector of Italian Futurists. I am grateful to Mrs. Malbin for kindly providing information and a photograph of the Monet in her collection in New York.

130. Erich Wagner, "Ein Unbekannter Raphael," in *Zeitschrift für Kunstgeschichte* 5 (1936), 288-291.

131. Federico Zeri, "Raffaele Arcangelo e Raffaello Sanzio," *Proporzioni* 2 (1948), 178-180. As John Pope-Hennessy pointed out in a review of Dussler's *Raphael* of 1971 in *The Times Literary Supplement*, June 11, 1978, 668, Zeri did not claim that the Detroit fragment was a fake, as Dussler mistakenly states (*Raphael*, 58). Professor Zeri kindly permitted us to republish his photograph of the altarpiece.

132. Valentiner, "Zu dem neugefundenen Raphael," in *Zeitschrift für Kunstgeschichte* 6 (1937), 327-329.

133. Another picture, a half-length *Saint Sebastian* in the Kress Collection in the museum at Trenton, New Jersey, was attributed to Raphael throughout the nineteenth century in England. And predictably enough the painting continued to be called an "original early work" by the master after the Kress acquisition in 1948, even though it is characteristic of the anonymous follower of Perugino whom Zeri has called the "Master of the Greenville Tondo" (Fern Rusk Shapley, *Paintings from the Samuel H. Kress Collection. Italian Schools XV-XVI Century* [London, 1968], 100-101, fig. 241, no. K1557, as Follower of Perugino). The Raphael attribution was maintained by William Suida in *Philadelphia Museum Bulletin* 46, no. 227 (autumn 1950), 8, cat. no. 4. The correct attribution is due to Everett Fahy. Further works of this type are a *Marriage of Saint Catherine*, sold as by Raphael with the collection of Dr. John E. Stillwell at the Anderson Galleries, New York, December 1-3, 1927 (lot no. 485, illus.); and a half-length *Saint Michael* copied

from Perugino in the collection of Richard H. Rush (exhibited as by Raphael at the Carpenter Art Galleries, Dartmouth College, May-June 1959, cat. no. 3 [illus]).

134. John Shearman, "Raphael at the Court of Urbino," *The Burlington Magazine* 112 (February 1970), 72-78.

135. *The New York Times*, December 16, 1969, 54, col. 1.

136. The picture, back in Italy, is being restored and restudied (*Art News* 81, no. 4 [April 1982], 12-13). For further details see Nathaniel Burt, *Palaces for the People: A Social History of the American Art Museum* (Boston, 1977), 406-409.

137. A *Seated Evangelist and Two Standing Saints*, bought as a Pinturicchio on Berenson's recommendation in 1909 and so labeled in the Johnson collection in Philadelphia (Barbara Sweeney, *John G. Johnson Collection: Catalogue of Italian Paintings* [Philadelphia, 1966], 65, no. 142, was given to the youthful Raphael under Pinturicchio's influence by Roberto Longhi in 1955, followed by Ettore Camesasca (Dussler, *Raphael*, 64).

138. Frank Jewett Mather, Jr., "The Princeton Raphael," *Art in America* 14, no. 2 (February 1926), 73-80.

139. *The New York Times*, December 1, 1925.

140. A version of the *Madonna dell'Impannata* in the Pitti Gallery was promoted by its restorer, Pasquale Farina, as Raphael's original. Discovered in America, the panel was supposed to have been purchased by the expatriot sculptor Hiram Powers in Rome in 1843 for a patron in the United States (Pasquale Farina, *The Original and Authentic Madonna dell'Impannata by Raffaello Sanzio da Urbino Has Been in America since 1843. Is the Celebrated "Impannata" in the Pitti Palace in Florence a Copy?* [Philadelphia, 1929]). The controversy thus aroused over the two pictures was so great that they were juxtaposed in the Pitti Gallery for three months in 1935 (Farina, "La Madonna dell'Impannata di Raffaello Scoperta in America," *Arte Cristiana* 25, no. 3 [March 1937], 54-67). See also Amadore Porcella, "La vera 'Madonna dell'Impannata' di Raffaello," *L'illustrazione Vaticana* 8, no. 5 (1937), 209-212. The matter was not settled until an x-radiograph of the Pitti painting was published two years later (Piero Sanpaolesi, "Due esami radiografici di dipinti," in *Bollettino d'Arte* 31, [May 1938], 495-505). The x-radiograph revealed variations in design beneath the present surface of the *Madonna* in the Pitti which correspond to preliminary drawings by Raphael

(Dussler, *Raphael*, 38-39). Therefore, only that painting could be the original. The American version, which subsequently belonged to Dr. Victor C. Thorne in New York, was a contemporary copy. Yet another instance of a copy after Raphael being acquired as an original is the *Madonna and Child* now in the Cummer Gallery of Art, Jacksonville, Florida. In 1966 the panel was given to the museum by the family of John C. Myers of Ashland, Ohio. Myers had bought the picture in the 1930s as a Raphael, apparently without realizing that it reproduces the *Colonna Madonna* in Berlin (*The Art Quarterly* 30 [Spring 1967], 64, 69 [illus.]). Additional information was kindly provided by the director of the Cummer Gallery, Robert W. Schlageter, according to whom the picture was purchased from the Day Collection by the London firm of Henry Graves. It later entered, as Raphael, the collection of Charles Butler, Warren Wood, Hatfield, England, and was subsequently acquired before World War I by Gordon and Fox, English dealers. Who sold the painting to Myers is not known to me, though he dealt extensively with Newhouse Galleries in New York. Another example of this type is the copy of the *Bridgewater Madonna*, which belonged to Mary L. Overbeck of San Diego, California (Geoffrey Wills, "A Newly Discovered Raphael Madonna and Child in America," *The Connoisseur* 164, no. 660 [February 1967], 133-134). Myers also owned a partial copy of Raphael's mural of the *Disputà*, which now belongs to Ashland College (oil on canvas measuring 20 x 26 inches, according to Duncan R. Jamieson of Ashland College). The group reproduced is that in the lower left of the fresco. Listed as a copy in Fredericksen and Zeri, *Census*, 171.

141. Fogg Art Museum, Harvard University, Inv. no. 1959.36. The panel, which had earlier belonged to Baron Rumohr, was donated to the museum by the Warburg Foundation. Letters of authentication were given to Contini by Bode, the director of the Berlin museum (4/11/24); August Mayer of the Alte Pinakothek in Munich (4/8/24); and Georg Swarzenski of the Stadelsches Kunstinstitut in Frankfurt (4/5/24). Against the opinion of these German museum officials was Berenson, who wrote on the back of a photograph at I Tatti, "Alfani?"

142. National Gallery of Art no. 266. See Shapley, *Italian Paintings*, 361-362. The painting was cradled, cleaned, and restored soon after it was acquired by Samuel H. Kress in 1935.

143. See *Catalogue of the Art Treasures of the United Kingdom Collected at Manchester in 1857* (London, 1857), no. 140; *Exhibition of Works by the Old Masters* (London, 1883), no. 176; *Exhibition of Early Italian Art* [The New Gallery] (London, 1893-1894), no. 246.

144. Shapley, *Kress Collection*, 104-105, no. K302. The attribution was rejected by Dussler, *Raphael*, 67. The compiler's own reassessment also recommended returning the painting to Perugino (see Shapley in note 142).

145. The *Annunciation* was attributed to Perugino by a number of experts who provided the dealer Contini Bonacossi with certificates of authenticity at the time the picture was sold to Samuel H. Kress in 1935. The following manuscript opinions are on file at the National Gallery. William Suida, dated March 1935; August Mayer, dated March 13, 1935; Giuseppe Fiocco, dated March 15, 1935; Roberto Longhi, dated March 20, 1935. Published attributions to Perugino include Camesasca in *Tutta la pittura del Perugino* (Milan, 1959), 93; and his *Perugina*, no. 78; Francesco Santi, "Perugino" in *Encyclopedia of World Art* 11 (New York, 1966), col. 269; Fredericksen and Zeri, *Census*, 161; and Shapley, *Italian Paintings*, 361-362. A dating of about 1500-1510 was suggested for the painting by the similiar ornamental design on the vault of the hall of the Collegio del Cambio, which Perugino had underway toward the end of the century.

146. Venturi, manuscript opinion on file at the National Gallery, dated March 21, 1935. See also the opinion of George Gronau, dated March 22, 1935, on file at the National Gallery. Alfred Frankfurter compared the Madonna's facial type specifically to that of her counterpart in Perugino's *Adoration of the Child* in the Uffizi (*The Art News* 34 [March 14, 1936], 6).

147. Raimond Van Marle, manuscript opinion on file at the National Gallery. Van Marle favored an attribution to Raphael while a pupil of Perugino, and F. Mason Perkins was so inclined too (manuscript opinion).

148. Anna Brownell Jameson, *Collection of Pictures of W. G. Coesvelt* (London, 1836), vii.

149. Crowe and Cavalcaselle, *Raphael*, 2:558.

150. W. Burger [E. J. T. Thoré], *Trésors d'art exposés à Manchester en 1857* (Paris, 1857), 61.

151. Bernard Berenson, *The Central Italian Painters of the Renaissance* (New York, 1909), 193. Berenson's attribution was recorded by Umberto Gnoli in *Pittori e miniatori*

nell'Umbria (Spoleto, 1923), 139.

152. Berenson, *Italian Pictures* (1968), 1:333.

153. See note 148. The print was "drawn and etched by F. Joubert" as an illustration of no. 80. The example in the Raphael Study Collection from Windsor Castle is further inscribed: "Published by James Carpenter & Son, Old Bond Street, London, 1835" and numbered 80 (Portfolio 5, B.II.2). For the etching see Anna Brownell Jameson, *Legends of the Madonna as Represented in the Fine Arts*, 2d. ed. (London, 1857), pl. 17.1, opp. 167, by Gerardine. Further about the illustration see Brown, *Connoisseurship*, 36-37.

154. The photograph at I Tatti is labeled on the back "Henry Dixon photographers, Albany Street, London." Another old photograph showing the picture in the same state and out of its frame is in the Kunsthistorisches Institut, Florence, no. 2983 (numbered 246). The photograph in the Raphael Collection (Portfolio 5, B. II.1) is smaller and shows the painting in its frame, through the state once again is the same. It was catalogued in 1876.

155. Known chiefly as a collaborator in the decoration of the Collegio del Cambio in Perugia, Giannicola (recorded 1484-died 1544), called Smicca, was one of Perugino's principal followers. He had studied with Perugino, according to Vasari, and his well-documented activity centered on Perugia. His main achievement remains the chapel of Saint John the Baptist in the Cambio, where, among other works, he executed the frescoed vault between 1513 and 1518. About the artist see: Gnoli, *Pittori e miniatori*, 135-140; Walter Bombe, *Urkunden zur Geschichte der Peruginer Malerei im 16 Jahrhundert* (Leipzig, 1929), 48-67; Raimond Van Marle, *The Development of the Italian Schools of Painting* 14 (The Hague), 421-432; and Giovanna Sapori, "Per un riesame di Giannicola di Paolo," in *Esercizi. Arte Musica Spettacolo, Istituto di Storia dell'Arte Medioevale e Moderna, Università degli Studi* (Perugia, 1979), 57-63.

156. The spatially incoherent landscape, the long-fingered hands, the awkward gestures, and the rather flaccid handling of the drapery folds recall the same features in Giannicola's *Madonna Enthroned with Saints* of 1510 in the Gambier Parry Collection in the Courtauld Institute Galleries in London (no. 2). The painting was attributed, correctly in my opinion, to Giannicola di Paolo by Van Marle (*Italian Schools*, 14:430), and by Berenson (photo I Tatti). The inscribed signature is no longer decipherable, but the date is

clear: MCCCCCX. I am indebted to Gillian Kennedy for information about the inscription, which is not visible in the photograph. The color in the National Gallery painting is also typical of Giannicola: deep rose red and olive green for the figures and a lighter yellow green and pale blue for the landscape. The classical type of ornament surrounding the roundels in the Washington painting was a speciality of Giannicola. Parallels abound with the vault of the Cambio which he decorated with *grottesche* between 1513 and 1518 (Nicole Dacos, *La Découverte de la domus aurea et la formation des grotesques a la Renaissance* [London, 1969], 85-86 and figs. 134-135).

157. Alfred Frankfurter in "Important Italian Paintings Recently Added to American Collections," *The Art News* 34 (March 14, 1936), 6, found a "good likelihood that Perugino may have been assisted by Raphael in this perfect jewel of Umbrian painting" and in *The Kress Collection in the National Gallery* (New York, 1944), 72, he claimed that the picture shows many evidences of Raphael's own hand. See also note 147.

158. About Mrs. Gardner as a collector see Rollin van N. Hadley and Frances L. Preston, "Berenson and Mrs. Gardner: The Venetian Influence," *Fenway Court* (1972), 11-17; and "Berenson and Mrs. Gardner: The Museum Years," *Fenway Court* (1974), 5-13. About her collection see Hendy, *Gardner Museum,* and about her museum, *The Connoisseur* 198, no. 795 (May 1978).

159. Morris Carter, *Isabella Stewart Gardner and Fenway Court* (Boston, 1925).

160. Letter from Berenson of February 16, 1898, to Mrs. Gardner, at Fenway Court.

161. The first idea had been simply to add a gallery to her Beacon Street house, but by 1896 she determined to build one on the outskirts of Boston. After her husband's death Mrs. Gardner set to work on the plans, and the building itself was begun in 1900.

162. Letter from Mrs. Gardner to Berenson, dated March 11, 1901, at I Tatti.

1963. Letter from Mrs. Gardner to Berenson, dated July 22, 1901, at I Tatti.

164. Letter from Berenson to Mrs. Gardner, dated November 17, 1901, at Fenway Court.

165. Letter from Berenson to Mrs. Gardner, dated December 23, 1901, at Fenway Court.

166. Letter from Mrs. Gardner to Berenson, dated April 1, 1902, at I Tatti.

167. Letter from Mrs. Gardner to Berenson, dated April 28, 1902, at I Tatti.

168. Letter from Berenson to Mrs. Gardner, dated August 28, 1902, at Fenway Court.

169. Letter from Berenson to Mrs. Gardner, dated September 25, 1902, at Fenway Court.

170. Letter from Mrs. Gardner to Berenson, dated December 23, 1902, at I Tatti.

171. Letter from Berenson to Mrs. Gardner, dated June 1, 1903, at Fenway Court.

172. Letter from Berenson to Mrs. Gardner, dated July 1903, at Fenway Court.

173. Letter from Mrs. Gardner to Berenson, dated June 7, 1905, at I Tatti. Berenson replied on June 23, 1905, "I scarcely expected you to buy the Raphael portrait. But I wanted you to know that such a thing was going."

174. Letter from Berenson to Mrs. Gardner, dated February 7, 1900, at Fenway Court.

175. Letter from Berenson to Mrs. Gardner, dated August 14, 1907, at Fenway Court.

176. Letter from Berenson to Mrs. Gardner, dated November 16, 1907, at Fenway Court.

177. James K. Kettlewell, *The Hyde Collection Catalogue* (Glens Falls, N.Y., 1981), 66-68, inv. no. 1971.36.

178. Letter from Berenson to Mrs. Gardner, dated September 16, 1898, at Fenway Court. See Rollin van N. Hadley, "What Might Have Been: Pictures Mrs. Gardner Did Not Acquire," *Fenway Court* (1979), 44.

179. *Arundel Club, First Year's Publications,* 1904, no. 1 (as Raphael, Collection of the Executors of the late W. C. Whitney, New York, now deposited with Messrs. Agnew & Sons).

180. According to a letter from Agnew's of April 19, 1982, the portrait was called "The Elder Doni," implying a comparison with Raphael's picture in the Pitti Gallery.

181. The letter from Speelman, a dealer, on file at the Hyde Collection, indicated that W. R. Valentiner was involved in the sale and that Adolfo Venturi was expected to provide a certificate of authenticity.

182. Letter from Agnew's to Mrs. Hyde, dated November 22, 1938, on file at the Hyde Collection.

183. Frederick J. Fisher in Kettlewell, *Hyde Collection*, ix-xi.

184. The Raphael attribution was accepted by Oskar Fischel, who dated it to "the transitional period or the very beginning of the Roman period (Oskar Fischel, *Raphael*, 2 vols. [London, 1948], 1:362). On the basis of a photograph, Dussler also tentatively ascribed the picture to Raphael, noting the relationship to the *Portrait of Angelo Doni* in the Pitti Gallery (Dussler, *Raphael*, 17-18). He dated the Hyde portrait, more or less as Fischel did, to the end of the Florentine period. It is listed as an "attribution" in the Freder-

icksen and Zeri *Census* (172). Comparison with the Pitti portrait by Raphael provided a solution to the attribution problem. There are differences, of course. The sitter in the Hyde portrait, unidentified so far, is reversed and is bust length; Doni is portrayed half-length, with hands. The Hyde portrait has a neutral background, too, while Doni is shown against a landscape. Nevertheless, aside from similarities in costume, the two portraits are clearly related in concept and style. In each case the sitter is depicted in three-quarter view, turning to look at the viewer with a piercing glance. Both portraits are inspired by realistic Flemish prototypes, especially Memling, and both affirm the impact of Leonardo's *Mona Lisa*. The *Angelo Doni* is datable stylistically to 1506, and the Hyde portrait cannot be much later. The painter of the Hyde portrait, moreover, would seem to have had Raphael's painting foremost in his mind, as we see in devices common to both like the way the face is set off against the mass of hair. But the resemblance is one of imitation, not identity of hand. In the Hyde portrait, it is the brightly lit side of the face that is juxtaposed to the dark mass of hair. Such sharp contrasts of light and dark are unlike Raphael's softer modeling. The Hyde portrait is conceived, too, in sober tones of black and gray, while Raphael's coloring is mellow and variegated. In short, the Hyde portrait is plastic and sculptural, clearly the work of a Florentine painter, whereas Raphael's Doni portrait, for all its involvement with Florentine art, betrays his Umbrian origins. Berenson's original suggestion of Ridolfo Ghirlandaio should be reconsidered, I believe, and, in fact, an attribution to that artist has been made verbally, I am informed, by Professor Sydney Freedberg. Further evidence that the Hyde portrait is by a Florentine artist like Ridolfo Ghirlandaio and not by Raphael is offered by an x-radiograph of the picture made at the National Gallery. The way the paint is broadly and vigorously applied and the lack of smoothly blended middle tones in the modeling are different from any work by Raphael that I know. The x-radiograph shows that, even though the painting was transferred and "prettified," as Berenson said, its condition remains good, except for the mass of hair which was expanded by overpainting, perhaps to make it look more like that in the Doni portrait. The brushstrokes in the background curve around a smaller, more compact mass of hair.

185. Hendy, *Gardner Museum*, 195-196.

186. Crowe and Cavalcaselle, *Raphael*, 2:235.

187. About Morelli's method see Brown, *Connoisseurship*, 33-35.

188. Giovanni Morelli, *Italian Painters: Critical Studies of Their Works. The Borghese and Doria-Pamfili Galleries in Rome*, trans. Constance Jocelyn Ffoulkes (London, 1892), 58-59. About the Raphaels in the Uffizi and Pitti Galleries, see 33-59.

189. Even Morelli's enemies accepted his attribution. See, for example, Wilhelm von Bode's edition of Burckhardt's *Cicerone* (Leipzig, 1893), pt. 2:791-792; and Bode's commentary on the Gardner version in *Noteworthy Paintings in American Private Collections*, ed. John La Farge and August F. Jaccaci (New York, 1907), 98.

190. Berenson, *Central Italian Painters*, 1897, 174.

191. Julia Cartwright, *Raphael in Rome*, The Portfolio Series (London, 1895), 136. Berenson copied out this passage on a scrap of paper kept among the correspondence with Mrs. Gardner at I Tatti.

192. Letter from Berenson to Mrs. Gardner, dated January 16, 1898, at Fenway Court.

193. Letter from Berenson to Mrs. Gardner, dated February 2, 1898, at Fenway Court.

194. Letter from Mrs. Gardner to Berenson, dated February 2, 1898, at I Tatti.

195. Letter from Mrs. Gardner to Berenson, dated February 3, 1898, at I Tatti.

196. Letter from Berenson to Mrs. Gardner, dated February 19, 1898, at Fenway Court.

197. Letter from Berenson to Mrs. Gardner, dated March 5, 1898, at Fenway Court.

198. Letters of March 3, March 7, and March 8, 1898, from Mrs. Gardner to Berenson, at I Tatti.

199. Letter from Berenson to Mrs. Gardner, dated March 13, 1898, at Fenway Court.

200. Letter from Berenson to Mrs. Gardner, dated March 21, 1898, at Fenway Court.

201. Letter from Mrs. Gardner to Berenson, dated March 25, 1898, at I Tatti.

202. Letter from Mrs. Gardner to Berenson, dated April 6, 1898, at I Tatti.

203. Letter from Berenson to Mrs. Gardner, dated Easter Sunday, 1898, at Fenway Court.

204. August F. Jaccaci, *Concerning Noteworthy Paintings in American Private Collections* (New York, 1909), 11. About this remarkable publishing venture see Garnett McCoy, "The Price of a Small Motor-Car," *Fenway Court* (1972), 26-32.

205. For reviews of the first volume devoted principally to the Gardner Collection see Léonce Bénédite, "Les Collections d'art aux Etats-Unis," *La Revue de l'Art Ancien et Moderne* 1 (1908), 161-176; and Maurice Tourneux, "Les Galeries privées en Amérique," *Gazette des Beaux-Arts* 40 (November 1908), 417-425.

206. Georg Gronau in *Noteworthy Paintings*, 93, 97; and Herbert Horne, 97-98.

207. Scholars differ as to the merits of the later version in the Pitti. Some feel that picture, too, is wholly autograph (Luisa Becherucci, "Raphael and Painting," in *The Complete Work of Raphael*, ed. Mario Salmi [New York, 1969], 138; and John Pope-Hennessy, *The Portrait in the Rennaisssance* [New York, 1963], 117, 119, and 316-317 note). Others argue that it is only a studio replica, showing little or nothing of the master's hand (Ettore Camesasca, *All the Paintings of Raphael* [New York, 1963], 82-83; and Dussler, *Raphael*, 34-35). Sydney Freedberg has claimed that the Pitti version, which he dates 1516?, differs significantly enough from the one in Boston, about 1513, to be considered a revision "probably by Giulio Romano but perhaps touched in the face and hands by Raphael himself (*Painting of the High Renaissance in Rome and Florence*, 2 vols. [Cambridge, Mass., 1961], 1:177-178; and *Painting in Italy 1500 to 1600*, Pelican History of Art Series [Harmondsworth, 1970], 470, note 36).

208. The varnish and part of the repaint were removed in 1953, revealing the extent of damage (Hendy, *Gardner Museum*, 195). The picture is now being cleaned again (autumn 1982). Enough of the paint surface remains to determine that the Gardner picture, like the one in the Pitti, is close in style to the portraits in Raphael's *Mass of Bolsena* in the Vatican of about 1512. The same colors—green, red, white, and black—are found in both the fresco and the painted portraits, the original of which should be dated to the same time.

209. Hendy, *Gardner Museum*, 193-195. Oil on wood panel. 23.5 x 28.8 cm. (9¼ x 11⁵⁄₁₆ in.). When the picture was cleaned in 1953, it was found to be only slightly abraded and retouched.

210. Letter from Berenson to Mrs. Gardner, dated October 25, 1900, at Fenway Court.

211. Crowe and Cavalcaselle, *Raphael*, 1:236. Müntz also saw fit to treat the panels in some detail "for though Raphael worked upon them as mere accessories of a larger composition, each of them has for us the value and importance of a true historical picture." (*Raphael*, 166).

212. Adolfo Venturi, *Raffaello* (Rome,

1920), 119.

213. Berenson had not seen the painting either, as we learn from a letter to him from Otto Gutekunst, director of Colnaghi's, who sold it to Mrs. Gardner (November 1, 1900, at I Tatti): "I am glad you have offered Mrs. Gardner the little Raffaelle; the only pity is that you never saw it, for it is such a perfectly enchanting little gem!" About the problem in general see David Alan Brown. "Berenson and Mrs. Gardner: the Connoisseur, the Collector and the Photograph," *Fenway Court* (1978), 24-29.

214. About Morgan as a collector see "Mr. John Pierpont Morgan," *The Burlington Magazine* 23 (May 1913), 65-67; Frederick Lewis Allen, *The Great Pierpont Morgan* (New York, 1949), 136-148; Aline B. Saarinen, *The Proud Possessors* (New York, 1958), 59-91; and Francis Henry Taylor, *Pierpont Morgan as Collector and Patron, 1837-1913*, rev. ed. (New York, 1970).

215. Steichen explained how he achieved the "Dynamic self-assertion" of Morgan's portrait in *A Life in Photography* (New York, 1963), ch. 3, n.p.

216. *Burlington* (1913), 65.

217. Quoted in Virginia Woolf, *Roger Fry: A Biography* (New York, 1940), 141. For Fry's estimate of Morgan see *Letters of Roger Fry*, ed. Denys Sutton (New York, 1972), 1:23-29, 226-234, 241-242, 250-256, 272, 274, 324, 327.

218. Calvin Tomkins, *Merchants and Masterpieces: The Story of the Metropolitan Museum of Art* (New York, 1970), 98-99.

219. Quoted in Taylor, *Morgan*, 39.

220. Federico Zeri, *Italian Paintings: A Catalogue of the Collection of the Metropolitan Museum of Art. Sienese and Central Italian Schools* (New York, 1980), 72-75, no. 16.30. Tempera on wood panel. The painted surface of the main panel measures 169.5 x 168.9 cm. (66¾ x 66½ in.) and the lunette 64.8 x 171.5 cm. (25½ x 67½ in.).

221. For a reconstruction of the altarpiece see Everett Fahy, "Italian Paintings at Fenway Court and Elsewhere," *Connoisseur* 198 (May 1978), 39.

222. "Raphael's Great Madonna," in *The World*, January 11, 1886. The article claimed that the Prussian government was also contending for the picture.

223. Letter in the *Liverpool Daily Post*, January 3, 1874, printed in *The Works of John Ruskin* 34, ed. E. T. Cook and Alexander Wedderburn (London, 1908), 512-513. Ruskin's letter was reprinted in *The Art Journal* 13 (1874), 61. Calling it "perhaps the most interesting picture by Raphael in the world," he again urged the purchase of the picture for England in *The Eagle's Nest* (*Works* 23 [London, 1906], 140). The price had evidently been reduced to £25,000.

224. Information from files at the Metropolitan Museum of Art, New York.

225. A letter from Colnaghi of July 12, 1896, on file at the Metropolitan Museum, refers to the picture's "present wonderful condition."

226. Letter from Berenson to Mrs. Gardner, dated November 9, 1897, at Fenway Court. See Hadley, *Fenway* (1979), 37.

227. Letter from Mrs. Gardner to Berenson, dated November 14, 1897, at I Tatti.

228. Letter from Berenson to Mrs. Gardner, dated November 17, 1897, at Fenway Court.

229. Letter from Berenson to Mrs. Gardner, dated January 14, 1901, at Fenway Court. He wrote again five days later that "Pierpont Morgan's $500,000 Raphael is now on exhibition at the Old Masters in London and none of the critics have a good word to say about it. . . ."

230. Berenson, *Central Italian Painters* (1909), 233 (in part); *Italian Pictures* (1932), 481 (great part); *Italian Pictures* (1968), 353 (great part).

231. Julia Cartwright puffed the painting, newly acquired by Morgan, in *The Art Journal* (October 1901), 284-286. The terms in which she praised this "magnificent example of Raphael's best period," that it was "recognized as genuine by all the critics" and was in "excellent preservation," suggest that some criticism may have reached Morgan's ears.

232. The bill of sale, dated April 27, 1901, was for 2,000,000 francs.

233. The marble veining of the steps and the gilding of the orb held by God the Father in the lunette, removed in a recent cleaning of the picture and referred to by John Brealey in *Metropolitan Museum Journal* 12 (1978), 91, may have been added by the dealer with Morgan's taste in mind.

234. *The Madonna of Saint Anthony of Padua also known as the Great Colonna Madonna Painted by Raphael Sanzio*, Charles Sedelmeyer, 6 rue de la Rochefaucauld, Paris, 1897. That Morgan took Sedelmeyer's argument to heart is suggested by an incident Roger Fry recounted about a trip to an exhibition in Perugia he made with the collector in 1907. Morgan brought the conversation around to Raphael in order to boast that his picture, then on loan to the National Gallery, was better than the Ansidei altarpiece (Woolf, *Fry*, 142-143).

235. This and the following quotations are from L. Vitet in *Revue des deux mondes* (March 1, 1870), cited in Sedelmeyer (1897), 19-21.

236. Cass Canfield, *The Incredible Pierpont Morgan: Financier and Art Collector* (New York, 1974), 122.

237. William Roberts, *Pictures in the Collection of J. Pierpont Morgan at Princes Gate and Dover House* (London, 1907).

238. *The New York Times*, February 3, 1916.

239. Letter from Otto Gutekunst to Berenson, dated May 19, 1909, at I Tatti. Gutekunst wrote Berenson again about the painting on June 3, 1909, saying that, according to Max J. Friedländer, it was Bode who fathered the transaction. Bode listed the picture as one of four authentic Raphaels in America in *Die Woche* 13, no. 50 (December 1911), 2100.

240. Letter from Berenson to Mrs. Gardner, dated July 11, 1909, at Fenway Court. In the letter Berenson described Morgan as "affable, simple, as proud and eager as a nice schoolboy, and a thoroughly life-enhancing person." Earlier, on April 6, 1909, Morgan had written Berenson from Rome of his "most pleasant recollections of the days we passed together in the Library in New York." (I Tatti).

241. Parke-Bernet Galleries, New York, sale no. 547, Part II. March 22-25, 1944, lot no. 437. 19½ x 14½ in. Purchased by Mr. Fred Liod.

242. Information provided in a letter from Federico Zeri, dated April 8, 1982.

243. Sylvie Béguin et al., *La Madone de Lorette*. Les dossiers du département des peintures 19 [Musée Condé, Chantilly] (Paris, 1979). The rediscovery is due to Cecil Gould.

244. Passavant, *Raphael*, 2:101, note 1.

245. Passavant, *Raphael*, 2:102.

246. A. F. Gruyer, *Les Vièrges de Raphael*, 3 vols. (Paris, 1883), 3:321-322, note 4.

247. Crowe and Cavalcaselle, *Raphael*, 2:110-111. S. Vögelin also claimed the picture was partly by Raphael (*Die Madonna von Loreto* [Zurich, 1870], 72-75).

248. Mary Berenson wrote on the back of a photograph at I Tatti "The Pierpont Morgan Library—temporarily. To be exterminated as soon as possible. Copy of Raphael."

249. Other versions in America include the following: the *Infant Christ* in the Johnson Collection in Philadelphia, catalogued by Berenson as a partial copy (Sweeny, *Johnson Collection*, 66, no. 152); the canvas in the Allen Memorial Art Museum (*Catalogue of European and American Paintings and Sculp-*

ture [Oberlin, Ohio, 1967], 125); the version in the J. Paul Getty Museum at Malibu, California, until recently believed by some scholars to be the lost original (Alfred Scharf, "Raphael and the Getty Museum," *Apollo* 79 [February 1964], 114-121; Burton B. Fredericksen, *Catalogue of the Paintings in the J. Paul Getty Museum* [Malibu, 1972], 24-26, cat. no. 27; and Fredericksen, "New Information on Raphael's Madonna di Loreto," *The J. Paul Getty Museum Journal* 3 [1976], 5-45); and the version from Getty's personal collection now belonging to Bernard C. Solomon in Beverly Hills, California. According to Fredericksen (*Masterpieces of Painting in the J. Paul Getty Museum* [Malibu, 1980]), meeting Berenson stirred in Getty a lifelong interest in the Italian Renaissance. After his version of the *Madonna of Loreto*, bought as a copy, was claimed in 1963 to be the lost original, Getty became fascinated by anything connected with Raphael and spent much of his time over the next ten years studying the artist.

250. Letter from Berenson to Mrs. Gardner, dated June 26, 1907, at Fenway Court. Berenson also reported that, according to Roger Fry, "Morgan's desire now is to re-value the masterpieces of Italian art."

251. About Walters as a collector see Constable, *Art Collecting*, 52-55; Denys Sutton, "Connoisseur's Haven," *Apollo* 84, no. 58 (December 1966), 422-433; and Federico Zeri, "The Italian Pictures: Discoveries and Problems," *Apollo* 84, no. 58 (December 1966), 442-451.

252. For full details about the picture see Federico Zeri, *Italian Paintings in the Walters Art Gallery*, 2 vols. (Baltimore, 1976), 2:348-354, cat. no. 232.

253. Letter from Henry Walters to Berenson, dated January 4, 1910, at I Tatti, kindly brought to my attention by Ernest and Jayne Samuels.

254. For Ingres' copy of 1817 see Georges Wildenstein, *Ingres* (London, 1954), 183, cat. no. 116 and fig. 145; and for his involvement with the *Madonna of the Candelabra*, Robert Rosenblum, *Ingres* (New York, 1967), 29; and Jon Whiteley, *Ingres* (London, 1977), 84, no. 65.

255. Letter from Berenson to Mrs. Gardner, dated August 11, 1897, at Fenway Court. Berenson claimed that the "next thing we shall hear is that the Boston Museum of Fine Arts has bought it for $100,000. My acquaintance was asked £8,000 for it. I think £800 a fairer price." See Hadley in *Fenway* (1979), 37, 42.

256. G. F. Waagen, *Treasures of Art in Great Britain*, 3 vols. (London, 1854), 2:132.

257. Passavant, *Raphael*, 2:243.

258. See George Redford, *Art Sales*, vol. 1 (London, 1888), 272-280. The *London Times* for June 3, 1878, reports 19,500 guineas rather than pounds.

259. J. C. Robinson, *Memoranda on the Madonna dei Candelabri* (London, 1878).

260. Letter from Hurlbut to Palma di Cesnola, director of the Metropolitan Museum, dated November 1, 1882, reprinted in an article in the *New York World*, November 15, 1882, 5, col. 3.

261. Letter from Cesnola to Hurlbut, November 5, 1882, printed in the *New York World*, November 15, 1882, 5, col. 3. The picture would already have been familiar to readers of Walker's *Book of Raphael's Madonnas*, published in New York in 1860, in which it was discussed and illustrated in the form of a photograph of a reproductive engraving.

262. *New York World*, November 5, 1882, 5, cols. 1 and 2.

263. *The New York Herald*, November 7, 1882, 5, col. 6.

264. *The New York Herald*, November 14, 1882, 4, col. 5.

265. *The New York Herald*, November 15, 1882, 4, col. 3.

266. *New York World*, November 17, 1882, 4, col. 4.

267. *The New York Herald*, November 18, 1882, 6, col. 4.

268. *Harper's Weekly* 26, no. 1354 (December 2, 1882), 757.

269. *New York Daily Tribune*, December 12, 1882, 4, col. 6.

270. *Pictures by Old Masters in the East Gallery* [Hand-book no. 1, Metropolitan Museum of Art] (New York, 1882). The booklet was later criticized for giving a biased account of the picture, which the museum wished to acquire.

271. The *Art Amateur* 8, no. 1 (December 1882), 2.

272. *New York Daily Tribune*, December 12, 1882, 5, col. 2.

273. *The New York Times*, December 12, 1882, 5, cols. 2 and 3.

274. *The Critic* 2, no. 51 (December 16, 1882), 346-347.

275. *New York World*, December 23, 1882, 4, col. 4.

276. *New York World*, December 31, 1882, 6, col. 4.

277. *Boston Evening Transcript*, January 3, 1883, 6, cols. 4-5.

278. *Magazine of Art* (March 1883), Monthly Record of American Art, xi.

279. See Zeri, *Walters Art Gallery*, 2:348-354.

280. De Ricci, *La Renaissance*, 1016.

281. About the Widener Collection see: E. Waldmann, "Die Sammlung Widener," *Pantheon* 22 (November 1938), 334-343; Constable, *Art Collecting*, 115-119; and John Walker, *Self-Portrait with Donors* (Boston, 1969), 139. In addition to the published sources, I have been able to consult a valuable account of the collection written by Edith Standen, who in the 1930s was in charge of it, on deposit at the National Gallery.

282. *Catalogue of Paintings Forming the Private Collection of P. A. B. Widener . . .* (n.p., 1900), no. 239. Another copy of the Julius portrait was bought as an original by lumber baron Thomas Barton Walker (1840-1928), who opened his gallery in Minneapolis in 1879 (*The Walker Art Galleries* [Minneapolis, 1927], no. 239, as Raphael). The painting was sold by the museum on September 29, 1945. About Walker as a hapless collector of Old Masters see Constable, *Art Collecting*, 92-94.

283. Cecil Gould, *Raphael's Portrait of Pope Julius II: The Re-emergence of the Original* (London, 1970) and Konrad Oberhuber, "Raphael and the State Portrait—I: The Portrait of Julius II," *The Burlington Magazine* 113 (March 1971), 124-131.

284. Quoted in Brown, *Connoisseurship*, 19.

285. P. A. B. Widener, *Without Drums* (New York, 1940), 57-58.

286. *Pictures in the Collection of P. A. B. Widener . . . Early Italian and Spanish Schools* (Philadelphia, 1916), no. 18.

287. *Paintings in the Collection of Joseph Widener at Lynnewood Hall . . .* (Philadelphia, 1923 and 1931). Joseph E. Widener Collection Sale, Samuel T. Freeman & Co., Philadelphia, June 20-24, 1944, p. 80, lot no. 425 (sold for $1,000).

288. John Walker, *National Gallery of Art, Washington, D.C.* (New York, 1963), 33-34.

289. J. D. Passavant, *Tour of a German Artist in England*, 2 vols. (London, 1836), 1:221; and *Raphael*, 2:26.

290. George Scharf, *A Handbook to the Paintings by Old Masters in the Art Treasures Exhibition* (London, 1857), 25. Influenced by Ruskin, Charles Eliot Norton actually preferred the "simplicity and feeling" of the early works by Raphael exhibited ("The Manchester Exhibition," *Atlantic Monthly* 1 [November 1857], 37-38).

291. *Passages from the English Note-Books of National Hawthorne*, 2 vols. (Boston, 1870),

2:330.

292. Crowe and Cavalcaselle, *Raphael*, 1:250-251.

293. Giovanni Morelli (Ivan Lermolioff), *Italian Masters in German Galleries: A Critical Essay on the Italian Pictures in the Galleries of Munich, Dresden, and Berlin*, trans. from the German ed. of 1880 by Louise M. Richter (London, 1883), 332-333. The quotation is repeated in *Italian Painters: Critical Studies of New Works. The Galleries of Munich and Dresden*, trans. Constance Jocelyn Ffoulkes (London, 1893), 252.

294. Alfred R. Dryhurst, *Raphael* (London, 1905), 26 (also ed. of 1909, 26).

295. Louis Gillet, *Raphaël* (Paris, 1906), 44.

296. Gustavo Frizzoni, "Opere di Raffaello rievocate ne'suoi disegni a Firenze," *Nuova Antologia* 50, no. 1032 (January 16, 1915), 216.

297. Berenson, *Widener Collection* (1916), no. 18. Though not "one of the great Raphaels," the *Small Cowper Madonna* was the "most graceful and generally pleasing of all Raphael's early Madonnas," according to Frank Jewett Mather, Jr. ("The Little Madonna by Raphael" in *Art in America* 2, no. 4 [June 1914], 312-313).

298. Julia Cartwright, *The Early Work of Raphael* (London, 1895), 53.

299. Julia Cartwright, *Christ and His Mother in Italian Art* (London, 1897), 71 and no. 148 (also editions of 1907 and 1917).

300. Julia Cartwright, *Raphael* (London and New York, 1905), 66. The painting, or rather an engraving after it, had been illustrated as plate IV, facing page 174, in Charles C. Perkins, *Raphael and Michelangelo* (Boston, 1878).

301. About Johnson as a collector see Saarinen, *Proud Possessors*, 92-117.

302. Letter from Johnson to Berenson, dated October 10, 1913, at I Tatti.

303. Letter from Johnson to Berenson, dated May 4, 1914, at I Tatti.

304. Letter from Johnson to Berenson, dated May 7, 1914, at I Tatti.

305. Letter from Johnson to Berenson of May 1914, at I Tatti.

306. Widener, *Without Drums*, 66.

307. *The New York Times*, November 26, 1913, 1, col. 5.

308. *Daily Telegraph*, November 26, 1913.

309. *The New York Herald*, November 26, 1913.

310. *The New York Times*, November 26, 1913, 1 and 2.

311. *Morning Post*, November 26, 1913.

312. *London Times*, November 26, 1913, 26, col. 8.

313. *The Daily Mail*, November 26, 1913.

314. *Daily Telegraph*, December 22, 1913.

315. According to Edward Fowles, who, as Duveen's right-hand man, was in a position to know, when the Wideners were approached by the firm about the possibility of acquiring the picture, they gave an "order to purchase it for a sum up to $500,000. The negotiations took some months, and it was not until the end of November that the purchase was concluded." The picture was delivered to the Wideners on February 14. "The bill totalled £113,000—the additional sum covered the cost of cleaning, framing, insurance and payment to an intermediary whose name was used as purchaser." (*Memories of Duveen Brothers* [London, 1976], 82). Fowles disputed the claim made by S. N. Behrman that the picture had originally been intended for Benjamin Altman, who inconveniently died (*Duveen* [Boston, 1972], 72-73).

316. *The New York Herald*, February 7, 1914.

317. *The New York Times*, February 7, 1914, 1, col. 8, and 2.

318. *The Standard*, February 9, 1914.

319. About the Mackay Collection see W. R. Valentiner, "The Clarence H. Mackay Collection," *International Studio* 81 (August 1925), 335-345; and Royal Cortissoz, "The Clarence H. Mackay Collection," *International Studio* 94 (December 1929), 29-34, 120-122.

320. Wilhelm R. Valentiner, *The Clarence H. Mackay Collection: The Italian Schools* (New York, 1926). The copy exhibited is inscribed: "To Mr. Andrew W. Mellon in appreciation of a delightful visit with him in Washington Jan. 31st 1928 and the opportunity of seeing his beautiful collection. Clarence Mackay, Feb. 15, 1928."

321. Paul Schubring, "Die Predella zu Raffaels Altar für S. Antonio in Perugia," *Der Cicerone* 15, no. 1 (1923), 3-6. Having come to light in Germany, the picture was then in the collection of John Milton Gittermann. More recently it was auctioned in Cologne (Dussler, *Raphael*, 16).

322. About Mellon as a collector see Constable, *Art Collecting*, 122-125; Walker, *Self-Portrait*, 102-131; and David Edward Finley, *A Standard of Excellence: Andrew W. Mellon Founds the National Gallery of Art at Washington* (Washington, 1973).

323. For full details on the picture see Zeri, *Metropolitan Museum*, 78-80, inv. no. 49.712.

324. A bust-length variant of the portrait of Giuliano, showing what is clearly the same sitter against an open landscape, is or was in the collection of Mrs. Edsel Ford in Detroit. Dussler (*Raphael*, 58), who mistakenly claims this portrait is of an unknown man and in the style of Raphael, lists a further variant in a private collection in Los Angeles. For reproductions of various versions of the Giuliano portrait see Fernanda de' Mattei in *L'Arte* 58 (n.s. 24), no. 4 (October-December 1959), 309-324.

325. C. E. de Liphart, *Notice historique sur un tableau de Raphaël* (Paris, 1867).

326. *Die Sammlung Oscar Huldschinsky* (Frankfurt, 1909), 6-8, 39, and cat. no. 41.

327. Royal Cortissoz, "Raphael and the Art of Portrait Painting," in *Personalities in Art* (New York, 1925), 66-67. In its account of the purchase of May 6, 1925, *The New York Times* described the picture as "perhaps the most important that has been sold in the last half century," and incorrectly as the "last work of the master in private hands."

328. Quoted from an unpublished biography of Mellon by Burton J. Hendrick, chapter 21, 6. There is evidence that Duveen also offered the picture to the Frick Collection, which contained no Raphael. On September 10, 1927, Berenson, at Duveen's request, cabled the Frick trustees that the "Huldschinsky Raphael was painted by Raphael himself and is in excellent condition."

329. William Larimer Mellon, with Boyden Sparkes, *Judge Mellon's Sons* (n.p., 1948), 426.

330. As suggested by John Walker in *National Gallery of Art* (New York, n.d.), 31. Lionello Venturi (*Italian Paintings*, note to pl. 446) noted the "ruthless realistic construction" of the sitter's face, which according to Cortissoz (*Personalities*, 69) was of the "Medicean type, including a long hooked nose, almond-shaped eyes, and a beard and mustache kept short to suit a small chin and upper lip."

331. A letter to Berenson from Edward Fowles, dated December 14, 1928, and kept at I Tatti, reported that the portrait, recently cleaned for the second time, was hanging at Bache's and that he was pleased with it. See *Catalogue of Paintings in the Collection of Jules S. Bache* (New York, 1929), n.p.; ed. 1937, no. 13; ed. 1943, no. 12.

332. *The New York Times*, March 13, 1929, 30, col. 6.

333. Colonel G. F. Young, *The Medici*, 2 vols., 3d. ed. reprinted (London, 1925), 1:frontispiece and 394-395. The book came

out in 1909, 1911, and 1912. The third edition was reprinted four times in the 1920s, before Bache acquired the portrait.

334. Letter from Edward Fowles to Berenson, dated May 11, 1928, at I Tatti. Berenson, who had read about the sale in the newspapers, was concerned that he would not receive his usual commission.

335. *The Evening News*, May 11 and 12, 1928.

336. The painting, "perhaps the greatest masterpiece in the world," cost $875,000, according to *The New York Times*, May 11, 1928.

337. *The Daily Telegraph Exhibition of Antiques and Works of Art* [Olympia, July 19-August 1] (London, 1928), cat. no. X 40.

338. Hendrick, "Unpublished Biography," chapter 21, 34. Finley recalled that Mellon was contemplating the Gallery in 1927 (*Mellon*, 12).

339. According to Walter Heil, the *Madonna* was "not only an authentic Raphael —there are not more than two in this country [the *Small Cowper Madonna* and the Colonna altarpiece] that are without question by the master's hand—but a Raphael which can stand comparison with any of his most famous pictures in the great European collections." ("A New Raphael in America," *Art in America* 15, no. 1 [December 1928], 50).

340. *The New York Times*, May 11, 1928, 1, col. 2.

341. Robert C. Williams, *Russian Art and American Money 1900-1940* (Cambridge, Mass., 1980), 147-187.

342. William Martin Conway, *Art Treasures in Soviet Russia* (London, 1925), 155.

343. Emil Waldmann et al., *The Madonna di Gaeta: A Picture by Raphael. Treatises and Expertises* (Leipzig, n.d.). Given to the National Gallery Library by the A. W. Mellon Educational and Charitable Trust.

344. Dussler, *Raphael*, 35-36. Theodor Musper recounts a scheme by which the painting was supposed to be offered to Hitler (*Die Weltkunst* 21, no. 13 [July 1951], 7).

345. *The New York Times*, August 18, 1934, 8.

346. Constable, *Art Collecting*, 124, note 1.

347. National Gallery of Art no. 534. For detailed information see Shapley, *Italian Paintings*, 394-396.

348. Charles Avery, "Benvenuto Cellini's Bronze Bust of Bindo Altoviti," *The Connoisseur* 198 (May 1978), 62-72.

349. *Italian Painters: Critical Studies of Their Works. The Galleries of Munich and Dresden*, trans. Constance Jocelyn Ffoulkes (London,

1893), 112-114. Morelli's doubts were based on the "form of the ear" and the "treatment of the hair and of the eyebrows."

350. H. Dollmayr in *Jahrbuch der Kunsthistorischen Sammlungen* 16 (1895), 357.

351. *Katalog der Kgl. Älteren Pinakothek*, 11th ed. (Munich, 1911), 129-130, cat. no. 1052; and *Katalog der Älteren Pinakothek* (Munich, 1925), 123, cat. no. 536.

352. Letter from Edward Fowles to Berenson, dated September 22, 1924, at I Tatti.

353. In a letter to Isabella Stewart Gardner of July 6, 1898, Berenson had said the picture was by Raphael (quoted in Avery, *Connoisseur*, 63). Shortly afterwards he followed Morelli in doubting the attribution to Raphael and suggested Baldassare Peruzzi instead ("Le Portrait Raphaelesque de Montpellier," *Gazette des Beaux-Arts* 37 [March 1907], 209 [208-212]). He later repented this "eresia morelliana" ("Quadri Senza Case: Il Quattrocento Senese," *Dedalo* 11 [April 1931], 766 [reprinted as *Homeless Paintings of the Renaissance*, ed. Hanna Kiel (Bloomington, Ind., 1970), 741]), and restored the picture to Raphael (*Italian Pictures* [1932], 481; *Pitture Italiane del Rinascimento* [Milan, 1936], 413; and *Italian Pictures*, 1:355).

354. About Kress see: Constable, *Art Collecting*, 133-137; Walker, *Self-Portrait*, 133-153; and Brown, *Connoisseurship*, 23-24. About his collection see Fern Rusk Shapley, *Paintings from the Samuel H. Kress Collection: Italian Schools. XIII-XV Century* (London, 1966); Shapley, *Kress Collection*; and Fern Rusk Shapley, *Paintings, from the Samuel H. Kress Collection: Italian Schools. XVI-XVIII Century* (London, 1973).

355. A copy of the *Portrait of Bindo Altoviti* was acquired by the Havemeyers, more famous as collectors of the impressionists, directly from the Altoviti in Italy. Evidently, a century after the picture had been sold in 1808, the Altoviti were still claiming that they had the original (Louisine W. Havemeyer, *Sixteen to Sixty: Memoirs of a Collector* [New York, 1961], 128-129). The picture was auctioned at the American Art Association-Anderson Galleries, New York, on April 10, 1930, as lot no. 122. A variant of *Bindo Altoviti* belonging to Sydney M. Shoenberg was included in an exhibition of Old Master paintings from St. Louis collections (*Bulletin of the City Art Museum of St. Louis* 20, no. 3 [July 1935], 34, cat. no. 22 [illus.]). The picture was said to have been authenticated by Berenson, Fiocco, Suida, and Van Marle.

356. *Duveen Pictures in Public Collections of America: A Catalogue Raisonné with 300 Illus-*

trations of Paintings by the Great Masters which have passed through the House of Duveen (New York, 1941). The book sought to "emphasize to the public the tremendous strides which the collecting of masterpieces has made since the turn of the century."

357. Sydney Freedberg at first gave only the design to Raphael (*High Renaissance*, 1:338-339), though he now thinks the execution may also be by the master (*Painting in Italy*, 471, note 49). Pope-Hennessy attributes the picture unreservedly to Raphael (*Raphael*, 219), and it is so listed by Fredericksen and Zeri in their *Census*, 172. De Vecchi (*Complete Paintings*, no. 118) also gives the portrait to Raphael, though Dussler does not (*Raphael*, 66).

II Raphael's Creativity as Shown by His Paintings in America

HAVING CONSIDERED Raphael from the standpoint of taste and collecting, we now go on to explore certain of his paintings in America in the context of the period in which they were made. The first part of the exhibition showed the enormously high value American collectors placed on Raphael's pictures, the tangible product of his genius. But Raphael is no longer "the most famous name in Western art," and what we are primarily interested in today is the mind that lies behind and explains his achievement as a painter. Accordingly, the second part of the exhibition will examine the process that led up to the works on which Raphael's reputation was based.

A painting by Raphael is the product of a series of decisions. To appreciate fully a given work by him we must relate it to his visual experience and not merely describe what we see. An examination of the artist's own efforts—earlier paintings and preliminary drawings—as well as his understanding of other artists' works can reveal much about his creativity. Raphael's artistic thinking was partly intuitive, of course, and this aspect remains a mystery and cannot be demonstrated. But we can reconstruct in a limited way that part of his procedure which was conscious and deliberate.

The second part of the exhibition consists of a series of case studies of Raphael's creative process. In each instance a painting is juxtaposed with preparatory or related drawings and visual sources. The resulting comparisons provide an insight into the genesis of individual pictures, taken in chronological order. In one case, at least, that of the *Saint George and the Dragon*, the visual evidence is so abundant that we seem to be able to glimpse Raphael's mind at work. The heart of the matter lies in small but significant details.

Support for this approach, focusing on sources and preparatory drawings, is found in Vasari's *Life* of Raphael, where the painter appears as a diligent student of other artists' works. Vasari's characterization is not merely a literary device but contains an essential truth. Indeed, it has long been recognized that Raphael's capacity to learn from other artists was the foundation of his greatness. At the same time, he possessed powers of invention second to none. The drawings, in their sheer number and variety, demonstrate his search for perfection in working out a composition.

In adopting this problem-solving approach to Raphael's works,

we must bear in mind that the record is incomplete. There is seldom sufficient evidence to trace every stage in the evolution of a given painting. Often we must be content to discover hints about his methods. Furthermore, the nature of the exhibition, which includes only pictures from American collections which could be lent, imposes its own limitations. For purposes of comparison certain relevant works by Raphael and other artists, which do not appear in the exhibition, are included in the text.

Formation

What little we know about Raphael's beginnings comes chiefly from Vasari, whose *Lives* was first published in 1550, thirty years after the artist's death.[1] Born in Urbino on April 6, 1483, Raphael received his initial training, according to Vasari, from his painter father, Giovanni Santi. Recognizing his own limitations, Santi is said to have taken his son to study with Perugino, the leading painter in Central Italy. The young Raphael so completely absorbed Perugino's teaching that the works of the pupil could scarcely be distinguished from those of his master. Vasari goes on to enumerate four of Raphael's Peruginesque altarpieces. He first cites the *Coronation of the Virgin* painted for Perugia. Next follow the *Coronation of Saint Nicholas of Tolentino* and the *Crucifixion,* made for churches in the Umbrian town of Città di Castello. For Vasari, Raphael's youthful period culminated in the work in which he surpassed his master, the *Marriage of the Virgin,* painted for a chapel in Città di Castello when he was no more than twenty-one years old.

Perugino's importance for Raphael has never been doubted. But scholars have disagreed as to when their closest association took place. Vasari is often cited to support the view generally held today that Raphael entered Perugino's workshop early, while still under the guidance of Giovanni Santi or soon after his death.[2] Yet, in claiming that it was his father who placed Raphael with Perugino, Vasari was apparently unaware that Giovanni Santi died in 1494, when the boy was only eleven.[3] If we proceed from his account of the early works, it is clear that Vasari believed Raphael was most closely connected with Perugino during the years immediately preceding the *Marriage of the Virgin* of 1504. Therefore, the writer's remarks can be taken to support the view that Raphael continued in his father's workshop in Urbino until 1500 and then went to Perugia.[4] In this regard, it is significant that attempts to trace Raphael's hand in Perugino's works before 1500 remain unconvincing.[5]

Though the *Crucifixion* [52] in the National Gallery of Art is now admired as one of Perugino's masterpieces, it was wrongly believed to be a youthful work by Raphael until well into the twentieth century.[6] The painting (plate 7) was attributed to Raphael not because it

resembled his work in any significant way, but because it was felt to be too good for Perugino. Nevertheless, Perugino's authorship became clear when it was discovered that the donor of the triptych died in 1497. Raphael, then aged fourteen, could not have executed it. The style of the painting, moreover, points to an even earlier date in Perugino's oeuvre, about 1485.

Pietro Vannucci (probably 1445-1523), called Perugino, was the major artistic personality in Umbria until he was overshadowed by his famous pupil. After experiencing the tradition of Piero della Francesca, Perugino went to Florence where he enrolled in the painters' Confraternity of Saint Luke in 1472. Besides an unsurpassed technical skill, his early works reveal a complete grasp of the plastic style of Verrocchio. During a career that lasted more than half a century, Perugino made Florence, Perugia, and Rome the chief centers of his highly successful activity. The workshops he headed in Perugia and Florence produced innumerable pictures in his style, not all of which are by his own hand. As a religious painter, Perugino brought a heightened but gentle emotional quality to his works—an "aria angelica et molto dolce," as a contemporary put it.[7] Gradually, he gave up structural clarity to achieve a softer and more graceful style, one that corresponded better to the delicate introspective temperament of his figures. More and more generalized in shape and detached in mood, Perugino's saints finally seem to merge with their setting in an ethereal world of air and light.

The National Gallery *Crucifixion* exemplifies Perugino's Umbrian style. Static figures, symmetrically placed, are in harmony with their spacious landscape setting. The painting does not depict an actual event nor a specific place. It is rather a meditation upon the theme of the Crucifixion. Christ is raised high up on the cross, silhouetted against the sky. Both visually and symbolically he is above suffering, while the saints, though pensive, do not grieve. They contemplate the significance of Christ's sacrifice. The serene mood of the saints pervades the landscape as well. The whole tenor of the painting does not suggest conflict or violence—on the contrary, it seeks to dispel the anguish which the subject brings to mind.

In Perugino's *Crucifixion,* the pose of Mary Magdalene, with her hands clasped as she gazes up at Christ, is virtually the same as the prayerful attitude of Saint John. These figures and the others too, are all familiar in Perugino's oeuvre. For example, toward the end of his career, the master or a pupil repeated, almost without change, the mourners in the central panel of the triptych. Their tilted heads and clasped hands reappear in a pair of roundels (figs. 43, 44) from a late altarpiece, now in the Kress Collection at Raleigh.[8] Once in possession of a successful formula, Perugino was content to reuse it again and again.

As Raphael's youthful works became better known in this century, the *Crucifixion* was no longer included among them. Yet he did as-

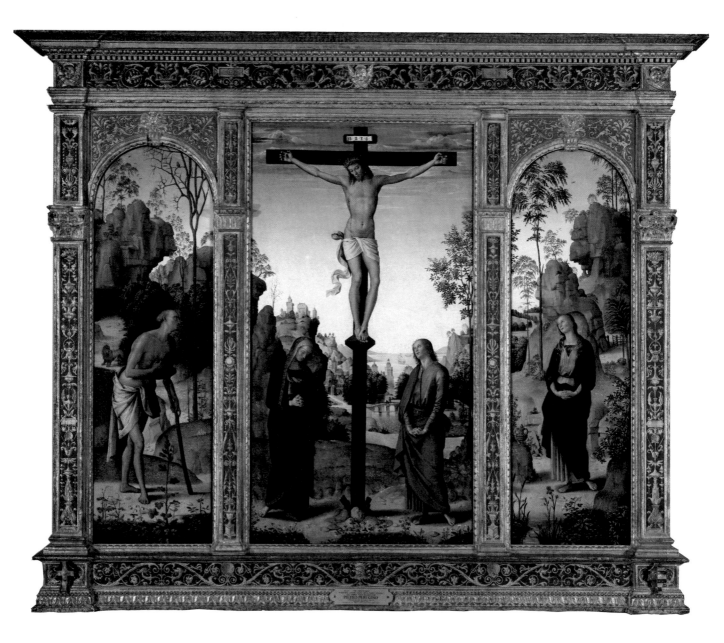

Plate 7. *Pietro Perugino,* Crucifixion with Saints. *National Gallery of Art, Washington, Andrew W. Mellon Collection, 1937.*

Left: *Fig. 43. Studio of Perugino,* The Mourning Virgin. *North Carolina Museum of Art, Raleigh, Gift of the Samuel H. Kress Foundation.*

Right: *Fig. 44. Studio of Perugino,* Saint John the Evangelist. *North Carolina Museum of Art, Raleigh, Gift of the Samuel H. Kress Foundation.*

similate the style of his master. Indeed, his own early version of the Passion theme, the large altarpiece known as the *Mond Crucifixion* (fig. 45), now in the London National Gallery, is deeply indebted to

Perugino's example.[9] Vasari said of this painting that without Raphael's signature, it would be taken for a work by his teacher.[10] Completed in 1503 for the church of San Domenico in Città di Castello, the altarpiece is Raphael's most Peruginesque production. Its principal source is Perugino's exactly contemporary painting of saints surrounding a carved wooden crucifix from San Francesco al Monte in Perugia.[11] The individual figures, their poses, gestures, and expressions, and the landscape in Raphael's painting are all derived from Perugino. The Madonnas are almost exactly the same. Since this Perugino prototype did not offer a suitable model for the crucified Christ, Raphael may have gone back to the Washington *Crucifixion*, then in San Gimignano, for the figure's pose.

One of the predella panels [53] from Raphael's altarpiece is in the North Carolina Museum at Raleigh.[12] The small painting (plate 8) depicts a miracle of Saint Jerome, in which the saint appears in the sky to prevent the beheading of a bishop. While the Christian kneels in preparation for martyrdom, his false accuser, the forger Sabinian, falls to the ground instead, miraculously beheaded.

Except for its simplified technique appropriate to a predella, the style of the *Saint Jerome* agrees with that of the *Crucifixion* originally above it. The conception of the predella also follows the larger panel. Aside from the similar landscape, the small tree in the center of the Raleigh picture echoes the cross in the *Crucifixion*, while the two figures kneeling and standing to the right of the tree recall the Magdalen and Saint John.[13] Indeed, the correspondence is so close that preparatory studies for the Magdalen, like one at Oxford showing a studio apprentice in contemporary dress, may even have served for the pose of the young man in the predella.[14] For these subdued figures in the predella Raphael employed Perugino's stereotypes. But for the others, fleeing in terror and dismay, he did not. The reason must be that Perugino's gentle manner was incapable of rendering effectively a violent subject such as Raphael was here called upon to portray.

At the time it was acquired in 1965, Raleigh's new Raphael displeased several museum trustees precisely on account of its gruesome theme.[15] Like *Tommaso Inghirami*, the painting simply did not look like a Raphael. It fell to a scholar to explain why so much had been paid for a seemingly marginal picture by the great master. Observing that this was Raphael's earliest small work of known date, Creighton Gilbert proposed that the influence of Luca Signorelli, as opposed to that of Raphael's teacher, Perugino, "throws much light on the reasons why this painting does not show, after all, the qualities of idealism and gracefulness that are commonly associated with the artist."[16] The more forceful works of Signorelli could well have provided a ready source of ideas and motifs. Several years before Raphael completed the *Crucifixion* for Città di Castello, Signorelli had worked in that town. And Raphael is known to have copied one of the pictures he left there.[17] Raphael therefore seems to have taken Perugino as a

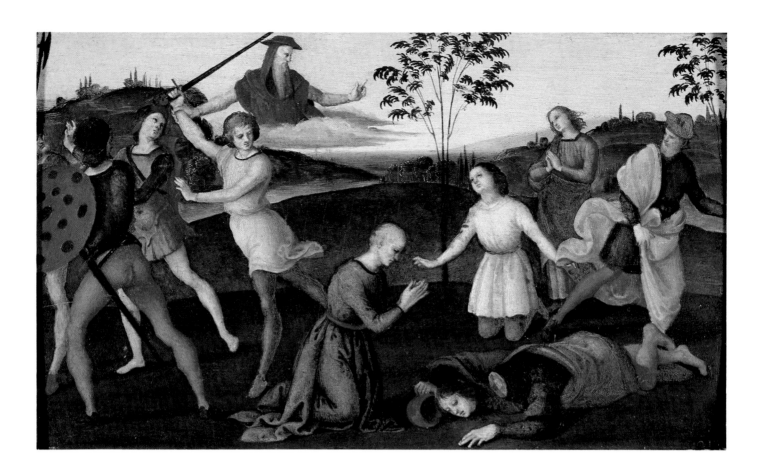

Plate 8. Raphael, Saint Jerome Punishing the Heretic Sabinian. *North Carolina Museum of Art, Raleigh.*

model for the passive figures in his picture and Signorelli for the more active ones fleeing the scene of punishment, thus demonstrating considerable sophistication in his use of sources.

Although he followed Perugino's example in the *Crucifixion,* Raphael was freer to try out his own ideas in the less noticeable area of the altarpiece represented by the predella. The diminutive scale of the work may actually have encouraged him to experiment. The most remarkable result of his freedom to invent is the executioner, whose pivoting action looks forward to Raphael's small *Saint Michael* in the Louvre.[18] But such originality on the part of a young artist had its risks as well. The incompletely resolved relation between the figures in the predella caused some early critics to doubt that it was by Raphael.[19] In fact, the picture was not composed by the standards of Raphael's later work, but is made up of individually studied figures which look as if they had been brought together from his drawings.[20]

❋ ❋ ❋

A SECURE BASIS for understanding the early phase of Raphael's career is established by the *Crucifixion* of 1503 and its predella, as the altarpiece is the first work to be signed by him. The first documented work, the now fragmented *Saint Nicholas of Tolentino* for Città di Castello, dates from 1501.[21] This earlier altarpiece is also related to Peru-

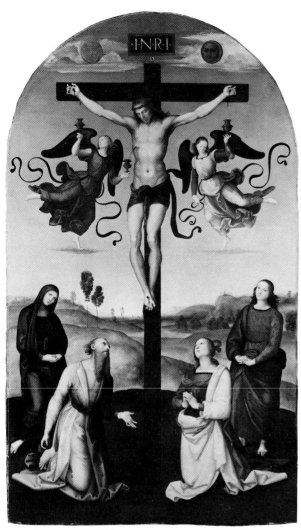

Fig. 45. Raphael, Crucifixion with the Virgin Mary, Saints and Angels (Mond Crucifixion). *The National Gallery, London.*

gino, but only in a general way for its design and scarcely at all in color and handling. It suggests that Raphael's close association with the older master was still to come. Raphael shared the commission and presumably the execution of the altarpiece with a former assistant of his father named Evangelista da Pian di Meleto. The context for the painting's style is the milieu of Urbino.

The civilized life of the Urbino court was famous throughout Italy. And the city's cultural climate undoubtedly had a lasting impact on Raphael. According to Vasari, Raphael painted three pictures for Duke Guidobaldo da Montefeltro, who maintained the glory of the court until his death in 1508.[22] Guidobaldo's wife, the Duchess Elisabetta Gonzaga, is said to have been another early patron.[23] Later in Rome the artist was on familiar terms with the luminaries of the Urbino court at the time of his service there. Proof in painting of Raphael's involvement with the ducal family is the series of portraits he made of them.

One of these portraits is the *Emilia Pia* [54] in the Baltimore Museum of Art.[24] Like the *Saint Jerome* in Raleigh, the *Emilia Pia* (plate 9) is a modern rediscovery. The painting turned up on the Vienna art market in the early 1920s. Despite its damaged condition, Georg Gronau recognized the picture at once as the work of the young Raphael.[25] Recommended by Berenson as "one of Raphael's highest achievements," the panel was purchased by Kleinberger Galleries in New York. The dealer then offered the painting to Jacob Epstein (1864-1945), a Baltimore businessman, philanthropist, and collector. Epstein had followed the usual pattern of American collectors by initially acquiring fashionable painters. Only in the 1920s, when a new museum was being realized for Baltimore, did he turn to the Old Masters.[26] As there was no portrait by Raphael in America, Kleinberger claimed, the acquisition would "create the greatest possible sensation." Epstein bought the picture in 1925 and bequeathed it to the Baltimore Museum of Art.[27]

The sitter of the portrait has been identified as Emilia Pia da Montefeltro on the basis of an old inscription formerly on the back of the panel. In addition, the same strong features of the woman in the painting are found in a bronze medal of Emilia (fig. 46) by Adriano Fiorentino.[28] The youngest daughter of Marco Pio, ruler of Carpi, Emilia married Antonio da Montefeltro, half brother of Duke Guidobaldo, in 1487. After her husband's death in 1500, Emilia remained at the court of Urbino, where she died in 1528.[29]

The identity of the sitter is not in doubt, but the attribution of the painting is controversial. The uncertainty is partly due to its condition. The face alone is well preserved. The woodenly painted costume, which detracts from the picture, appears incongruous. And technical examination has confirmed that the dress and veil were modified and extensively repainted. Thus, only the face should be taken into account in determining Raphael's authorship.

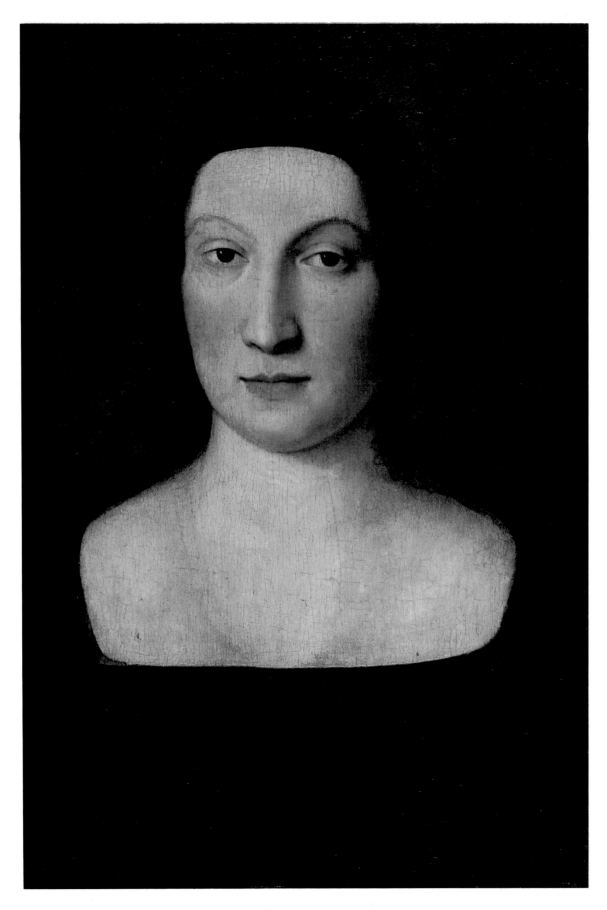

Fig. 46. Adriano Fiorentino, Medal of Emilia Pia.
Museo Nazionale del Bargello, Florence.

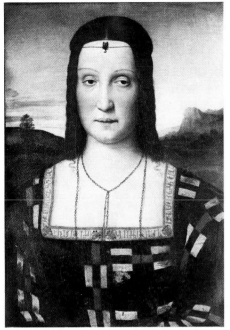

Fig. 47. Raphael, Portrait of Elisabetta Gonzaga.
Galleria degli Uffizi, Florence. Alinari/Editorial
Photocolor Archives.

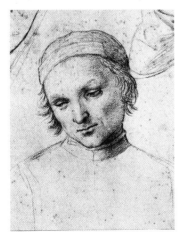

Fig. 48. Raphael, Study for the Head of God the
Father or Saint Nicholas (detail). Musée des Beaux-
Arts, Lille.

Left: Plate 9. Raphael, Portrait of Emilia Pia. The
Baltimore Museum of Art, The Jacob Epstein Collection.

From the time the painting came to light, it was compared to the better known portraits of Guidobaldo da Montefeltro and Elisabetta Gonzaga (fig. 47), given to Raphael, in the Uffizi.[30] The *Guidobaldo* may be excluded from the group, as it differs in size and support from the other two. Most scholars have concluded that the two female portraits were painted by the same artist and in the same period, based on similarities in conception, style, and technique.

Gronau compared the frontal pose and expression of the sitters to ascribe both portraits to Raphael. Ursula Schmitt agreed with Gronau's comparison but rejected his attribution.[31] She claimed that the portraits lacked the nobility of Raphael's style and that they were not sufficiently idealized. The realism Schmitt saw in the paintings led her to give them to Francesco Bonsignori, a favored portraitist at the court of Mantua. The Bonsignori attribution has been denied by Raphael scholars, with the exception of Luitpold Dussler. He observed, correctly in my opinion, that no affinities with Raphael's Peruginesque early works can be found.[32]

The paintings manifest a straightforward realism untypical of the young Raphael in the period 1502-1504. They cannot date from that time. Nevertheless, they are undeniably Raphaelesque, as we see by comparing the face of the generally accepted *Risen Christ* of about 1505 in Brescia. The portraits and the *Christ* are similar, but in facial type and expression, not in style. If the *Emilia Pia* had been painted at that time, as has been suggested,[33] it would be stylistically more advanced.

The *Emilia Pia* is by Raphael, in my opinion, but it must belong to the period which precedes his association with Perugino. The evidence for attributing the portrait to the very young artist is provided by a drawing (fig. 48) at Lille for the documented Saint Nicholas altarpiece of 1500-1501.[34] The drawing, a detail study for the head of God the Father or Saint Nicholas in the altarpiece, makes an apt comparison, since it is also a kind of portrait, recording the features of a model in the workshop. Both the painted portrait of Emilia and the likeness of the youth in the drawing display the same combination of restrained expression, careful rendering of form, and underlying clarity of structure.

A very early date, about 1500, would explain why the *Emilia Pia* and the *Elisabetta Gonzaga* have seemed to stand outside Raphael's oeuvre. In his development, they should be placed before such Peruginesque productions as the London *Crucifixion*, which they do not resemble. Datable around the turn of the century, perhaps before Raphael left Urbino, the portraits exhibit a somewhat archaic style, but one appropriate to the time and place in which they were produced.[35] Significantly, the influence of Piero della Francesca was detected by Berenson and others in these stern, almost hieratic likenesses.[36] The young Raphael is likely to have received such an influence, not only from Piero's pictures in Urbino, but also from

Fig. 49. X-radiograph of the Portrait of Emilia Pia. *The Baltimore Museum of Art.*

their reflection in the work of his father.

A date for the portrait of about 1500 agrees with the apparent age of the sitter, who was born in 1471. The circumstance that in August 1500 Emilia became a widow may also have a bearing on the precise dating and authorship of the painting. In the present state of the picture she appears in the black dress and veil of a widow. This would suggest a date after her husband's death. Nevertheless, as already mentioned, technical evidence [55] indicates that the costume was altered. The x-radiograph (fig. 49) shows that the bust of the sitter was originally covered with a V-shaped bodice or ornament. The thinly repainted shoulder areas appear dark in the x-radiograph, suggesting that the original ground layer was removed. The area of the throat and neck is intact, however, and shows up lighter. Likewise, the dark area of the forehead indicates that here too the original design and ground layers were replaced. The dress and the veil in their present form have been considered the work of a modern restorer attempting to cover abrasion. But they are more likely to be modifications, not restoration. Possibly, the garment was altered in Emilia's lifetime, after she became a widow in 1500, to allude to her changed status. Originally, the costume may have resembled the elaborate dress and coiled hair we see on her medal. The clumsy alteration is probably due not to Raphael but to some other less skillful Marchigian painter. Disconsolate at her husband's death, Emilia afterwards remained faithful to his memory. Her devotion is celebrated on the emblematic reverse of her medal, which features a pyramid bearing an urn with the inscription: CASTIS CINERIBUS. It has been suggested that the reverse of Emilia's medal was reworked to refer to her widowhood.[37] In a different way her painted portrait by Raphael also seems to have been updated.

Emilia Pia is remembered primarily for her role in Baldassare Castiglione's famous *Book of the Courtier.* Indeed, Berenson suggested to Epstein that, having purchased the portrait of Emilia, he would enjoy reading about that "fascinating Renaissance Court Lady" in the book. And we would do no less well to compare Castiglione's treatment of Emilia with Raphael's. Though the discussions about the perfect courtier and court lady which make up the *Courtier* are imaginary, the speakers themselves are vividly characterized. In narrating their remarks and behavior, Castiglione took into account their individuality as he remembered it. The literary likenesses add a realistic note to what he pointedly called his "portrait of the Court of Urbino."[38] In the book the duchess Elisabetta deputizes Emilia to lead the discussions. Their pairing in the *Courtier,* like their companionship in life, suggests that the striking resemblance between their painted portraits is not accidental. As an aristocrat with a humanistic education, Castiglione was among equals at the court of Urbino. He felt free, therefore, to show the human side of Emilia, which he knew very well. In the *Courtier* she is remembered as vivacious and witty.

Castiglione's characterization of Emilia Pia's animated personality contrasts with the stiff pose and serious expression of Raphael's portrait. The difference may reflect the fact that Emilia was a very recent widow, mourning her husband, if the picture dates from after, rather than before 1500. But the painted likeness of Emilia, like that of the duchess Elisabetta, also conforms to portrait types current in Mantua and Urbino at the end of the century. By that time, the earlier profile portrait had been largely superseded by a frontal design. Already in Laurana's posthumous marble bust of Battista Sforza (died 1472) in the Bargello, Florence, we encounter the full face.[39] It has the same erect quality as the portraits of Emilia and Elisabetta. Several of Gian Cristoforo Romano's sculpted portraits, done for the Mantuan court in the 1490s, are also frontal.[40] Equally close in type to the *Emilia* and the *Elisabetta* are portraits, drawn or painted, by Francesco Bonsignori.[41] Giovanni Santi had been asked to paint a likeness of the duchess Elisabetta, which he was unable to complete.[42] When Elisabetta turned from the father to the son for her portrait, the younger painter adopted the customary frontal pose for he had, in a sense, inherited the commission.

As for the restrained expression in Raphael's early attempts at portraiture, decorum dictated a certain reserve. Even so, the painting in Baltimore seems to lack the confidence that came from the familiarity the artist had with his later sitters. Raphael, we know, was greatly impressed by the eminent personages of the court. His attitude toward the rulers of Urbino, as we find it in his letters, betrays a genuine deference. For its part, the ducal family seems to have regarded Raphael as his father's son, even after he became prominent. Thus, the "discreet and gentle youth" to whom Giovanna della Rovere, the duke's sister, referred in 1504, may well have felt some hesitation when, as a young and little known artist, he was asked to paint the portraits of the duchess Elisabetta and the equally formidable Emilia. Perhaps the sitters' air of aloofness was the way they appeared to Raphael.[43]

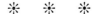

WE HAVE SEEN that as a young artist Raphael conformed to established artistic conventions and to the taste of his patrons. At this stage his originality was expressed in details rather than in the overall conception and style of his paintings. A related but slightly later example [56], which raises additional questions, is the predella panel (plate 10) from the Colonna altarpiece in the Metropolitan Museum.[44]

Here Raphael treated the subject of the Agony in the Garden. To portray this scene of inner conflict he followed the pictorial tradition of contrasting the figure of Christ, kneeling in prayer before an angel, with those of the three sleeping apostles. The drama is further heightened by placing the figures against a landscape lit by the dawn.

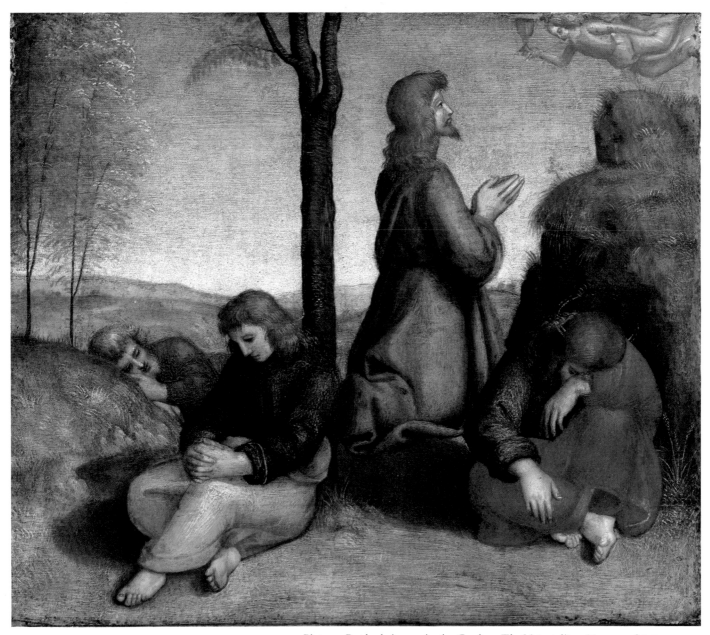

Plate 10. Raphael, Agony in the Garden. *The Metropolitan Museum of Art, New York.*

Despite its achievement of a genuinely evocative mood of reverie, the painting has occasionally been attributed to the hand of an assistant working from Raphael's design.[45] The probable reason is that the free brushwork of the little panel, which has the spontaneity of a drawing, did not appeal to early critics.

One writer censured as well the awkward figure of the angel presenting the chalice to Christ.[46] This motif was not part of the original conception, however. We know this from the damaged cartoon (fig. 50) or preparatory drawing of exactly the same size, which is in the Morgan Library.[47] Except for one or two details the painting follows

Fig. 50. Raphael, Cartoon for the Agony in the Garden. The Pierpont Morgan Library, New York.

Fig. 51. X-radiograph of the Agony in the Garden. The Metropolitan Museum of Art, New York.

Fig. 52. Florentine Engraver, Agony in the Garden. The Cleveland Museum of Art, Dudley P. Allen Fund.

the contours, pricked for transfer, in the cartoon [57]. Instead of the angel in the painting, a chalice rests on a hillock in the upper right in the drawing. As it was originally intended, the motif of the chalice appears to fit the restricted format of the predella better than the figure of the angel we see now. Raphael transferred it, along with the rest of his design, onto the panel, as we can determine from an x-radiograph (fig. 51) of the painting. The x-radiograph [58] reveals a cup underneath the present surface of the painting, in the same position as it is in the drawing. Nevertheless, despite its greater suitability for the composition, the chalice was replaced in the completed work by an angel. Since the change did not result in an improvement in the design and was thus presumably not an aesthetic decision, why was the substitution made?

The change may have been imposed on the artist by his patrons, who perhaps desired a more traditional iconography. In asking Raphael to substitute the angel for a chalice, if they did so, the nuns of Sant'Antonio were requiring him to conform to the more customary treatment of the scene.[48] This iconography is well represented in an anonymous Florentine engraving (fig. 52) of the later fifteenth century.[49] It is even possible that for the figure of Christ, kneeling in profile to the right with upturned head, and the angel above him, Raphael was enjoined to follow the example of the engraving [59] or a design like it. Though the apostles differ in the print and the painting, the figure of Christ is similarly shown between a tree and hillock.

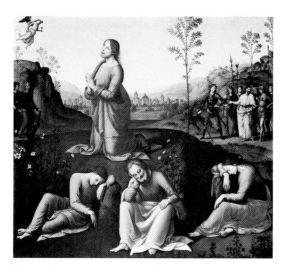

Fig. 53. Lo Spagna, Agony in the Garden. *The National Gallery, London.*

Fig. 54. Pietro Perugino, Agony in the Garden. *Galleria degli Uffizi, Florence.*

An Umbrian painting by Raphael's contemporary Lo Spagna (fig. 53), in the National Gallery in London, also features the angel.[50] Lo Spagna's model was evidently Perugino's version of the theme for the convent of San Giusto in Florence (fig. 54), now in the Uffizi.[51] Details like the profile pose of Saint John or the head of Saint Peter indicate that Raphael, too, looked to this altarpiece by Perugino as a prototype. Taken together, the engraving and the paintings by Perugino and Lo Spagna indicate how the nuns of Sant'Antonio would have expected the subject to be portrayed. Moreover, the comparison with Perugino's altarpiece clearly shows that, to be effective, the motif of the chalice-bearing angel needed ample space. Lo Spagna was free to solve the problem by drastically reducing the scale of his angel. The design of Raphael's predella panel, on the other hand, was already complete. Thus he, or possibly even another artist, was called in to paint the angel over the chalice in a space too narrow for it. The challenge was how to paint an aesthetically satisfying picture, given the requirements of his patrons. Having acceded to their wishes and inserted the angel in a space inadequate for it, Raphael tried to repair the damage by balancing the angel with some feathery trees, which he painted with the lightest touch over the sky on the left. The trees were not part of his original conception, as they do not appear in the preliminary cartoon, nor in the x-radiograph. He even highlighted the foliage with the same pink color he had used for the angel's tunic.

The *Agony in the Garden* was a traditional religious picture for a convent church in Perugia. The predella panel, like the whole altarpiece to which it belonged, was "full of devout feeling," according to Vasari, and was "held in the utmost veneration by the nuns" for whom it was painted.[52] In describing the main panel of the altarpiece (fig. 33), Vasari singled out for comment the fact that the Christ Child is fully dressed. He plausibly attributed this unusual feature to the preference of the "simple and pious" nuns. Thus it would appear that the nuns of Sant'Antonio obliged the painter in both the main and predella panels to conform to their own conservative taste.

The commission of Raphael's altarpiece does not survive, so we cannot be sure of the conditions it set for him. Nevertheless, I believe that the conservative features of the iconography of the painting—the chalice-bearing angel of the predella and the dressed Christ Child—may be explained, as Vasari implied, as concessions to the nuns who ordered it. It has often been claimed that the altarpiece was begun before Raphael went to Florence in 1504 and that it was finished later.[53] But there is no technical evidence to suggest that it was conceived and executed in two stages. On the contrary, the paint surface is entirely uniform. Coexisting with features of a traditional cast are more advanced ones. For example, the grandeur of the figures of Saints Peter and Paul in the main panel has been repeatedly attributed to the influence of Fra Bartolomeo.[54] But, as Konrad Oberhuber has shown, the saints have nothing to do with that artist.[55] What

Fig. 55. Raphael, Agony in the Garden *(detail). The Metropolitan Museum of Art, New York.*

they do resemble are the monumental male figures which close the composition of Leonardo's *Adoration of the Magi,* today in the Uffizi.⁵⁶ Raphael's Saints Peter and Paul were painted after he had gained his first impressions of Florentine art. At this transitional stage in his development, however, his awakening to Leonardo is not yet an integral factor in his style, which remains basically Umbrian.

Like the main panel of the altarpiece, the *Agony in the Garden* combines seemingly incompatible elements. We have seen how Raphael was obliged to substitute the iconographically correct angel for the compositionally better suited cup in his painting. The nuns did not object, however, to a genuinely remarkable feature, the pose of the sleeping apostle (fig. 55) on the right. Lo Spagna had followed Perugino in showing the corresponding figure in profile. Raphael's disciple, however, is an experiment in foreshortening. Here, as in the *Saint Jerome* predella, Raphael inserted an innovative figure of his own creation within a design that remains largely traditional. His solution in each case is not only a compositional device but also contributes to the meaning of the picture. In the *Agony in the Garden,* the disciple on the right sinks into an unconscious state, unaware of his master's anguish. The other recumbent figures, too, though they were borrowed from Perugino, have been adapted so that they seem convincingly asleep, lying against a tree and a hill.

Florence

To learn and to perfect his art Raphael went to Florence toward the end of 1504. So states a letter of October 1 of that year, in which Giovanna della Rovere, sister of the Duke of Urbino, recommended the young painter to Piero Soderini, head of the Florentine government.⁵⁷ Raphael had probably been in Florence before, traveling with Perugino on various occasions. But this date marks the beginning of an extended residence in the city, interrupted only by periods in Perugia and Urbino. The letter of recommendation implies, moreover, that Raphael had already become acquainted with Florentine art and had been impressed by it. Nevertheless, nothing in Raphael's work to date betrays the decisive impact that Florence, the city and its art, would have on him. In particular this is true of Leonardo. The fugitive Florentine echoes that can be found in Raphael's early works are better explained, perhaps, as the result of his association with Perugino, who was trained in Florence. The important point is that Florentine art began to have a significant effect on Raphael's work only after he had an opportunity to study it in depth and after he was prepared to understand it.

Vasari grasped the crucial importance of Florentine art for this period of Raphael's career when he wrote in the *Lives* that "after Raphael had been to Florence, he is known to have much changed and im-

proved his manner, from having seen the many works by excellent masters to be found in that city. . . ."[58] Vasari might have been describing the predella panels of *Saint Jerome* and of the *Agony in the Garden* when he said that "Raphael had imitated the manner of his master, Pietro Perugino, but had greatly ameliorated the same." Nevertheless, on "becoming acquainted with the works of Leonardo da Vinci . . . Raphael stood confounded in astonishment and admiration: the manner of Leonardo pleased him more than any other that he had ever seen, and he set himself zealously to the study thereof with the utmost zeal; by degrees therefore, abandoning, though not without great difficulty, the manner of Pietro Perugino, he endeavored as much as was possible to imitate that of Leonardo."[59]

If success involves a coincidence of talent and opportunity, a pupil of Perugino could hardly have chosen a less auspicious moment to come to Florence. By late 1504 Perugino's reputation had begun to decline. Less than a decade before, in 1496-1497, Ludovico Sforza, Leonardo's patron, had tried to lure Perugino to Milan, esteeming him as one of the leading painters of the day.[60] And four years later, when Raphael went to study with Perugino, the younger artist's patron-to-be, Agostino Chigi, called Perugino, without qualification, the best master in Italy.[61] Another North Italian ruler, Isabella d'Este had likewise asked Perugino to provide an allegory for her *studiolo* in Mantua. But when, after long negotiations and delays, the painter's contribution was finally delivered in 1505, it did not compare favorably.[62] Taste was changing. In the very same year, Perugino's double-sided altarpiece for the Florentine church of SS. Annunziata aroused criticism for its lack of originality.[63] We can imagine the dismay Raphael must have felt when his master's work was ridiculed and when Perugino himself was forced to withdraw from the Florentine arena of the arts.

The *Small Cowper Madonna* [63] (frontispiece and fig. 56) in the National Gallery is one of Raphael's first Florentine works.[64] To judge from its style and sources, he must have painted it within months of his arrival in the city late in 1504. The picture clearly demonstrates his intention to improve his art, as stated both in the letter of Giovanna della Rovere and the biography of Vasari. Compared with the artist's previous productions, the *Madonna* displays a greater solidity of form, a more fluid, tightly knit composition, and a convincing integration of figures with their landscape setting.

Raphael's original spatial conception for the painting is now visible as a result of the recent cleaning. Previously, darkened varnish and extensive repaint combined to give the panel a markedly different appearance. The chief revelation of the cleaning is the existence of a parapet behind the figures. Earlier, a dark shape, perhaps meant to represent a hill or a cloth backdrop, divided the composition horizontally. It also considerably flattened the design. Evidence, both literary and visual, had indicated that the dark area was painted over a stone para-

Fig. 56. Raphael, Small Cowper Madonna. *National Gallery of Art, Washington, Widener Collection, 1942.*

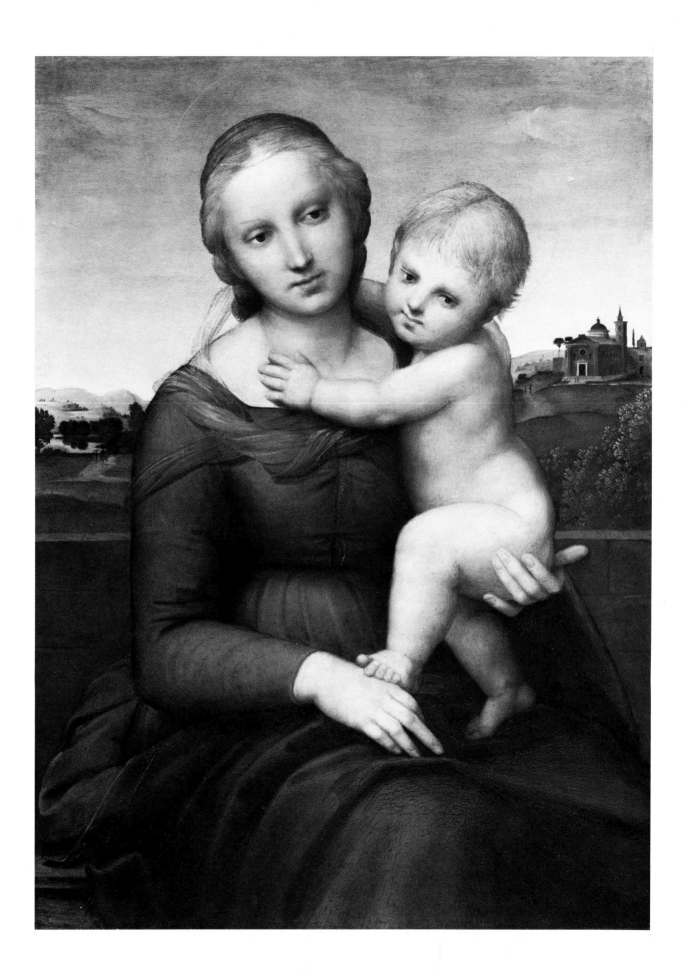

Fig. 57. Contemporary copy of Raphael's Small Cowper Madonna. *Present whereabouts unknown. Photograph Courtesy of the Photographic Archives of the National Gallery of Art, Washington.*

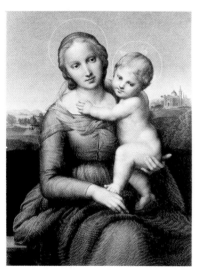

Fig. 58. Eduard Mandel, Engraving after the Small Cowper Madonna. *National Gallery of Art, Washington.*

pet. Early descriptions of the picture place the Madonna and Child "near" or "before" a wall.[65] The wall figures too in early reproductions of the painting.[66] An analogous use of such a structure by Raphael is found, moreover, in the contemporary *Terranuova Madonna* (fig. 61) in Berlin. Most important, an old copy of the National Gallery painting (fig. 57) displays the horizontal ledge.[67] By 1871, however, when Eduard Mandel reproduced the picture [60] in an engraving (fig. 58), the parapet had disappeared.

This evidence led to the decision to remove the repaint, which turned out to contain bitumen, a pigment not commonly found before the eighteenth century. From under the flat and opaque layer the parapet reappeared. In its cleaned state, the gray of this structure distinguishes it from the Virgin's seat, painted in a warm brown tone. The ledge is further given a marked three-dimensional character by the individual blocks of stone which make it up and by its light-colored top. The reemergence of the parapet after more than a century restores to the painting Raphael's desired effect of depth and recession. The wall serves not only to set the figures off, but also, by its foreshortening, to link them to the landscape.[68]

The recent cleaning has also brought to light the subtlety and brilliance of Raphael's color. We can now appreciate details that were formerly obscure, like the sunlight on the distant hills and the yellowish tinge of the Virgin's veil. In addition, the treatment confirmed that the picture is for the most part in good condition, as was noted already by writers in the 1830s.[69] The same critics observed the summary execution of the flesh tones visible again as a result of conservation.[70] The flesh tones and hair appear somewhat abraded. But they also do not seem to me to have been entirely finished. It was presumably to disguise their incomplete or abraded state that a heavy varnish was applied. With the old varnish removed, the pigment layer in some areas is so transparent that the preliminary drawing may be seen. Almost resembling hatchings, the fluid paint application in the *Small Cowper Madonna* contrasts with more densely structured layers in works otherwise comparable in style, like the *Madonna of the Meadow* (fig. 63) dated 1505 or possibly 1506, in Vienna.

Now that the *Small Cowper Madonna* has been restored to an approximation of its original beauty, we can better assess its nature. It is transitional, betraying a divided allegiance between Raphael's Umbrian beginnings and his new experience of Florentine art. In part the painting continues to recall precedents by Perugino [61], like the exactly contemporary *Madonna and Child* (fig. 59) in the National Gallery.[71] Both pictures are of the same type, showing the three-quarter-length Madonna seated before a landscape. Raphael also retained facial features from the older master, in addition to attitudes and gestures such as the graceful turn of the heads with their wistful sentiment. In each case, too, the Madonna wears a transparent veil winding about her bust.

Fig. 59. Pietro Perugino, Madonna and Child. *National Gallery of Art, Washington, Samuel H. Kress Collection, 1939.*

In spite of these similarities of type and motif, the two paintings differ significantly. Unlike the dress of Perugino's Madonna, for example, that of Raphael is close to contemporary feminine attire. And Raphael's setting likewise has the sense of a particular identity. Perugino's landscape, with its soft blue-green valley, gold-dotted trees, and hills sloping to meet the Virgin's shoulders, is a pleasing foil to his figures. But, as the little tower shows, it is purely imaginary. By contrast, the church on the hill in the *Small Cowper Madonna* is so individual that it has been taken to represent an actual structure.[72]

The fundamental difference between the two Madonnas lies in the way they are composed. Perugino followed his usual method of repeating motifs he had used previously, without regard to their new context. Thus the Child as he appears here is found in almost exactly the same pose both earlier and later in the artist's work.[73] In this case, though, the posture of turning to look over his shoulder is unmotivated, and his hand gestures are meaningless. The mannered hands

Fig. 60. Luca della Robbia, Madonna and Child. *Museum of Fine Arts, Boston, Gift of Quincy A. Shaw through Quincy A. Shaw, Jr., and Mrs. Marion Shaw Haughton.*

of the Madonna and her inclined head are likewise workshop properties, recurring in Perugino's oeuvre.[74] Even before he came to paint the *Small Cowper Madonna,* the young Raphael had examined critically his master's method of self-borrowing. In the *Solly Madonna* of about 1503, in Berlin, he adopted the Perugino formula but provided a motivation for the glances and gestures of his figures.[75] The Madonna and Child look at a book. And the Child now holds a goldfinch tethered to his finger.

In the *Small Cowper Madonna* Raphael integrated the figures by having them both look out of the painting. The directness of their glances, engaging the viewer, is the equivalent, psychologically speaking, of the convincingness of their forms. Yet even this aspect of Raphael's image, so apparently lifelike, has an artistic source, in the work of the great Florentine sculptors, especially Luca della Robbia.[76] From childhood Raphael knew a lunette by Luca in Urbino.[77] And when he came to Florence he would have encountered innumerable half-length Madonna reliefs in enameled terracotta [62] from the della Robbia workshop. In one of these reliefs (fig. 60) by the master himself, in Boston, the Madonna holds the Child on the right, as in Raphael's painting, while he affectionately places his arms around her neck.[78] The glances of the figures in the relief are similarly directed toward the viewer, though Luca's are more sharply focused. Raphael evidently perceived a lack of psychological coherence in Perugino for which he found a remedy in Florentine sculpture.

In creating the *Small Cowper Madonna,* Raphael thus turned to the tradition of Florentine art. He discovered a far more advanced source than Luca della Robbia, however, in Leonardo da Vinci. Newly returned to Florence from Milan, Leonardo was revolutionizing the whole art of painting. As Vasari suggested, the older master's impact on Raphael was both immediate and long lasting. There can be no doubt about the importance Leonardo had for the *Terranuova Madonna* (fig. 61), which may precede the National Gallery painting among Raphael's first Florentine works. It has been repeatedly noted that the Virgin's face and left hand were taken over from Leonardo's *Madonna of the Yarnwinder* (fig. 62) of 1501, now lost but known from copies.[79] Raphael's *Madonna of the Meadow* (fig. 63) in Vienna includes the same kind of literal borrowings that characterize the *Terranuova.*[80] The kneeling Baptist, for instance, with his curly hair, was derived from the *Virgin of the Rocks,* as was the Madonna's hand on the Christ Child's back. Though Leonardo's altarpiece was painted for Milan, Raphael might have known the composition in Florence in the form of preliminary drawings or copies.[81] Yet another Leonardo model, the *Virgin and Child with Saint Anne* (fig. 64), in the Louvre, provided the right arm of Raphael's Madonna.[82] The same source lies behind the most explicit of all these derivations, the Madonna's extended right foot.[83]

The *Small Cowper Madonna* belongs to the stage in assimilating

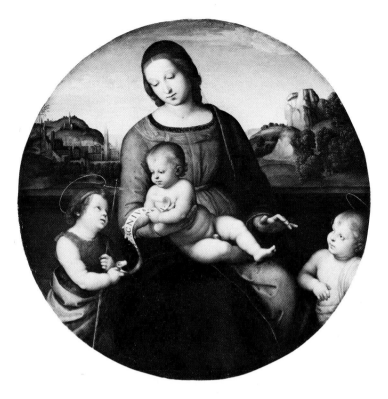

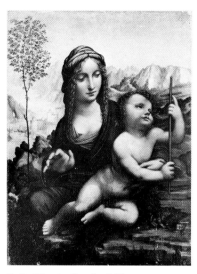

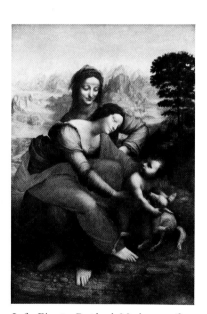

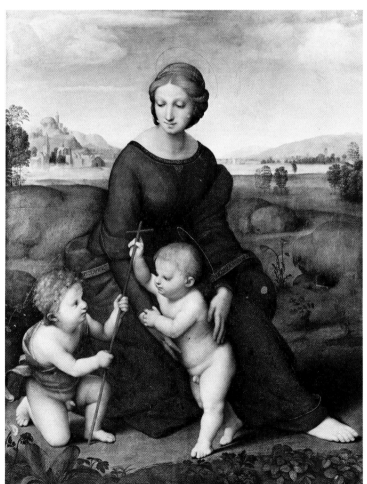

Leonardo's art that is represented by the *Madonna of the Meadow*, and the same models lie behind both pictures. The *Saint Anne* may have suggested the loop of drapery that encircles the Virgin in the National Gallery picture, her robe having fallen from her shoulders. The way the drapery lies on the stone bench on which she is seated points to Leonardo's early *Benois Madonna*, in Leningrad. Raphael used the looped drapery to form one corner of the base of a pyramidal figure group, just as he did the motif of the foot derived from Leonardo in the *Madonna of the Meadow*. Likewise, Mary's right hand, much admired by early writers on the painting,[84] is a direct quotation from *Mona Lisa*.

At this stage in his development, Raphael used his newly acquired knowledge of Florentine art, and of Leonardo in particular, mainly to revise the manner he had learned from Perugino. Raphael's Madonna, for instance, retains some of the older master's wistfulness at the same time that her head and features are cast in a Leonardesque vein. The *Small Cowper Madonna* does not represent a break with tradition. Rather, Raphael attempted to integrate two or three different styles. The originality of the picture lies in the way the young artist combined sources so that they complement each other. The painting reveals his unprecedented ability to analyze visual prototypes and to take from each exactly what he needed. This method corresponds to Vasari's description of how Raphael worked later in his career.[85]

No preparatory drawings for the *Small Cowper Madonna* are known to have survived.[86] Nevertheless, incised contours of the halos and the parapet may be seen on the surface of the painting. And an underdrawing [64] is partly visible in the flesh tones. Technical examination with the aid of an infrared vidicon has revealed the presence of the drawing (fig. 65) in other areas as well. In this process infrared light penetrates to the picture ground where it can detect an underdrawing. The impression such a drawing makes, registered on a screen, is called a reflectogram. In this case, the reflectogram shows that the contours of the figures in Raphael's painting were loosely sketched in black chalk on a white ground. This design and the completed painting agree, except for the transparent veil over the Virgin's bodice, which in the drawing was placed somewhat lower. In its succinct definition the image revealed by the reflectogram resembles Raphael's independent sketches. Evidently it served as a compositional guide once the design had been transferred (by pricking the outlines of a cartoon) on to the panel.

The *Small Cowper Madonna* has always been considered close in style and composition to the *Granduca Madonna* (fig. 66). A drawing by Raphael (fig. 67), a preparatory study [65] in black chalk for the Pitti painting, helps to clarify the relation between the two pictures.[87] Heretofore the *Granduca Madonna* has been regarded the earlier of the two.[88] The drawing suggests otherwise. The figures in the sketch are shown against an open landscape, as in the *Small Cow-*

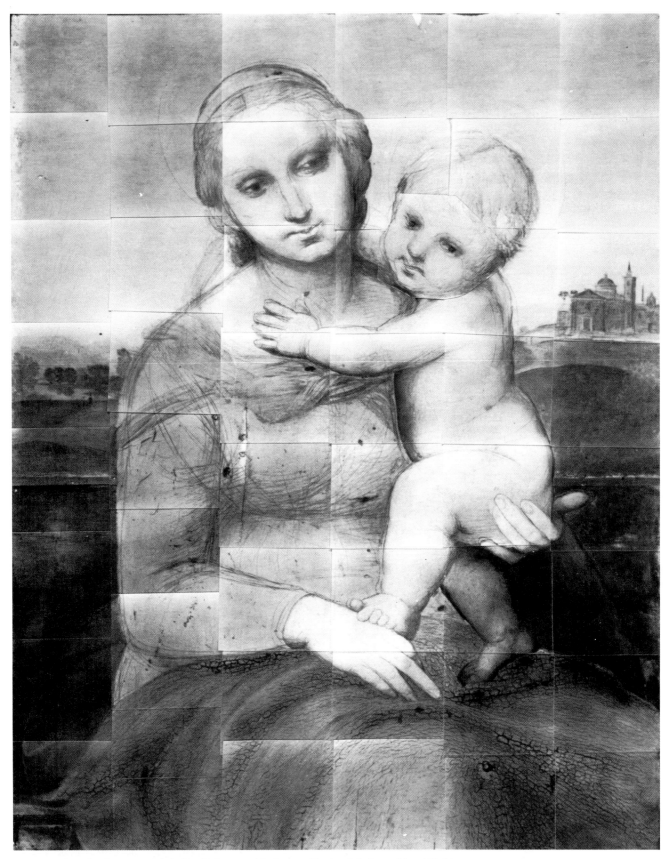

Fig. 65. Infrared reflectogram of the Small Cowper Madonna. *National Gallery of Art, Washington.*

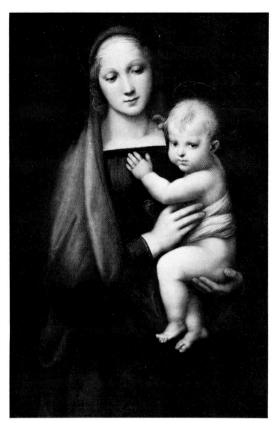

Fig. 66. Raphael, Granduca Madonna. *Galleria Pitti, Florence.*

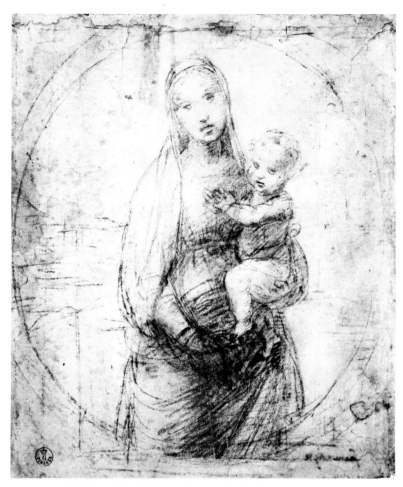

Fig. 67. Raphael, Study for the Granduca Madonna. *Gabinetto Disegni e Stampe degli Uffizi, Florence.*

per Madonna. Also closer to the National Gallery painting is the way the Madonna holds the Child, with her right hand lowered to support his foot. Moreover, the Child's right leg, even though it hangs free, recalls the standing position in the *Small Cowper Madonna.*[89] In the Pitti painting the Christ Child's legs are brought closer together. Thus, the drawing seems to have been made between the *Small Cowper Madonna* and the *Granduca Madonna;* it recalls the one at the same time that it prepares for the other.

A comparison of the paintings themselves confirms the chronology indicated by the drawing. They differ not only in size (the *Granduca* is considerably larger), but also in their relation to Leonardo. In the *Small Cowper Madonna* Raphael borrowed two motifs from Leonardo and reworked the Virgin's facial type on his example. But aside from the rather obvious pyramidal grouping, nothing in the picture suggests that Raphael at this time yet understood the full import of his Leonardo prototypes. The *Granduca Madonna* reveals a more advanced understanding of the formal and expressive principles underlying Leonardo's works. The paint structure is smoother and denser, as in Leonardo, and the forms are softer and are modeled more deci-

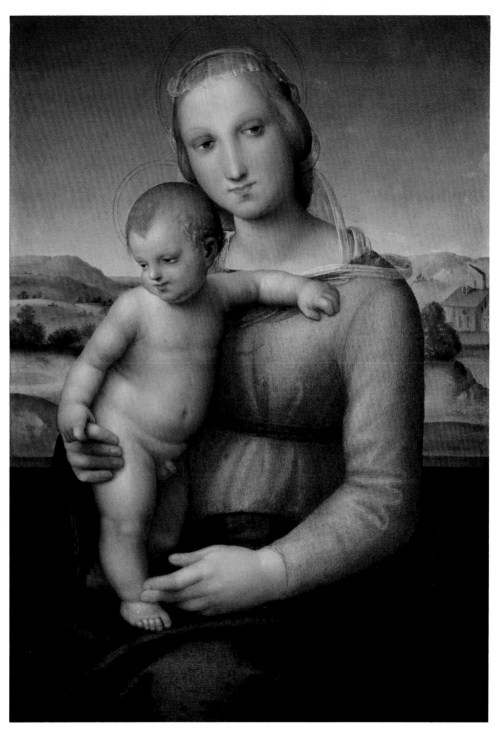

Plate II. Master of the Northbrook Madonna, Virgin and Child (Northbrook Madonna). Worcester Art Museum.

sively. The Christ Child is held by his mother in a firmer and more convincing manner.[90] And the face of the Madonna now bears an unmistakably Leonardesque character.

Raphael would have been relatively unknown in Florence when he painted the *Small Cowper Madonna* soon after arriving there. Nevertheless, several copies and imitations of his painting were made.[91] Of these the most important is the so-called *Northbrook Madonna* (plate II) in the Worcester Art Museum.[92] The painting [66] has been re-

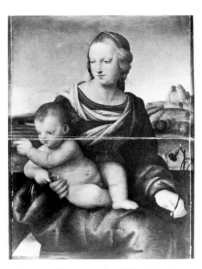

Fig. 68. Photograph of the Madonna with a Carnation *by a Raphael follower. Foteca Berenson, Villa I Tatti, Harvard University Center for Italian Renaissance Studies, Florence.*

peatedly compared to the *Small Cowper Madonna,* one writer claiming that it was modeled on the one in Washington, and it has generally been dated to the same time, about 1505.[93] The two pictures, although reversed, are indeed related in color, the pose of the Madonna, the large drapery fold over her knee, and the relation of the figures to their setting, including the parapet. It is more problematic whether the *Northbrook Madonna* is an autograph work by Raphael.

Whatever its attribution, the *Northbrook Madonna* bears a distinguished provenance, having belonged to successive aristocratic English collectors, the last of whom was the Earl of Northbrook (hence its name). In 1927 Langton Douglas, Berenson's rival in the art trade, sold the painting to Theodore Ellis (1867-1937), a Worcester newspaper publisher and inventor and manufacturer of a press blanket, which made his fortune. To acquire the picture without Berenson's stamp of approval was risky, and it was obviously to set his doubts at rest that Douglas wrote Ellis on September 20, 1927, that Berenson failed to appreciate that the painting was "not only entirely by Raphael's own hand" but "it was also one of the most charming and characteristic works of his Florentine period."[94] While lamenting that "another Raphael has left Europe for America," Umberto Gnoli, the leading authority on Umbrian art, admitted that "this happy purchase by Mr. Ellis will enrich American collections with a rare masterpiece by the greatest genius of Italian painting."[95]

Though obviously reflecting Raphael's Florentine style, as most critics have agreed, the *Northbrook Madonna* could not, in my opinion, have been painted by him.[96] In mood the painting is insipid, rather than tender or charming. And in design it lacks Raphael's structural clarity. By contrast to the *Small Cowper Madonna,* the robe does not form a compositional base for the figure; the folds are meaningless, as they are in the Virgin's sleeve. The anatomies are wooden, and the architecture and foliage in the distance are equally conventional and unconvincing. The way the Child stands on his mother's lap is especially telling: though usually described as posed on her knee, he, in fact, places his right foot illogically on the drapery between her legs.

The *Northbrook Madonna* emulates Raphael's early Florentine paintings and drawings. The downward glance of the Child, for example, can only be explained by assuming that the figure was borrowed from a work like the *Terranuova Madonna* or the *Madonna of the Meadow,* in which the Child looks at another figure.[97] An even more obvious reuse of such a motif, extracted from a different context, appears in a work closely related to the Worcester painting, the so-called *Madonna with a Carnation* (fig. 68). This picture, known to me only in photographs, was given to Raphael when it was sold at auction in New York in 1931.[98] But it, too, is a pastiche of his early Florentine Madonnas. The pose of the Child and the relation of the figures to their setting derive from the *Terranuova Madonna,* while

the Virgin's contrapposto and drapery come from the *Madonna of the Meadow*. The resemblance, amounting to an identity of hand, between the *Northbrook Madonna* and the *Madonna with a Carnation* was observed by more than one writer who had the opportunity to compare them.[99] The painter responsible for the two pictures was probably an Umbrian imitator of Raphael, thoroughly familiar with his early Florentine works. Until his identity is established, we may call him the Master of the *Northbrook Madonna*.[100]

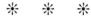

RAPHAEL'S *Saint George and the Dragon* (plate 12) in the National Gallery [77] belongs to a different category of images from those we have discussed.[101] In scale, the picture resembles the predella panel from an altarpiece, but it was never meant to be part of a larger ensemble. Rather, as an independent work, intended to be viewed close-up, it is finished with the delicacy of a manuscript illumination. The little panel, signed on the breast strap of the horse, belongs, in fact, to a series of miniature paintings, more or less secular in character, which Raphael apparently made for the court of Urbino.[102] Another member from the same group (fig. 69) also depicts Saint George and the Dragon. Along with its companion piece representing Saint Michael and the Demon, it is today in the Louvre.[103] Though both versions of *Saint George* have been dated within a year or two of each other, the painting in Washington reveals a striking difference in the way Raphael treated the theme.

The two pictures illustrate basic elements of the Saint George legend. A Roman soldier of Christian faith, Saint George saved the daughter of a pagan king by subduing a dragon with his lance; the princess then led the dragon to the city, where the saint killed it with his sword, prompting the king and his subjects to convert to Christianity. In the Middle Ages Saint George came to personify the power of good over evil. By the fifteenth and sixteenth centuries, artists like Raphael depicted the saint dressed in contemporary armor and mounted on a rearing horse. Raphael followed the visual tradition, too, in showing the saint either impaling the dragon with his lance, as in the Washington painting, or else slaying it with his sword, as in the one in the Louvre. The combat takes place in a natural setting, which includes the dragon's cave.

Within the landscape in each painting is a female figure which in the Louvre version is clearly the princess of the legend. Her counterpart in Washington, however, has a halo, like Saint George, instead of the customary crown. In this respect the painting differs not only from the one in the Louvre but from other known versions of the theme. The female figure shown with a halo cannot be the princess who, though converted to Christianity, was not a saint. Another highly unusual feature has been commented upon by every writer on the painting. Saint George wears a blue garter on his outstretched

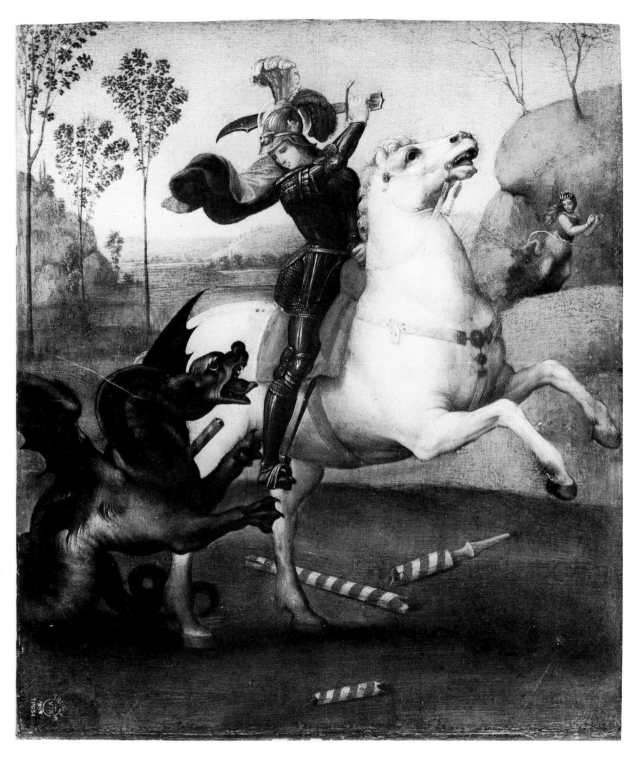

Above: Fig. 69. Raphael, Saint George and the Dragon. *Musée du Louvre, Paris.*

Left: Plate 12. Raphael, Saint George and the Dragon. *National Gallery of Art, Washington, Andrew W. Mellon Collection, 1937.*

leg. The garter is inscribed HONI, the beginning of the motto, "Honi soit qui mal y pense," of the order of which he was the patron.

Both of these elements—the female figure and the garter—may be explained, perhaps, as references to Duke Guidobaldo of Urbino. In May of 1504, the duke was made a knight of England's noblest and most exclusive chivalric order by King Henry VII.[104] At the same time that he was invested with the insignia of the order, including the

garter, Guidobaldo was appointed captain general of the Church by the pope. The presence of the garter in the picture surely indicates that it was meant to commemorate the great honor newly bestowed on the duke. And if Raphael's painting also celebrates Guidobaldo's papal appointment, then the haloed figure in the background might personify Faith or the Church.[105]

That Raphael was chosen to execute such an important work indicates the growing esteem in which he was held by the court circle of his native city. It has often been assumed that his painting was commissioned by the duke as a gift for King Henry VII of England in return for the Order of the Garter. Raphael's picture is supposed to have been among the gifts—horses and falcons—which Castiglione, serving as proxy for Guidobaldo, brought to the English king on the occasion of the duke's induction as knight of the order in 1506. The fact that the warrior saint in the painting wears the garter on which is inscribed the motto of the order made what is no more than a hypothesis seem virtually certain.[106]

Nevertheless, while it is true that the gift of the painting would seem a fitting gesture, no document records such a commission and no account of the gifts taken by Castiglione on his diplomatic mission mentions any painting at all. Moreover, the picture cannot be identified with any of the items in sixteenth-century inventories of the Royal Collection. These describe a composition of Saint George and the Dragon which corresponds less closely to the Washington painting than to the earlier version by Raphael (fig. 69), in the Louvre.[107] Accordingly, that painting has sometimes been proposed as the ducal gift.[108] It is true that to judge from its style, the Louvre *Saint George* would fall within the time period of the hypothetical commission, that is, between 1504, when Guidobaldo was awarded the Garter, and 1506, when Castiglione left for England. Nevertheless, there is evidence, hitherto overlooked or misinterpreted, suggesting that the painting in the Louvre, together with its pendant, the *Saint Michael,* was in Milan in the sixteenth century.[109]

The painting now in the National Gallery of Art was in England by 1627, the date of an engraving [67] reproducing it in reverse by Lucas Vorsterman. As we learn from the printed dedication, the picture belonged to the Earl of Pembroke, but how it came into his collection is not known.[110] Reflecting the state of the panel in the seventeenth century, the engraving shows it in much the same condition as it is today, very well preserved except for losses confined to the edges.[111]

The precise relation between Vorsterman's print and Raphael's painting may be gauged better from the counterproof [68] after the engraving (fig. 70), in which the image corresponds in direction to the picture. Assuming that Vorsterman accurately copied the painting, his engraving includes a number of differences which may have been present when he saw it. Sometime after the print was made,

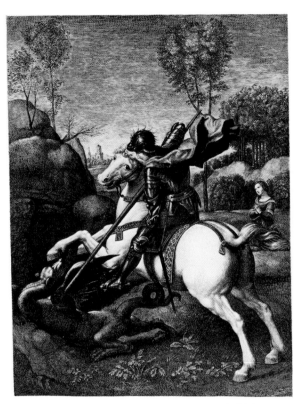

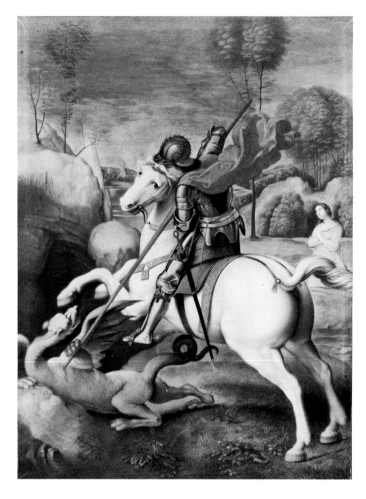

Left: Fig. 70. Lucas Vorsterman, Counterproof of Saint George and the Dragon. *Trustees of the British Museum, London.*

Right: Fig. 71. Peter Oliver, Saint George and the Dragon. *Windsor Castle, Reproduced by gracious permission of H.M. Queen Elizabeth II.*

damage and restoration occurred to the plants and foliage along the bottom and in the upper left corner of the panel. Other differences affect not only the appearance of the painting but its meaning as well. The print shows a cross on the smaller of the two towers in the background. If originally present in Raphael's painting, the cross would have underscored its Christian character. The confrontation of the warrior saint and the dragon may also have been more dramatic than it appears today. In the print the saint's eyes are wide open, fixed on the dragon. In addition, the animal was once more menacing. Its proper right wing is apparent above the paw at the margin of the print. And blood clearly flows from its wound. Furthermore, the beast once had a forked tongue, and smoke issued from its mouth. The latter detail is described in the *Golden Legend,* where the dragon was said to have poisoned all who came within reach of its breath.[112]

The 1628 copy of *Saint George* (fig. 71), made for Charles I by Peter Oliver [69], agrees in nearly all respects with Vorsterman's engraving. By 1639 the king had acquired Raphael's painting from the Earl of Pembroke. In that year it appears in an inventory of the Royal Collection. In Oliver's painted copy the tower in the background lacks the cross found in Vorsterman's engraving. And the dragon is missing the forked tongue. But the monster breathes smoke, as in the

Fig. 72. Albrecht Dürer, Saint George and the Dragon. *National Gallery of Art, Washington.*

Fig. 73. Raphael, Cartoon for the *Louvre* Saint George and the Dragon. *Gabinetto Disegni e Stampe degli Uffizi, Florence.*

print, and blood flows from its wound. The saint likewise has his eyes open. These features, which are found in the print and the painted copy but not visible today, had evidently disappeared by the time of the engraving after the painting which Larmessin made for the Cabinet de Crozat in 1729.

The *Saint George and the Dragon* in Washington differs fundamentally in conception and style from the earlier version. The Louvre *Saint George* (fig. 69) reflects a late Gothic tradition in which the warrior saint and the fabulous beast confront each other in heraldic fashion. An example of this type is Dürer's woodcut (fig. 72), datable to the years just before the Northern master's second trip to Italy in 1505. It may have provided a model for Raphael's contemporary painting.[113] Though the weapon employed is different in each case, the disposition and relative scale of the figures are similar, as are the fantastic type of dragon (especially the head), and the stunning plumed helmet of the saint. As in Dürer's woodcut, the horse, rider, and dragon in Raphael's painting are depicted parallel to each other, their silhouettes making an ornamental contrast to their surroundings. Even closer to the woodcut is the preparatory drawing for Raphael's Louvre picture in the Uffizi (fig. 73), where we find the same gruesome skull and bones scattered about on the ground.[114] These will be replaced in the painting by the shattered fragments of the lance. The princess does not appear in the drawing, leaving the saint and the dragon to confront each other as they might on a medallion. Whether or not it depends upon Dürer's woodcut or some other similar source, Raphael's *Saint George* in the Louvre reflects an older tradition of symbolic rather than dramatic representation.

The dynamic conception and naturalistic style of the Washington painting reveal Raphael's debt to different, more modern sources of inspiration. Donatello's marble relief (fig. 74) of *Saint George and the Dragon* from Or San Michele in Florence has long been recognized as a model for Raphael's composition.[115] Though the relief was one of the first statements of the new Renaissance style, later artists, includ-

Fig. 74. Donatello, Saint George and the Dragon. *Or San Michele, Florence. Alinari/Editorial Photocolor Archives.*

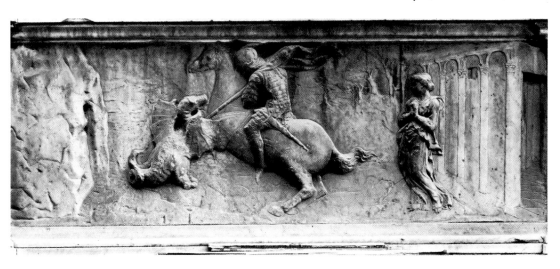

Fig. 75. Leonardo da Vinci, Dragon Fight Studies. *Cabinet des Dessins, Musée du Louvre, Paris, Rothschild Collection.*

ing Raphael, turned to this early fifteenth-century work for guidance.[116] Since he made a drawing of the free-standing statue of the saint which surmounted the relief, Raphael undoubtedly knew the original in detail.[117] With the relief in mind, Raphael reversed the composition of the Louvre *Saint George* and showed the horse and rider moving diagonally into space. The relation between the sculpture and the painting even extends to such motifs as the helmet, the fluttering cape, and the lance. The pose of the saint is similar, too, though Donatello's figure rides without stirrups in the antique manner, and his horse is rearing while Raphael's is lunging forward.[118]

Yet Donatello's relief—or Raphael's understanding of it—fails to account for what is perhaps most remarkable about the painting, namely, its dynamic naturalism which can be shown to derive from Leonardo. Once again, as in the *Small Cowper Madonna,* Raphael updated a visual tradition by taking as sources both Early Renaissance sculpture and works by Leonardo. But in the *Saint George,* dating a year or so after the *Madonna,* Raphael's debt to Leonardo is not merely for borrowings of motifs. In a general way, it seems, he was inspired by a series of drawings of horsemen fighting a dragon which Leonardo had begun around 1481, at the time he was working on the *Adoration of the Magi.*[119] Among these sketches is a sheet from a small vellum notebook in the Rothschild Collection in the Louvre (fig. 75), in which two horsemen attack a dragon with spear and lance.

Fig. 76. *Raphael*, Saint George and the Dragon *(detail). National Gallery of Art, Washington.*

Fig. 77. *Zoan Andrea*, Combat of a Lion and a Dragon. *Kupferstichkabinett, Staatliche Museen, Berlin.*

Right: Fig. 78. Leonardo da Vinci, Studies of Saint George and the Dragon. *Windsor Castle, Reproduced by gracious permission of H.M. Queen Elizabeth II.*

Leonardo was probably not thinking specifically of Saint George. Nevertheless, admirers of his work, like Raphael, could and did find an explicit use for his combat scenes by adapting them for compositions of the saint and the dragon.[120] They did so in part because, according to the new artistic standards Leonardo was setting in Florence, an imaginary animal like a dragon needed to be represented in a convincing manner. Thus, if the beast in Raphael's earlier *Saint George* moves about improbably on its tail, its four-footed counterpart (fig. 76) in the Washington version is rendered more believably. The older master's monsters were based on his painstaking studies of real animals; Raphael found it preferable to combine parts of monsters ready made.[121] Thus, it is likely, as Popham suggested, that Raphael adapted for his dragon the hindlegs of a similarly crouching lion by Leonardo. Raphael found the motif in a composition of a lion combating a dragon, now lost, but known in a number of copies, including an engraving (fig. 77) by Zoan Andrea.[122] Raphael likewise probably derived the wolflike head at the end of the dragon's long serpentine neck from another Leonardo prototype.

Though none of Leonardo's sketches corresponds exactly with Raphael's painting, the type of dragon and the way it confronts the horse, seen from behind in three-quarter view, occur on several sheets. A particularly close comparison is a pen and ink drawing [70] at Windsor Castle (fig. 78), containing a number of sketches of horses. This sheet, much later than the one in the Louvre, shows that Leonardo continued to explore the dragon fight theme throughout his career.[123] While Leonardo's interest was focused on the twisting

Fig. 79. Fra Bartolomeo, Saint George and the Dragon. *Museum Boymans-van Beuningen, Rotterdam.*

movement of the horse, the pose of the horse and rider in the center of the sheet may have provided a model for Raphael's *Saint George.* The dragon in the Washington painting (fig. 76) more nearly recalls the beast beneath the horse's hooves in the group to the upper right of the page. The coiling neck and snarling head are especially close. The *contrapposto* of the dragon in each case indicates that while retreating, it has turned to confront its attacker. This extraordinary concept, in which the dragon is made believable, could only come from Leonardo, who, we are told, tamed a lizard and used it to terrify his friends. As if to expand Leonardo's idea by adding a narrative context, Raphael included the dragon's lair in the Washington painting (it is not present in the Louvre version). In this way we see the place from which the monster came to devour the princess and to which it now seeks desperately to return.

Raphael, significantly, was not alone in adapting Leonardo's studies to a scene of Saint George and the Dragon. A sketch [71] by Fra Bartolomeo (fig. 79) in black chalk heightened with white, in Rotterdam, belongs to a series of explorations of this subject by the artist.[124] It bears the same relation to Leonardo as does Raphael's picture. Fra Bartolomeo's principal group, composed of the horse galloping away from the viewer and the rider in profile, his cape billowing out behind him, was inspired by the older master. The dragon, with its twisting neck, likewise writhes beneath the horse's hooves. If they did not share a common source in Leonardo, we might postulate that Raphael's painting and Fra Bartolomeo's drawing, though reversed in composition, were directly related to each other.

Raphael's painting also depends upon another less obvious Leonardo source, the *Battle of Anghiari.* Whether or not Vasari was right in saying that Raphael went to Florence specifically in order to study that work, it is clear that once he arrived in the city, the mural or drawings for it made a great impression on him. Leonardo began to prepare the battlepiece for the Hall of Great Council in the Palazzo della Signoria in 1503, but he left it unfinished in 1506. Now lost, its appearance must be reconstructed from sketches by the master and from contemporary and later copies. One of these copies is a drawing [72] in the Fogg Museum. Derived, perhaps, from Rubens' famous study after Leonardo in the Louvre, Edelinck's drawing (fig. 80) records the central incident of the lost battlepiece, the Combat for the Standard.[125] The dynamic role of the horses in the Combat for the Standard, their almost human intensity, struck Raphael, as we can deduce from a drawing of 1505 in the Ashmolean Museum in Oxford.[126] In the lower right-hand corner of the sheet are faintly sketched heads of two struggling horses. This motif reveals that Raphael grasped the animating principle underlying Leonardo's horses. The lesson he learned was then demonstrably put to use in the Washington painting. Saint George's horse, like the dragon be-

Fig. 80. Gerard Edelinck (?) after Rubens (after Leonardo), Combat for the Standard. *Courtesy of the Fogg Art Museum, Harvard University, Cambridge, Gift of Edward W. Forbes.*

Fig. 81. Raphael after Leonardo, Combat for the Standard *from a sheet of studies for the* Trinity of S. Severo. *The Ashmolean Museum, Oxford.*

neath its hooves, is a sentient creature that responds to the conflict.[127]

It was not only the astonishing behavior of the horses that fired Raphael's imagination. He also sketched the design of the central episode from the battlepiece in the opposite corner of the Oxford sheet (fig. 81). In the drawing Raphael completes and emphasizes the pole of the standard, which presumably was only partly visible behind the figures in his prototype. From the way he has clarified the motif of the standard we can be certain that Raphael understood its function as the unifying device by means of which Leonardo had organized his horsemen in a tightly knit group. Raphael also adapted this feature for use in the Washington painting, in which the lance plays a similar compositional role. The dragon grasps it at one end, and the saint at the other.

Beyond such intelligent adaptations of motifs, Raphael derived his conception of the event as one that might actually have occurred from Leonardo. The symbolic confrontation of horse, rider, and dragon in the earlier version in the Louvre (fig. 69) is here revised for greater coherence and dramatic effect. Raphael had previously depicted the saint with his sword drawn, finishing off the beast. At this point in the sequence of events, the dragon, which is supposed to be mortally wounded, is too active. In the Washington painting, however, Raphael focused on the climactic moment when the saint's lance first pierces the monster, which twists around to grasp it. The horse looks out at the viewer apprehensively, indicating that the outcome of the struggle is still uncertain.

Raphael's experience of the *Battle of Anghiari* marks a turning

point in his career. The *Saint George* in Washington reveals that he understood the principles underlying Leonardo's achievement. Raphael's comprehension of these principles, and not only of specific motifs, now enabled him to create in a manner worthy of his mentor. The imaginative process leading up to the finished work emerges clearly from the artist's preparatory designs. In the current Raphael literature only one drawing is connected with the *Saint George and the Dragon,* the cartoon for the painting in the Uffizi. Nevertheless, several other sheets are also preparatory to the picture.

The first of the drawings in their presumed order of execution is a metalpoint study [73] of a horse and rider (fig. 82) in the Ashmolean

Museum in Oxford.[128] The equestrian image was cut at some time from its original sheet and pasted onto another, which has been re-mounted for the exhibition. Though the drawing is now tentatively given to Luca Signorelli, an attribution going back to Berenson, nothing in that artist's work is comparable.[129] Earlier, so gifted a connoisseur as J. C. Robinson considered it a study for the National Gallery painting.[130] While the damaged state of the drawing makes a definitive attribution difficult, the older view that it was done by Raphael is, in my opinion, correct. Its connection with the *Saint George* is beyond dispute. The attitudes of horse and rider in both drawing and painting are nearly identical, and the resemblance extends to details like the fluttering cape. The round shield carried by the warrior and his raised arm, not found in the picture, suggest that the drawing is for the painting, not after it. A certain refinement of execution, still partly visible, points to Raphael rather than Signorelli as the author.

The drawing is significantly closer to Raphael's Leonardo sources than is the painting for which it served. The rider's upraised arm recalls the dragon fight drawings, for example. And the head and twisting body of the horse also approximate the type favored by the older master.[131] The difference between the horses in the drawing and the painting by Raphael is one of anatomy. Another difference, however, affects the entire meaning of the picture. In the drawing the horseman's mouth is open, giving him an excited expression. His profile recalls that of the scowling warrior on the right in the Combat for the Standard. That and other angry faces by Leonardo express his concept of warfare as a "bestial madness," in which men and animals are reduced to the same savage fury. The drawing indicates that Raphael understood this concept. Nevertheless, for the painting he rejected it in favor of another ideal (fig. 83). As in Leonardo, Raphael's protagonists directly confront each other, their line of sight reinforced by the lance. But Saint George looks serenely confident, not agonized or furious. Raphael adopted for his saint the same calm and pure facial type already found in the sleeping Saint John in the *Agony in the Garden* (plate 7). Though the style of his youth was incapable of rendering the new more powerful content that came into art around the turn of the century, he recognized that that style did have a particular relevance for his characterization of Saint George. As the embodiment of chivalry, the saint was traditionally conceived as a gentle rather than fiercely aggressive warrior. In Raphael's painting, especially in its original state as shown by the print, the glance of the saint, alert and determined, is contrasted with the apprehensive expression of the horse and the defiant look of the dragon in order to reveal the rider's superior courage and capacity for reason.

The horseman in the Ashmolean drawing was evidently holding a sword or a spear, now missing, whereas the corresponding figure in the Washington panel carries a lance. A rare, anonymous engraving

Fig. 83. Raphael, Saint George and the Dragon *(detail). National Gallery of Art, Washington.*

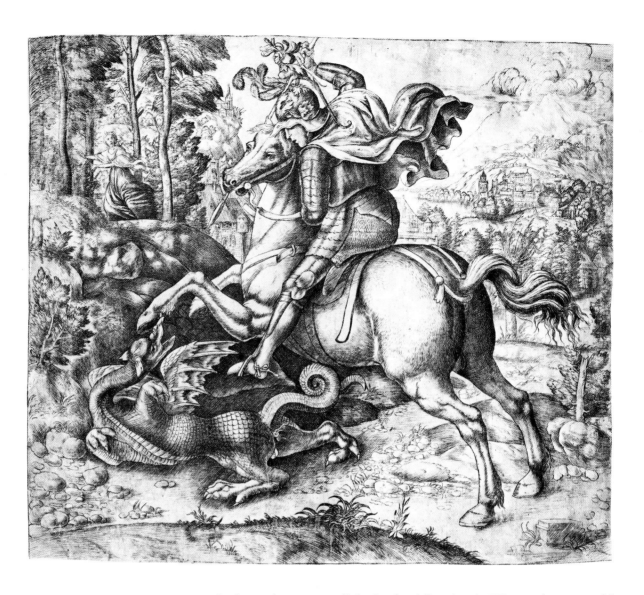

[74], newly come to light in the Albertina in Vienna, bears on this
and other problems relating to the genesis of the picture. As Bartsch
and Passavant long ago recognized, the print (fig. 84) is clearly after
a lost preparatory study for the painting.[132] Comparing the two, we
find that the group in the foreground is basically the same. Though
the printmaker may have elaborated upon the landscape, he appears
to have followed closely the principal figures in the original study.
The engraving demonstrates Raphael's tendency to build upon and
modify his previous conceptions while evolving new ones. Thus, the
princess copied in the print is shown fleeing, like her counterpart in
the Louvre *Saint George.* She also does not yet have the halo and
prayerful gesture of the figure in the Washington painting. The rider
in the engraving, with arm upraised and mouth open, recalls the
horseman in the Ashmolean drawing, though the shield has been
eliminated. Both the drawing and the engraving suggest that Raph-
ael's first idea for the painting was to show Saint George with his arm
poised to strike the dragon. At the same time the print agrees with

the painting in certain details, indicating that Raphael's lost study
followed the Ashmolean drawing in the sequence leading up to the
painting. As in the picture, the horse's head in the engraving is small,
and its chest and forelegs are turned in lost profile.

A further stage in the evolution of Raphael's design [75] is marked
by a recently rediscovered drawing (fig. 85), now belonging to the
National Gallery of Art.[133] The image, drawn in black chalk, brush
with brown wash, and white heightening, is badly effaced by abra-
sion and exposure to water. Despite the damage, it is evident that the
drawing is connected with Raphael's painting. The final solution, in
which the rider holds a lance instead of a spear, has here been estab-
lished. The drawing is not a copy of the painting, however, for it dif-
fers in several details. The warrior wears a soft feathered cap of the
type favored by Perugino and his pupils, instead of the military hel-
met found in the picture.[134] The trappings of the horse vary a little
too. And the landscape on the right, though only barely sketched in
black chalk, contrasts with the arrangement in the picture. These dif-

Fig. 86. Raking light photograph of Raphael's study for Saint George and the Dragon. *National Gallery of Art, Washington.*

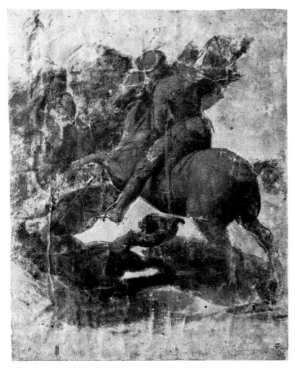

Fig. 87. Ultraviolet photograph of Raphael's study for Saint George and the Dragon. *National Gallery of Art, Washington.*

ferences in costume and setting, while they are not conclusive, lead us to deduce that the drawing preceded the picture as a preparatory study.

When he made the Washington drawing Raphael was nearing the definitive solution for his painting. The foreground figures, whose poses had already been determined, are here modeled in light and shade. As a chiaroscuro study, the drawing belongs to a recognizable category in Raphael's graphic oeuvre. At least two other relatively early sheets by the artist, one in the Louvre for a Madonna and the other at Chatsworth for an altarpiece, may be compared in technique and function to the drawing in question.[135] In all three the figures are built up of large areas of brown washes, overlaid with more carefully defined white heightening. All three show a primary interest in the figures, the Louvre and Washington sheets having similar quick sketches of a distant landscape. The motifs in the drawing of Saint George also correspond in size to those in the painting; on a one-to-one basis the drawing served as a guide.

The function of the drawing seems clear. But its badly damaged condition does raise a question about attributing it to Raphael. As we have noted above, the unusual technique is distinctive of two similar drawings, also badly damaged, which are by Raphael. In the newly rediscovered sheet, the least damaged area is the center with the bodies of the horse and rider. Here certain details, like the left leg of the rider or the feathers of his cap, possess the deftness of stroke and quality of an autograph drawing by the master. In particular, the white hatchings preserved in this portion of the sheet are delicate, lively, and accurately descriptive. They also match exactly the small, careful, parallel strokes of white used in the other early chiaroscuro studies. More than any other aspect of the drawing in its present condition, they point to Raphael as its author.

The Washington drawing fits into the sequence of preparatory studies for the painting. The essential change of mind recorded here, as compared with the print, is the lance, which serves to integrate the horse, rider, and dragon. The motif of the pendant sword is likewise introduced for the first time. The plumed cap of the rider is also a new motif, but it is not found in the finished painting, which adopts the helmet used earlier. This detail of the cap in the drawing appears to be an afterthought. It was rendered in wash over the incised contour of a helmet (fig. 86), which is revealed by raking light. The incised lines found throughout the main figure group were presumably made, as the design was transferred onto the sheet, to provide a basis for elaborating it in light and dark.

Technical examination shows that the drawing, for all its similarity to the painting, still follows the design of the print in certain details. The dragon's incised snout, for example, appears longer and more Leonardesque than it does in the painting, and the monster's wings are scalloped, not deeply indented. Another detail found in the print,

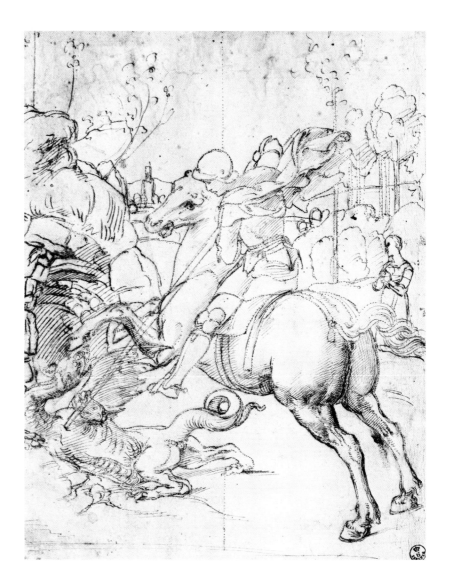

Fig. 88. Raphael, Cartoon for Saint George and the Dragon. *Gabinetto Disegni e Stampe degli Uffizi, Florence.*

the princess, does not at first appear to be visible on the present surface of the drawing. But her figure (fig. 87) emerges when viewed under ultraviolet light. She is shown standing on a hill in the upper left with her arms raised in alarm. The princess was drawn only in wash, indicating that, like the landscape, her final form and placement were still to be decided.

The cartoon for Raphael's painting [76] has long been recognized in a pen and ink drawing (fig. 88), pricked for transfer, in the Uffizi.[136] In the sequence of extant preliminary studies, it stands closest to the picture. Here, for example, appear many features missing or barely indicated on the Washington sheet, including the landscape. Admittedly, certain motifs, like the halo and sword of the saint and the bridle and trappings of his horse, are not found as they are in the painting. In the process of working out the composition, Raphael varied such details from drawing to drawing or left them out, even though he apparently intended to include them in the finished work. The major change in design reflected in the cartoon concerns

the princess and her position. Raphael transferred the figure from the left to the right side and showed her kneeling in prayer. The hill on which she had been standing in the Washington drawing became the dragon's cave, its entrance clearly visible for the first time. This change allowed an opening into the distance, where Raphael featured a view of a city, probably the one mentioned in the legend of the saint.

In its linear precision, moreover, the cartoon differs from the newly discovered chiaroscuro study in Washington. The two drawings complement each other by performing separate functions in relation to the painting. One delineated the contours of forms and served directly to transfer the design onto the panel. The other provided a ready reference for the artist as he modeled forms in his painting. In the earlier cartoon (fig. 73) for the Louvre *Saint George*, the two functions—delineating and modeling—were joined. Evidently, during the time that elapsed between the two paintings, Raphael's working procedure had become more complex. The drawings for the Washington panel together show the careful and deliberate approach that Raphael had learned from the Florentine painters. The painting demonstrates as well his mastery of their naturalistic ideals.

The four drawings we have considered, one in the form of a reproductive print, reveal much about Raphael's methods of working out a figure composition. But they tell us less about his concern with the setting. It is only when the cartoon stage is reached that we find a fully articulated landscape design. This landscape agrees with the background of the Washington panel, except for a few details. When he came to execute the painting, Raphael eliminated the tree extending diagonally into the sky and moved the remaining trees to a lower rocky outcrop. At the same time he added the pool of water, in which the praying figure is reflected, the foreground plants, and a second smaller tower in the distance.

In the Louvre *Saint George* Raphael had relied on Perugino's formula for spatial recession. In the Washington painting, however, the landscape is arranged in overlapping planes which block the view into the distance, thereby focusing on the active center. The compositional principle of intersecting diagonals which unite the horse, rider, and dragon is extended to the surrounding landscape. The cave on one side continues the axis of the horse, while the grove of trees on the other extends the cross-axis of the lance and cape of the saint. In this way the figures in the painting are integrated with their setting. This sophisticated design looks forward to Raphael's later achievements in the Stanze.

Aside from its compositional complexity, the landscape possesses what has been called an "over-meticulous" effect unprecedented in Raphael's work.[137] By contrast to the soft atmospheric setting of the earlier *Saint George* with its more limited range of hues, the landscape in the Washington painting is rich in brightly colored detail, ren-

dered with the same keen observation that produced the scales of the dragon and the gleaming armor of the saint. As a description of the natural scene, Raphael's landscape reinforces the dynamic confrontation of the saint and dragon, lending the imaginary setting a reality familiar to the artist's contemporaries.

Raphael's painting does not represent the countryside around Florence or Urbino. Of the various artistic sources proposed for it, neither Credi, Francia, nor Pinturicchio explains the distinctly Flemish look of the natural world Raphael portrayed.[138] The actual source for his landscape is the paintings of Hans Memling (c. 1433-1494). In particular, Memling's *Saint John the Baptist* (fig. 89) in Munich and the *Saint Veronica* (plate 13) in the National Gallery in Washington [78], which most likely once formed a diptych, seem to have been Raphael's models.[139] The rocks in the *Saint John* have been likened to those in the *Saint George*,[140] and this and other works by Memling have been related in a more general way to Raphael's picture. But the relevance of Memling's *Baptist* for the *Saint George* has not been adequately demonstrated, and the *Veronica* in Washington, its probable companion piece, has never been brought into the discussion.[141]

Before evaluating the visual evidence in favor of connecting the paintings by Memling with Raphael, we must examine the problem of whether the *Saint John* and the *Saint Veronica* do, in fact, belong together and, if so, how Raphael might have seen them. The *Baptist* is usually paired with the *Veronica* because the two are identical in size and similar in style. The scale of the figures corresponds, moreover, and the landscape is continuous from one panel to another. As the most recent student of the problem concluded, it is "reasonable to assume that they are from the same diptych," the *Saint John* on the left and the *Veronica* on the right.[142]

The complete history of the panels is not known, but the diptych they comprised has been convincingly identified with one that was in Italy in the early sixteenth century.[143] Some time in the 1520s, the diarist Marcantonio Michiel recorded a diptych that he had seen in Padua in the collection of the humanist writer Pietro Bembo (1470-1544). Michiel describes a small painting on two panels by Memling, representing Saint John the Baptist dressed and seated in a landscape with a lamb and the Madonna and Child in another landscape.[144] Michiel's description applies to the picture now in Munich, of course, but not, apparently, to its counterpart in Washington, which depicts Saint Veronica, not the Madonna. The discrepancy does not rule out the claim of the *Veronica* to belong to Bembo's diptych, however. Michiel's account is brief and may be inaccurate. He may have mistaken or mistakenly remembered the *Veronica* for a Madonna. A Flemish diptych does appear already in 1502 in the collection of Pietro's father Bernardo Bembo in Venice. This diptych depicted Saint John the Baptist and Saint Veronica.[145] It is likely that

Fig. 89. Hans Memling, Saint John the Baptist.
Alte Pinakothek, Munich.

Right: Plate 13. Hans Memling, Saint Veronica. National Gallery of Art, Washington, Samuel H. Kress Collection, 1952.

the diptychs cited in 1502 and in the 1520s were one and the same and that the paintings in Munich and Washington were in the Bembo family collection by the first years of the sixteenth century. If the *Saint John* belonged to Bembo, then the *Veronica* presumably did too.

The sources mention Venice and Padua. In 1502, the diptych was briefly lent to Isabella d'Este in Mantua. Though he may have seen the picture in North Italy, Raphael is not known to have been in any one of these cities. On the other hand, it is possible that the picture found its way to Urbino. Pietro Bembo certainly had the diptych later. And in 1506 he left the family home in Venice to take up residence at the Urbino court. Having visited the city on several occasions before 1506, in September of that year he came to stay.[146] If

154

Fig. 90. Raphael Follower, Portrait of a Young Man. *Alte Pinakothek, Munich.*

Bembo brought his diptych—a small portable object for private devotion—Raphael, who also belonged to the court circle of his native city, could easily have seen it. No document records that Raphael joined Bembo in Urbino in 1506.[147] Nevertheless, we do learn, again from Michiel, of a portrait of Bembo by Raphael, a drawing or a small painting made "when the writer was a young man at the court of Urbino."[148] The portrait is lost, unfortunately, but the way Michiel refers to it serves to link Raphael and Bembo in Urbino at this time. Perhaps the artist encountered the Flemish diptych as he recorded Bembo's features. Unless the *Saint George* was taken to England by Castiglione in July of 1506, for which, as I have said, there is no proof, Raphael's picture could just as well have been painted in the autumn as the spring of that year. Though the proposed dates of execution range from 1504 to 1506, the latter is surely preferable if we place the less advanced Louvre version at the beginning of the period.[149]

A confirmation that Memling's *Saint John* was in Urbino early in the sixteenth century is provided by a picture now also in Munich (fig. 90), thought by some critics to be a self-portrait of the young Raphael. To judge from its style, the portrait was indeed painted by an Urbinate, not Raphael but Timoteo Viti or Evangelista, perhaps.[150] The painter must have seen the *Saint John* when it belonged to Bembo in Urbino, for, as Carlo Volpe observed, the grove of trees with the deer drinking from a pool in the background of the portrait was taken over almost exactly from the Flemish landscape.[151] This kind of literal imitation contrasts with the way Raphael analyzed the Memling landscape so that he could re-create one substantially like it in his own painting.

The realistic forms of Raphael's landscape come from careful observation of Memling. Raphael seems to have combined elements from both members of the diptych, taking the general arrangement of the landscape, in reverse, from the *Saint John* and individual details from the *Veronica*. In both the *Saint George* and the *Saint John* a grove of trees in the background is balanced by tall rocks, permitting a glimpse of the horizon behind the figures. The *Veronica* offered Raphael suggestions for motifs such as the grassy mounds, the trees growing out of the rocks, the tiny towers surrounded by small round trees, the pools of water in the middle distance, and the plants in the foreground.[152] Some of the same motifs are also found in the *Saint John*. Particularly characteristic in both Memling's and Raphael's paintings is the minute treatment of foliage with carefully applied highlights. The general tonality and even specific hues are similar, too, from the yellowish green and brown of the ground planes, to the gray rocks with brown grass, to the darker green foliage, and the blue sky lightening at the horizon.

No other landscape painted by Raphael betrays the deep involvement with Memling that we find in the *Saint George and the Dragon*.

It is not enough to say that the diptych struck Raphael with the force of a novelty. It must also have exactly suited the requirements of his painting. Raphael's figure group derives from Leonardo, we have seen, yet his setting does not. Leonardo's fantastic landscapes seem to have held little appeal for his contemporaries. Artists, in imitating his figures, frequently omitted their setting in favor of one of Flemish inspiration. Displaying a reality both convincing and familiar, Raphael's *Saint George* is a picture of this type. Assuming that it belonged to Bembo, Memling's *Saint Veronica*, brought together with the *Saint George* in the exhibition, may have been linked in Raphael's mind as well.

<div align="center">✳ ✳ ✳</div>

BY THE TIME OF the *Niccolini-Cowper* or *Large Cowper Madonna* (plate 14), signed and dated 1508, Raphael had mastered Leonardo's idiom and was now working independently on an equal basis with the older master.[153] Significantly, the larger and later of the two Cowper Madonnas betrays no obvious indebtedness to other artists' works. In fact, were it not for a Raphael composition, now lost but known in copies, we would be unaware of the indirect link between the *Large Cowper Madonna* [81] and Leonardo. One of these copies [79] of the lost *Madonna of the Pinks* (fig. 91), larger than the original, is in the Detroit Institute of Arts. It was done by Raphael's faithful seventeenth-century imitator, Sassoferrato.[154] The original from which Sassoferrato's painting was made resembled the *Niccolini-Cowper Madonna,* but in reverse. The setting differed, but the pose of the half-length Virgin was much the same, as was that of the Child, seated astride a cushion. The resemblance does not extend to the action of the figures, however. In the *Niccolini-Cowper Madonna* the Virgin looks down at the Child, who places his hand in her bodice, as if wishing to nurse. At the same time he regards the viewer with an impish smile which has delighted some critics and disturbed others. In the lost picture, the figures were united by the motif of offering flowers. This device, as well as the design as a whole, derives from Leonardo's much earlier *Benois Madonna.*[155] To judge from the copies, Raphael's lost picture updated his model, eliminating some but not all of its quattrocento delicacy and transposing it into the more monumental idiom of the High Renaissance. When, presumably after the *Madonna of the Pinks,* Raphael came to paint the *Niccolini-Cowper Madonna,* he simply reversed the composition, changed the setting from a room to the out-of-doors, and varied the figures, which approach life size. The result is a masterpiece which stands entirely on its own merits.

The seemingly effortless relation between the figures and their ease and freedom of movement are essential to the total effect of Raphael's painting. Combining naturalness with grace and a sense of grandeur, the picture differs markedly from the earlier *Cowper Ma-*

Fig. 92. Raphael, Niccolini-Cowper Madonna *(detail). National Gallery of Art, Washington.*

Fig. 91. Sassoferrato after Raphael, Madonna of the Pinks. *The Detroit Institute of Arts.*

Right: Plate 14. Raphael, Niccolini-Cowper Madonna. *National Gallery of Art, Washington, Andrew W. Mellon Collection 1937.*

donna, which dates from the outset of Raphael's Florentine period. It is true that the Virgin (fig. 92), looking down and clasping her breast, has the customary air of maternal solicitude. And she wears the graceful diaphanous veil favored by the late quattrocento masters, especially in Florence. The Child's gesture of grasping his mother's bodice is likewise traditional. Yet the way Raphael has treated these time-honored motifs is new in his work. The veil, usually static, is here gently animated by a breeze. Similarly, the weighty Child appears to bear down on the cushion. Eager to nurse, he tugs at the Virgin's dress, causing the fabric to pucker at her shoulder. For all their realism, however, Raphael does not allow us to forget the spiritual dimension of his figures, whose attitudes seem both tender and imposing.

Most remarkable of all, perhaps, is the Madonna, her head lowered in near profile and her hair swept back. Around the curve of her shoulder the transparent veil flutters, and her sleeve is enlivened with rippling folds. Set off against the blue sky, she is an artistic invention of great beauty. Though Fra Bartolomeo was also experimenting at this time with the Madonna in profile and though the picture is

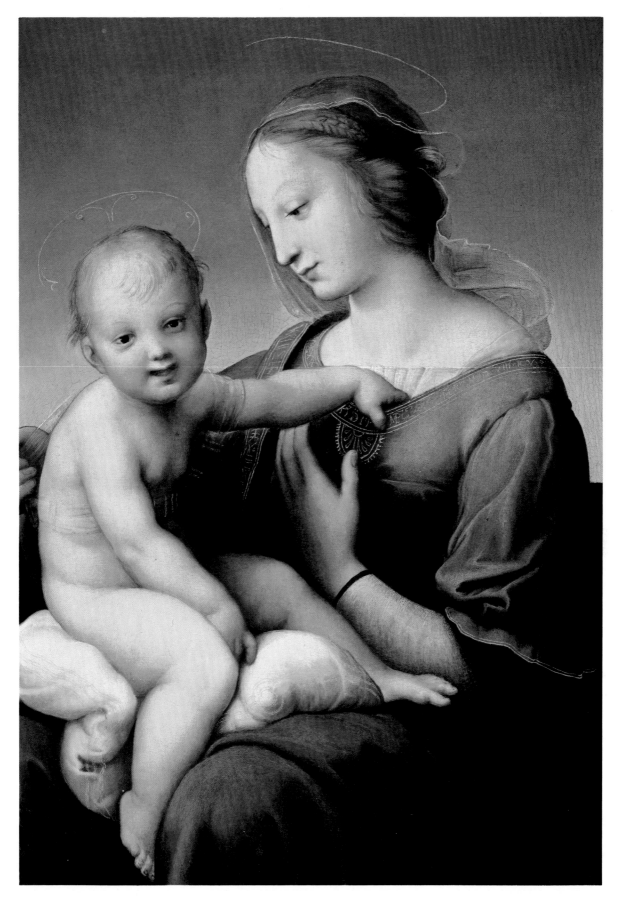

Fig. 93. Raphael, Study of a Madonna and Child. *Gabinetto Disegni e Stampe degli Uffizi, Florence.*

Fig. 94. Raphael, Studies of a Madonna and Child. *Graphische Sammlung Albertina, Vienna.*

surely indebted to him in a general way for its deep shadows and monumentality,[156] the figure of the Madonna, as Raphael conceived it, is his own. And it is not unique in his work. A similar sequence of smoothly interlocking forms had already served for the Virgin in the *Canigiani Holy Family* in Munich of about 1507.[157] In the *Holy Family* the Virgin is shown bending over the Child, who stands on the ground. By adapting the figure in the altarpiece to a half-length format Raphael has given the *Large Cowper Madonna* an imposing air which led some writers to suppose, unnecessarily, that it was painted in Rome. Perhaps the last in Raphael's Florentine series of Madonnas, the picture demonstrates the evolution his art underwent. Presumably, like the *Small Cowper Madonna*, it was made for a private patron, yet the earlier painting by comparison looks simple and derivative in style and naive in mood.

With no direct sources for comparison, we must turn to the one or two extant preliminary studies for the *Niccolini-Cowper Madonna* to gain some understanding of how Raphael's design evolved.[158] The first of these (fig. 93), in the Uffizi, is a pen and ink sketch [80] of a Madonna with the Child on her lap.[159] As Pope-Hennessy has noted, the posture of the Child in the drawing bears a certain resemblance to that in the painting.[160] But in other respects the drawing is not close enough to have been made with the picture in mind. The Madonna's oval-shaped head and small features, her proper right hand, echoing Mona Lisa's, and her rather stiff pose appear, on the contrary, to look back to the *Small Cowper Madonna*. It may be that the figure of the Virgin in the earlier painting, a composite of several sources, served as a point of departure for Raphael's work on a series of Madonnas. The drawing marks an advance over the *Small Cowper Madonna* in the better foreshortened and motivated right hand of the Virgin holding the Child. But Raphael clearly had some difficulty with the Virgin's other hand which he drew in three different positions.

The only drawing unquestionably for the *Niccolini-Cowper Madonna* (fig. 94) is in the Albertina in Vienna. In the center left of this sheet Raphael rapidly sketched in pen and ink a half-length Madonna and Child which correspond to the figures in the picture.[161] The drawing is not a simple preparatory study, however, for the other studies on the sheet are associable not with this picture but with others of about the same time. Evidently, when Raphael came to paint a Madonna toward the end of his stay in Florence, he was able to choose from among a whole series of solutions he had explored in his drawings. Though they were to result in different paintings, the studies on the Albertina sheet cannot be dissociated from each other. They all concentrate on the formal and psychological relation between the Virgin and Child. Focusing single-mindedly on this particular problem and excluding others, Raphael went so far as to render the Madonna's head as a simple oval, without hair or head-

dress. The drawing is full of expression, but devoid of Raphael's charm. He could only have learned such a highly intellectual approach to draftsmanship in Florence, from Leonardo, Michelangelo, and Fra Bartolomeo.[162] The result of this exploratory method of constructing and relating figures is the remarkable agility of the Child in the *Niccolini-Cowper Madonna.*

Raphael enlivened the formality of his *Madonna* by means of realistic accents which seem appropriate to its character as a devotional image. When he tried to combine the same features in a large altarpiece, however, the result was less successful. The picture closest in style to the *Niccolini-Cowper Madonna* is the *Madonna of the Baldacchino* (fig. 95), also of 1508, in the Pitti Gallery. This problematic altarpiece was partly finished by an assistant after Raphael left Florence for Rome. Yet the spirit in which it was composed and even the handling of certain details, like the sleeves of the angels' tunics, are comparable. The group of the Madonna and Child is similar in each work, too, though in the altarpiece it is Saint Peter, not the viewer, whom the Christ Child observes.[163] The question arises, then, as to

Fig. 95. Raphael, Madonna of the Baldacchino. *Galleria Pitti, Florence.*

Right: Fig. 96. Raphael, Studies of a Madonna and Child. *Ecole Nationale Supérieure des Beaux-Arts, Paris.*

which was done first, the scheme in the devotional panel or the one in the altarpiece? An answer is provided, perhaps, by a Raphael drawing [82] in the Ecole des Beaux-Arts in Paris. This sheet (fig. 96) contains rapid pen and ink sketches ostensibly for the Child in the altarpiece.[164] From the drawing we learn that at one time Raphael meant to have the infant looking at his mother. His legs are also apart, as in the *Niccolini-Cowper Madonna,* and his left hand likewise grasps her bodice. Thus, in the way this motif developed, the drawing seems to stand between the devotional panel and the altarpiece. Since the infant's impish behavior is uncustomary in a monumental altarpiece, it seems likely that Raphael adapted it from a more intimate work of half-length format, the *Niccolini-Cowper Madonna* perhaps, by way of drawings like the one in Paris. In any case, Raphael must have felt

Fig. 97. Raphael, Madonna and Child with an Angel. *Trustees of the British Museum, London.*

that the infant's gesture of trying to nurse was unsuitable for the enthroned figures in a *sacra conversazione,* and so he changed it. Unfortunately, in the process the gesture in the altarpiece became less meaningful.

Viewed in context, the *Large Cowper Madonna* represents one solution to problems Raphael explored in his drawings. No solution was final, however, and he often used his paintings as a beginning to explore further a given theme. A figure or two might be added, the setting or format changed, but the germ of the idea can almost always be detected in its later permutations. A revealing instance of this tendency is a pen and ink drawing [83] of a Madonna and Child (fig. 97) in the British Museum.[165] The drawing is a quick composition sketch, consisting of little more than outlines. There is virtually no modeling in light and shade, and the costumes and background

are barely indicated. Despite the summary nature of the sketch, the Madonna, lowering her head in profile, and the Child, straddling her knee, recall the group in the *Large Cowper Madonna.*[166] To these figures, shown full length in the drawing, Raphael added the motif, popular in Florence, of the kneeling angel supporting the Child. This addition results in a loosening of design unlike the strictly pyramidal structure of Raphael's contemporary paintings. The drawing can be dated on the basis of style to the time of the *Niccolini-Cowper Madonna.* It is possible, therefore, that he used the compact grouping in the picture as a starting point for the concept projected in the drawing. As far as we know, no picture corresponding to the sketch was ever completed, and it may be that, after transferring the support of the Child from his mother in the picture to the angel in the drawing, Raphael decided that the composition was too casual.

The Christ Child in the *Niccolini-Cowper Madonna,* we have seen, is both playful and imposing. His smiling expression, his gesture of wishing to nurse, and his posture of straddling the cushion all have the freshness and immediacy of an infant's behavior. On the other hand, his large-proportioned body and the way his right arm hangs heavily at his side suggest the importance proper to the Son of God. The same combination of dissimilar or even opposed characteristics is found in other contemporary treatments by Raphael of themes involving children. In a pen and ink drawing [84] at Oxford, for example, a group of seven nude infants (fig. 98) are shown at play.[167] Though lacking wings, they belong to a long tradition of representing such putti, including sculptural reliefs by Luca della Robbia and Donatello. Indeed, the frieze of a Donatello pulpit in San Lorenzo in Florence has been suggested as a source for the Oxford drawing.[168] But Raphael's children, unlike Donatello's, have an earnest air, as they enact the scene of a prisoner unwillingly brought be-

fore a judge seated on an urn. Just as the Christ Child in the National Gallery painting is not merely tender, so the putti playing in the drawing are not only humorous. The Oxford sheet has been dated to the time of the painting on the basis of style. Raphael's distinctive conception of childlike behavior as having its serious side also serves to connect the two works.

Rome

Florence was Raphael's destination when he undertook to improve his art. But after four years there he found that opportunity lay elsewhere. Not content to go on producing portraits and Madonnas, and apparently having failed to obtain a commission he sought for a monumental work, Raphael set out for Rome. Exactly when and under whose auspices he went there are still matters of debate. A letter to his uncle of April 1508 was addressed from Florence, while another letter to the painter Francia, the authenticity of which has been contested, was sent in September of the same year from Rome.[169] Was Raphael invited by Julius II to join the artists already at work decorating the papal apartment in the Vatican? Or was he asked to come to Rome by his compatriot Bramante, the architect of the new Saint Peter's? Another possibility, perhaps the most likely one, is that he was brought in to collaborate with his old master Perugino, who in 1508 began his share of the decoration, the ceiling of the room later to be called the Stanza dell'Incendio.[170]

At first Raphael played a minor role, limited to painting the vault of the Stanza della Segnatura, stylistically the least mature part of the room. His contribution was evidently seen as having surpassed Perugino's, however, for, unlike his former teacher, he was asked to proceed with the decoration of the walls. The completed cycles in this and the other Stanze of the Vatican are unquestionably Raphael's central achievement as a painter. His easel pictures and compositions dating from this period cannot be considered independently, for, as we shall see, the pictorial innovations developed for the frescos appear equally in his other work.

The ceiling of the Stanza della Segnatura bears directly on one of the first projects Raphael undertook after coming to Rome. About 1509-1510 he prepared a design of the Massacre of the Innocents, which was engraved by the Bolognese printmaker Marcantonio Raimondi (c. 1480-c. 1530), himself newly arrived in the city. One of the most famous reproductive prints ever made, Marcantonio's engraving (fig. 99) is known in two nearly identical versions. Though the precise attribution and dating of the prints are controversial, the example exhibited [86]—the one with the small pine tree in the upper right corner—bears Marcantonio's monogram on the pedestal on the left.[171] The engraving, which is datable about 1510-1511, is

among the earliest of Marcantonio's reproductions of Raphael's designs. It shows the women of Bethlehem fleeing with their children, pursued by Herod's soldiers. Represented nude, the executioners seize the women by the hair, seeking to stab their infants, some of whom lie dead on the pavement. Raphael's treatment of this pathetic theme contrasts the brutality of the soldiers with the protective gestures and pleading expressions of the mothers. The tumult is set off against the regular paving stones that recede toward a parapet and a city in the background.

A tour de force of classical narrative, the print does not seem to depend directly upon specific antique sources, however.[72] What Raphael had in mind in designing it was clearly Michelangelo's famous cartoon for the *Battle of Cascina* of 1505. That work, now lost, was well known to the younger artist before he left Florence. In fact, a sheet with preparatory drawings for the *Massacre of the Innocents*, now in the British Museum, also includes a copy of a figure from the cartoon.[73] But the relevance of Michelangelo's prototype to Raphael's design is not limited to borrowings, nor to the compositional scheme which the two works share. The cartoon of bathing soldiers being roused to battle was never carried out as a mural. Nevertheless, as a record of Michelangelo's concept, it captured the imagination of other artists, including Raphael. The idea was considered to be of value in itself.

On his way to Rome Marcantonio stopped in Florence, where in 1510 he engraved parts of the Bathers cartoon.[74] It may have been these copies that recommended him to Raphael when the painter presently decided to have one of his own concepts reproduced as an engraving. Unlike Michelangelo, however, Raphael never seems to have intended to turn his composition into a painting. In choosing to make a design specifically to be engraved, Raphael displayed the self-assurance which, along with his ability, won him the commission to decorate the Vatican Stanze. Despite its debt to Michelangelo, his design of the Massacre of the Innocents is highly original.[75] Significantly, he took credit for it on the pedestal in the print, which is inscribed "RAPH/URBI/INVE."

In Raphael's first Roman works the emphasis shifts decisively from imitation to invention. The extant preliminary studies for the *Massacre of the Innocents*, for example, indicate the care with which he conceived the composition. One of these, a sketch of five male nudes, has already been mentioned. Another pen and ink drawing (fig. 100) in the British Museum, representing the principal figures, is the same size and in the same direction as the print.[76] Though the figures in the drawing [85] agree with those in the engraving, there are a few significant differences. As a study of movement, the drawing represents all the figures nude, whereas in the print the women are clothed. Moreover, for the engraving, several subsidiary characters were added on the left to complete the design.

Fig. 99. *Marcantonio Raimondi after Raphael*, Massacre of the Innocents. *National Gallery of Art, Washington.*

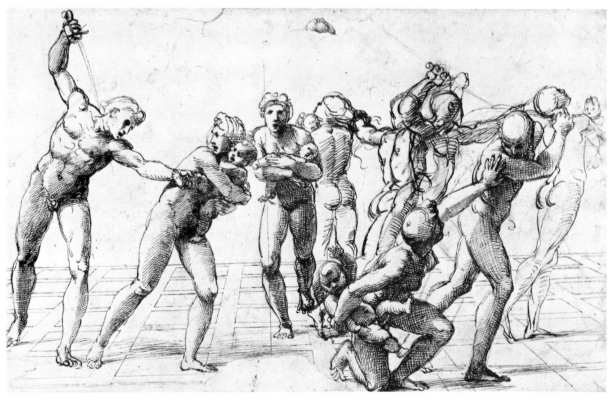

Fig. 100. *Raphael*, Massacre of the Innocents. *Trustees of the British Museum, London.*

Fig. 101. Orazio Fontana after Marcantonio's print,
Massacre of the Innocents. *Musée du Louvre, Paris.*

The major difference concerns the group in the right background. In the drawing the executioner seen from behind, grasping a woman by the hair, was depicted twice in opposite directions. Of the two alternatives Raphael evidently preferred the pair of figures moving toward the left, for it is that motif which is found in the print, offset there by a less active group on the right. The outlines of the figures in the drawing are pricked for transfer, except for the two on the right. As an afterthought Raphael discarded, they do not appear in a composition sketch at Windsor Castle that corresponds closely to the finished design in the engraving.[177] A further sheet elaborating individual figures, in the Albertina, also contains studies for the *Judgment of Solomon* on the Segnatura ceiling, thereby establishing a concrete link between the *Massacre of the Innocents* and the fresco.[178] It may have been Raphael's work on the fresco, in fact, which prompted him to take up the similar theme of the engraving.

The *Massacre of the Innocents,* perhaps the most renowned of all such engravings after Raphael, was the means by which his concept became widely disseminated. As a monochrome, the engraving concentrated on the formal structure of the original design. The sensuous, coloristic aspect missing in the print, as compared to Raphael's paintings, was supplied, however, when ceramicists adopted it as a model for the tin-glazed earthenware known as maiolica. Though Raphael did drawings for the decorative arts, chiefly mosaics and tapestries, his influence on ceramics was indirect, through engravings reproducing his designs.[179] Of the maiolica plates with the *Massacre of the Innocents,* one [87] by Orazio Fontana (1510-1571) is now in the Louvre.[180] Fontana's signed plate (fig. 101) dates from the

early 1540s, when he was still active in his father's workshop in Urbino. In fact, most of the maiolica based on Raphael was made after the time of his death. His design for the *Massacre of the Innocents*, further diffused in this way, had also to be modified in adapting the print to the circular shape of a plate. Thus, the infants lying dead in the engraving are missing on the ceramic, while domed structures added to the architecture in the background now rise above the figures. Similarly, the foliage at the sides was extended to suit the circular format. As painted, the design has a distinctly decorative character, provided not only by the more elaborate setting but also by the rich polychrome. In the translation much of the dramatic force of the original was lost. Nevertheless, the expressions and gestures of the figures, though bland and unmoving, are appropriate to maiolica, with its ornamental and functional purpose.

<p style="text-align:center">✳ ✳ ✳</p>

THE MAJOR WORK IN America from Raphael's Roman period is the *Alba Madonna* (plate 15) in the National Gallery.[181] Before it was transferred from a wood support to a square canvas in the mid-nineteenth century, the panel [92] had developed two extensive vertical cracks, one in the center through the Virgin's face and the other on the right through the landscape. The transfer resulted in a certain flattening of the surface, which thereby lacks some of the painterly nuances of better preserved works by the master's hand. Though not perfectly preserved, the painting, nevertheless, remains a masterpiece. In every respect—grace, majesty, complexity of form and idea—it surpasses Raphael's Florentine works.

Even before he came to paint the *Alba Madonna*, Raphael was experimenting with the old Madonna of Humility theme, in which he had the Virgin seated not on a cushion but directly on the ground. Four related sketches of the Virgin and Child with the Infant Saint John are presumed to be copies after a lost drawing by Raphael. The best of these [88] is in the British Museum.[182] The profile and left arm of the Virgin (fig. 102) recall the *Niccolini-Cowper Madonna*, suggesting a Florentine date for the lost original. The copies indicate that Raphael was working toward the solution that he would eventually adopt in the *Alba Madonna*. The composition anticipated the tondo in several ways, notably the pose of the Virgin with the Child on her right leg. The little Saint John in the sketch, however, is most unlike the picture. Omitted altogether in one copy, his figure is not adequately integrated with the group in the others, including the one exhibited. He might appear to be an afterthought, but this is not the case. The upright position of the Baptist is what Raphael found in contemporary Florentine sculpture. Both the circular marble relief of the subject by Rustici, now in the Bargello,[183] and the more famous tondo by Michelangelo in the Royal Academy in London,[184] include the Baptist as a standing figure, approaching the Madonna

Fig. 102. After Raphael, Sketch of a Madonna and Child with the Infant Saint John. *Trustees of the British Museum, London.*

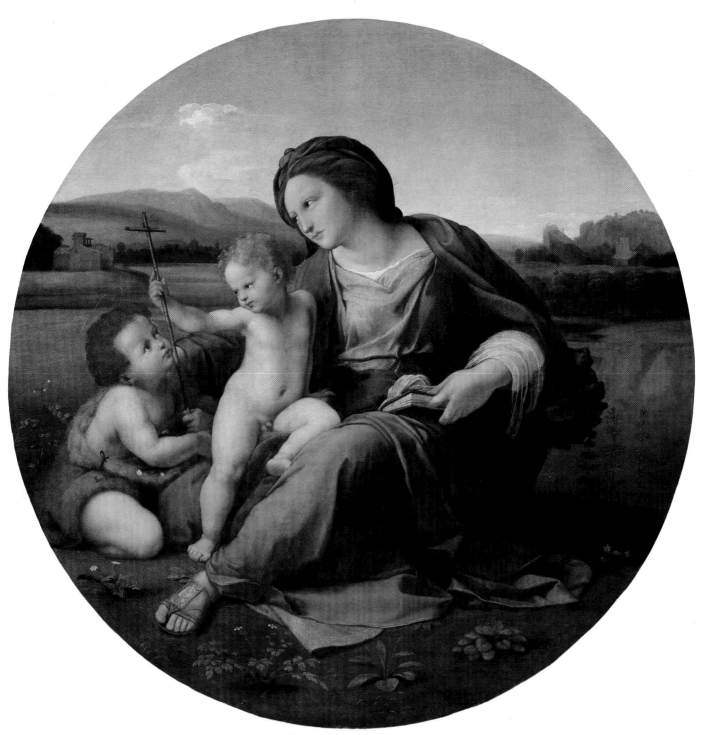

Plate 15: Raphael, Alba Madonna. *National Gallery of Art, Washington, Andrew W. Mellon Collection, 1937.*

Fig. 103. *School of Lorenzo di Credi*, Virgin and Child with the Infant Baptist. *Musée du Petit Palais, Avignon.*

Fig. 104. *Fra Bartolomeo*, Virgin and Child with the Infant Saint John. *Musée Bonnat, Bayonne.*

and Child from the left. Both reliefs show the Madonna in profile as well. In Rustici's she and her son ignore the Baptist, as in Raphael's lost drawing.

After coming to Rome, Raphael again took up the theme of the Madonna and Child with the Infant Saint John. In the *Alba Madonna* he grouped the figures in a broad low pyramid, aligning them within the circle in such a way that they not only conform to their space but dominate it as well. By contrast to the earlier lost drawing, the Virgin in the circular format now bends sharply forward, and the Baptist is represented kneeling. Perhaps because the tondo is preeminently a Florentine form, Raphael again chose to recall Florentine precedents, but from painting rather than sculpture. The Doni Tondo of Michelangelo in the Uffizi is an obvious and often cited source, but there are others.[185] Though differing in many details, a work in Avignon (fig. 103) by a pupil of Lorenzo di Credi has the same basic scheme.[186] Even closer in design to the principal figures in the *Alba Madonna* is a black chalk drawing in Bayonne of the Virgin and Child with Saint John (fig. 104) by Fra Bartolomeo.[187] Aside from the way the Baptist joins the group, what these works have in common with Raphael's is, above all, the extended left leg of the Virgin. In Fra Bartolomeo's drawing and in Raphael's painting the Christ Child is placed close to his playmate, allowing the Virgin's projecting left leg to form a base for the figures.

Raphael thus continued to feel the impact works of art had made on him in Florence. As Heinrich Wölfflin noted in his classic study of High Renaissance style, the *Alba Madonna*, in particular the way the Virgin gracefully bends over the children, echoes Leonardo's *Saint Anne*.[188] But far from being retrospective, Raphael's painting is a Roman work, as different from the *Nicolini-Cowper Madonna* as that picture is from an Umbrian one. The *Alba Madonna* no longer attempts to combine the particular sense of immediacy and grandeur of Raphael's later Florentine productions. This painting, and the one most like it, the *Madonna Aldobrandini* in the London National Gallery, have a delicacy of color and mood not found in Raphael's oeuvre since his Umbrian period.[189] Dressed in hues of rose pink, pale blue, and green, the figures in each painting are placed before bucolic landscapes. Though the setting in the *Alba Madonna* has often been identified as the Tiber valley, the landscape, like the figures, belongs to the idealized classical world which Raphael evoked in the Stanza della Segnatura.[190] Among the frescos of Raphael's first mural decoration in Rome, it is the *Parnassus* which is closest in style and date to the Washington painting.[191]

Raphael's Madonna has the dignified, serious, but gentle aspect of the muses in the fresco. What is most remarkable about her figure is the way she is seated on the ground. Some hints toward this highly unusual pose were offered by Florentine art, as we have seen. But its only real analogues are in the Stanza. The figure of Diogenes, for in-

stance, reclining on the steps in the *School of Athens,* is similar in reverse. But the nearest parallel is found among the company of muses in the *Parnassus.* Sappho, in the lower left, her leg drawn up and foreshortened, is comparable. The relationship may be seen even more clearly in the preliminary drawing [89] in the British Museum (plate 16) for this and seven other figures on the left in the fresco. The careful finish of the drawing, in metalpoint on pink prepared paper, made it suspect as a copy, but Oberhuber rightly perceived the mastery with which the hatchings complete the faint outlines of the figures.[192] Sappho's dynamic pose and delicate modeling in the drawing have precisely the same character as the treatment of the Virgin in the *Alba Madonna.*

A first idea for the Washington Madonna is contained, perhaps, in a drawing at Oxford, where a nude female figure, sketched in pen and ink, is shown seated on the ground.[193] The arms are supported and extended in a manner similar to the painting, and the right leg is foreshortened, too. Though it may have served for the *Alba Madonna,* the female figure in the drawing was evidently made for the muse reclining to the left of Apollo in the *Parnassus.* The attitude in the fresco and the drawing is nearly identical, except for the head in the sketch, which is lowered, as in the *Alba Madonna,* suggesting further that the drawing for the muse may have been the germ from which the figure of the Virgin grew.

Raphael's muse has a classical source in a statue of Ariadne in the Vatican. A drawing by the artist in the Albertina links the fresco with the antique precedent on an almost one-to-one basis.[194] The question naturally arises, therefore, as to whether the analogous figure of Raphael's Madonna, with her classical costume of turban, sandals, and flowing robes, does not also have a source in ancient art. Like the *Parnassus,* the *Alba Madonna* does show the impact that ancient Rome first had on Raphael's imagination. The accessories, even the landscape have an antique cast, as we have seen. Less obvious, but no less important, a work of ancient sculpture may have provided the pose for the Madonna in the picture. This is not surprising, since the *Parnassus* is full of recollections, almost archeological, of classical sculpture.[195] Furthermore, the pose in question is so unusual for a Madonna that it is difficult not to believe that Raphael adopted it out of admiration for some work of classical art he had seen. The distinctive arrangement of the legs of Raphael's Virgin, one of which is extended while the other is bent beneath her, and the movement of her upper body, leaning forward, rule out the standard types of recumbent or seated figures. The complexity of the pose is shown more clearly in the drawing at Lille from a live model (fig. 106) than in the draped figure in the picture. The sharply bent leg suggests Michelangelo's *ignudi* on the Sistine Ceiling, which Raphael could have seen at this time, as well as Michelangelo's source in the classical type of seated Diomedes.[196] But that is only one element in the pose of Raph-

Plate 16. *Raphael, Figure Studies for the* Parnassus. *Trustees of the British Museum, London.*

ael's Madonna, which differs in other respects.[197] Perhaps, for all the various suggestions lying behind it, the contortion of the figure is not a quotation from antique sculpture, but Raphael's personal invention. He varied it several years later for the figure of Saint John in the *Transfiguration.*

Even if not derived from a specific antique, the pose of Raphael's Madonna recaptures the complex movement of ancient sculpture. The greater amplitude of the figure points to the same source. But while the underlying allusions might have gone unnoticed by Raph-

ael's contemporaries, the *cognoscenti* would have recognized the costume of the Virgin as antique in manner, especially the sculptural rhythm of the draperies. Their rich folds and the subtle play of light over them would have delighted a humanist, such as Paolo Giovio. He is sometimes said to have given the picture to the Olivetan monastery at Nocera dei Pagani near Naples, where it was originally located.[198] Not only in form but also in concept, the *Alba Madonna* adopts the classical language of the Stanza della Segnatura. The tondo reflects the same synthesis of Christian and pagan culture that inspired the decoration of the room. The meaning of the fresco program has been variously interpreted, but all writers agree that the harmonization of Christian and classical thought is its organizing principle. The Virgin in the *Alba Madonna,* among the most remarkable of Raphael's pictorial inventions, is in this sense a kind of sacred muse.

Fig. 105. *Raphael,* Sketch of a Madonna and Child with the Infant Saint John. *Musée des Beaux-Arts, Lille.*

Fig. 107. *Biagio Pupini,* Holy Family with Saint John. *Cabinet des Dessins, Musée du Louvre, Paris.*

One of Raphael's most important and celebrated drawings, the large double-sided sheet at Lille already mentioned, contains studies for the *Alba Madonna.*[199] The main composition on the front side of the sheet (fig. 105) could only be for that painting, while the other pen and ink sketches at the top are usually connected with the *Madonna della Sedia* or the *Madonna della Tenda* in Munich. The pen and ink study of the Child in the lower right corner is apparently an alternative for the Christ Child in the *Alba Madonna.* At this stage in the evolution of his design, Raphael already had the circular format in mind, as indicated by the framing lines around the figures. In the drawing, however, the figures are larger in scale in relation to the frame, which their rhythmical postures accentuate. When he did the painting, Raphael expanded the space around the figures and gave the Virgin's drapery a classical amplitude, thereby lending a greater stability to the group. By enlarging the setting, Raphael also gave it a more explicit character: the Madonna rests against a tree stump, surrounded by flowers and a serene expanse of sky.

The technique of the main sketch, rendered in pen and ink over red chalk, provides a clue to its purpose, other than that of establishing the composition. Certain of the contours were reinforced in pen, marking the faces and upper bodies of the Christ Child and Saint John as being of special concern to the artist. It is here in working out the relation between the two children that the only changes of mind occur. Careful examination of the sheet reveals that the Baptist was originally shown holding and offering a lamb, not flowers or a cross, to his playmate. The Child, accordingly, rests his right hand on the lamb's head, drawn in pen over chalk, and in another overlapping variation raises his hand to point upwards. The lowered arm was drawn first in red chalk and then gone over in pen, whereas the arm which is raised, as in the final painting, was rendered only in pen, indicating that it occurred to Raphael while he was in the process of working out the composition. The arm drawn first was then canceled with parallel hatchings to suggest shadow. Behind the two children in the drawing we can make out an open book, held by the Madonna in her right hand. Her left grasps a fold of drapery.

Changing the Child's gesture in the drawing brought the raised arm into conflict with the book held up by the Virgin. Raphael corrected this problem on the back of the sheet (fig. 106), already mentioned, which contains a red chalk study of an assistant dressed in contemporary costume. Mainly an attempt to clarify the difficult posture of the Virgin, the drawing also reveals that Raphael had decided to transfer the book from the figure's right hand to the left. The right hand is now extended palm upwards, the artist having evidently determined to show the Madonna caressing the chin of the little Saint John, not embracing him, as in the picture. The book, too, which the Virgin has closed, keeping her place, is held at a different angle here than in the finished painting.

Fig. 106. Raphael, Study of a model for the Alba Madonna *(reverse of 105). Musée des Beaux-Arts, Lille.*

Fig. 108. Raphael, Alba Madonna *(detail). National Gallery of Art, Washington.*

This stage in the composition, involving the transfer of the book, is reflected in two copies of a lost drawing by Raphael. One of these copies, formerly considered autograph, is in the Albertina.[200] The other [90], attributed to the sixteenth-century Bolognese artist Biagio Pupini, is in the Louvre (fig. 107).[201] In the copies, the book is held in the Virgin's left hand in the more vertical position of the Lille drawing, while the Christ Child's pointing gesture is set off above his companion. The Baptist's head, in three-quarter view in the copies, is closer to the painting than is the profile in the Lille drawing. The Virgin's gesture of caressing the Baptist's chin in Pupini's drawing explains the extended right arm of the figure on the verso of the Lille sheet. The Saint Joseph and the background are presumably the copyist's additions.

A study in Rotterdam [91] for the figure of Saint John (plate 17), in metalpoint on cream prepared paper, records a later stage in the composition.[202] The carefully finished technique of this drawing, like that of the study for the *Parnassus* in the British Museum, caused some writers to doubt its authenticity. But such delicacy is characteristic of certain of Raphael's early Roman works, both drawings and paintings. Evidently, a fresco or picture of the period around 1510, like the *Parnassus* or the *Alba Madonna*, was the product of two different and seemingly incompatible means of graphic preparation: once the composition had evolved in free sketches like the one at Lille, Raphael apparently felt the need to restudy individual figures in drawings whose fineness approaches that of the paintings themselves.

The little Saint John in the Lille drawing and the Louvre and Albertina copies was represented praying or holding the lamb between his arms and his right leg, which is drawn up. In the Rotterdam drawing he is shown kneeling. And he holds an armful of flowers rather than the lamb. The floral motif, found first in the Rotterdam drawing, was the one that prevailed in the picture. There, however, the infant wears a hairshirt instead of the cloth garment in the drawing. The lamb, which the Baptist offered to the Child in the previous drawings, signified Christ's future self-sacrifice. A motif so important could not be omitted without a loss of meaning. Accordingly, in the Rotterdam drawing Raphael substituted a reed cross, the symbol of the Baptist. Its faintly drawn shaft can just be discerned in the boy's left hand.

The drawing, limited only to Saint John, does not reveal the crucial role the cross will play as a compositional and emotional focus in the final painting (fig. 108). In the *Terranuova Madonna* (fig. 61), painted some six years earlier, Raphael had introduced a small reed cross as the attribute of Saint John, who offers a scroll to the Christ Child. Soon afterwards, in the *Madonna of the Meadow* (fig. 63), the Child grasps the cross now held up to him by the Baptist. The two children look at each other. Later, in the *Alba Madonna*, it is the cross,

or rather the Christ Child's gesture of taking it, which is the focus of attention for all three figures. Their gazes are fixed on the symbolic act, as if they had some knowledge of its significance for Christ's future sacrifice. The flowers in the painting also have a symbolical as well as decorative significance. The anemones, for example, gathered up in the arms of Saint John, are sometimes called the flower of the Resurrection and are thus a symbol of immortality, while the white dandelion between Saint John and the foot of the Virgin was considered a bitter herb and so a symbol of the Passion.[203]

The profundity of emotion which Raphael's picture conveys may have been a result of his work on the *Massacre of the Innocents* (fig. 99).[204] The maternal grief he had to communicate in the print came to mind, perhaps, when he took up the theme of the painting. In the *Alba Madonna,* however, the figures gaze at the cross with expressions that are poignant, not shrill. Their intensity suggests that Raphael was recalling Leonardo's *Madonna with the Yarnwinder* (fig. 62). In that painting, now lost, the yarnwinder was held up by the Christ Child in the semblance of a cross, his gesture signifying the acceptance of his future Passion. Gradually, after the picture was taken to France, the motif of the yarnwinder seems to have been forgotten or ignored by imitators who adopted in its place the more explicit and familiar reed cross. As his Terranuova and Bridgewater Madonnas testify, Raphael was acquainted with Leonardo's composition. But in adopting the motif of the cross, Raphael only gave it the force of the original yarnwinder after he left Florence. In the *Alba Madonna* he even retained the gesture of Leonardo's Christ Child, his index finger pointing upward as he grasps the cross. But it is the little Baptist in particular who recaptures the sense of wonder expressed by the Christ Child in the earlier work, a feature which struck viewers of Leonardo's picture.[205] The seriousness and dignity of Raphael's figures, and their air of foreboding, contrast with the domestic intimacy and lightness of mood of his earlier Madonnas.

We have seen how Raphael's preparatory studies for the *Alba Madonna* were copied and adapted by his contemporaries. Three pages of pen and ink sketches in the British Museum, Windsor Castle (fig. 109), and the Louvre show that the finished painting also provided a stimulus to artists.[206] During the last century these drawings were published as by Leonardo and even cited as sources, moreover, for Raphael's *Alba Madonna*.[207] Later they were correctly attributed to Cesare da Sesto (1477-1523), a Milanese follower of Leonardo.[208] The sheet at Windsor has been catalogued as a copy by Cesare after lost Raphael sketches for the painting.[209] This view is the one held by Jack Wasserman in his recent analysis of the genesis of the Washington picture. But Cesare's drawings are not, in my opinion, precise copies of free sketches, but an eclectic blend of motifs derived from the great High Renaissance masters. His drawings of the type under consideration here are not his own preparatory sketches, nor are they

Fig. 109. Cesare da Sesto, Studies of the Madonna and Child with Saint John.
Windsor Castle, Reproduced by gracious permission of H.M. Queen Elizabeth II.

exact and reliable copies of such sketches by other artists. Instead, as the rather finished penwork indicates, they are variants of works in painting. Their interest lies not in the development of a specific composition by Cesare or another artist but in the way Cesare has recalled and cleverly combined motifs from disparate sources.[210]

Having left Milan for Rome during the second decade of the sixteenth century, Cesare admired the current work of Raphael and Michelangelo. Said to have been personally acquainted with Raphael, he could easily have seen the *Alba Madonna* in progress. In the British Museum drawing [93] the Virgin is depicted twice, and in each case her left arm either resembles that in the painting or supports her figure on the ground. In the sketch enclosed in a rectangular frame in the upper left, the two children are included. They are shown embracing, a favorite theme of Leonardo and his circle. In the sketch on the left in the Windsor sheet [94], the children are likewise entwined. But in the alternate design on the right, the Christ Child blesses the Infant Baptist, who kneels praying, as in the *Madonna of the Rocks.* Below in several sketches Cesare has the Baptist climb on the lamb, a motif adapted from Leonardo's *Saint Anne.* Finally, in the Louvre drawing [95] the Christ Child straddles his mother's left leg and blesses his playmate, again astride the lamb. To judge from his reflections of the *Alba Madonna,* Cesare da Sesto was fascinated by its strongly projecting curved forms. His sketches after it have a playful mood, not the depth of feeling of the original, and he shows little sympathy for the classical grandeur Raphael achieved.

177

OF THE THREE great masters of the High Renaissance in Central Italy it is Raphael who, in the way we have seen him develop, appears the most modern. Leonardo, after he returned to Florence in 1500, shows little change in his style. Instead, through the immense conceptual effort recorded in his drawings, he saw fit to create works of art which, like his scientific inventions, were final, consummate statements of principle. In certain genres—the portrait, the battle-piece, half- and full-length Madonnas—Leonardo established models which he pondered and slowly elaborated. The execution of his designs as finished paintings was prolonged over many years. In Michelangelo's case the changes that occurred in his art were not so much a matter of developing from one style to another as a deepening of qualities present from the beginning. What differences can be observed between his frescos and sculpture have to do with an oscillation between two seemingly contradictory tendencies, one toward ornament and artifice and the other toward a profound spirituality. Always at the center of Michelangelo's world is the male nude. Less intellectual than Leonardo and less passionate than Michelangelo, Raphael is the only one of the three to show the kind of rapid growth in response to new stimuli which we have come to regard as typifying creative genius. But because Raphael is the paradigm of the artist in this sense, we are likely to forget just how extraordinary and unprecedented his development was. After he came to Rome, the central focus of change in his style was the frescos of the Stanze. The dramatic narratives of the Stanza d'Eliodoro, for example, succeed the harmonious compositions of the Stanza della Segnatura. Such changes as we find from one room to another, or, indeed, from one fresco to another in a given room are reflected in the easel paintings of the time.

The controversial attribution of one of these oil paintings, the *Portrait of Bindo Altoviti* (plate 18), has already been discussed in connection with its acquisition by Samuel H. Kress.[211] The portrait [98] differs in so many ways from Raphael's earlier, more classical works, such as the *Alba Madonna*, that it has often been attributed to his pupil, Giulio Romano. Yet the flesh does not seem like enamel, nor the hair metallic, as in comparable portraits by Giulio, like the *Young Woman* in Strasbourg or the *Boy* in the Thyssen Collection in Lugano.[212] In addition, like the *Alba Madonna*, it bears a definite relation to Raphael's work in fresco. Some authors who consider the painting to be by Raphael do so on the basis of his responsibility for the *Fire in the Borgo* fresco in the Vatican of 1514-1515.[213] Raphael, it is now realized, played a decisive role in the execution and not just the design of the mural.[214] Nevertheless, the most nearly comparable figures in the fresco, namely, the so-called Aeneas and Anchises group to the left, appear to me to show a somewhat more developed style newly influenced by Leonardo who came to Rome late in 1513.[215] The difference in style between *Bindo Altoviti* and the *Fire in*

Left: Plate 18. Raphael, Portrait of Bindo Altoviti. National Gallery of Art, Washington, Samuel H. Kress Collection, 1943.

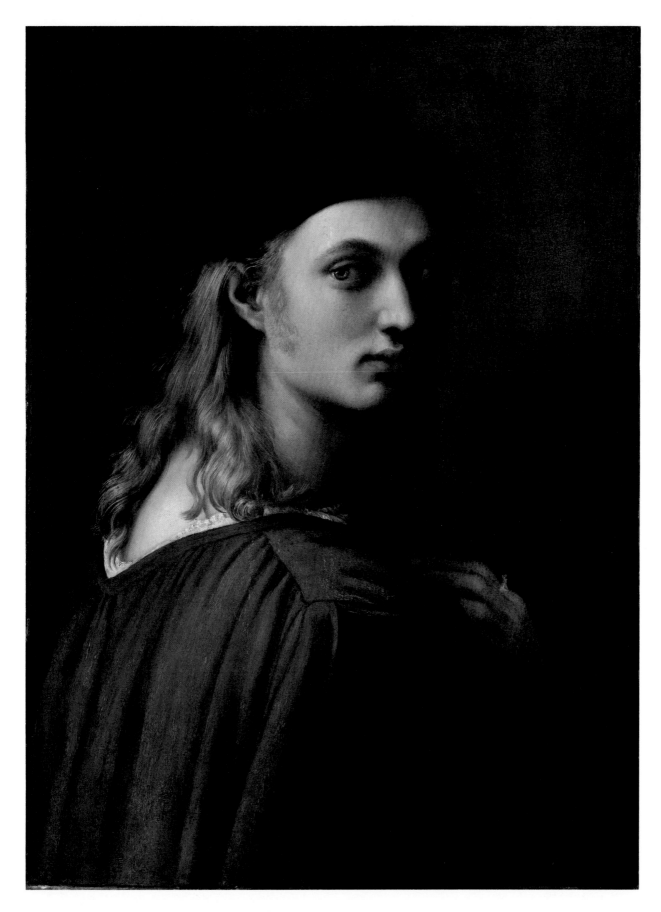

Fig. 110. *Raphael, Detail of Saint John from the* Saint Cecilia *altarpiece. Pinacoteca Nazionale, Bologna.*

the Borgo is even more apparent if we compare the portrait with easel works datable to the time of the fresco, such as the *Saint Cecilia* altarpiece in Bologna. Here the forms of the similarly youthful figure of Saint John (fig. 110) are larger and more softly modeled than in *Bindo Altoviti.* Turning to a portrait of this period, the *Castiglione* in the Louvre, we find that the modeling is more careful than in *Bindo Altoviti* and that the sitter is characterized so as to give us a sense of his individual humanity.

The seemingly mannerist characteristics in *Bindo Altoviti,* the florid flesh color, the twisting glance over the shoulder, and the dark shadows, which have been taken to suggest Giulio, are found, on the contrary, in works by Raphael, but not those of 1515. The work

Fig. 111. *Raphael,* Expulsion of Heliodorus *(detail). Stanza di Eliodoro, The Vatican. Alinari/Editorial Photocolor Archives.*

which seems to me to be closest in style and mood to the portrait is the *Expulsion of Heliodorus* in the Vatican of 1512.[216] In the group of portrait figures surrounding the pope on the left in the fresco (fig. 111) appear the same turn of the head to look at the viewer, the same heavy facial features, and the same silky hair falling in long curls over the neck. In *Bindo Altoviti* the drama of the pose is heightened by the brilliant color scheme, which sets rose red lips and pink cheeks, shimmering golden hair, and a blue garment against a vibrant green background.[217] The colors used in the fresco, though not precisely the same, are similarly set off by somber tones of black and gray. Such a rich color combination of blue, green, and gold, contrasted with black and gray, as we find in the portrait was also adopted for the *Madonna of Foligno* of 1512 in the Vatican. The use of color in Raphael's later works, among which *Bindo Altoviti* is often placed, tends to be more jarring.

180

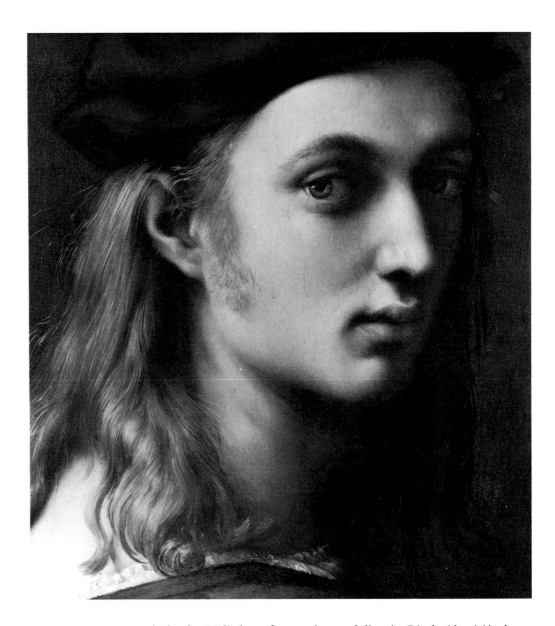

Fig. 112. Raphael, Bindo Altoviti *(detail). National Gallery of Art, Washington.*

As in the *Heliodorus* fresco, the modeling in *Bindo Altoviti* is dense (as the x-radiograph shows, with a great deal of white lead) and schematic, built up of contrasts of light and dark gray shadows. Indeed, the concept of chiaroscuro in the portrait was adopted from the fresco, where the portrait heads already mentioned emerge from the darkness into the light. Photographs of *Bindo Altoviti,* exaggerating the tonal contrasts and lacking color altogether, distort the balance of light and color and deceptively give the painting the look of a late work. As for the psychology of Raphael's portrait (fig. 112), the twisting glance over the shoulder shares the dramatic tenor of the fresco. The sitter—young, handsome, and rich—has a vivacity and directness of expression quite unlike the finely nuanced characterization of the *Castiglione.* The *Portrait of Bindo Altoviti* thus seems to fall between the delicate style of Raphael's *Cardinal* in Madrid, datable to the time of the Stanza della Segnatura, and the more mature and

Fig. 113. Agostino Veneziano, Figures from the School of Athens. *Trustees of the British Museum, London.*

refined style of the *Castiglione,* which mirrors the *Fire in the Borgo.* It clearly reflects the dramatic manner evolved for the *Expulsion* fresco of 1512. If this date is acceptable for *Bindo Altoviti,* Giulio Romano, then aged thirteen, is ruled out as its author. The sitter, born on November 26, 1491, would have been twenty-one years old at the time his portrait was painted.

Raphael has portrayed Bindo from the side in a daringly contrived pose which contributed to the belief that the painting was a self-portrait of the artist. The sense of a figure in motion is partly lost in the picture in its present state, because the folds of the sleeve of the extended right arm have become obscure. This quality of animation is better conveyed by reproductive engravings (fig. 114), showing the painting as it looked more than a century ago. In pose the *Bindo Altoviti* is most like a figure in near profile in the *Heliodorus* fresco, sometimes identified as Raphael himself. This figure wears a similar garment, cut low in the back emphasizing the curve of the shoulder, and also raises his left hand to his chest. The gesture of the hand held lightly on the chest recurs among the acolytes and bystanders in the fresco of the *Mass at Bolsena* adjacent to the *Heliodorus.*

The origin of the pose lies in the *School of Athens* in the preceding Stanza, specifically in the tall young disciple in white robes standing behind Pythagoras on the left.[218] Looking over his shoulder at the viewer, the youth has not surprisingly been called a portrait, but in fact the outward glance would seem to be a traditional communicative device.[219] How effectively this figure relates to the viewer may be seen from the way it is featured in an engraving (fig. 113) of the group of Pythagoras and his disciples [97], made four years after the death of Raphael by Agostino Veneziano. Perhaps to facilitate the sale of the sheet, Agostino represented the philosopher as Saint Luke in the act of writing on a tablet.[220] Better in the print perhaps than in the group in the mural, we grasp the implication that the youth was moving forward a moment before, but that his progress to the right has been interrupted by the viewer, whom he confronts with an arresting glance. The figure's left hand, visible behind his sloping right arm, serves to close off or stabilize the strongly directional aspect of the pose. Just such a formula, combining dynamic movement with a pause to face the viewer, was adapted from the free-standing figure in the fresco for the half-length *Portrait of Bindo Altoviti.* In the portrait the head and body are likewise turned in opposite directions. The way the complicated pose is played off against the picture plane is what lends Raphael's portrait its extraordinary boldness.

Just as Agostino Veneziano later isolated the Pythagoras group from the *School of Athens* for his print, so Raphael seems to have taken over the pose of the youth in the fresco for his independent *Portrait of Bindo Altoviti.* Other sources have been proposed, but it is, perhaps, more likely that Raphael's picture provided a model for them. The Venetian analogues for the pose of glancing over the shoulder, like

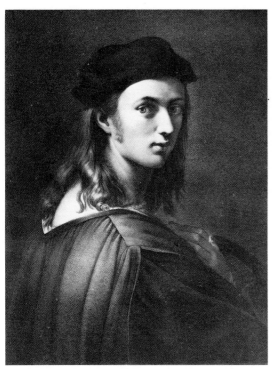

Fig. 114. Ferdinand Piloty, Portrait of Bindo Alto-
viti. *Trustees of the British Museum, London.*

one attributable to Palma Vecchio in Munich, show the right arm
bent, as if resting on a ledge.[221] Sebastiano del Piombo's *Violinist* in
the Rothschild Collection in Paris, painted in Rome about 1515,
would seem to combine the Venetian type with a dynamic sugges-
tion of movement from *Bindo Altoviti*.[222] In Florence, the *Portrait of
a Man,* attributed to Sarto by Shearman and dated by him about
1515-1516, corresponds in reverse to Raphael's likeness of the Flor-
entine banker,[223] while Franciabigio's *Portrait of a Man* in Detroit,
recently dated 1513-1514, combines a design and chiaroscuro struc-
ture remarkably like Raphael's with a Leonardesque pointing ges-
ture.[224] Since the animating device of the over-the-shoulder pose was
of concern to several artists, it is difficult to say whether their por-
traits derive from Raphael's or are independent of it. *Bindo Altoviti,*
however, would seem to have priority in respect to the others.

The painting is generally recognized today as the portrait men-
tioned by Vasari of the young banker by Raphael. It has nevertheless
been the subject of much dispute in the past regarding the identifica-
tion of the sitter. The controversy arose from the ambiguity of
Vasari's description. His phrase "il ritratto suo" might be taken to
refer to a self-portrait of Raphael.[225] As such, the picture was repro-
duced in an early lithograph (fig. 114) by Ferdinand Piloty [96]
made after the original, then in Munich. Though the view that Vasari
referred to a self-portrait has now lost favor—we know from other
likenesses that Raphael had dark hair and eyes—the belief that the
portrait was not only by but of the most revered of artists brought it
an extraordinary fame early in the nineteenth century. It was end-
lessly reproduced in prints like Piloty's.[226] And the polemic about
whether or not it depicted Raphael aroused the kind of passion nor-
mally reserved for debates about politics or religion. When, after
much intrigue, the "heavenly painting of the immortal Raphael" was
finally acquired for Ludwig of Bavaria in 1808, his agent rejoiced
that, like a relic, it preserved "the spirit, the soul of a saint of art."[227]

The concern with Raphael's physiognomy peaked when his tomb
in the Pantheon was opened in 1833.[228] The skeleton was well pre-
served, and the skull, when measured, was found to be consistent
with the self-portrait in the *School of Athens.* Before Raphael's remains
were reinterred, a cast was made of his skull. Half a century later, to
celebrate the artist's 400th birthday, the German anthropologist
Hermann Schaaffhausen published a book on the subject.[229] Coin-
ciding with the heyday of craniometry, Schaaffhausen's book in-
cluded a woodcut [99] of Raphael's skull (fig. 115), made after the
cast, which he had been permitted to study some years before. By an-
alyzing the skull, Schaaffhausen found that its small size and rather
feminine features were in accord with Raphael's well-known love of
beauty and graceful style of painting. Commenting on Schaaffhau-
sen's anniversary booklet in an article [100] that came out the follow-
ing year, anthropology professor Hermann Welcker from Halle at-

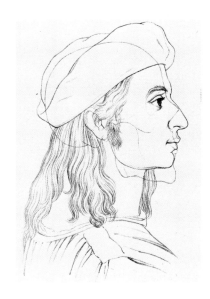

Left: Fig. 115. Plate from Schaaffhausen's Schädel Raphaels *of 1883, showing Raphael's skull (reversed).*

Right: Fig. 116. Plate from Welcker's "Schädel Rafael's" of 1884, showing the skull imposed on a profile version of Bindo Altoviti.

tempted to place the results of science in the hands of art historians. He hoped to settle once and for all the issue of which of the alleged Raphael portraits or self-portraits most resembled his skull. Superimposing a profile drawing of the portrait now in Washington on the skull (fig. 116), Welcker concluded that it had none of Raphael's features, but rather belonged in "forehead, nose, eyes, mouth, and chin to another, radically different type."[230] Unfortunately, Welcker's investigation yielded few conclusive results, since none of the other portraits exactly corresponded to the skull either.

Jean-Auguste-Dominique Ingres, the great French painter regarded as the heir of Raphael in the nineteenth century,[231] was convinced by the identification of Raphael's portrait as a self-portrait. He used it or a version of it as a reference in his *Betrothal of Raphael and the Niece of Cardinal Bibbiena* (plate 19) of 1813, now in the Walters Art Gallery in Baltimore.[232] Henry Walters, perhaps because he had just acquired a painting by Raphael which Ingres admired, was led in 1903 to purchase this work [101] by the French master. The Baltimore painting is the first in a series in which Ingres intended to depict the main events in the life of his idol, as they were described in various literary accounts which he consulted.[233] Like many of his colleagues in the nineteenth century, Ingres was drawn to the lives of the artists of the Renaissance. But in this case, his absorbing interest in Raphael's life and work is comparable in its own way to Passavant's pioneering monograph, of which the French edition was, in fact, dedicated to Ingres.[234] It is not only that the composition of the *Betrothal* is appropriately based on Raphael's *Marriage of the Virgin* in the Brera. Like an art historian investigating an artist's sources, Ingres went on to take the heads of the three main characters in his picture from sources in works by or attributed to Raphael. The cardinal's likeness in the center of the composition is copied from the portrait of him, once attributed to Raphael, in the Pitti Gallery.

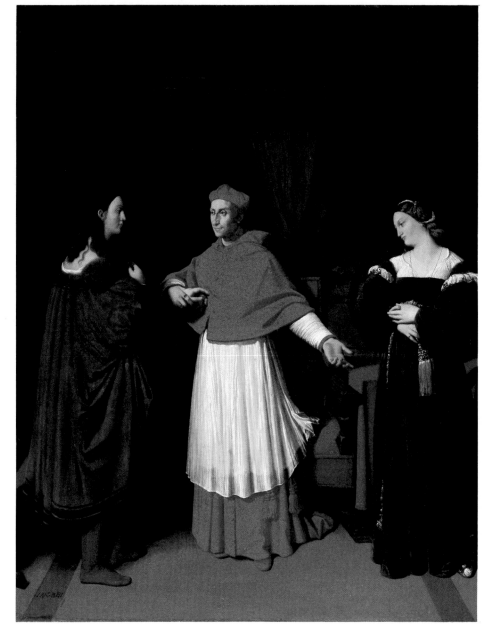

Fig. 117. Jean-Auguste-Dominique Ingres,
Betrothal of Raphael to the Niece of Cardinal Bibbiena. *Cabinet des Dessins, Musée du Louvre, Paris.*

Right: Plate 19. Jean-Auguste-Dominique Ingres, Betrothal of Raphael and the Niece of Cardinal Bibbiena. *Courtesy of the Walters Art Gallery, Baltimore.*

Maria Bibbiena's features are modeled on those in Sebastiano's so-called *Fornarina* in the Uffizi Gallery, then given to Raphael. And, as we have already noted, the head of Ingres' figure of Raphael on the left is an adaptation of *Bindo Altoviti*.[235] To suit his narrative Ingres turned the head from three-quarters to a profile view. But the facial features, the costume, and above all the pose, with the hair falling over the back turned to the viewer, are unmistakably similar. Ingres substituted a green tunic in his painting for the blue one found in Raphael's, so we cannot be sure whether his model was the picture or an engraving after it.[236]

Ingres' painting follows a drawing [102] of the same subject (fig. 117), signed and dated 1812, in the Louvre.[237] Recently, it has been suggested that the drawing may actually have been done in the 1820s

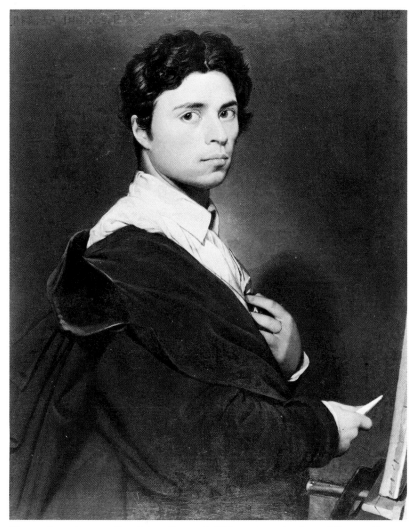

Fig. 118. Jean-Auguste-Dominique Ingres, Self-Portrait at the Age of Twenty-Four. *Musée Condé, Chantilly.*

as a pendant to a drawing of Raphael and the Fornarina of 1825.[238] This is unlikely for the simple reason that the figure of Raphael in the drawing of the *Betrothal* is even closer to Ingres' source, *Bindo Altoviti,* than is that figure in the Baltimore painting. Thus the drawing most likely preceded the painting. In the drawing, as in Raphael's portrait, the young artist raises his left hand to his chest and extends the right hand, grasped by Bibbiena, toward the cardinal's niece. Evidently Ingres found this position for the hands awkward and reversed them in his picture. It is now the right hand which is raised, and the left extended. Several other variations are introduced too. The Louvre drawing was repeated in 1864, with a few additional changes, on a sheet with colored washes in the Fogg Museum.[239] Ingres, it seems, never lost his fascination with the theme.

Ingres' admiration for Raphael was unbounded. Moreover, his borrowings from the earlier artist's works involve a strong element

of self-identification. Thus, it is not surprising, though it never seems to have been noticed before, that Ingres' *Self-Portrait* (fig. 118) at Chantilly takes *Bindo Altoviti* as its inspiration.[240] Though he began it in 1804, when he was twenty-four, Ingres repainted the canvas shortly before 1851, perhaps in preparation for the engraving by Réveil [103], published in that year, which shows the painting in its present state. In his self-portrait Ingres has consciously modeled his features on those which he believed to be Raphael's, and he has captured as well the intensity of the gaze over the shoulder. The coat worn back on his shoulders recalls *Bindo Altoviti,* and so do the hands, which are posed as in Raphael's painting; the one raised to the chest even displays a ring. The gesture of the extended right arm, which in Raphael is indefinite, is made specific by Ingres, who shows himself working at an easel. Thus, in the Chantilly *Self-Portrait,* just as in the *Betrothal* in Baltimore, Ingres openly declares his homage to Raphael.

We no longer believe that *Bindo Altoviti* is a self-portrait, for, unlike the golden youth portrayed in the painting, Raphael was quite ordinary looking. But if we are forced to give up a myth about the artist's appearance, we have gained a significant addition to his oeuvre. Once believed to be a pupil's work, *Bindo Altoviti* is now generally recognized as a masterpiece of portraiture by Raphael himself. The picture may not display the sweetness and grace of the Madonnas, yet it is equally characteristic of the master. In preferring a Madonna, the American collectors we have discussed were true to the taste of their time. But they ignored or underestimated the broad range of Raphael's achievement. Today, we encounter his art without the overwhelming convictions about its value that were held in the past. Nevertheless, our more dispassionate attitude is a better way of approaching Raphael than through the sentimental haze of the nineteenth century. If we no longer admire him so much as a paradigm of classicism, we can genuinely appreciate his gifts of resourcefulness and originality. All that is needed for our encounter to be rewarding is for us to give his works the careful scrutiny they deserve. Raphael's greatness lies not in his idealism but in his continuous search for perfection in his art.

1. The standard edition is Giorgio Vasari, *Le Vite de' più eccellenti pittori, scultori, ed architettori*, ed. Gaetano Milanesi (Florence, 1879), 4:311-416.

2. See Crowe and Cavalcaselle, *Raphael*, 1:26-44; Oskar Fischel, *Raphael* (London, 1948), 20; (Berlin, 1962), 16; Roberto Longhi, "Percorso di Raffaello giovane," *Paragone* 6, no. 65 (May 1955), 12-17; Creighton Gilbert, "A Miracle by Raphael," *North Carolina Museum of Art Bulletin* 6 (Fall 1965), 16, 24; S. J. Freedberg, *Painting in Italy 1500 to 1600*, The Pelican History of Art Series (Harmondsworth, 1971), 29 and note 20, 469; S. J. Freedberg, *Painting of the High Renaissance in Rome and Florence*, 2d ed. (New York, 1972), 625 [revising an earlier view]; and Konrad Oberhuber, "The Colonna Altarpiece in the Metropolitan Museum and Problems of the Early Style of Raphael," *Metropolitan Museum Journal* 12 (1977) [copyright 1978], 67. Since Perugino was active outside of Perugia, it has been argued that Raphael joined him in Florence by Luisa Becherucci in "Raphael and Painting" in *The Complete Work of Raphael*, ed. Mario Salmi (New York, 1969), 12; and by the same author, "Il Vasari e gl'inizi di Raffaello" in *Il Vasari storiografo e artista* (Atti del Congress Internazionale, 1974) (Florence, 1976), 185-186, 191-195.

3. Raphael's father died on August 1, 1494. See Passavant, *Raphael*, 1:35, 42. Vasari's credibility is not improved when he relates the tearful farewell that Raphael received on his departure from his mother, who died in 1491 when he was eight years old. Later in the biography Vasari claims that Raphael was obliged to return to Urbino from Florence, where he went in 1504, to deal with matters arising from the demise of his parents, implying that their deaths had occurred not long before.

4. Anton Springer, *Raffael und Michelangelo*, 3d ed. (Leipzig, 1895), 52; W. Bombe, *Perugino* (Stuttgart, 1914), xxiv; S. J. Freedberg, *Painting of the High Renaissance in Rome and Florence*, 2 vols. (Cambridge, Mass., 1961),

1:62 [for his revised view, see note 2]; Rudolf Wittkower, "The Young Raphael," in *Allen Memorial Art Museum Bulletin* 20, no. 3, (Spring 1963), 160; and James Beck, *Raphael* (New York, 1976), 12-13.

5. For the view favoring Raphael's collaboration see Crowe and Cavalcaselle, *Raphael*, 1:36-37, 90-91, and Becherucci in *Raphael*, 16-26. For opposing views see Beck, *Raphael*, 15, and Oberhuber in *Metropolitan Museum*, 65, note 21, and 78, note 62.

6. Fern Rusk Shapley, *Catalogue of the Italian Paintings* [National Gallery of Art] (Washington, 1979), 360-361, no. 27.

7. Quoted from a letter recommending Perugino to the Duke of Milan, for a prospective patron, in Fiorenzo Canuti, *Il Perugino*, 2 vols. (Siena, 1931), 1:239.

8. Shapley, *Kress Collection, XV-XVI Century*, 100, nos. K1153 A and B.

9. About this picture, the first signed work by Raphael extant, see Luitpold Dussler, *Raphael* (London, 1971), 8-9. A rather similar *Crucifixion* from a standard in Città di Castello was given to the young Raphael by Longhi despite its poor quality (*Paragone*, 15, and figs. 7-8).

10. Vasari, *Vite*, 4:318.

11. Now in the gallery in Perugia. Ettore Camesasca, *Tutta la pittura del Perugino* (Milan, 1959), 99 and fig. 166.

12. North Carolina Museum of Art, Raleigh, no. G.65.21.1. See Dussler, *Raphael*, 10, and for the companion panel with another miracle of Saint Jerome in the National Museum in Lisbon, 9-10.

13. Cecil Gould noted the similarity between the Saint John and the standing figure in the predella ("Raphael's St. Jerome Punishing Sabinian," in *Art News* 65, no. 4, [Summer 1966], 44-45, 68-69).

14. K. T. Parker, *Catalogue of the Collection of Drawings in the Ashmolean Museum. The Italian Schools* (Oxford, 1956), 259, no. 509 and plate CXVIII. Fischel had connected this study specifically with the youth in the predella (Oskar Fischel, *Raphaels Zeichnungen*, 8 vols. [Berlin, 1913-1941], 1:61, 63), but that figure,

unlike the female saint above, lacks a halo.

15. *Greensboro Daily News* (Greensboro, North Carolina, November 7, 1965). Another trustee is reported by the *Winston-Salem Journal* on November 9, 1965, to have said that the picture "is not a great painting although by a great artist. . . . I think a great deal of people are going to be disappointed in this picture—it will not be the Raphael they have in mind. . . . If it were a typical Raphael, that would be something else again." Although the painting was acquired by a public museum rather than a private individual, the purchase was not unlike those that preceded it in America in that more than half of the price was paid by a descendent of R. J. Reynolds, founder of the tobacco company of that name. Thus, one more American fortune was tapped to bring a work by Raphael from an English private collection, via the London art market, to these shores. The moving force behind the acquisition was Robert Lee Humber, who was put on to the painting by Carl Hamilton, a former protégé of Berenson. Purchased in March 1965, the *Saint Jerome* put the museum in the privileged company of the American institutions —the National Gallery and the Metropolitan and Gardner Museums—which possessed undisputed works by Raphael. And just as earlier acquisitions of his paintings had marked the cultural coming of age of the nation as a whole, so this one meant to show that "culture exists in abundance in the South, that we . . . [possess] those qualities which give life fuller meaning." (Quoted from the remarks of the son of the principal donor in the *Winston-Salem Journal*, November 7, 1965.) Though traditionally given to Raphael, the painting is, in effect, a discovery of modern connoisseurship, having first been discussed in 1882 and first reproduced in 1900. In the beginning the attribution of the panel was doubted; Berenson, for example, believed that it was only in part by Raphael (*Central Italian Painters* [New York, 1909], 234). It is universally accepted today as his work.

16. Gilbert, *North Carolina Bulletin*, 2-35.

17. Gilbert, *North Carolina Bulletin*, 24-25.

30. Crowe and Cavalcaselle (*Raphael*, 1:126) compared the fleeing soldier, viewed from behind, specifically to Signorelli, while Fischel (*Zeichnungen*, 1:80) linked the foreshortened body of the dead man to Signorelli's *Last Judgment* cycle in the Cathedral at Orvieto. The problem of Signorelli's influence is further discussed by Dussler (*Raphael*, 9). While Signorelli clearly provided the young Raphael with a stimulus lacking in Perugino, it is odd that Raphael's derivations from Signorelli are not more explicit, given the exactitude of his drawing after the figure of an archer in Signorelli's *Saint Sebastian*, painted, as was Raphel's *Crucifixion*, for S. Domenico in Città di Castello (Fischel, *Zeichnungen*, 1:no. 2). The reason may be simply that Raphael was familiar with works by Signorelli which are now lost. (Several from Città di Castello are listed in Mario Salmi, *Luca Signorelli* [Novara, 1956], 69-70.)

18. Noted first by Crowe and Cavalcaselle, *Raphael*, 1:126-127. The authors further observed that the fleeing soldier who turns as he runs away recalls a fugitive guard in the Vatican *Resurrection*, of which there is some reason to believe that Raphael may have been involved in the design.

19. Umberto Gnoli in "La Pittura Umbra alla mostra del Burlington Club," *Rassegna d'Arte Umbra* 1, no. 2 (1910), 51-52; and in "L'Art italien aux expositions de Londres en 1910," *Revue de l'Art Chrétien* (September-October 1910), 324-325. See also Berenson cited in note 15.

20. Compare the study of a kneeling youth at Oxford (Parker 509), and the studies for a *Resurrection* also at Oxford (Parker 505).

21. Dussler, *Raphael*, 1-3.

22. Vasari, *Vite*, 4:322-323.

23. Vincenzo Golzio, *Raffaello nei documenti* (Vatican City, 1936), 284.

24. Baltimore Museum of Art no. 51.114. See the detailed entry on the painting by Getrude Rosenthal in *Italian Paintings XIV-XVIIIth Centuries from the Collection of the Baltimore Museum of Art* (Baltimore, 1981), 149-161. Jan Lauts, recorded by Rosenthal as opposed to the Raphael attribution, has recently accepted it (letter of September 5, 1982, on file at the museum). Records relating to the acquisition are preserved in the museum's files.

25. Georg Gronau, "I Ritratti di Guidobaldo da Montefeltro e di Elisabetta Gonzaga in Firenze," *Bollettino d'Arte* 4, no. 2

(1924-1925), 456-459.

26. Lester S. Levy, *Jacob Epstein* (Baltimore, 1978), 87-96.

27. Between correspondence at Villa I Tatti, museum files, and newspaper accounts, Epstein's acquisition of the Raphael is unusually well documented. Berenson had not been shown the portrait by Duveen, who found it "too severe." It was "not one of the great Raphaels," Mary Berenson admitted in the draft of a letter to Edward Fowles of Duveen Brothers of December 24, 1924 (Villa I Tatti), "but B.B. likes it ever so much better than the Medici portrait" (which later belonged to Jules Bache). He cabled his approval of the painting to Kleinberger on October 16, 1925. Ten days later the picture was offered to Epstein, who, after examining it, agreed in November to purchase it. On December 5, 1925, two days after delivery, he sent a check to the dealer for $140,000. In the meantime Kleinberger had cabled Berenson on November 14, 1925, asking him to provide the purchaser with a letter about the painting. Only after Epstein had bought the panel was Kleinberger able to forward the desired letter on December 8, from which "you may realize," he wrote, "what an exceedingly important acquisition you have made." In the letter, dated November 22, Berenson stated that the painting had "all the characteristics of Raphael's early works." His letter is quoted in *Italian Paintings*, ed. Rosenthal, 160. Epstein in turn wrote Berenson on December 10, 1925, that he had "visited Italy several times and may be there again next spring. If so, I shall take the liberty of calling upon you personally and thanking you for the recommendation you have given my painting." When the acquisition was announced, Berenson's remarks were widely quoted verbatim and at length in the press. On March 3, 1927, *The New York Times* reported, with some exaggeration, that the price paid for the picture was $250,000, "one of the highest ever recorded for an old master of this size and type."

28. George Francis Hill, *A Corpus of Italian Medals of the Renaissance*, 2 vols. (London, 1930), 1:86, no. 345, and 2:pl. 56.

29. About Emilia Pia see: Alessandro Luzio and Rodolfo Renier, *Mantova e Urbino* (Turin and Rome, 1893), 88, esp. note 1; and Julia Cartwright, *The Perfect Courtier: Baldassare Castiglione*, 2 vols. (New York, 1927), 1:87-91.

30. Dussler, *Raphael*, 59-60.

31. Ursula Schmitt, "Francesco Bonsignori," *Münchner Jahrbuch der bildenden*

Kunst, series 3, 12 (1961), 100-104, 113, 116-117 and cat. nos. 1 and 4.

32. Dussler, *Raphael*, 56.

33. The Baltimore and Florence portraits were dated 1504 by William Suida in *Raphael* (New York, 1941), 6, and Ettore Camesasca in *All the Paintings of Raphael* (New York, 1963), 44. Rosenthal in *Italian Paintings*, 154, prefers "shortly before 1502." In a letter of November 6, 1975, cited by Rosenthal, Konrad Oberhuber tentatively regards the paintings as "the earliest portraits by Raphael known to us, probably dating from around 1502."

34. Musée des Beaux-Arts, Lille, inv. no. 474-475 (Fischel, *Zeichnungen*, 1:no. 6). Raphael's drawings at Lille and Oxford for the altarpiece seem superior to me in quality to the corresponding motifs in the painted fragments in Naples. These look coarse and provincial, not immature but refined, as we would expect if they were by Raphael. Two portraits often ascribed to the young Raphael do not offer good comparisons, as they are, in my opinion, misattributions: *Portrait of a Young Man*, Museum of Fine Arts, Budapest (Dussler, *Raphael*, 8); *Portrait of a Man* (surely by Perugino) Galleria Borghese, Rome (Dussler, *Raphael*, 8).

35. Ortolani hypothesized that Giovanni Santi began the portrait of Elisabetta and that after his death in 1494 it was finished by his son (Sergio Ortolani, *Raffaello* [Bergamo, 1945], 23). See also Becherucci in *Raphael*, 65-66.

36. In Berenson's letter to Epstein of November 1925, the portrait was said to be "as simple, as direct and as convincing as any masterpiece by . . . Piero della Francesca. . . ." See also Rosenthal cited in note 24.

37. See note 28.

38. Baldassare Castiglione, *The Book of the Courtier*, trans. Charles S. Singleton (Garden City, 1959), 3. The author specifically cited Raphael in comparing his own less artful portraits of the Urbino courtiers. Though the conversations related in the book are supposed to have taken place in 1506, Castiglione, who was not present, did not begin preparing his manuscript until nearly a decade later. After numerous revisions, it was finally published in 1528. Emilia Pia was said to have died while discussing the book, instead of while taking the sacraments.

39. See W. R. Valentiner, "Laurana's Portrait Busts of Women," *Art Quarterly* 5, no. 4 (Autumn 1942), 280-281, 284, and fig. 7; Charles Seymour, Jr., *Sculpture in Italy 1400 to 1500*, Pelican History of Art Series (Har-

mondsworth, 1966), 164-165, and pl. 102A.

40. See Adolfo Venturi, *Storia dell'arte italiana* 6 (Milan, 1908), 1130-1132 and fig. 775, 1135-1136 and fig. 778.

41. See Schmitt, *Münchner Jahrbuch*, 92, fig. 17 and cat. no. 20. Perhaps relevant too were cat. nos. 39 and 42, portraits of Eleonora Gonzaga and Isabella d'Este of 1494 and 1495, both lost.

42. In a letter of October 13, 1494, shortly after Giovanni Santi's death, Elisabetta wrote to her brother, the Marchese of Mantua, that because of ill health the artist had not been able to finish his portrait nor to do the one of her that she had commissioned. She added that she intended to have her portrait painted by another skillful artist. See Giuseppe Campori, *Notizie e documenti per la vita di Giovanni Santi e Raffaello Santi da Urbino* (Modena, 1870), 4.

43. See note 57. Isabella d'Este, sister-in-law of the Duchess Elisabetta, referred to Raphael as late as 1512 as "Raphaelle de Zoanne de Sancto da Urbino" (Golzio, *Raffaello*, 26).

44. Metropolitan Museum of Art, no. 32.130.1. For full details about the painting see Federico Zeri, *Italian Paintings. Sienese and Central Italian Schools* [Metropolitan Museum of Art] (New York, 1980), 75-78.

45. For example by Passavant, *Raphael*, 2:29; Crowe and Cavalcaselle, *Raphael*, 1:236-238; J. P. Richter, "The 'Old Masters' at Burlington House," *Art Journal* no. 3 (March 1902), 84 (Eusebio); and Adolf Rosenberg and Georg Gronau, *Raffael. Des Meisters Gemälde*, Klassiker der Kunst series, 5th rev. ed. (Stuttgart, 1923), 223-224 (Eusebio).

46. G. F. Waagen complained of defects in the rendering of the angel, suggesting that Raphael's design was carried out by an incompetent follower (*Works of Art and Artists in England*, 3 vols. [London, 1838], 2:136; and *Treasures of Art in Great Britain*, 3 vols. [London, 1854], 2:76). Though not referring specifically to the angel, Crowe and Cavalcaselle also found defects in the drawing of the figures (see note 45).

47. The Pierpont Morgan Library, no. I, 15. The sheet has a distinguished provenance going back to Timoteo Viti. Differences in the brown wash shading in the drawing seem to have the character of a misunderstanding, so that it may have been added later. Fischel considered the drawing superior to the painting, in line with the older view that Raphael only designed the panel (*Zeichnungen*, 2:91, no. 66). About this now damaged drawing see further: Ulrich Middeldorf,

Raphael's Drawings (New York, 1945), 33, no. 20; and Jacob Bean and Felice Stampfle, *Drawings from New York Collections. I. The Italian Renaissance* [exh. cat., Metropolitan Museum of Art and Pierpont Morgan Library] (New York, 1965), 39-40, cat. no. 48. Dussler (*Raphael*, 15) failing to observe the chalice, claimed incorrectly that the angel was found "vaguely outlined" in the drawing.

48. Zeri, *Italian Paintings*, 76. Louis Réau suggests that the angel, whose appearance was mentioned by Saint Luke, came to carry a chalice rather than a cross in the visual representation of the Agony in the Garden because the former motif was familiar in Crucifixion scenes (*Iconographie de l'art Chrétien*, 3 vols. in 6 (Paris, 1957), 2:427-431. See also Gertrud Schiller, *Iconography of Christian Art*, trans. Janet Seligman, 2 vols. (Greenwich, Conn., 1972), 2:51.

49. The engraving is one of a series of plates depicting the life of the Virgin and of Christ by an anonymous Florentine engraver close to Baldovinetti. See for various examples of it, Arthur M. Hind, *Early Italian Engraving* (London, 1938), pt. I:1, 123, no. 6. About the impression shown here from the Cleveland Museum of Art (no. 49.540), see Henry S. Francis in *Bulletin of the Cleveland Museum of Art* 38, no. 3 (March 1951), 64-65; and *Prints 1400-1500* [exh. cat., Cleveland Museum of Art] (Cleveland, 1956), 13, cat. no. 78.

50. Martin Davies, *The Earlier Italian Schools* [The National Gallery, London] 2d rev. ed. (London, 1961), 495-496, no. 1032. Passavant claimed that this was the version of the subject painted by Raphael, according to Vasari (*Vite*, 4:322-323), for Duke Guidobaldo of Urbino (*Raphael*, 2:20-22). Another painting of Christ and the angel without the apostles, also attributed to Lo Spagna, is no. 1812 in the same gallery. Additional versions, including a cartoon in the Uffizi, are listed by the compiler.

51. Camesasca, *Perugino*, 64, no. 74. For the relationship see John Pope-Hennessy, *Raphael* (New York, 1970), 135-136. Raphael's composition also may recall the scene of Christ in Agony in the background of Perugino's fresco of the *Last Supper* from the ex-convent of Sant'Onofrio, as was first pointed out by Bryson Burroughs in *Bulletin of the Metropolitan Museum of Art* 28, no. 3 (March 1933), 58-59 (illus.). The derivation proposed by Burroughs was rejected by Dussler (*Raphael*, 15-16) and accepted by Oberhuber (*Metropolitan Museum*, 75).

52. Vasari, *Vite*, 4:324. Certain aspects of Raphael's painting—the type of the Madonna and the dark robe, decorated with gold—recall Pinturicchio so insistently that we are led to suppose that Raphael may have been enjoined by the nuns to follow the older master's example. This kind of deliberate recalling of another artist's work was not uncommon in Umbrian painting of the time.

53. See among others: Crowe and Cavalcaselle, *Raphael*, 1:219-220; Rosenberg and Gronau, *Raffael*, 224; Dussler, *Raphael*, 14. Oberhuber would date the painting as early as 1502 (*Metropolitan Museum*, 72, 76).

54. See Crowe and Cavalcaselle and Dussler in the preceding note; also Adolfo Venturi, *Raffaello* (Urbino, 1920), 119; Ortolani, *Raffaello*, 20, among others.

55. Oberhuber in *Metropolitan Museum*, 59-60. In my view, it is the modeling of the figure of Saint Nicholas on the right in the *Madonna Ansidei* of 1505 which first shows Fra Bartolomeo's influence.

56. Writers do occasionally cite Leonardo as a source for the Colonna altarpiece but only generally and secondarily to Fra Bartolomeo. See, for instance, Ortolani and Dussler in the preceding notes.

57. About this letter (now lost) and the doubts sometimes expressed over its authenticity, see Golzio, *Raffaello*, 9-10.

58. Giorgio Vasari, *Lives of Seventy of the Most Eminent Painters, Sculptors, and Architects*, ed. E. H. and E. W. Blashfield and A. A. Hopkins (New York, 1896), 3:139-140; and *Vite*, 4:325.

59. Vasari, *Lives*, 3:213; and *Vite*, 4:373.

60. See Canuti, *Perugino*, 1:240 and 2:291-292, docs. 511-514.

61. In a letter of November 7, 1500, published in Canuti, *Perugino*, 2:40.

62. About Perugino and Isabella d'Este see Julia Cartwright, *Isabella d'Este*, 2 vols. (London, 1903), 1:328-340; and for the documents, Canuti, *Perugino*, 1:175-179 and 2:208-237.

63. Vasari, *Vite*, 3:585-586.

64. National Gallery of Art, no. 653. See the catalogue entry in Shapley, *Italian Paintings*, 396-397.

65. The figures were seated "near a wall," according to Passavant (J. D. Passavant, *Rafael von Urbino und sein Vater Giovanni Santi*, 3 vols. [Leipzig, 1839 and 1858], 2:37; Passavant, *Raphael*, 2:26; J. D. Passavant, *Raphael of Urbino and His Father Giovanni Santi* [London, 1872], 208). F. A. Gruyer (*Les Vièrges de Raphael et l'iconographie de la Vièrge*, 3 vols. [Paris, 1869], 3:38) states more specifically

that the Virgin was on a ledge "adossé à un mûr d'appui fort bas. . . ."

66. The engraving after the *Small Cowper Madonna* by Karl Kappes (d. 1857), illustrated in Passavant's *Rafael* (3:plate XVIII, opp. 89), was probably made from the writer's copy drawing. The print is too schematic to be of much value, but the plane behind the figure does have a straight upper edge. A slightly later photograph by Caldesi and Montecchi, made in connection with the Manchester Exhibition of 1857 and published in an album, shows both the parapet with a straight edge and an irregularly contoured shape above it (*Gems of the Art Treasures Exhibition, Manchester, 1857*, photographed by Caldesi & Montecchi, Ancient Series [London, 1857], no. 8). By the time of the engraving by Mandel of 1871 and of the photograph issued by Adolphe Braun, only the dark irregular form was visible.

67. Known to me only in a photograph at the National Gallery. This much damaged picture (transferred, it would seem, to canvas) remains legible enough, I believe, to suggest that its author might be an Umbrian imitator of Raphael, like Domenico Alfani.

68. The rediscovered parapet tends to confirm the view that the so-called Uffizi "cartoon" for the *Small Cowper Madonna* was copied from the painting. Earlier, the drawing (1775E) was claimed to be preparatory, despite the fact that the design is reversed (Bernard Berenson, *Widener Collection*, note to the painting). But Fischel (*Zeichnungen*, 3:134) and Dussler (*Raphael*, 19) consider it a copy. The drawing contains the irregularly contoured dark area of overpaint behind the figures, not the straight-edged parapet. The badly damaged sheet is currently undergoing conservation measures at the Uffizi (*Restauro e conservazione delle opere d'arte su carta* [exh. cat., Gabinetto Disegni e Stampe degli Uffizi] (Florence, 1981), 151-155, no. 56, and figs. 92-97).

69. According to Waagen (*Works of Art*, 3:5; *Treasures*, 3:9) the "preservation is excellent"; and Passavant said it was "perfectly preserved" (*Rafael*, 2:37; *Raphael*, 2:26). Crowe and Cavalcaselle observed that the Madonna's right hand was abraded (*Raphael*, 1:251).

70. The summary handling led Passavant to think at first that the painting might possibly be by a fellow pupil of Perugino (J. D. Passavant, *Kunstreise durch England und Belgien* [Frankfurt, 1833], 99; *Tour of a German Artist in England*, 2 vols. [London, 1836], 221; *Rafael*, 2:37; *Raphael*, 2:26). George Scharf

(*A Handbook to the Paintings of Ancient Masters in the Art Treasures Exhibition, Being a Reprint of Critical Notices Originally Published in "The Manchester Guardian"* [London, 1857], 26) likewise noted the transparency of the color, while Müntz referred to the execution as "facile, rapide, légère" (Eugène Müntz, *Raphaël: Sa vie, son oeuvre et son temps* [Paris, 1881], 176; *Raphael: His Life, Works, and Times* [London, 1882], 170). Crowe and Cavalcaselle refer to "some thinness in the pigments," which, according to them, made the picture "just inferior" to the *Granduca Madonna* (*Raphael*, 1:251). In the Italian edition of their monograph (*Raffaello: La sua vita e le sue opere*, 3 vols. [Florence, 1884-1891], 1:255), the ground is specifically stated to be visible in the flesh tones.

71. For full details on the painting see Shapley, *Italian Paintings*, 362-363, no. 326.

72. Berenson proposed that the church was meant to be San Bernardino, "a charming stroll" from Urbino (*Widener Catalogue*, note to the *Cowper Madonna*). His identification, which has been widely accepted, remains possible even though the structure in the painting and the church as it exists today, with its façade, belltower, and dome, and in reconstructions differs in some details.

73. Pope-Hennessy, *Raphael*, 177 and note 3, 284, and "The Ford Italian Paintings," in *Bulletin of the Detroit Institute of Arts* 57, no. 1 (1979), 22. I would date Perugino's painting in Detroit after the one in Washington.

74. Compare the altarpieces of the Madonna Adoring the Child, in London, New York, and Munich (Camesasca, *Perugino*, figs. 99, 105, and 155).

75. Dussler (*Raphael*, 4) dates the picture earlier than I do.

76. Luca della Robbia has been cited in a general way as a source for Raphael's early Madonnas by Longhi (*Paragone*, 22), Pope-Hennessy (*Raphael*, 183-184), and Beck (*Raphael*, 23).

77. John Pope-Hennessy, *Luca della Robbia* (Ithaca, N.Y., 1980), 251-252, cat. no. 30, figs. 23-24, pl. 95.

78. Pope-Hennessy, *Della Robbia*, 65, 255, and cat. no. 40, and fig. 28. Another and, according to the author, a better version, is in the Metropolitan Museum of Art (color plate XXIX). In some of these reliefs, similar in composition to Raphael's painting, the Madonna looks at the Child (Pope-Hennessy, *Della Robbia*, cat. no. 24 and pl. 92), while in others the two figures look at each other (*Paintings and Sculpture of the Samuel H. Kress Collection* [Philbrook Art Center, Tulsa,

1953], 70-71).

79. About the influence of Leonardo on Raphael's painting see most recently Everett Fahy, *The Legacy of Leonardo* [exh. cat., National Gallery of Art, Washington; Knoedler Galleries, New York; Los Angeles County Museum of Art] (New York, 1979), 41.

80. Dussler, *Raphael*, 20.

81. It can hardly be coincidental that Perugino's version of the theme of the Madonna with two children at Nancy, painted at this time (Camesasca, *Perugino*, 103 and fig. 174), betrays an acquaintance with the *Madonna of the Rocks*. The comparison with Raphael's *Madonna of the Meadow*, depending on the same source, is instructive.

82. Raphael's derivation in a work of 1505 or 1506 supports a dating for the origin of Leonardo's picture earlier than 1508-1510, favored by many scholars today. The design at least must have been established before 1505, though the execution may well have been protracted. See Ludwig H. Heydenreich, "La Sainte Anne de Leonard de Vinci," *Gazette des Beaux-Arts* 10 (October 1933), 205-219; and A. E. Popham, *The Drawings of Leonardo da Vinci* (London, 1949), 72-75.

83. Raphael was not the only artist to appreciate the motif. A Milanese pupil of Leonardo copied it in a black chalk drawing (Kenneth Clark, *The Drawings of Leonardo da Vinci in the Collection of Her Majesty The Queen at Windsor Castle*, 2d. ed. revised with the assistance of Carlo Pedretti, 3 vols. [London, 1968], 1:97, no. 12536).

84. See Passavant, *Rafael*, 2:37; *Raphael*, 2:26; *Raphael* (English ed.), 208; Waagen, *Works of Art*, 3:4; *Treasures*, 3:9; Gruyer, *Vièrges*, 3:38; and Müntz, *Raphaël*, 176; *Raphael*, 170.

85. Vasari, *Vite*, 4:376-377.

86. Several drawings have been mistakenly connected with the *Small Cowper Madonna*. A metalpoint study on gray prepared paper of the head of an infant, in the Städelsches Kunstinstitut in Frankfurt (inv. no. 384), was considered by Passavant a study for the Christ Child (*Rafael*, 3:89-90, and *Raphael*, 2:26 and 455, no. 278). Crowe and Cavalcaselle doubted that the drawing was genuine (*Raphael*, 1:251, note). To judge from the photograph, it might be by an imitator of Raphael like Alfani. A metalpoint drawing of the heads of a Madonna and Child in the British Museum (Philip Pouncey and J. A. Gere, *Italian Drawings in the Department of Prints and Drawings in the British Museum* [London, 1962], cat. no. 24) was claimed by Charles Ricketts to be a study for the *Small*

Cowper Madonna (Vasari Society, 2d series [1926], 7:no. 6), but it appears to be somewhat later in date than the painting. A pen and ink sketch of the Christ Child on the upper left of another sheet in the British Museum (Pouncey and Gere, *Drawings*, cat. no. 19 D), linked with the painting by Pope-Hennessy (*Raphael*, 186), likewise seems to date from the end rather than the beginning of Raphael's Florentine period. Of the alternatives posed by Pope-Hennessy, his suggestion that the drawing developed from the painting is preferable.

87. Gabinetto di Disegni, no. 505E. See Fischel, *Zeichnungen*, 3:131, no. 105. A copy of the drawing, attributed to Timoteo Viti, is in the British Museum (Pouncey and Gere, *Drawings*, cat. no. 289).

88. Both works have been dated in or around 1505, and the National Gallery painting has usually been thought to follow the one in the Pitti on account of its landscape and liveliness of movement.

89. As observed long ago by Anton Springer, *Raffael und Michelangelo* (Leipzig, 1878), 67.

90. Frank Jewett Mather, one of the few authors to date the *Small Cowper Madonna* before the *Granduca Madonna*, noted in the former the "extravagantly delicate hands, quite unlike the capable hands which Raphael gave to the *Granduca*. . ." ("Little Madonna," 312).

91. One such copy was sold at Parke-Bernet Galleries in New York on March 2, 1950, as lot no. 29, the sale catalogue entry providing full information and a reproduction. See also *Newsweek* 35, no. 11, March 13, 1950, 76; and *The New York Times*, September 14, 1970, 12 col. 1.

92. For full details about the picture see Martin Davies in *European Paintings in the Collection of the Worcester Art Museum* (Worcester, 1974), 445-448, no. 1940.39. Technical examination has revealed that serious damage is mostly confined to the blue drapery.

93. The following writers have compared the *Northbrook Madonna* in one way or another to the *Small Cowper Madonna*: J. P. Richter in *A Descriptive Catalogue of the Collection of Pictures Belonging to the Earl of Northbrook* (London, 1889), 153, no. 202; Adolf Rosenberg, *Raffael: Des Meisters Gemälde*, Klassiker der Kunst series (Stuttgart-Leipzig, 1906), 157, note to reprod. on 140; Berenson, *Widener Catalogue*; Umberto Gnoli, "Theodore Ellis Buys Famous Raphael" *The Art News* 26, no. 38 (July 14, 1928),

1; Dussler, *Raphael*, 61.

94. Denys Sutton, "Robert Langton Douglas, Part III," *Apollo* 109, no. 208 (June 1979), 472. Ellis paid Douglas £27,000 for a group of four pictures that included the *Northbrook Madonna* (Sutton, "Douglas," 470). There is no breakdown into individual prices. When the Ellis collection was donated to the museum in 1940, the painting was reported to have been valued at three hundred thousand dollars.

95. Gnoli, *Art News*, 1. Douglas' chief ally in the transaction was Gnoli, the director of the Perugia Gallery, who provided letters attesting to the painting's authenticity on August 3 and August 19, 1927. See also by Gnoli, *Rassegna*, 51, and *L'Art Chrétien*, 324.

96. The traditional attribution to Raphael was rejected by Waagen and by Joseph Archer Crowe and Giovanni Battista Cavalcaselle, when they saw the picture in the middle of the nineteenth century. Waagen claimed that the painting was by Lo Spagna (*Treasures*, 2:176), while Crowe and Cavalcaselle detected a mixture of his style with that of Eusebio da San Giorgio (*A New History of Painting in Italy* [London, 1866], 3:327-328, 342). Their doubts about the Raphael attribution were shared by the compiler of the Northbrook catalogue, J. P. Richter, who tentatively opted for Timoteo Viti, the Umbrian master taken to have been Raphael's teacher by Morelli (*Descriptive Catalogue*, 154). Berenson, in the List of Raphael's works appended to the 1909 edition of his essay on the Central Italian painters, gave the design to Raphael and the execution to Eusebio or possibly to Domenico Alfani, another Perugian imitator (Berenson, *Central Italian Painters*, 233).

That same year, when the picture was exhibited as "attributed to Raphael" at the Burlington Fine Arts Club in London, marked a turning point in its critical fortune (*Catalogue of a Collection of Pictures of the Umbrian School* [Burlington Fine Arts Club, London] [London, 1910], 19, cat. no. 10). In a review Roger Fry disagreed with the view that the *Northbrook Madonna* was merely a school version of the *Small Cowper Madonna*, shown in the same exhibition (in *The Burlington Magazine* 16, no. 88 [February 1910], 273). Instead, he claimed that the *Northbrook Madonna* was worthy of the master himself. (Fry's review and another favorable one by Claude Phillips in the *Daily Telegraph* are quoted in the catalogue of 1910, p. 19. Phillips had previously referred to the picture as "Raphaelesque" in the *North American Re-*

view 169, no. 4 [October 1899], 462). Tancred Borenius soon afterwards came out, reluctantly, for Raphael in his revised edition of Crowe and Cavalcaselle's *A History of Painting in Italy* (London, 1914), 5:447, note 1. See also "La Mostra dei maestri umbri a Londra," *Rassegna d'Arte* 10, no. 3 (March 1910), 45.

Berenson cannot have been unaware of this shift of opinion when he wrote in his catalogue of the Widener Collection that although the *Northbrook Madonna* was "closest akin" to the *Small Cowper Madonna* of all the early works, it was "as surely designed as it was certainly not executed by Raphael" (*Widener Catalogue*, n.p.). Though he had listed the *Northbrook Madonna* under Raphael in 1909 as a work of collaboration, Berenson omitted the picture altogether from his corrected Lists of 1932. Unaccountably, given his revaluation, the *Madonna* reappears, simply as Raphael, in the posthumous edition of the Lists (*Italian Pictures of the Renaissance: Central Italian and North Italian Schools*, 3 vols. [London, 1968], 1:355). Although the painting has been given to Raphael by recent Italian critics, none of whom can ever have seen it, the attribution remains most doubtful. All of the following writers, who accept the picture as a Raphael, indicate that it was still in the Northbrook Collection, though it was sold before 1927: Ortolani, *Raffaello*, 28; Longhi in *Paragone*, 18, 22 (reprinted in his *Cinquecento classico* [1976], 19, 23, and fig. 17); Ettore Camesasca, *Tutta la pittura di Raffaello* (Milan, 1956), 45; Camesasca, *Raphael*, 50; Anna Maria Brizio, "Raphael," in *Encyclopedia of World Art* 11 (New York, 1966), col. 844; Pierluigi De Vecchi, *L'Opera completa di Raffaello* (Milan, 1966), 96, no. 67; Pierluigi De Vecchi, *The Complete Paintings of Raphael* (London, 1969), 96, no. 67; and Becherucci in *Raphael*, 46, 73.

97. Dussler suggests the *Madonna of the Goldfinch* (*Raphael*, 61).

98. Sold American Art Association-Anderson Galleries, Inc., New York, February 4, 1931, lot 157. Panel. 56 x 45.7 cm. (24 x 18 in.). Consigned to settle an account from the Achillito Chiesa estate and purchased by the Plaza Curiosity Shop for two hundred dollars, the picture was published as Raphael's work by William Suida, *Raphael* (New York, 1941), 9 [reprod.] and 32. The painting subsequently appeared in an exhibition in Mexico as belonging to Seligman (*Catalogo de la gran exposición de quadros de fama mundial* [Galerias Ordáz, Mexico City, December

1944]; and Antonio Rodriguez, "Mexico, Mercado de la pintura falsificada," *Así* no. 218 [January 13, 1945], 52-55). The present whereabouts of the picture is unknown.

99. In their *History of Painting in Italy* of 1866 (3: 327-328), Crowe and Cavalcaselle noted that a "Virgin and Child, called a Penni at Stafford House in London . . . is very like [the *Northbrook Madonna*] as regard stamp and handling." The painting in question had been catalogued as Penni's in the Sutherland Collection by Mrs. Anna Jameson, whose account of it corresponds to the *Madonna of the Carnation* (*Companion to the Most Celebrated Private Galleries of Art in London* [London, 1844], 196, cat. no. 70). Later, J. P. Richter in his catalogue of the Northbrook Collection claimed that the *Madonna with a Carnation*, which he gave to Timoteo Viti rather than Penni, "beyond doubt" had "all the characteristics both as regard colouring and drawing" of the *Northbrook Madonna* (*The Northbrook Gallery*, ed. Lord Ronald Gower [London, 1885], 6. [See also the 1889 catalogue, 154]). The *Madonna with the Carnation* was sold at Christie's in London on July 11, 1913, as lot 74, the sale being noted in the edition of Crowe and Cavalcaselle's *History* compiled by Borenius, who found the picture "much inferior" to the *Northbrook Madonna*, which he believed was by Raphael (*History*, 447, note 3).

100. Of known artists, Domenico Alfani (c. 1480-after 1553), proposed by Berenson as the executant of the *Northbrook Madonna*, is the most likely choice as the author. On the back of a photograph sent by Duveen Brothers on April 1, 1927, Berenson wrote "Raphael cartoon, painted by Dom. Alfani." Parallels for the facial types of the Madonna and Child, their light flesh tones and blond hair, as well as the color and forms of the landscape, can be found in Alfani's *Holy Family with Saints and Cherubim* in the Perugia Gallery. The difficulty is that that work was only designed by Alfani with the aid of a Raphael drawing (Fischel, *Zeichnungen*, 3:nos. 161-162). In execution it is drier and harder than the *Northbrook Madonna*.

101. For detailed information see Shapley, *Italian Paintings*, 391-394, no. 26.

102. The extant members of the group include two pairs of diptychs—the *Dream of the Knight* in London and the *Three Graces* at Chantilly, and the *Saint George* and *Saint Michael*, both in the Louvre. They were linked with Urbino by Crowe and Cavalcaselle (*Raphael*, 1:195). Shearman has plausibly

suggested that the latter pair may have been commissioned by Duke Guidobaldo's sister Giovanna della Rovere, an early patron of Raphael. Her father and brother were honored with the Order of the Garter, and husband and son, with the French Order of Saint Michel (*The Burlington Magazine*, 1967, 77, note 23). The distinction between the highly finished miniatures for the court and more loosely painted predella panels for religious patrons was made by Gilbert in *North Carolina Museum Bulletin*, 7, 15.

103. Dussler, *Raphael*, 5-6.

104. For the historical background see Cartwright, *Baldassare Castiglione*, vol. 1 in general; James Dennistoun, *Memoirs of the Dukes of Urbino*, 3 vols. (London-New York, 1909), 2:3-90 and appendix 2, 462-470; and Cecil Clough, "The Relations between the English and the Urbino Court, 1474-1508," in *Studies in the Renaissance* 14 (1967), 202-218, esp. 206-207 (reprinted in the author's *The Duchy of Urbino in the Renaissance* [London, 1981]).

105. The princess saved by the saint was sometimes interpreted as a symbol of the Christian Church delivered from its enemies, and she was occasionally assimilated with Saint Margaret, who, like Saint George, vanquished a dragon. See Réau, *Iconographie*, 3:pt. 2, 571-579. In type Raphael's figure resembles the Virgin in the *Small Cowper Madonna*.

106. Passavant, *Rafael*, 1:109-110, 2:57, no. 43; and *Raphael*, 1:90 and 2:42-43, cat. no. 37. According to André Félibien, *Entretiens sur les vies et sur les ouvrages des plus excellens peintres anciens et modernes*, 6 vols. (Paris, 1725), 1:333, repeating the edition of 1666, Raphael painted the Louvre *Saint George* for "Henri VIII, Roi d'Angleterre." This erroneous statement was repeated by Florent le Comte in *Cabinet des singularitez* (Paris, 1699), 64. In the *Recueil d'estampes d'après les plus beaux tableaux . . . dans le Cabinet du Roi . . .* (Paris, 1763), 9, 13, Félibien's claim that Raphael painted a Saint George for Henry VIII is applied instead to the version now in Washington, on the basis of the Order of the Garter worn by the saint in that painting. Vertue, writing between 1717 and 1721 (Note Books in *Walpole Society* 18 [1929-1930], 47), claimed to have been told by Lord Pembroke that an ancestor of his, that is, Pembroke's, had been given Raphael's painting by Castiglione, who commissioned it. The credit for first questioning in print the whole notion of the ducal gift belongs to Shapley in *Italian Paintings*, 391-394.

107. Two inventories of 1542 and 1547 both

describe a painting of Saint George in the Royal Collection which depicted the saint, sword in hand, his spear having broken (*Three Inventories of the Years 1542, 1547, and 1549-1550 of Pictures in the Collections of Henry VIII and Edward VI*, ed. W. A. Shaw [London, 1937], 45). But the inventories do not necessarily refer to the Louvre painting. None of the works listed is ascribed to an artist, and no dimensions or detailed descriptions are given. Many other representations of the popular saint are mentioned, moreover (*Inventories*, 27, 29, 30, 35, 36, 45, 47, and 64).

108. See in particular James B. Lynch, "The History of Raphael's *St. George* in the Louvre," *Gazette des Beaux-Arts* 59 (April 1962), 203-212. This view, first proposed by Julia Cartwright (*The Early Work of Raphael* [London, 1895], 58-62) and supported by Edward McCurdy (*Raphael* [London, 1917], 137-139), is accepted by Alfred R. Dryhurst (*Raphael*, 2d ed. [London, 1909], 32); tentatively by Camesasca (*Raphael*, 49); and by Clough in *Studies*, 202. The theory is rejected by John Shearman in "Raphael at the Court of Urbino," *The Burlington Magazine* 112 (February 1970), 77, note 23 and by Dussler (*Raphael*, 5), because the Louvre *Saint George* formed a diptych with the *Saint Michael* (Dussler, *Raphael*, 5-6) which would doubtless also have been listed in the inventories. The inventories mention a picture (diptych?) of *Saint Michael* and *Saint George*, but the latter was shown with a banner (*Inventories*, 29).

109. The Milanese art theorist Giovanni Paolo Lomazzo refers in 1584 to a Saint George painted by Raphael for the Duke of Urbino, but his confused recollection cannot be identified with either of Raphael's known versions of the theme, as Lynch attempts to do (*Gazette*, 208-209). For the reference in Lomazzo see his *Trattato dell'arte della pittura* [orig. ed. Milan, 1584] (Rome, 1844), 1:75-76 (also in Golzio, *Raffaello*, 309-310). In the *Rime* of 1587 (181), Lomazzo describes together a *Saint George* and a *Saint Michael* by Raphael, obviously referring to the works now in the Louvre. The poem was quoted and translated by Lynch (*Gazette*, 207-208), who, however, failed to see its implication. According to Lomazzo, the paintings had formerly belonged to a Milanese who sold them to Count Ascanio Sforza of Piacenza. Since Lomazzo went blind by about 1570, we can conclude, rather uncharitably, that he must have seen them by that time. They were copied by his disciple Stresi

as well (Lynch, *Gazette*, 208-209). Visual evidence hitherto overlooked confirms the inference from Lomazzo's *Rime* that the *Saint George* and *Saint Michael* were in Milan in the sixteenth century. This evidence is provided by a sheet in an album of drawings by the Milanese artist Cesare da Sesto (d. 1523) in the Morgan Library (no. II, 26 [fol. 22]). The sheet includes three studies of Saint Michael and one of Saint George and the Dragon. The presentation of the images of the two saints at the top of the sheet, juxtaposed and in the same scale, suggests that Cesare had them concurrently in mind. Gustavo Frizzoni observed that Cesare's drawing echoed the principal figures in Raphael's *Saint Michael*, but he failed to deduce that that picture and presumably its pendant were, therefore, available to Cesare in Milan ("Certain Studies by Cesare da Sesto in Relation to his Pictures," *The Burlington Magazine* 26 [February 1915], 193, and pl. IB and C). Cesare's Saint George bears only a slight resemblance to Raphael's picture, however. The other studies of Saint Michael on the Morgan sheet show that Cesare also knew the composition of Raphael's monumental *Saint Michael*, painted in Rome in 1518. That it was in his native Milan, after his return there about 1520, where Cesare saw the small *Saint Michael*, is confirmed by yet another copy of slightly later date, a drawing by the Milanese artist Ambrogio Figino in the Biblioteca Ambrosiana (Giulio Bora, *Disegni di manieristi lombardi* [Vicenza, 1971], 53, cat. no. 85 and fig. 85).

110. Henri Hymans, *Lucas Vorsterman, 1595-1675, et son oeuvre gravé* (Amsterdam, 1972), 104-105, cat. no. 70.

111. The engraving throws some light, too, on the problematic question of the artist's signature, which is inscribed in gold letters on the breast strap of the horse in the painting. Since the spelling RAPHELLO is incorrect for Italian, the authenticity of the signature has sometimes been doubted (Dussler, *Raphael*, 13, and Shapley, *Italian Paintings*, 391-392). In the dozen or more accepted signatures, the Latin form RAPHAEL or RAPHAELLO is used. The mispelling of the signature, without the "A," has suggested that the name was added at a later date or that it was due to a restorer's mistake. But it must have been in place as early as 1627, when Vorsterman reproduced it in his engraving. The Latin dedication below the printed image also spells the artist's name as RAPHEL. This spelling of the name is common to the engraved image, the dedication below, and to

the National Gallery painting. And it agrees with the spelling of the name, RAPHEL, in Peter Oliver's miniature copy of 1628, to be discussed, as well as in an engraving by David Granges of the same date.

The evidence provided by the painting itself is no less equivocal. Since the present signature, like the other gold decoration on the panel, displays a crackle pattern and is beneath the varnish, it is old, if not original. On the other hand, if original, it is in unusually good condition. And if repainted, it does not reinforce traces of earlier gold paint. What the evidence suggests is that the signature in the painting in its present form dates from at least the time of the early seventeenth-century copies. But we cannot be sure whether it reinforces, or replaces, an earlier, correctly spelled inscription which had become abraded. Though the breast strap is not found in the preliminary cartoon for the painting, to be discussed, it is present, without an inscription, in the underpaint of the picture, as revealed by the x-radiograph. Perhaps the strap was added to bear the signature.

112. Jacobus de Voragine, *The Golden Legend*, trans. Granger Ryan and Helmut Rippergor (New York, 1941), 233.

113. The letter from Giovanna della Rovere, written in Urbino on October 1, 1504, shows that Raphael was in the city in the autumn of 1504 and that he intended to go to Florence in the near future. Commissioned perhaps by Giovanna della Rovere before Raphael's departure, the Louvre version was painted, in my opinion, late in 1504 or early in 1505. The pendant to the *Saint George*, the *Saint Michael*, also in the Louvre, seems to me to be slightly more advanced in style, more like the first Florentine works, the *Madonna Ansidei* of 1505, and the *Small Cowper Madonna*. The *Saint George* in Washington is decidedly more mature in style.

Dürer's woodcut (B. vii, 3) is dated c. 1501-1504 by Joseph Meder (*Dürer Katalog* [Vienna, 1932], 189 and xii, no. 225); 1504 by Willi Kurth (*The Complete Woodcuts of Albrecht Dürer*, trans. S. M. Welsh [New York, 1962], 27, 42); c. 1504 by Erwin Panofsky (*Albrecht Dürer* [Princeton, 1943], 2:40, no. 331); and c. 1505 by Campbell Dodgson (*Catalogue of Early German and Flemish Woodcuts in the British Museum* [London, 1903], 1:287, no. 36). Compare also the following engravings by Schongauer (Alan Shestack, *Fifteenth Century Engravers of Northern Europe* [exh. cat., National Gallery of Art] [Washington, 1967-1968], cat. no. 43

and fig. 43, and cat. no. 78 and fig. 78), by Master FVB (cat. no. 128 and fig. 128), and by Master MZ (cat. no. 146 and fig. 146).

114. Gabinetto Disegni e Stampe degli Uffizi, Florence, no. 530E. Pen and ink, partly pricked for transfer. See Fischel, *Zeichnungen*, 1:no. 57. The motif of skull and bones, quite frequent in depictions of Saint George, need not be derived specifically from Dürer, of course, but in the context of dependence it makes a further connection. By the time Raphael came to transfer the design onto the panel, he had decided not to use the motif, as the skull and bones are not pricked.

115. See Müntz, *Raphaël*, 139-140, 226-228, and *Raphael*, 133, 220; August Schmarsow, "Raphaels Heiliger Georg in St. Petersburg," in *Jahrbuch der Königlich preussischen Kunstsammlungen* 2 (1881), 256-257; Crowe and Cavalcaselle, *Raphael*, 1:279; Wilhelm Vöge, *Raffael und Donatello* (Strassburg, 1896), 2-6; Claude Phillips in *The North American Review* 169, no. 4 (October 1899), 461-462; Dryhurst, *Raphael*, 33, 73-74; Adolf Paul Oppé, *Raphael* (London, 1909), 41-42, 48; Otto von Taube, *Die Darstellung des Heiligen Georg in der italienischen Kunst* (Halle, 1910), 93-94; McCurdy, *Raphael*, 132, 135; Carlo Gamba, *Raphaël*, trans. Jean Alazard (Paris, [1932]), 41; and Anna Forlani Tempesti, "The Drawings," in *The Complete Work of Raphael*, ed. Mario Salmi (New York, 1969), 338-339. The suggestion of Donatello's influence was rejected by Adolf Rosenberg and Georg Gronau, however (*Raffael. Des Meisters Gemälde*, 4th ed., Klassiker der Kunst Series [Stuttgart-Berlin, 1919], 1922 ed., 225, note to repro. on p. 31).

116. About a copy in stucco reproducing the central figures see John Pope-Hennessy, *Catalogue of Italian Sculpture in the Victoria and Albert Museum*, 3 vols. (London, 1964), 1:82, cat. no. 67 and fig. 84. A virtual copy of Donatello's relief at a different scale and in a different medium is the altarpiece attributed to Andrea della Robbia at Brancoli (Alan Marquand, *Andrea della Robbia and his Atelier* [Princeton, 1922], 2:86 and cat. no. 210, fig. 182, with the date 1490-1500).

117. See Parker, *Ashmolean Museum*, 2:271-272, cat. no. 523.

118. Some writers have also compared the figure of the "princess" in Raphael's painting to her counterpart in Donatello's relief, but the only resemblance is in their praying action. The type of Donatello's princess, like that of his horseman, depends upon the Antique.

119. See Kenneth Clark, "Leonardo's *Adoration of the Shepherds* and *Dragon Fight*," *The Burlington Magazine* 62, no. 358 (January 1933), 25-26; and by the same author, *Leonardo Drawings*, 1:appendix I, xxii-xxxvi; A. E. Popham, "The Dragon Fight," in *Leonardo. Saggi e ricerche* (Rome, 1954), 223-227; and Parker, *Ashmolean Museum*, 2:11-12, cat. no. 17.

120. About an engraving by Palumba of about 1500, based on Leonardo, see Konrad Oberhuber, *Early Italian Engravings from the National Gallery of Art* [exh. cat., National Gallery of Art] (Washington, 1973), cat. no. 160. As is so often the case with borrowings from Leonardo, the artist derived the setting for the figures from another source, in this case, Dürer.

121. Leonardo recommended that the artist compose a dragon out of the parts of real animals. See Jean Paul Richter, *The Literary Works of Leonardo da Vinci*, 3d ed. (London, 1970), 324, no. 585.

122. Popham in *Leonardo*, 227, note 8. The author posits a connection too with Raphael's Louvre *Saint George*, which I do not see. About the engraving see Hind, *Italian Engravings*, pt. 2:5, no. 7, 65. For Lomazzo's discussion of this composition see Carlo Pedretti, "Un soggetto anamorfico di Leonardo ricordato dal Lomazzo (la zuffa del drago col leone)," *L'Arte* 55, no. 19 (January-August 1956), 12-22. Lomazzo's praise of Leonardo's composition that it depicted the combat "con tanta arte, che mette in dubbio chiunque lo riguardo chi di loro debba restare vittorioso" (*Trattato*, 1:302) might also be applied to Raphael's painting. Leonardo's crouching lion came to mind more than once when in a drawing datable to the early Roman period Raphael represented Hercules overpowering a lion (Parker, *Ashmolean Museum*, 2:286-287, cat. no. 540, and pl. CXXIX).

123. Pen and ink over traces of chalk. 29.8 x 21.2 cm. See Clark, *Leonardo Drawings*, 1:29-30, cat. no. 12331. Though the dating of the drawing is controversial, it appears to belong to the period of the *Battle of Anghiari* or slightly later. Those scholars who date it at the time of Raphael's painting are Heinrich Bodmer, *Leonardo* (Stuttgart, 1931), 414-415, no. 320: c. 1505-1508; Ludwig H. Heydenreich, *Leonardo da Vinci* (New York, 1954), 2:note to pl. 205, xviii: about 1505; and Ludwig Goldscheider, *Leonardo da Vinci* (London, 1959), 177 and pl. 105: c. 1506. The drawing was considered to be Raphael's source by Paul Müller-Walde, "Beiträge zur

Kenntnis des Leonardo da Vinci. 7," in *Jahrbuch der preussischen Kunstsammlungen* 20 (1899), 110; and Taube, *Die Darstellung*, 94-95. Any connection between the drawing and Raphael's painting is denied by Kenneth Clark, who dates the sheet c. 1513-1514. Pedretti would date the drawing as late as about 1516-1517 ("Leonardo da Vinci: Manuscripts and Drawings of the French Period, 1517-1518," *Gazette des Beaux-Arts* 76 [November 1970], 300). Berenson says: "Probably later than the Studies for the Battle, which would make it almost contemporary with Raphael's St. George. . ." (*The Drawings of the Florentine Painters*, 3 vols., 2d rev. ed. [Chicago, 1938], 2:136, no. 1228).

There is a copy of the central group in the Windsor drawing on a sheet in the Biblioteca Ambrosiana in Milan (Adolf Rosenberg, *Leonardo da Vinci* [Bielefeld-Leipzig, 1898], 35, fig. 33, cited in connection with Raphael's painting by Taube, *Die Darstellung*, 94-95). About other Saint George representations influenced by Leonardo's drawings see Taube, *Die Darstellung*, 96-97.

124. Museum Boymans-van Beuningen, Rotterdam, no. M 89. Black chalk with white heightening. From an album, recently taken apart for conservation reasons. The others in the series are M 88 (Gernsheim photo 30.619), M 90 (Gernsheim 30.621), M 91 (Gernsheim 30.622), and N 7 (Gernsheim 30.782). The bared teeth of the horse in certain of these drawings are particularly suggestive of Leonardo. The fact that several are squared for enlargement indicates that the artist had a definite picture in mind, probably a fresco, now lost but mentioned by Vasari. About the series, formerly in Weimar, see Hans van der Gabelentz, *Fra Bartolomeo und die Florentiner Renaissance*, 2 vols. (Leipzig, 1922), 2:208-210, nos. 548-551 and 2:248, no. 668. The derivation from Leonardo was noted by Suida, *Leonardo und sein Kreis* (Munich, 1929), 70, 244. Albert Schug in "Zur Chronologie von Raffaels Werken der Vorrömischen Zeit," *Pantheon* 25 (November-December 1967), 476, noted the similarity between Raphael's painting and Bartolomeo's drawings, dated somewhat later.

125. Brown and gray wash heightened with white. See Agnes Mongan and Paul J. Sachs, *Drawings in the Fogg Museum of Art* (Cambridge, Mass., 1940), 1:246-247, cat. no. 473. The attribution of the drawing to Edelinck is not to be considered certain, however, for as Konrad Oberhuber pointed out to the author, it is not incised for transfer, and

may simply be a copy after the Louvre drawing by Edelinck or some other follower of Rubens. About the whole problem of copies of Leonardo's battlepiece see Julius Held, *Rubens: Selected Drawings* (Garden City, N.Y., 1959), 1:157-159, cat. no. 161.

126. Metalpoint on cream colored paper. 21.1 x 27.4 cm. (8¼ x 10¾ in.). See Parker, *Ashmolean Museum*, 2:281-282, cat. no. 535. The sheet contains studies for saints in the Trinity fresco in S. Severo in Perugia, begun in 1505.

127. The importance of the *Battle of Anghiari* for Raphael's horse has been stressed by McCurdy, *Raphael*, 135-136; Adolfo Venturi, *Storia dell' arte italiana*, 9:pt. 2, 126; Cecil Gould, *Leonardo, the Artist and the Non-Artist* (Boston, 1975), 149. Shapley (*Italian Paintings*, 392), compares Raphael's horse and rider to a mounted figure in a pen and ink sketch by Leonardo for the battlepiece (Popham 192 B). The type of horse in Raphael's painting of Saint George in the Louvre is also said to have been derived from Leonardo. See Venturi, *Raffaello*, 125, and by the same author, *Storia*, 9:pt. 2, 129-130; Gamba, *Raphael*, 39; Ortolani, *Raffaello*, 21; Longhi, *Paragone*, 18; Luciano Berti, *Raphael*, trans. Sylvia Sprigge (New York, 1961), 39; Brizio, *Encyclopedia*, col. 842; Forlani Tempesti, *Complete Work*, 333; Pope-Hennessy, *Raphael*, 127; and De Vecchi, *Raffaello*, 18. For an opposed view see Dussler, *Raphael*, 5. Rather, it has a distinctly classical, un-Leonardesque character that serves to link it instead with some antique monument. The celebrated *Horses* on the Quirinal in Rome have sometimes been proposed. See Hermann Grimm, "Zu Raphael. III. Die Rossebändiger auf Monte Cavallo," in *Jahrbuch der Königlich preussischen Kunstsammlungen* 3 (1882), 267-274; Eugène Müntz, *Raphael: His Life, Works, and Times*, 2d rev. ed. (London, 1888), 92 note 1; Oppé, *Raphael*, 41-42; and Taube, *Die Darstellung*, 91. Like many other artists, Raphael certainly knew the free-standing marble *Horses*, but the proportions of the horse in a drawing he made after one of them (James Byam Shaw, *Old Master Drawings from Chatsworth* [exh. cat., International Exhibitions Foundation and participating museums] [Washington, 1969], no. 56) are not so close to the animal in the Louvre painting as are analogous motifs found on reliefs. Giovanni Becatti attributes the classical character of Raphael's horse to the artist's affinity for the antique rather than his use of any particular source ("Raphael and Antiquity" in *Complete Work of Raph-*

ael, ed. Mario Salmi [New York, 1969], 502). However, the proportions of the horse, with its small head and massive body, suggest an antique relief, a sarcophagus perhaps. And so do its upraised head and profile view to the right. Even the movement of Raphael's warrior saint, turning to strike, recalls the twisting action of horsemen on antique sarcophagi. A related drawing by Raphael of horsemen, as in a frieze, in the Uffizi bears a marked resemblance to equestrian battle-pieces of the classical type (Fischel, *Zeichnungen*, 1:no. 60), in which the figures move in unison toward the right. We can well imagine that the way Raphael has updated the horse in his painting by using a classical source—a Saint George *all'antica*—would not have gone unappreciated in Urbino where there were in the ducal palace, according to Castiglione, "countless ancient statues of marble and bronze" (*Courtier*, 13).

128. Metalpoint, heightened with white and cut along the outlines and incorrectly laid down in a near horizontal position. See Parker, *Ashmolean Museum*, 2:29-30, cat. no. 44. The drawing is badly abraded and the white heightening has oxidized.

129. See Berenson, "Nouveaux dessins de Signorelli," *Gazette des Beaux-Arts* 10 (November 1933), 279-280 and fig. 1; and by the same author, *Florentine Drawings*, 1:39-40, and 2:334, cat. no. 2059-G-1. Berenson was following a suggestion of Fischel. Though the drawing was exhibited as Signorelli's (*Mostra di Luca Signorelli* [exh. cat., Cortona-Florence] [Cortona, 1953], cat. no. 79), it finds no convincing parallel, as Parker noted (*Ashmolean Museum*, 29-30), in his work, not even with a painting of Saint George in the Rijksmuseum (*Mostra*, cat. no. 34). Nor are there any metalpoint drawings by Signorelli to compare.

130. The drawing was listed as Raphael's by Passavant (*Raphael*, 2:503, no. 498), but it was J. C. Robinson who first connected it with the painting now in Washington (*A Critical Account of the Drawings by Michel Angelo in the University Galleries* [Oxford, 1870], 151-152, cat. no. 35). For the Raphael attribution see also Ruland, *Raphael Collection*, VII.6, iii; Crowe and Cavalcaselle, *Raphael*, 1:278-279; F. O. Gordon, *Saint George* (London, 1907), 129-130; and McCurdy, *Raphael*, 132. The drawing is also accepted as a Raphael by Paul Joannides, *The Drawings of Raphael* (Oxford, 1983), cat. no. 117.

131. The anatomically correct head of the horse in Raphael's painting was aptly compared by Taube (*Die Darstellung*, 94-95) to a

Leonardesque drawing (F 263.INF no. 72), in the Biblioteca Ambrosiana (Rosenberg, *Leonardo*, 36, pl. 34). The motif in the Oxford drawing is even closer.

132. About the print recently located in the Albertina (Inv. 241 22, p. 22), see Adam Bartsch, *Le Peintre graveur* 15 (Vienna, 1813), no. 3, 24-25, under "School of Marcantonio"; and Passavant, *Raphael*, 2:574, cat. no. 34. In the *Recueil d'estampes d'après les plus beaux tableaux . . . dans le Cabinet du Roi . . .* (Paris, 1763), 1:13, it is stated that Crozat had "aussi un Dessein à la plume de la première pensée de Raphael pour ce tableau," that is, the one now in Washington. From this description we cannot be sure whether this drawing was the one copied by the engraver. It must have differed considerably from the painting, in any case, to qualify as a "première pensée."

133. National Gallery of Art, B-33,667. The contours of the figures are incised with a stylus. From the collections of Nicholas Laniere (Lugt 2886) and Sir Peter Lely (Lugt 2092). Pembroke Sale, July 5-6, 9-10, 1917, no. 354 as Raphael?; anonymous British collector via Sotheby's, London, 1982. Inscribed on the reverse: "sesant[u] peco dedessego"; and on the mount: "R U from vol 2nd N22." The drawing is accepted as Raphael's by Konrad Oberhuber (verbally) and by Joannides, *Drawings*, cat. no. 119.

134. Compare especially several horsemen in Raphael's early cartoon in the Uffizi for the fresco of the *Departure of Aeneas Sylvius for the Council of Basle* in the Libreria Piccolomini in Siena (Fischel, *Zeichnungen*, 1:no. 62).

135. Fischel, *Zeichnungen*, 3:nos. 143 and 144.

136. Gabinetto Disegni e Stampe degli Uffizi, Inv. no. 529E. See Fischel, *Zeichnungen*, 1:78; and Forlani Tempesti in *Complete Work*, 338-339 and 418, no. 76.

137. Pope-Hennessy, *Raphael*, 127.

138. Adolfo Venturi proposed Lorenzo di Credi as a source (*Grandi artisti italiani*, [Bologna, 1925], 261); Gamba, Francia (*Raphael*, 41); and Pope-Hennessy, Pinturicchio (*Raphael*, 127).

139. *Saint John the Baptist*, Alte Pinakothek, Munich, no. 652; *Saint Veronica*, Kress Collection, National Gallery of Art, no. 1125. About the paintings see Max J. Friedländer, *VI. Hans Memling and Gerard David*, trans. Heinz Norden (Leyden-Brussels, 1971), 51-52, no. 44, and 52, no. 46; and Giorgio T. Faggin, *L'Opera completa di Memling* (Milan, 1969), no. 59 A-C.

140. Carlo Volpe, "Due questioni Raffaellesche," *Paragone* 7, no. 75 (March 1956), 12.

The point is made in passing with no proof offered to connect the two pictures.

141. The landscape in the Saint George is "curiously Flemish," Martin Conway observed without citing a specific source, "and seems to prove that the painter had been looking at some picture by Memling and had borrowed from him trees and a tower" (*Art Treasures*, 155). Viscount Lee of Fareham also considered Memling a source for Raphael ("A New Version of Raphael's *Holy Family with the Lamb*," *The Burlington Magazine* 64, no. 370 [January 1934], 8). He did so not only for the *Saint George* in Washington, but also for the version in the Louvre, where, as I have noted, the landscape is entirely different. Moreover, the writer does not specifically compare the setting in the Munich picture to that of the Washington *Saint George*. Instead, he noted a "close resemblance between the *Saint George and the Dragon* in the background of [another version of *Saint John the Baptist* by Memling in the Louvre] with the treatment of the same subject by Raphael in both the Hermitage and Louvre versions." The resemblance is only general, and the whole point of bringing Memling into relation with the Washington *Saint George* is weakened when the writer considers it and the earlier Louvre version as similar in style and conception and as sharing a common source in Memling. The main purpose of the article, in any case, is to use the motif of the lamb in the Memling to support the attribution to Raphael of a version of the *Holy Family with the Lamb*. See Dussler, *Raphael*, 11-13, for the controversy surrounding this painting, dated 1504, and the one dated three years later in the Prado.

142. Lorne Campbell, "Notes on Netherlandish Pictures in the Veneto in the Fifteenth and Sixteenth Centuries," *The Burlington Magazine* 123 (August 1981), 471.

143. When the then little-known *Saint Veronica* in the Thyssen-Bornemisza Collection was exhibited at the Alte Pinakothek in Munich in 1930, under the same roof as the *Saint John*, the two paintings were linked by W. R. Valentiner and other scholars. It was Rudolf Heinemann who in 1937 went on to propose that the diptych was the one mentioned by Michiel as belonging to Bembo. Charles Sterling in 1952 dissented from this view, proposing that the *Saint John* belonged to Bembo but not the *Veronica*, which would be from a second diptych. The *Veronica* has accordingly sometimes been dated later than the *Saint John*. For the whole problem see Colin Eisler, *Paintings from the Samuel H.*

Kress Collection: European Schools Excluding Italian (Oxford, 1977), 55-57, who agrees with the view that both pictures made up Bembo's diptych. The argument thus turns on the accuracy [or not] of Michiel's description. The state of the question, in which the painted reverses of the panels also figure, is given by Campbell in *The Burlington Magazine*, 471.

144. See Eisler and Campbell cited in the previous note for the citation.

145. Campbell in *The Burlington Magazine*, 471. Clifford Brown has suggested that the Bembo diptych was possibly in Mantua, not Urbino, in the early sixteenth century, where it would have been adopted as a source by Lorenzo Costa for a *Veronica* ("Un tableau perdu de Lorenzo Costa et la collection de Florimond Robertet," *Revue de l'Art* 52 [1981], 24-28). Though the diptych was lent to Isabella d'Este in 1502, it is hard to believe that it remained in Mantua until 1507-1508, when Costa was commissioned to paint his *Veronica*, which in any case is lost without a trace. In 1504 Isabella apologized for returning so late some other works of art she had borrowed at the same time as the diptych.

146. About Bembo's arrival in Urbino see Clough, "Pietro Bembo, Luigi da Porto, and the Court of Urbino in the Early Sixteenth Century," *Archivio Veneto* 81, series 5 (1967), 77-87, esp. 82-83 (reprinted in the author's *Duchy of Urbino*). Further about Bembo see Carlo Dionisotti in *Dizionario biografico degli Italiani* 8 (Rome, 1966), 133-151. It is not to be excluded, however, that Bembo might have had the diptych with him on the occasion of one of his earlier brief visits, when Raphael could theoretically have seen it had he been in the duchy. Bembo was in Gubbio on May 3, 1505 (*Lettere di M. Pietro Bembo*, 5 vols. [Milan, 1809-1810], 1:27-29 [*Opere del Cardinale Pietro Bembo*, vols. 5-9 (Milan, 1808-)]) and in Urbino on January 7, 1506 (32-34). He was at Castel Durante near Urbino on February 5, 1506 (*Lettere* 3 [*Opere* 7], 10-12).

147. Raphael was in Urbino on May 6, 1507, and had been there *molti mesi*, according to a letter of Bembo (Golzio, *Raffaello*, 15-16). The fact that Raphael was again in Urbino on October 11, 1507 (Golzio, *Raffaello*, 17) makes clear that he went back and forth from Florence to Urbino, which he still regarded as his home. Not all of these trips are necessarily documented.

148. Whether the portrait was a drawing or a miniature depends on the reading of the ab-breviation "mta." See Golzio, *Raffaello*, 171, for the reference. Michiel saw the portrait along with Memling's diptych in Bembo's house in Padua.

149. A date of 1504-1505 is proposed by Gronau (*Raffael*, pl. 31), Suida (*Raphael*, pl. 71), and Fischel (*Raphael*, 358). Gamba (*Raphael*, 41) and Dussler (*Raphael*, 13) suggest 1505, and Pope-Hennessy (*Raphael*, 127), c. 1505. Other writers favor 1505-1506: Ortolani (*Raffaello*, 23), De Vecchi (*Paintings*, 95, no. 50), and Brizio (in *Encyclopedia*, col. 842). The date is narrowed to 1506 by Passavant (*Raphael*, 2:43), Müntz (*Raphael*, 226), Berti (*Raphael*, 40), Castelfranco (*Raphael*, 15) and Becherucci (*Raphael*, 57-58). During this period Guidobaldo was in Rome until June of 1504 and in Urbino from September to December of that year, when he left again for Rome. He remained there until August of 1505, when he returned to his duchy, coming to Urbino in March of 1506.

150. Rolf Kultzen, *Italienische Malerie, Alte Pinakothek* (Munich, 1975), 132-133, no. 1059, as Umbrian c. 1505. Compare the fragments of the Saint Nicholas altarpiece in Naples, which seem to me too poor in quality for Raphael though, like the Munich portrait, they reflect his early style. Neither the fragments nor the portrait is Peruginesque enough to be considered strictly Umbrian.

151. Volpe in *Paragone*, 12. Other Italian painters similarly excerpted landscape details from Memling's paintings. See Everett Fahy, "The Earliest Works of Fra Bartolomeo," *The Art Bulletin* 51 (June 1969), 147 and figs. 13 and 14; and Millard Meiss, "A New Monumental Painting by Filippino Lippi," *The Art Bulletin* 55 (December 1973), 485 and figs. 1, 2, and 10.

152. John Shearman has suggested that the larger tower on the horizon is the ancient Torre delle Milizie, which, according to him, Raphael would have seen on a brief visit to Rome before he went there to stay in 1508 ("Raphael, Rome, and the Codex Escurialensis," *Master Drawings* 15, no. 2 [Summer 1977], 132-133).

153. National Gallery of Art no. 25. See Shapley, *Italian Paintings*, 389-391. Inscribed with date and artist's monogram on the border of the Virgin's dress: MDVIII RV PIN (1508 Raphael of Urbino painted it). Old descriptions, engravings, and photographs of the picture, too numerous to cite here, when carefully examined, make clear that the present gold lettering replaces an identical earlier inscription, which was abraded.

154. Detroit Institute of Arts no. 89.25. About Sassoferrato and Raphael see Francis Russell, "Sassoferrato and his Sources: a Study in Seicento Allegiance," *The Burlington Magazine* 119, no. 895 (October 1977), 694-700. For the copies, one of which is dated 1508, see Dussler, *Raphael*, 63. The style reflected in the best of these small-scale copies is that of the end of Raphael's Florentine period. The number of nearly identical copies points to a lost original by the master himself, not a pupil, as is sometimes believed. One of these, attributed by Adolfo Venturi to Raphael, was sold at the American Art Association-Anderson Galleries on April 20, 1939 (lot no. 30). The sale catalogue claimed that the "arrival in the United States of one of Raphael's great paintings of the Madonna is an occurrence of world-wide significance." Yet another copy attributed to Sassoferrato, which was once with P. Jackson Higgs (*The Art News* 26, no. 38 [July 14, 1928], 17), now belongs to Saint James' Episcopal Church, Oneonta, New York.

155. Raphael's interest in this older work was shared by Fra Bartolomeo, as we see in a *Madonna* in the Metropolitan Museum, in which the cross axes of his figures closely follow Leonardo's invention (Fahy, *Art Bulletin*, 145-146 and figs. 8 and 9).

156. Noting Fra Bartolomeo's influence are Crowe and Cavalcaselle, *Raphael*, 1:357; Walter Heil in *Art and America* (1928), 49; and Bruno Santi, *Raphael* (Florence, 1979), 18. Lionello Venturi (*Italian Paintings*, note to pl. 445) cites Bartolomeo's *Vision of Saint Bernard* as a source.

157. Dussler, *Raphael*, 19. The dry detailed style of the painting and the interest in the *Doni Tondo* which it betrays point to a date of about 1507.

158. Two drawings are tentatively considered studies for the *Niccolini-Cowper Madonna* by Shapley (*Italian Paintings*, 389) and other earlier writers. The first of these, a study of a child's head at Lille (Fischel, *Zeichnungen*, 2:no. 72), is, as the vine leaves show, actually for an infant Bacchus and is later in date besides. The other, in the British Museum (Pouncey and Gere, *Drawings*, cat. no. 24, and pl. 29), includes a similarly smiling child, but is for the *Madonna Aldobrandini* or the *Mackintosh Madonna*, both in the London National Gallery.

159. Gabinetto Disegni e Stampe degli Uffizi, no. 501E. See Fischel, *Zeichnungen*, 3:no. 140; and Middeldorf, *Drawings*, 36-37, cat. no. 31. The latter dates the drawings c. 1507.

160. Pope-Hennessy, *Raphael*, 190.

161. Springer (*Raffael* [1878], 71), Fischel (*Zeichnungen*, 3:no. 110), Alfred Stix and L. Fröhlich-Bum, (*Beschreibender Katalog der Handzeichnungen in der Graphische Sammlung Albertina. III. Die Zeichnungen der Toskanischen, Umbrischen und Römischen Schulen* [Vienna, 1932], 10, cat. no. 53), Middeldorf (*Drawings*, 35, cat. no. 26), and Konrad Oberhuber (*I grandi disegni italiani dell' Albertina di Vienna* [Milan, 1972], cat. no. 35; and *Dessins italiens de l'Albertina de Vienne* [exh. cat., Musée du Louvre] [Paris, 1975], 72, cat. no. 28) have all observed the relation between the drawing (Sc.R. 250, Inv. no. 209 verso) and the painting. On the recto of the sheet (Fischel, *Zeichnungen*, 3:no. 111) is a study for the *Bridgewater Madonna*.

162. The debt to Leonardo was noted by E. H. Gombrich in *Norm and Form: Studies in the Art of the Renaissance* (London, 1966), 68.

163. Dussler (*Raphael*, 26) compares the Christ Child in each work. His claim that the two angels are later additions is debatable, however.

164. Ecole des Beaux-Arts, Paris. About the drawing see Fischel, *Zeichnungen*, 3:no. 146. On the other side of the sheet, a page from a sketchbook, are a drapery study for the *Madonna of the Baldacchino* and a profile portrait. Middeldorf noted that the child in the pen sketches is similar to that in the *Large Cowper Madonna* (*Drawings*, 37, no. 34).

165. British Museum no. 1895-9-15-637. Pouncey and Gere, *Drawings*, cat. no. 18.

166. Fischel (*Zeichnungen*, 3:no. 134) noted a connection between this sheet and the *Niccolini-Cowper Madonna*, and Middeldorf (*Drawings*, cat. no. 30) observed more specifically a similarity in the pose of the Child. Any connection between the drawing and painting is denied by Forlani Tempesti (*Complete Work*, 419, note 85) and by Dussler (*Raphael*, 26).

167. James Byam Shaw, *Drawings by Old Masters at Christ Church*, 2 vols. (Oxford, 1976), 1:118-119, cat. no. 362; and Terisio Pignatti, *Italian Drawings in Oxford* (Oxford, 1977), cat. no. 17. A similar drawing is on the verso of a sheet in the Ashmolean Museum in Oxford (Parker, *Drawings*, 2: 274-275, cat. no. 528).

168. Proposed by Fischel, *Zeichnungen*, 2:125, no. 102.

169. Golzio, *Raffaello*, 19-20.

170. Camesasca, *Perugino*, 111-112 and pls. 187-189.

171. Both versions are now generally accepted as by Marcantonio, who because of the popularity of the print would have been obliged to repeat it after the plate wore out. See Innis H. Shoemaker, *The Engravings of Marcantonio. Raimondi* [exh. cat., The Spencer Museum of Art, Lawrence, Kansas; The Ackland Art Museum, Chapel Hill, North Carolina; The Wellesley College Art Museum, Wellesley, Massachusetts] (Lawrence, Kansas, 1981), cat. nos. 21 and 26.

172. Wendy Stedman Sheard, *Antiquity in the Renaissance* [exh. cat., Smith College Museum of Art] (Northhampton, Massachusetts, 1979), cat. no. 45.

173. Pouncey and Gere, *Drawings*, 17, cat. no. 20 recto and pl. 25.

174. Shoemaker, *Marcantonio*, cat. no. 19.

175. Mantegna's example, too, was undoubtedly important. See Edit Pogány Balás, *The Influence of Rome's Antique Monumental Sculptures on the Great Masters of the Renaissance* (Budapest, 1980), 66-70.

176. Pouncey and Gere, *Drawings*, 18-19, cat. no. 21 and pl. 26.

177. A. E. Popham and Johannes Wilde, *The Italian Drawings of the XV and XVI Centuries . . . at Windsor Castle* (London, 1949), 310-311, cat. no. 793 and pl. 55. Though it was eliminated from the *Massacre of the Innocents*, the motif of the soldier and the fleeing woman does recur on the reverse of the Windsor sheet, transposed into a combat of marine deities (Popham and Wilde, *Windsor*, fig. 154).

178. Walter Koschatzky, Konrad Oberhuber, and Eckhart Knab, *I grandi disegni italiani dell' Albertina di Vienna* (Milan [c. 1972]), cat. no. 37. About a sheet in Budapest which may be a modello for the engraving see Shoemaker, *Marcantonio*, 96-97, fig. 23.

179. See Giuseppe Liverani, "La fortuna di Raffaello nella maiolica," in *Raffaello*, ed. Mario Salmi (Novara, 1968), 691-708.

180. Jeanne Giacomotti, *Catalogue des majoliques des musées nationaux. Musées du Louvre et de Cluny, Musée national de céramique à Sèvres, Musée Adrien-Dubouché à Limoges* (Paris, 1974), 323-324, cat. no. 993. Other versions include a damaged plate from Urbino, dated 1566, in the Bargello in Florence (Giovanni Conti, *Catalogo delle maioliche, Museo Nazionale del Bargello* [Florence, 1971], cat. no. 43 [illus.]); a damaged plate possibly by Nicola da Urbino of about 1528-1530, more faithful to the engraving, in Braunschweig (Johanna Lessman, *Italienische Majolika*, Herzog Anton Ulrich-Museum [Braunschweig, 1979], cat. no. 138 and pl. 24); and one, again unfortunately damaged, which once belonged to J. P. Morgan (*Sale of European Works of Art*, Sotheby Parke-Bernet, New York, May 21-22, 1982, lot no. 279 [illus.]) and which differs considerably from the engraving. Additional examples are cited by Liverani in *Raffaello*, 704.

181. *Madonna and Child with the Infant Saint John the Baptist*, known as the *Alba Madonna*, National Gallery of Art no. 24. For full details see Shapley, *Italian Paintings*, 386-389. In "The Genesis of Raphael's *Alba Madonna*," *Studies in the History of Art 8* (1978), 35-61, Jack Wasserman attempts to trace earlier stages in the development of the composition by means of drawings believed by him to be copied from supposed lost drawings by Raphael. Two of these in the Biblioteca Ambrosiana, Milan, and another in the Landsinger Collection, Munich, by anonymous artists, had previously been compared with the *Alba Madonna* to support the authenticity of the rival version in square format. They are not discussed in the Raphael literature and are at best of dubious value in reconstructing Raphael's project. Other drawings by Cesare da Sesto are not copies after drawings by Raphael, in my opinion, but variants of the finished painting. I do agree with Wasserman about two drawings in the Albertina and in the Louvre, plausible copies of lost drawings by Raphael, which are analyzed in my text.

182. British Museum no. Ff. I-38. Pouncey and Gere, *Drawings*, 46, cat. no. 59. A second copy in the same medium is also in the British Museum (45-46, cat. no. 58), and another is in the Uffizi (498E [photo Gernsheim 9046]), without the Saint John. The recto is inscribed in the lower right "Raffaello." A fourth copy is in the Brera (Braun photo no. 7, Hertziana, Rome).

183. About Rustici's relief in the Museo Nazionale del Bargello in Florence see John Pope-Hennessy, *Italian High Renaissance and Baroque Sculpture*, 3 vols. (Greenwich, 1963), 3:pt. 1, 64-65 and fig. 8, and 3:pt. 3, 41. As a collaborator of Leonardo in sculpture, Rustici here attempted to translate his mentor's painterly and compositional values into carved marble. A copy of a Leonardo drawing at Windsor, treating the theme of the Virgin seated on the ground, bears a resemblance to the relief. "How far he carried the idea we do not know," comments Clark, "but probably far enough to suggest to Raphael the motive of the Casa Alba Madonna . . ." (*Leonardo Drawings*, 1:107-108, no. 12564).

184. About the Taddei tondo see most recently R. W. Lightbown, "Michelangelo's Great Tondo: Its Origin and Setting," *Apollo* 89, no. 83 (January 1969), 22-31. Raphael's knowledge of this work is established by drawings and by the *Bridgewater Madonna*.

185. About the influence of the *Doni Tondo* see: Passavant, *Raphael*, 2:105; Crowe and Cavalcaselle, *Raphael*, 2:125; Oppé, *Raphael*, 136; McCurdy, *Raphael*, 151; Moritz Hauptmann, *Der Tondo* (Frankfurt, 1936), 259; and Dussler, *Raphael*, 35. Some of these writers also cite the Taddei tondo as a source.

186. Michel Laclotte and Elisabeth Mognetti, *Avignon: Musée du Petit Palais. Peinture italienne* (Paris, 1976), cat. no. 140, with an illustration and citing bibliography and analogous works. The picture, which also includes a female saint, is attributed by Berenson to the anonymous pupil of Credi called "Tomasso" and by others to the Master of the *Czartoryski Madonna*.

187. Musée Bonnat, Bayonne, no. 120. See Jacob Bean, *Les dessins italiens de la Collection Bonnat* (Paris, 1960), cat. no. 6. Though this particular drawing may not have been known to Raphael, Fra Bartolomeo took up the theme in an analogous manner throughout his career. Leonardo's example, of course, lies behind all these pyramidal compositions, and in this sense Wölfflin was right to compare the *Alba Madonna* with a Leonardesque tondo by Marco d'Oggiono, a Milanese follower of the master, now at Bob Jones University (*The Bob Jones University Collection of Religious Paintings* [Greenville, S.C., 1962], 69, cat. no. 34). See Heinrich Wölfflin, *Die Klassische Kunst* (Munich, 1899), 82, note 2; and for a more detailed comparison Wasserman, *Studies*, 47-48 and fig. 11.

188. Wölfflin, *Klassische Kunst*, 82. See also McCurdy, *Raphael*, 151; Gombrich, *Norm and Form*, 68-69; and Wasserman, *Studies*, 48.

189. Dussler, *Raphael*, 26-27 and pl. 71. The *Aldobrandini Madonna* may well have preceded the *Alba Madonna* in execution, but both works were conceived at the same time and in the same spirit, as is shown by a sheet at Lille with metalpoint studies on pink paper relating to both pictures (Fischel, *Zeichnungen*, 8:352). See also Albert Châtelet, *Disegni di Raffaelo e di altri maestri del Museo di Lille* (Florence, 1970), cat. no. 85 and fig. 71. In the lower of these studies lengthwise on the sheet, the Infant Baptist is drawn as he appears in the London painting. In the upper study, however, he is to the left of the principal group. His action of presenting the cross,

grasped by the Christ Child, is similar to that of Saint John in the *Alba Madonna*, as is the head of the Virgin. The sheet also includes a study for the *Madonna of Loreto*, recently rediscovered at Chantilly.

190. Crowe and Cavalcaselle, *Raphael*, 2:125; and Beck, *Raphael*, 132. The picture has also been compared, less convincingly, to the *Judicial Virtues* in the Stanza della Segnatura, but these are more Michelangelesque in spirit and design and obviously postdate the first unveiling of the Sistine Ceiling in August 1511. See Ortolani, *Raffaello*, 39; and Camesasca, *Pittura Raffaello*, 18, and *Raphael*, 19.

191. Dussler, *Raphael*, 74-76 and fig. 125. Whether it precedes or follows the *School of Athens*, the *Parnassus* is datable, in my opinion, to 1510-1511, after the *Disputà* of 1509 and before the *Virtues*, painted late in 1511. An earlier dating of 1508 for the Washington painting (Julia Cartwright, *Raphael* [London, 1900], 32; Gronau, *Raffael*, 74; and Hans Tietze, *Masterpieces of European Painting in America* [New York, 1939], 313, no. 79) has been generally superseded in the literature by the date suggested here. See: Camesasca, *Pittura Raffaello*, 55, and *Raphael*, 76; De Vecchi, *Complete Paintings*, 105, no. 90; Pope-Hennessy, *Raphael*, 205; Dussler, *Raphael*, 35; Beck, *Raphael*, 132; and Wasserman, *Studies*, 37. Freedberg, however, continues to date the picture c. 1509 (*Painting in Italy*, 34).

192. British Museum no. Pp. 1-73. Pouncey and Gere, after cataloguing the drawing as a copy, were led to accept it by Oberhuber (*Drawings*, 37, and viii and xvi, cat. no. 44). See Oberhuber's review of Pouncey and Gere, *Drawings* in *Master Drawings* 1, no. 3 (Autumn 1963), 47.

193. About the drawing in the Ashmolean Museum see Parker, *Ashmolean Museum*, 2:cat. no. 545 verso, and pl. 131. See also for the connection with the *Alba Madonna*, Fischel *Zeichnungen*, 6:no. 281; Middeldorf, *Drawings*, 45, no. 63; Pope-Hennessy, *Raphael*, 205; and Shapley, *Italian Paintings*, 386.

194. The pose in the *Alba Madonna* is compared to that in the drawing by Forlani Tempesti in *Complete Work*, 389. The fresco, the drawing (Fischel, *Zeichnungen*, 5:no. 250), and the statue, believed to be of Cleopatra in the Renaissance, are reproduced together and discussed by Pope-Hennessy in *Raphael*, 140-144. About Raphael and the antique see Cornelius Vermeule, *European Art and the Classical Past* (Cambridge, Mass., 1964), 62-67; and Beccati in *Complete Work*,

491-568. About the vast field of classical influence on Renaissance artists see most recently Sheard, *Antiquity*.

195. Emanuel Winternitz, "Musical Archaeology of the Renaissance in Raphael's *Parnassus*," in *Musical Instruments and their Symbolism in Western Art* (New York, 1967), 185-201.

196. Gisela Richter, *Engraved Gems of the Romans* (London, 1971), no. 664. Forlani Tempesti in *Complete Work*, 389, posits Michelangelo's Adam as a source, and Wasserman in *Studies*, 48, the *ignudi*.

197. If Raphael had a source for the pose in antique art, it might have been a small work like a cameo rather than a monumental relief. See, for example, the cameo reproduced in the *Gazette Archéologique* 10 (1885), 396-401, and pl. 42.

198. Shapley, *Italian Paintings*, 388, note 11. For other suggestions about the identity of the patron see Wasserman, *Studies*, 35-37. The antique dress of Raphael's Virgin was noted by Gruyer, *Vièrges*, 3:202-203; Crowe and Cavalcaselle, *Raphael*, 2:125; Julia Cartwright, "Raphael in Rome," in *The Portfolio*, no. 20 (August 1895), 27; Oppé, *Raphael*, 136; Dryhurst, *Raphael*, 112; McCurdy, *Raphael*, 150; Wasserman, *Studies*, 59-60; and Fahy, *Leonardo*, 42.

199. Musée des Beaux-Arts, Lille, nos. 456 (recto) and 457 (verso). Red chalk and pen and brown ink. 42.1 x 27.2 cm. See Fischel, *Zeichnungen*, 8:nos. 364-365; and Châtelet, *Disegni di Raffaello*, 65-66, cat. no. 84. There is an indication of a classical order on the right in the compositional sketch.

200. Once believed to be genuine, the drawing in pen and wash heightened with white, is now generally regarded as a copy of a lost preparatory study for the *Alba Madonna*, made between the Lille drawing and the finished painting. See Crowe and Cavalcaselle, *Raphael*, 2:128; Stix and Fröhlich-Bum, *Zeichnungen*, cat. no. 70 (Sc.R. 239, Inv. no. 199); Fischel, *Zeichnungen*, 8:text of no. 364; Dussler, *Raphael*, 35; and Wasserman, *Studies*, 56-57. The figures in the copy are compressed into an oval.

201. Musée du Louvre, Cabinet des Dessins, Inv. no. 4279. Philip Pouncey's attribution to Pupini is inscribed on the mount. The drawing was first published by Wasserman in *Studies*, 57-58 and fig. 21.

202. Museum Boymans-van Beuningen, Rotterdam, Inv. no. I-110. Fischel, correctly in my opinion, considered the drawing an original by Raphael rather than a copy after the painting. See by Fischel: "Some Lost

Drawings by or near Raphael," *The Burlington Magazine* 20 (February 1912), 299, no. 7; "Raphael's Pink Sketch-Book," *The Burlington Magazine* 74 (April 1939), 187; and *Zeichnungen*, 8:no. 355. Dussler (*Raphael*, 35) agrees with Fischel and says that the drawing is in poor condition. Forlani Tempesti (in *Complete Work*, 423, note 135) mistakenly claims that it is a forgery. For further details, including provenance and bibliography, see: E. Haverkamp-Begemann, *Vijf Eeuwen Tekekunst* [exh. cat., Museum Boymans-van Beuningen] (Rotterdam, 1957), 36-37, cat. no. 39; and *Italiaanse Tekeningen in Nederlands Bezit* [exh. cat., Institut Neerlandais, Paris; Museum Boymans-van Beuningen, Rotterdam; Teylers Museum, Haarlem] (n.p., 1962), 49-50, cat. no. 61.

203. Herbert Friedmann, "The Plant Symbolism of Raphael's *Alba Madonna*," *Gazette des Beaux-Arts* 36 (October-December 1949), 213-220.

204. Marielene Putscher, *Raphaels Sixtinische Madonna* (Tübingen, 1955), 124.

205. Fra Pietro da Novellara, who saw the picture on an easel in Leonardo's workshop, described the Child as having taken the reed, gazing attentively at the spokes which were in the form of a cross and holding it firmly. See Ludwig Goldscheider, *Leonardo da Vinci* (London, 1959), 37-38.

206. British Museum no. 1862-10-11-196. On the verso is a red chalk study of the head of an old man; Windsor Castle, no. 12563; Musée du Louvre, Cabinet des Dessins, Inv. no. 6781.

207. Ruland, *Raphael Collection*, 69, nos. 12-14. See also Adolfo Venturi, "Rapporti d'arte tra Raffaello e Leonardo," in *Per il IV centenario della morte di Leonardo* (Bergamo, 1919), 12.

208. About Cesare da Sesto see most recently Freedberg, *Painting in Italy*, 260-262.

209. Clark, *Leonardo Drawings*, 1:107.

210. For other examples see Bean and Stampfle, *New York Drawings*, 36-37, cat. no. 39 (leaves from an album).

211. For full details on the painting see Shapley, *Italian Paintings*, no. 534, 394-396. The condition is generally good, except for repaint, presumably covering abrasion, in the left eye and the hand.

212. About the Strasbourg portrait see: *Le XVIe siècle européen: peintures et dessins dans les collections publiques françaises* [exh. cat., Petit Palais, Paris] (Paris, 1965), cat. no. 245 (as Raphael ?); and John Shearman, "Le seizième siècle européen," *The Burlington Magazine* 108 (February 1966), 63-64 (as Giu-

lio). The hypothesis tentatively advanced in the catalogue (and rejected by Shearman) that the *Young Woman* and *Bindo Altoviti* may have been pendants, based on their identical dimensions, is contradicted by the different styles in which they are painted. The green background in the former is a curtain, moreover, while in the latter it is a flat plane (unmodified, as recent technical examination has shown). About the *Boy* see *From Van Eyck to Tiepolo. An Exhibition of Pictures from the Thyssen-Bornemisza Collection* [exh. cat., The National Gallery, London] (London, 1961), 28, cat. no. 49 (as Giulio).

213. Freedberg, *Painting in Italy*, 471, note 49; Shapley, *Italian Paintings*, 394.

214. Konrad Oberhuber, "Die Fresken der Stanza dell' Incendio im Werk Raffaels," in *Jahrbuch der kunsthistorischen Sammlungen In Wien* 58 (1962), 23-72.

215. Kathleen Weil-Garris, *Leonardo and Central Italian Art* (New York, 1974); and David Alan Brown and Konrad Oberhuber, "*Monna Vanna* and *Fornarina*: Leonardo and Raphael in Rome," in *Essays Presented to Myron P. Gilmore*, 2 vols. (Florence, 1978), 2:25-86.

216. Passavant (*Raffael*, 2:144 and *Raphael*, 2:117-119) dated the portrait 1512, adding that it recalled Giorgione in color. Crowe and Cavalcaselle also dated it 1512 (*Raphael*, 2:174-176). Cecil Gould has recently communicated to me (May 25, 1981; July 1, 1981) his view that, largely on the basis of costume and paint handling, the portrait must be "earlier than had been thought."

217. Already in the eighteenth century, the color of the portrait was compared favorably to Titian's. Quatremère de Quincy (*Histoire de la vie et des ouvrages de Raphael* [Paris, 1824], 147), agreeing with an earlier view.

218. As pointed out by Pope-Hennessy in *Raphael*, 219.

219. Konrad Oberhuber and Lamberto Vitali, *Raffaello: Il cartone per la Scuola d'Atene* (Milan, 1972), 33 and pl. 20. The figure is traditionally identified as Francesco Maria della Rovere.

220. Oberhuber and Vitali, *Cartone*, 27; and Anton Springer, "Raphaels Schule von Athens," *Die Graphischen Künste* 5 (1883), 83-85, where Vasari's use of the print to refresh his memory of the fresco is discussed.

221. Kultzen, *Italienische Malerei*, 138-140 and fig. 55, no. 524. The Venetian examples often brought into the discussion are distinctly different from *Bindo Altoviti* in their lack of implied movement.

222. Michael Hirst, *Sebastiano del Piombo*

(Oxford, 1981), 100 and pl. 71.

223. About the painting in the National Museum in Lisbon see John Shearman, *Andrea del Sarto*, 2 vols. (Oxford, 1965), 1:120, cat. no. 40 and pl. 45b. Accepting Hartt's attribution of *Bindo Altoviti* to Giulio and a date for the portrait of about 1520 (120, note 3), Shearman posits Sarto's portrait as a prototype for Raphael's. In addition, a damaged drawing of the head of a young man in the Biblioteca at Montecassino (Corrado Ricci in *Rassegna d'Arte* 7, no. 4 [April 1920], 89 and 90, as Franciabigio) inscribed as a self-portrait of Raphael, is related by Shearman to Sarto's portrait, though the features appear to have much in common with Bindo Altoviti's.

224. Susan Regan McKillop, *Franciabigio* (Berkeley and Los Angeles, c. 1974), 134-135, cat. no. 12, and fig. 31. She accounts for the resemblance between Franciabigio's and Raphael's portraits by assuming that both go back to the "Francesco Maria della Rovere" figure in the *School of Athens*. A reversed variant of Raphael's portrait, attributed to Perino del Vaga, is or was in the collection of Madame Pierre Fredet in Paris (Photo I Tatti).

225. "E a Bindo Altoviti fece il ritratto suo quando era giovane che è tenuto stupendissimo" (*Vite*, 4:351). This interpretation seems to have been first suggested by Bottari in his annotated edition of Vasari's *Lives* (Giorgio Vasari, *Vite de' più eccellenti pittori, scultori e architetti*, ed. Giovanni Gaetano Bottari, 3 vols. [Rome, 1759-1760], 2:88). In this edition the woodcut portrait of Raphael ornamenting the second edition of Vasari's *Lives* was substituted by an engraving based on the *Portrait of Bindo Altoviti*. The picture was exhibited as a self-portrait in the cloister of Santissima Annunziata in Florence in 1767 (Fabia Borroni Salvadori, "Le esposizione d'arte a Firenze 1674-1767," in *Mitteilungen des Kunsthistorischen Institutes in Florenz* 18 [1974], 49).

226. The prints after the painting, listed by Passavant (*Raphael*, 2:118-119) and Ruland (*Raphael Collection*, 9) and mostly available in the Albertina, the British Museum, and the Raphael Study Collection from Windsor Castle on deposit at the British Museum, some of them used as book plates, would be worth studying in detail in relation to the self-portrait issue.

227. *Briefwechsel zwischen Ludwig I von Bayern und Georg von Dillis*, ed. Richard Messerer (Munich, 1966), 64 note b.

228. The opening of the tomb is described

in a letter to Quatremère de Quincy printed in his *History of the Life and Works of Raphael*, trans. William Hazlitt (1896; reprint ed., New York, 1979), 416-419.

229. Hermann Schaaffhausen, *Der Schädel Raphaels: Zur 400 Jährigen Geburtstagsfeier Raphael Santi's* (Bonn, 1883). The prints for Schaaffhausen's book came from the wood engravings of the painter-physician Carl Gustav Carus published in his *Symbolik der Menschlichen Gestalt* (Leipzig, 1853), figs. 22 and 23.

230. Hermann Welcker, "Der Schädel Rafael's und die Rafaelporträts," *Archiv für Anthropologie* 15 (1884), 427, pls. 10 and 11.

231. For Ingres' involvement with Raphael, see most recently Eldon N. Van Liere, "Ingres' 'Raphael and the Fornarina': Reverence and Testimony," *Arts Magazine* 56, no. 4 (December 1981), 108-115. A comprehensive investigation of the problem, particularly as it relates to Raphael's reputation in the nineteenth century, has been undertaken by Jane Van Nimmen of the University of Maryland at College Park, who kindly shared with me some of her preliminary work.

232. About the painting (no. 37.13), signed in the lower left, see *Ingres* [exh. cat., Petit Palais, Paris] (Paris, 1966), cat. no. 63.

233. Chief among these sources was Comolli's forged biography of Raphael. See N. Schlenoff, *Ingres: ses sources littéraires* (Paris, 1956), 137-138. The only other of the projected paintings to be completed was *Raphael and the Fornarina*, of which there are several versions (Van Liere in note 231).

234. The editor of the French edition of Passavant's monograph prefaced the book with a letter to Ingres, invoking the painter as the most illustrious of Raphael's pupils, "the head of his school, the apostle of his doctrines, the continuer of his mission, the heir to his pencil and brush" (*Raphael*, 1:v).

235. The catalogue for the Warren sale, from which Henry Walters bought the painting, had suggested Sebastiano's *Violin Player*, then believed to be by Raphael, as a source (American Art Association, New York, January 8-9, 1903, no. 52). Writers citing *Bindo Altoviti* are Edward S. King, "Ingres as Classicist," *Journal of the Walters Art Gallery* 5 (1942), 77; Ettore Camesasca, *L'Opera completa di Ingres* (Milan, 1968), 95; Beck, *Raphael*, 53; Shapley, *Italian Paintings*, 395; and Marjorie B. Cohn and Susan L. Siegfried, *Works of J.-A.-D. Ingres in the Collection of the Fogg Art Museum* (Cambridge, Mass., 1980), 166 (where it is suggested that Ingres made further use of *Bindo Altoviti* for the

Fornarina of 1814 and the Louvre *Odalisque* of the same year). According to Van Liere (*Arts*, 108) the head of Raphael in Ingres' *Raphael and the Fornarina* of 1814 is also based on *Bindo Altoviti*.

236. There is a painted copy on canvas of *Bindo Altoviti*, nearly the same dimensions as the original, and doubtfully attributed to Ingres, in the Musée Ingres at Montauban (Daniel Ternois, *Montauban. Musée Ingres: Ingres et son temps* [Paris, 1965], cat. no. 178).

237. Musée du Louvre, Cabinet des Dessins, no. RF 1448. Henri Delaborde, *Ingres* (Paris, 1870), no. 210.

238. See Cohn and Siegfried, cited in note 235.

239. See Cohn and Siegfried cited in note 235 and Agnes Mongan and Hans Naef, *Ingres Centennial Exhibition* [exh. cat., Fogg Art Museum, Harvard University] (Cambridge, Mass., 1967), cat. no. 115.

240. See Georges Wildenstein, *Ingres* (London, 1954), cat. no. 17 and pl. 1; and Jon Whiteley, *Ingres* (London, 1977), 26, no. 11, discussing the reworking of the portrait to achieve a "Raphaelesque elegance." The supposed self-portrait of Raphael was also taken as a model by the Nazarene painter Johann Scheffer von Leonardshoff for his *Self-Portrait* of 1822 in the Österreichische Galerie in Vienna (*Die Nazarener* [exh. cat., Städelsches Kunstinstitut] [Frankfurt, 1977], 160, cat. no. D 23, and [illus.] 166).

List of Objects in the Exhibition

GRETCHEN HIRSCHAUER

I Raphael's Prestige

Early American Artists and Collectors

Thomas Crawford
1 *Portrait of Raphael*
Marble sculpture
104.1 x 40.6 x 35.6 cm. (41 x 16 x 14 in.)
Kennedy Galleries, Inc., New York

Sir Thomas Lawrence
2 *Portrait of Benjamin West*
Oil on canvas
271.8 x 176.5 cm. (107 x 69½ in.)
Wadsworth Atheneum, Hartford,
Purchased by Subscription

Benjamin West, after Raphael
3 *The Water Bearer*
Black chalk
57.8 x 42.9 cm. (22¾ x 16⁹∕₁₆ in.)
The Pierpont Morgan Library, New York

Benjamin West
4 *Mrs. Benjamin West and her Son Raphael*
Oil on canvas
91.4 cm. diam. (36 in. diam.)
Utah Museum of Fine Arts, Salt Lake City,
Gift of the Marriner S. Eccles Foundation

John Singleton Copley
5 *The Ascension*
Oil on canvas
81.3 x 73.7 cm. (32 x 29 in.)
Museum of Fine Arts, Boston,
Bequest of Susan Greene Dexter, in memory
of Charles and Martha Babcock Amory

John Vanderlyn
6 *The Calumny of Apelles*
Oil on canvas
57.2 x 72.4 cm. (22½ x 28½ in.)
The Metropolitan Museum of Art, New York,
Gift of the Family of General George H. Sharpe,
1924

Washington Allston
7 *Beatrice*
Oil on canvas
76.8 x 64.5 cm. (30¼ x 25⅜ in.)
Museum of Fine Arts, Boston, Anonymous Gift

Attributed to John Smibert
8 *Madonna and Child with Saints Elizabeth and John*
Oil on canvas
109.2 x 99.1 cm. (43 x 39 in.)
Bowdoin College Museum of Art, Brunswick

9 Reversed copy of an engraving by Caraglio, after
Raphael's *Small Holy Family*
32.7 x 26.8 cm. (12⅞ x 10⁹∕₁₆ in.)
Trustees of the British Museum, London

After Raphael
10 *Holy Family of Francis I*
Oil on canvas
97.8 x 67.3 cm. (38½ x 26½ in.)
Thomas Jefferson Memorial Foundation, Monticello

After Raphael
11 *Madonna of the Chair*
Oil on panel
74.1 x 74.5 cm. (29¼ x 29⅜ in.)
Mr. & Mrs. St. Clair M. Smith, Punta Gorda, Florida

Nathaniel Hawthorne
12 *Transformation: or, The Romance of Monte Beni*
(Leipzig, 1860)
Open to an illustration of Raphael's *Madonna
of Foligno*
The Library of Congress, Washington

After Raphael
13 *Sistine Madonna*
Hand-colored photograph
41.2 x 30.4 cm. (16¼ x 11¹⁵∕₁₆ in.)
Joseph Shepperd Rogers, Landover, Maryland

14 "Fairbank's Cherubs"
Chromolithographic tradecard
37.8 x 59.6 cm. (14¹⁵⁄₁₆ x 23½ in.)
The Library of Congress, Washington

Later American Collectors

Jean-François Millet
15 *L'Attente (Waiting)*
Oil on canvas
84.5 x 121.3 cm. (33¼ x 47¾ in.)
Nelson Gallery-Atkins Museum, Kansas City (Nelson Fund)

16 Isabella Stewart Gardner's copy of
Julia Cartwright, *Isabella d'Este* (New York, 1903)
Isabella Stewart Gardner Museum, Boston

McKim, Mead and White
17 Proposed design for the vaulted ceiling and apse of the Rotunda in the Morgan Library
The Pierpont Morgan Library, New York, Gift of Walker O. Cain, 1979

Henry Siddons Mowbray
18 Copy of Raphael's vault of the Stanza della Segnatura
Watercolor
46.3 x 29.8 cm. (18¼ x 11¾ in.)
Lent by a member of the artist's family

Henry Siddons Mowbray
19 Study for *Religion* on the ceiling of the Rotunda in the Morgan Library
Pencil
31.7 x 29.5 cm. (12½ x 11⅝ in.)
Lent by a member of the artist's family

20 Joseph Widener's copy of Crowe and Cavalcaselle, *Raphael* (London, 1882-1885)
National Gallery of Art Library, Washington

Anonymous Photographer
21 *Bernard Berenson*, 1909
Villa I Tatti, Harvard University Center for Italian Renaissance Studies, Florence

22 Joseph Widener's copy of Bernard Berenson, *Central Italian Painters of the Renaissance* (New York/London, 1907; orig. ed. 1897)
National Gallery of Art Library, Washington

23 Joseph Widener's copy of *Catalogue of Paintings and Sculpture in the Collection of Charles T. Yerkes, Esq.* (New York, 1904)
National Gallery of Art Library, Washington

Giannicola di Paolo
24 *Annunciation*
Oil on panel
40 x 36 cm. (15⅞ x 14⅛ in.)
National Gallery of Art, Washington, Samuel H. Kress Collection, 1939

25 X-radiograph of the *Annunciation*
National Gallery of Art, Washington

26 Early photograph of the *Annunciation* before restoration
Villa I Tatti, Harvard University Center for Italian Renaissance Studies, Florence

Baron Adolph de Meyer
27 *Isabella Stewart Gardner*, c. 1905
Photograph
19.7 x 15.8 cm. (7¾ x 6¼ in.)
Isabella Stewart Gardner Museum, Boston

Attributed to Raphael
28 *Portrait of a Young Man*
Oil on canvas
42.5 x 32.9 cm. (16¾ x 12¹⁵⁄₁₆ in.)
The Hyde Collection, Glens Falls, New York

29 Letter from Berenson to Mrs. Gardner about the *Portrait of a Young Man*, dated September 16, 1898
Isabella Stewart Gardner Museum, Boston

30 Early photograph of the version of the *Portrait of Tommaso Inghirami* in the Pitti Gallery, sent by Berenson to Mrs. Gardner
Isabella Stewart Gardner Museum, Boston

31 Joseph Widener's copy of *Noteworthy Paintings in American Private Collections* (New York, 1907)
Open to an illustration of *Tommaso Inghirami* at Fenway Court
National Gallery of Art, Washington

32 Early photograph of Raphael's *Lamentation*
Villa I Tatti, Harvard University Center for Italian Renaissance Studies, Florence

Edward Steichen
33 *J. Pierpont Morgan*
Photograph
33.8 x 26.8 cm. (13¼ x 10½ in.)
The Pierpont Morgan Library, New York

34 Joseph Widener's copy of *Pictures in the Collection of J. Pierpont Morgan* (London, 1907) Open to an illustration of the *Colonna Altarpiece* by Raphael National Gallery of Art Library, Washington

35 Early photograph of the West Room (Study) of The Pierpont Morgan Library, about 1910 The Pierpont Morgan Library, New York

36 Early photograph of a *Madonna and Child* mistakenly attributed to Raphael Villa I Tatti, Harvard University Center for Italian Renaissance Studies, Florence

After Raphael
37 *Holy Family* called the *Madonna of Loreto* Oil on panel transferred to canvas 115.6 x 87.3 cm. (45½ x 34⅜ in.) The Pierpont Morgan Library, New York

Raphael and Workshop
38 *Madonna of the Candelabra* Oil on panel 65.7 cm. vertical diam. (25⅞ in.) 64 cm. horizontal diam. (25¼ in.) Courtesy of the Walters Art Gallery, Baltimore

After Raphael
39 *Madonna of the Candelabra* Oil on panel 66.6 cm. diam. (26¼ in.) From the Collection of Mr. and Mrs. Bernard C. Solomon, Beverly Hills

40 *Catalogue of Paintings Forming the Private Collection of P. A. B. Widener* (1900) Open to an illustration of a copy of the *Portrait of Julius II* by Raphael National Gallery of Art Library, Washington

41 Julia Cartwright, *Raphael* (London/New York, 1905) Open to the frontispiece with the *Small Cowper Madonna* Villa I Tatti, Harvard University Center for Italian Renaissance Studies, Florence

42 Bernard Berenson, *Pictures in the Collection of P. A. B. Widener at Lynnewood Hall, Elkins Park, Pennsylvania: Early Italian and Spanish Schools* (Philadelphia, 1916) Open to an illustration of the *Small Cowper Madonna* National Gallery of Art Library, Washington

43 The Raphael Room at Lynnewood Hall Photograph enlarged from original National Gallery of Art, Washington

44 Newspaper clipping from *The New York Herald*, February 7, 1914, about the sale of the *Small Cowper Madonna* National Gallery of Art, Washington

45 Andrew Mellon's copy of *The Clarence H. Mackay Collection: The Italian Schools* (New York, 1926) Open to an illustration of the *Agony in the Garden* National Gallery of Art Library, Washington

46 Photograph of Andrew Mellon in his Washington apartment Lent by Paul Mellon, Upperville, Virginia

47 Colonel G. F. Young, *The Medici*, 3d. ed. (London, 1925; orig. ed. 1909) Open to the frontispiece with *Giuliano de' Medici* Villa I Tatti, Harvard University Center for Italian Renaissance Studies, Florence

48 Newspaper clipping from *The New York Times*, May 11, 1928, about the sale of the *Niccolini-Cowper Madonna* National Gallery of Art, Washington

49 *The Madonna di Gaeta: A Picture by Raphael. Treatises and Expertises* (Leipzig, n.d. [c. 1927-1930] Open to facing plates of the *Gaeta* and *Alba Madonnas* National Gallery of Art Library, Washington

50 Photograph of Samuel H. Kress, c. 1910 Samuel H. Kress Foundation, New York

51 *Duveen Pictures in Public Collections of America* (New York, 1941) Open to an illustration of *Bindo Altoviti* National Gallery of Art, Washington

Formation

Pietro Perugino
52 *Crucifixion with Saints*
Oil on panel transferred to canvas
Middle panel, 101.3 x 56.5 cm. (39⅞ x 22¼ in.)
Side panels, each, 95.2 x 30.5 cm. (37½ x 12 in.)
National Gallery of Art, Washington,
Andrew W. Mellon Collection, 1937

Raphael
53 *Saint Jerome Punishing the Heretic Sabinian*
Oil on panel
25.7 x 41.8 cm. (10⅛ x 16½ in.)
North Carolina Museum of Art, Raleigh

Raphael
54 *Portrait of Emilia Pia*
Oil on panel
42.5 x 28.5 cm. (16¾ x 11¼ in.)
The Baltimore Museum of Art,
The Jacob Epstein Collection

55 X-radiograph of the *Emilia Pia*
The Baltimore Museum of Art

Raphael
56 *Agony in the Garden*
Tempera and oil on panel
24.1 x 29.8 cm. (9½ x 11⅜ in.)
The Metropolitan Museum of Art, New York, Funds
from Various Donors, 1932

Raphael
57 Cartoon for the *Agony in the Garden*
Pen and brown ink, brown wash
22.6 x 26.5 cm. (8⅞ x 10⁷⁄₁₆ in.)
The Pierpont Morgan Library, New York

58 X-radiograph of the *Agony in the Garden*
The Metropolitan Museum of Art, New York

Florentine Engraver
59 *Agony in the Garden*
22.3 x 15.3 cm. (8¾ x 6 in.)
The Cleveland Museum of Art, Dudley P. Allen Fund

Florence

Eduard Mandel
60 Engraving after the *Small Cowper Madonna*
26.8 x 19.9 cm. (10½ x 7⅞ in.)
National Gallery of Art, Washington

Pietro Perugino
61 *Madonna and Child*
Oil on panel
70 x 51 cm. (27⅝ x 20 in.)
National Gallery of Art, Washington,
Samuel H. Kress Collection, 1939

Luca della Robbia
62 *Madonna and Child*
Tin-glazed earthenware relief
47 x 38.2 x 3.2 cm. (18½ x 15¼ x 1¼ in.)
Museum of Fine Arts, Boston, Gift of Quincy A.
Shaw through Quincy A. Shaw, Jr., and Mrs. Marion
Shaw Haughton

Raphael
63 *Small Cowper Madonna*
Oil on panel
59.5 x 44 cm. (23⅜ x 17⅜ in.)
National Gallery of Art, Washington,
Widener Collection, 1942

64 Infrared reflectogram of the *Small Cowper Madonna*
National Gallery of Art, Washington

Raphael
65 Study for the *Granduca Madonna*
Pen and ink with gray wash
21.3 x 18.8 cm. (8⅜ x 7⅜ in.)
Gabinetto Disegni e Stampe degli Uffizi, Florence

Master of the Northbrook Madonna
66 *Virgin and Child (Northbrook Madonna)*
Oil on panel
58 x 42.7 cm. (22¹³⁄₁₆ x 16¹³⁄₁₆ in.)
Worcester Art Museum, Theodore T. and Mary G.
Ellis Collection, 1940

Lucas Vorsterman, after Raphael
67 *Saint George and the Dragon*
Engraving
33.7 x 25.2 cm. (13³/₁₆ x 9⅞ in.)
Trustees of the British Museum, London

Lucas Vorsterman, after Raphael
68 *Saint George and the Dragon*
Counterproof of the engraving
30.3 x 21.8 cm. (11⅞ x 8½ in.)
Trustees of the British Museum, London

Peter Oliver, after Raphael
69 *Saint George and the Dragon*
Gouache on vellum
21.9 x 16.5 cm. (8⅝ x 6½ in.)
H.M. Queen Elizabeth II, Royal Collection,
Windsor Castle

Leonardo da Vinci
70 *Studies of Saint George and the Dragon*
Pen and ink with black chalk
29.8 x 21.2 cm. (11¾ x 8⅜ in.)
H.M. Queen Elizabeth II, Royal Collection,
Windsor Castle

Fra Bartolomeo
71 *Saint George and the Dragon*
Black chalk
33.5 x 27.5 cm. (13⅛ x 10⅞ in.)
Museum Boymans-van Beuningen, Rotterdam

Gerard Edelinck (?), after Rubens' copy of
72 Leonardo's *Combat for the Standard*
Brown and gray wash
45.3 x 64 cm. (17⅞ x 25³/₁₆ in.)
The Fogg Art Museum, Harvard University,
Cambridge, Gift of Edward W. Forbes

Here attributed to Raphael
73 *Study of Saint George*
Metalpoint on off-white paper
26.4 x 23.3 cm. (10⅜ x 9⅛ in.)
Lent by the Visitors of the Ashmolean Museum,
Oxford

Anonymous sixteenth-century engraver, after Raphael
74 *Saint George and the Dragon*
22.2 x 26 cm. (8¹¹/₁₆ x 10 ³/₁₆ in.)
Graphische Sammlung Albertina, Vienna

Raphael
75 *Saint George and the Dragon*
Black chalk, brown wash, and white heightening
24.4 x 20 cm. (9⅝ x 7⅞ in.)
National Gallery of Art, Washington

Raphael
76 Cartoon for *Saint George and the Dragon*
Black chalk, pen and brown ink
26.4 x 21.3 cm. (10⅜ x 8⅜ in.)
Gabinetto Disegni e Stampe degli Uffizi, Florence

Raphael
77 *Saint George and the Dragon*
Oil on panel
28.5 x 21.5 cm. (11⅛ x 8⅜ in.)
National Gallery of Art, Washington,
Andrew W. Mellon Collection, 1937

Hans Memling
78 *Saint Veronica*
Oil on panel
31.1 x 24.2 cm. (12¼ x 9½ in.)
National Gallery of Art, Washington,
Samuel H. Kress Collection, 1952

Sassoferrato, after Raphael
79 *Madonna of the Pinks*
Oil on canvas
74.9 x 60.3 cm. (29½ x 23¾ in.)
The Detroit Institute of Arts,
Gift of James E. Scripps

Raphael
80 *Study of a Madonna and Child*
Pen and ink
15.7 x 9.1 cm. (6³/₁₆ x 3⁹/₁₆ in.)
Gabinetto Disegni e Stampe degli Uffizi, Florence

Raphael
81 *Niccolini-Cowper Madonna*
Oil on panel
81 x 57 cm. (31¾ x 22⅝ in.)
National Gallery of Art, Washington,
Andrew W. Mellon Collection, 1937

Raphael
82 *Studies of a Madonna and Child*
Pen and brown ink
32.8 x 31.2 cm. (13 x 12⅜ in.)
Ecole Nationale Supérieure des Beaux-Arts, Paris

Raphael

83 *Madonna and Child with an Angel*
Pen and brown ink
20.6 x 22.7 cm. (8¹/₁₆ x 8⁷/₈ in.)
Trustees of the British Museum, London

Raphael

84 *Sketch of Putti at Play*
Pen and brown ink
14.5 x 21.4 cm. (5³/₄ x 8¹/₂ in.)
The Governing Body, Christ Church, Oxford

Rome

Raphael

85 *Massacre of the Innocents*
Pen and brown ink
23.2 x 37.7 cm. (9¹/₈ x 14³/₄ in.)
Trustees of the British Museum, London

Marcantonio Raimondi, after Raphael

86 *Massacre of the Innocents*
Engraving
27.7 x 43.3 cm. (10⁷/₈ x 17 in.)
National Gallery of Art, Washington

Orazio Fontana, after Marcantonio's print

87 *Massacre of the Innocents*
Maiolica plate
3 x 41 cm. (1¹/₄ x 16¹/₈ in.)
Musée du Louvre, Paris

After Raphael

88 *Sketch of a Madonna and Child with the Infant Saint John*
Pen and brown ink
18.1 x 16.9 cm. (7¹/₈ x 6⁵/₈ in.)
Trustees of the British Museum, London

Raphael

89 *Figure Studies for the* Parnassus
Metalpoint on pink prepared paper
28.8 x 18.3 cm. (11³/₈ x 7¹/₄ in.)
Trustees of the British Museum, London

Biagio Pupini

90 *Holy Family with Saint John*
Brown wash, white and gray gouache, black chalk
38.7 x 25.4 cm. (15⁵/₁₆ x 10¹/₈ in.)
Cabinet des Dessins, Musée du Louvre, Paris

Raphael

91 *Study of the Infant Saint John*
Metalpoint on cream-colored paper
11.5 x 10.4 cm. (4¹/₂ x 4¹/₈ in.)
Museum Boymans-van Beuningen, Rotterdam

Raphael

92 *Alba Madonna*
Oil on panel transferred to canvas
94.5 cm. diam. (37¹/₄ in. diam.)
National Gallery of Art, Washington,
Andrew W. Mellon Collection, 1937

Cesare da Sesto

93 *Studies of the Madonna and Child with Saint John*
Metalpoint, pen and brown ink
16.9 x 17.3 cm. (6⁵/₈ x 6¹³/₁₆ in.)
Trustees of the British Museum, London

Cesare da Sesto

94 *Studies of the Madonna and Child with Saint John*
Metalpoint, red chalk, pen and ink
13.3 x 20.3 cm. (5¹/₄ x 8 in.)
H.M. Queen Elizabeth II, Royal Collection, Windsor
Castle

Cesare da Sesto

95 *Studies of the Madonna and Child with Saint John*
Metalpoint, pen and ink
17.2 x 13 cm. (6¹³/₁₆ x 5⁵/₁₆ in.)
Cabinet des Dessins, Musée du Louvre, Paris

Ferdinand Piloty, after Raphael's

96 *Bindo Altoviti*
Lithograph
56.4 x 41.2 cm. (22¹/₈ x 16¹/₈ in.)
Trustees of the British Museum, London

Agostino Veneziano

97 *Figures from Raphael's* School of Athens
Engraving
43.8 x 32.4 cm. (17¹/₄ x 12³/₄ in.)
Trustees of the British Museum, London

Raphael

98 *Bindo Altoviti*
Oil on panel
60 x 44 cm. (23¹/₂ x 17¹/₄ in.)
National Galley of Art, Washington,
Samuel H. Kress Collection, 1943

99 Reversed photocopy of a plate from Schaaffhausen's
Schädel Raphaels of 1883, showing Raphael's skull

100 Photocopy of a plate from Welcker's "Schädel
 Rafael's" of 1884, showing the skull imposed on a
 profile version of *Bindo Altoviti*

 Jean-Auguste-Dominque Ingres
101 *The Betrothal of Raphael to the Niece of Cardinal
 Bibbiena*
 Oil on canvas
 59 x 46 cm. (23⁵⁄₁₆ x 18⁵⁄₁₆ in.)
 Courtesy of the Walters Art Gallery, Baltimore

 Jean-Auguste-Dominique Ingres
102 *The Betrothal of Raphael to the Niece of Cardinal
 Bibbiena*
 Black lead with white heightening
 23.4 x 18.9 cm. (9⁵⁄₁₆ x 7¹⁄₂ in.)
 Cabinet des Dessins, Musée du Louvre, Paris

 Photocopy of an engraving after Ingres'
103 *Self-Portrait at the Age of Twenty-Four*
 in *Oeuvres de J. A. Ingres* (Paris, 1851)
 Yale University Library, New Haven